TROPE
CITY
EDITION

VOLUME II

NO. 1

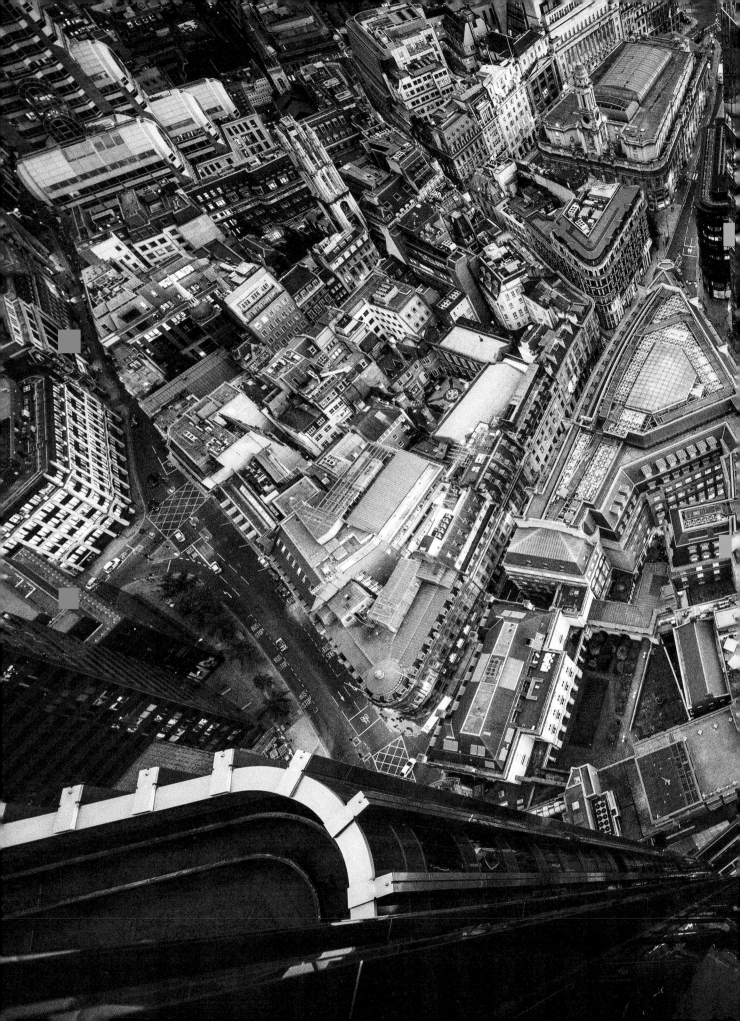

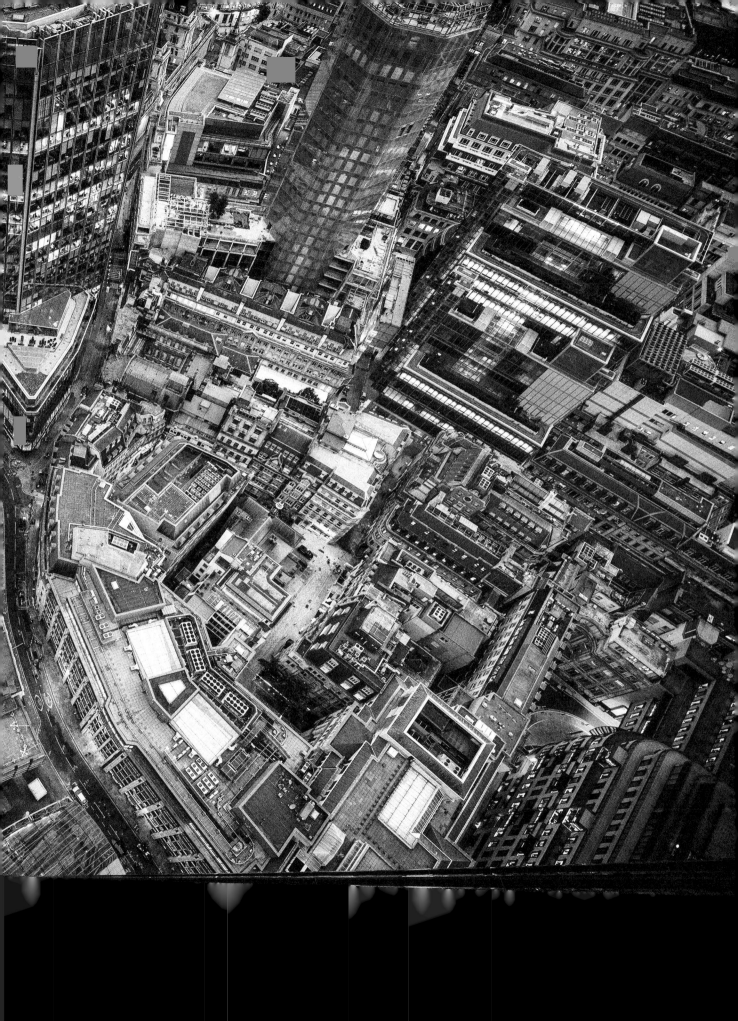

Cover: View from Westminster Bridge, north side « Ron Timehin
Previous Spread: View from Tower 42, looking southwest « Max Leitner

TROPE
CITY

EDITION

LONDON

VOLUME II

NO. 1

**EDITED
BY**

SAM
LANDERS
&
TOM
MADAY

THE TROPE CITY EDITION IS PART OF AN URBAN BOOK SERIES THAT SHOWCASES CONTEMPORARY
PHOTOGRAPHIC IMAGES CREATED BY EMERGING PHOTOGRAPHERS FROM CITIES AROUND THE WORLD.

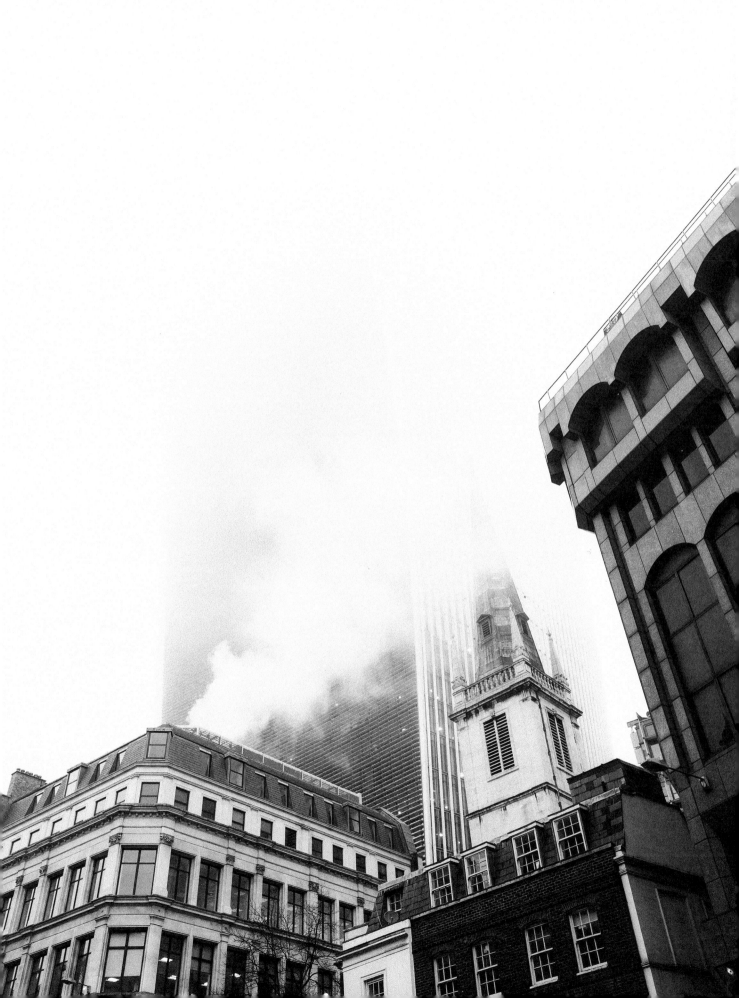

LCCN: 2018907480
ISBN: 978-1-7320618-1-1

Printed and bound in Latvia
First printing, 2019

Trope Publishing Co.
WWW.TROPE.COM

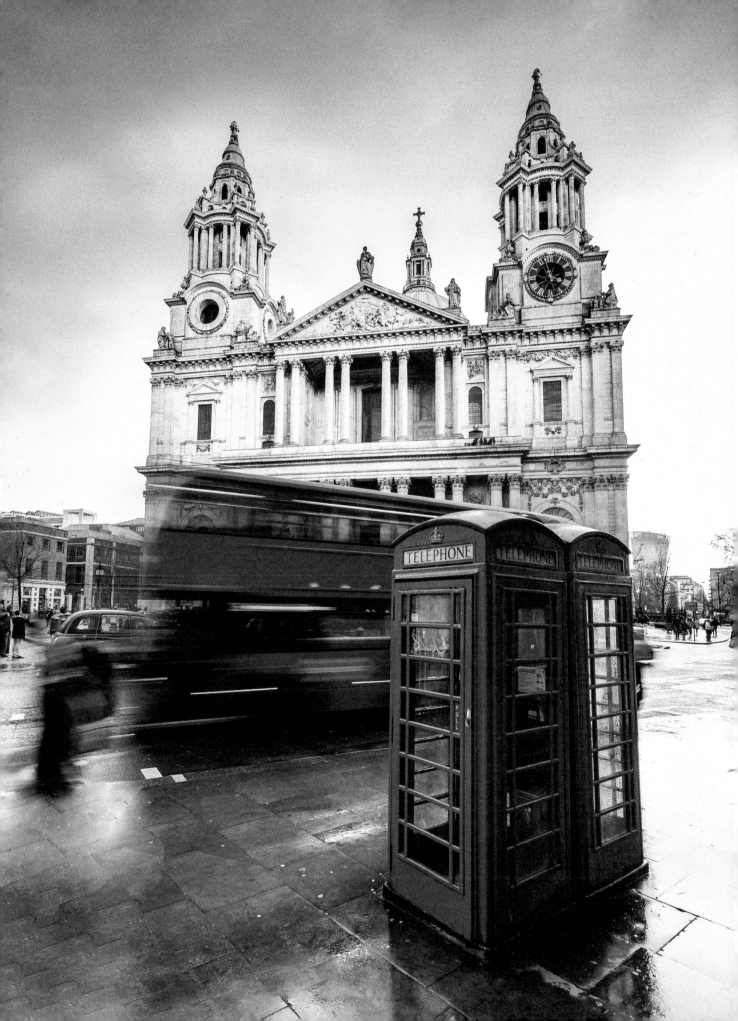

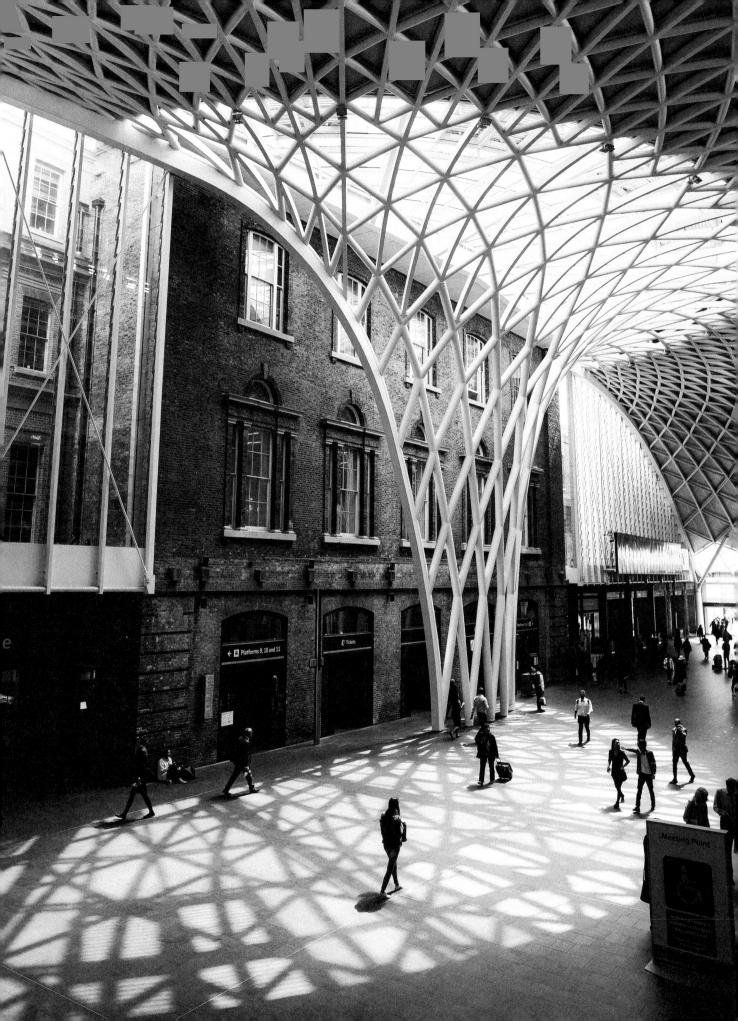

INTRODUCTION

The Trope City Edition series is a curated collection of urban images taken by photographers from around the world. The London Edition is the second title in the series, comprised of 199 photographs produced by 14 independent photographers from London and beyond. Editors Sam Landers and Tom Maday identified and met with the photographers, meticulously editing their portfolios to produce this unique edition. Whilst the photographers come from a wide range of backgrounds, they share a common passion to visually capture this historic city. Whether shooting during the day or at night, in good weather or rain and fog, they all pursue "the shot," and the resulting images offer a perspective of the city that few Londoners experience, representing a distinctively urban view of the city.

The London Edition is divided into nine chapters, primarily focused in the central city area, showcasing iconic London buildings and streets. Each chapter is accompanied by a map of the area along with the locations where the photographs were taken. The collection is first and foremost about photography, and the images reflect the interests of the photographers rather than serving as a comprehensive guide to the city. In many cases, there are several photographs of the same location, shot at different times of the day, in different seasons, with different tones. These studies offer a strong point-of-view, whether digitally processed, filtered, toned, or sharpened - giving each image a contemporary and urban sensibility.

London is truly a city of contrasts: old and new, orderly and chaotic, traditional and modern. It is said that London grew, not by planning, but by swallowing up the countryside village by village. The evidence is in the complexity of London's meandering streets, where modern structures sit quite comfortably next to 18th-century Georgian architecture. The at-times chaotic arrangement, with its tangled streets that change name or direction without much warning, invites and rewards those willing to get lost. A wrong turn can lead to provocative street art in the Waterloo Tunnel, medieval architecture in the City, and historic pubs tucked away on the most unassuming corners. London reveals itself ever so slowly, making for perhaps one of the world's most walkable cities - and a mecca for photographers from around the globe.

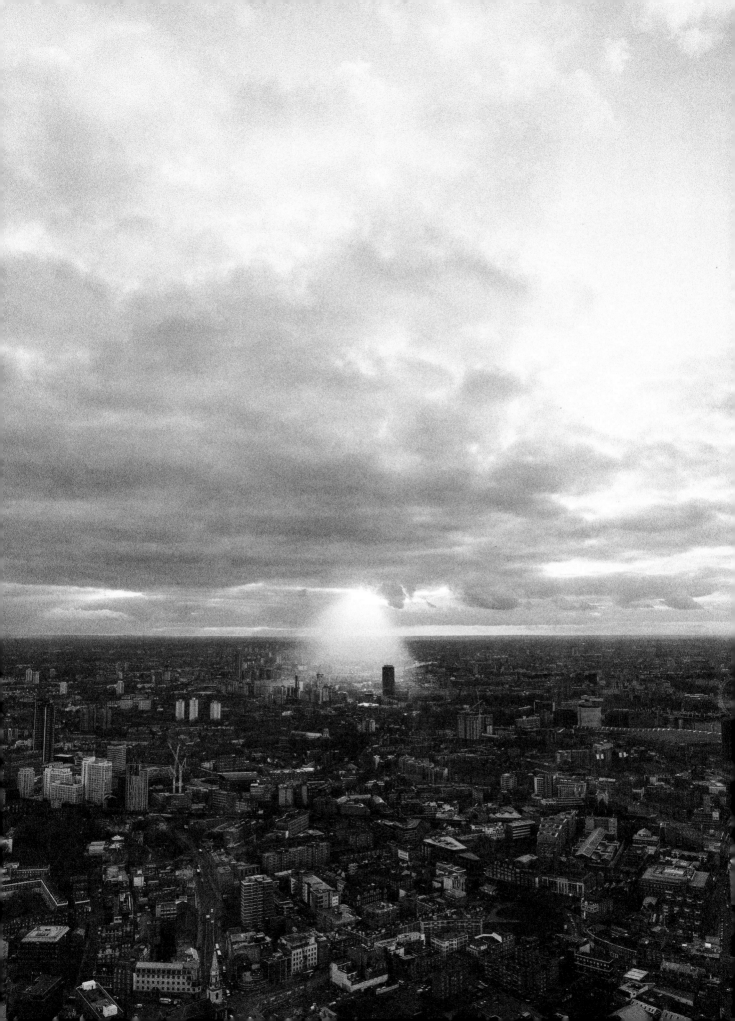

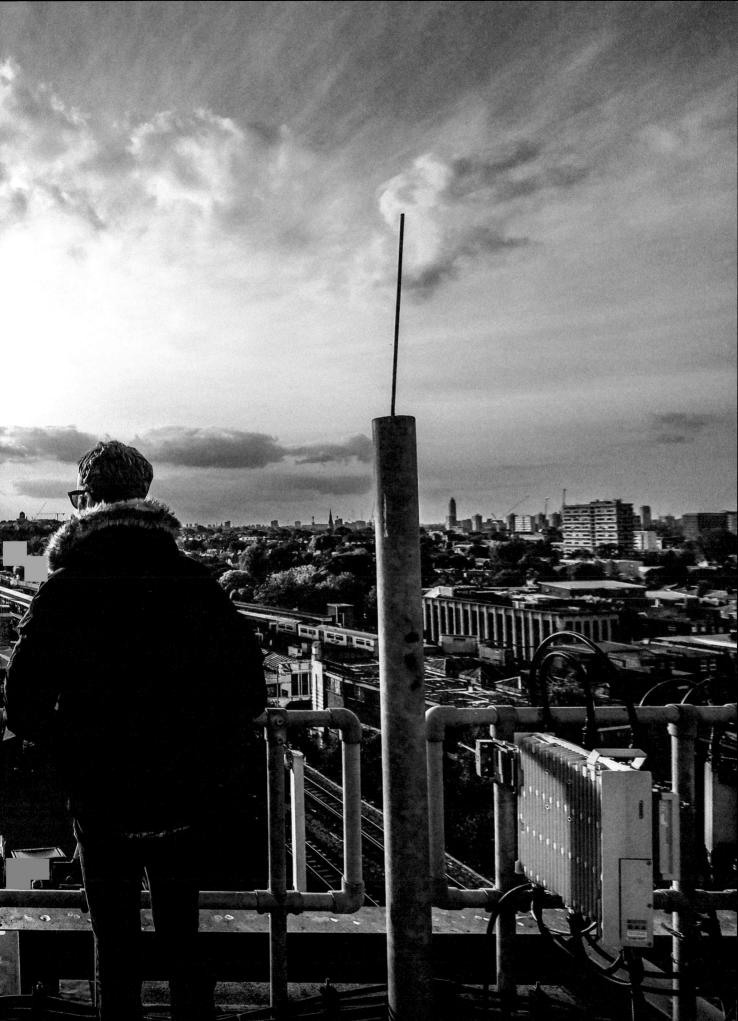

River Thames

Two hundred and fifteen miles end to end, England's longest river famously snakes right through the heart of central London. Once the backbone of the capital and a major trade route, the River Thames holds much of London's history in its tidal and non-tidal currents. ✚ Twenty-one tributaries, largely unknown to most city dwellers, feed somewhat secretly into the capital's main line. Starting as early as the 1460s, the waterways were seen as filthy and inconvenient, and were paved over to make way for London's mass expansion. Today, nearly two-thirds of the River Thames' branches in Greater London are covered, however they are still flowing — spotted by knowing eyes as they course discreetly through culverts and under grating. ✚ A 180-mile footpath jogs alongside the majority of the river, travelling from lush meadows and rural villages to the centre of the city and right past some of London's most famous icons. One of the river's more recent additions, a 135-metre tall cantilevered wheel of steel and glass known as the London Eye was launched in 2000 as a temporary structure, but its near-universal popularity earned it a permanent place on the banks of the River Thames.

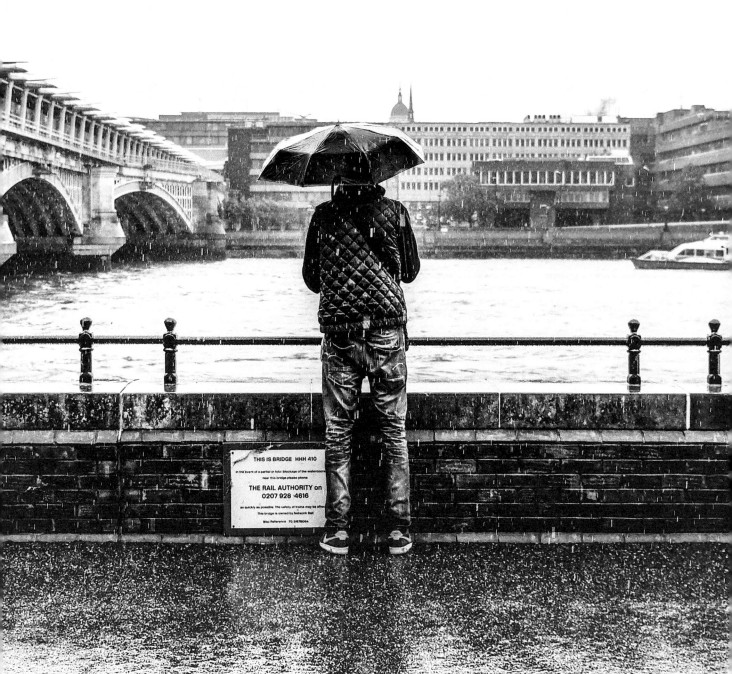

THIS IS BRIDGE HHH 410

In the event of a partial or total blockage of the watercourse
near this bridge please phone

THE RAIL AUTHORITY on
0207 928 4616

as quickly as possible. The safety of trains may be affected

This bridge is owned by Network Rail

Map Reference TQ 31578064

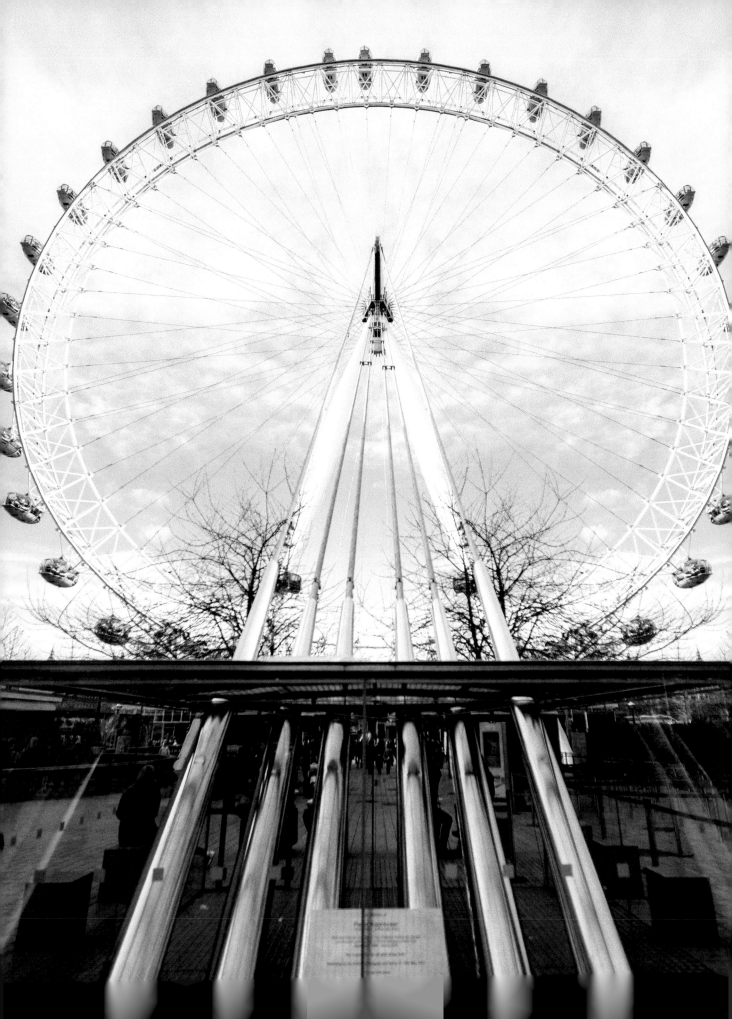

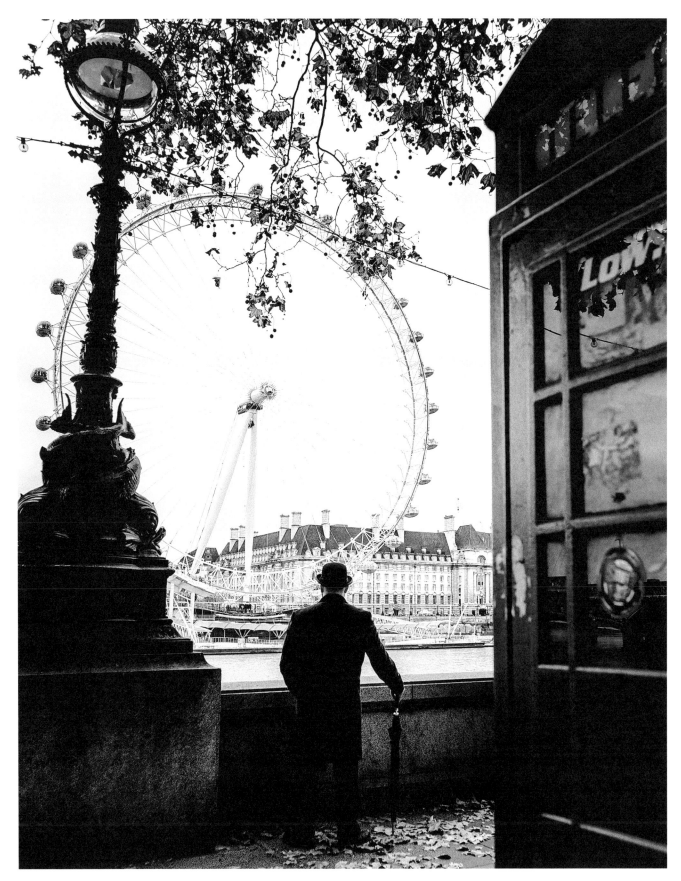

1 Previous Page: Thames Path at Blackfriars Railway Bridge, looking north
2 Left: Base of the London Eye, looking west
3 Above: Victoria Embankment at Horse Guards Avenue, looking southeast

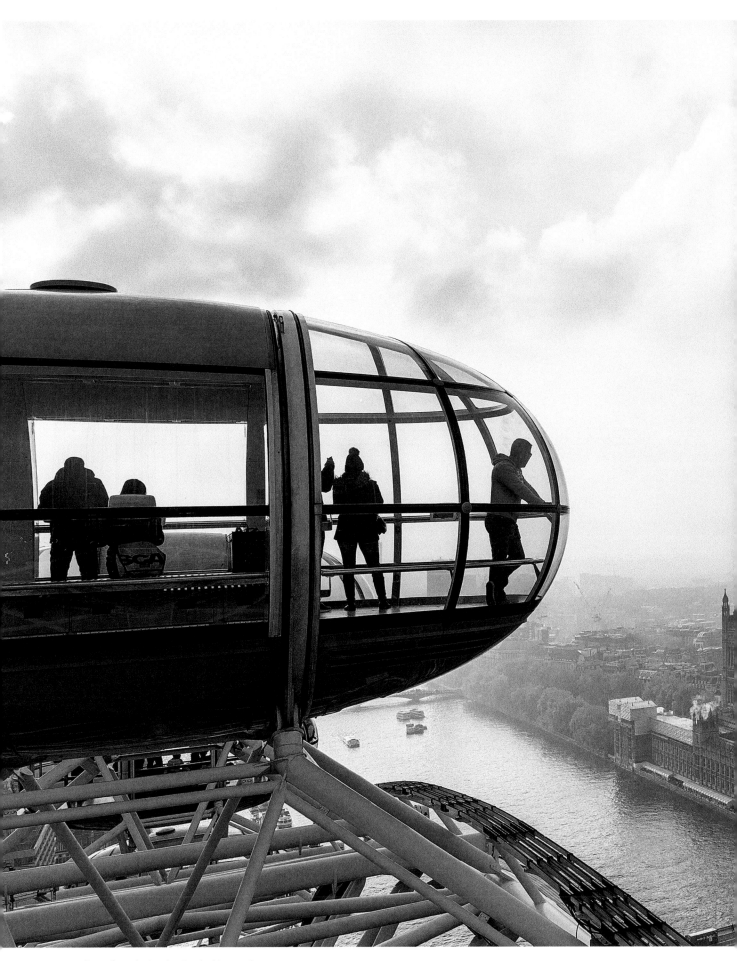

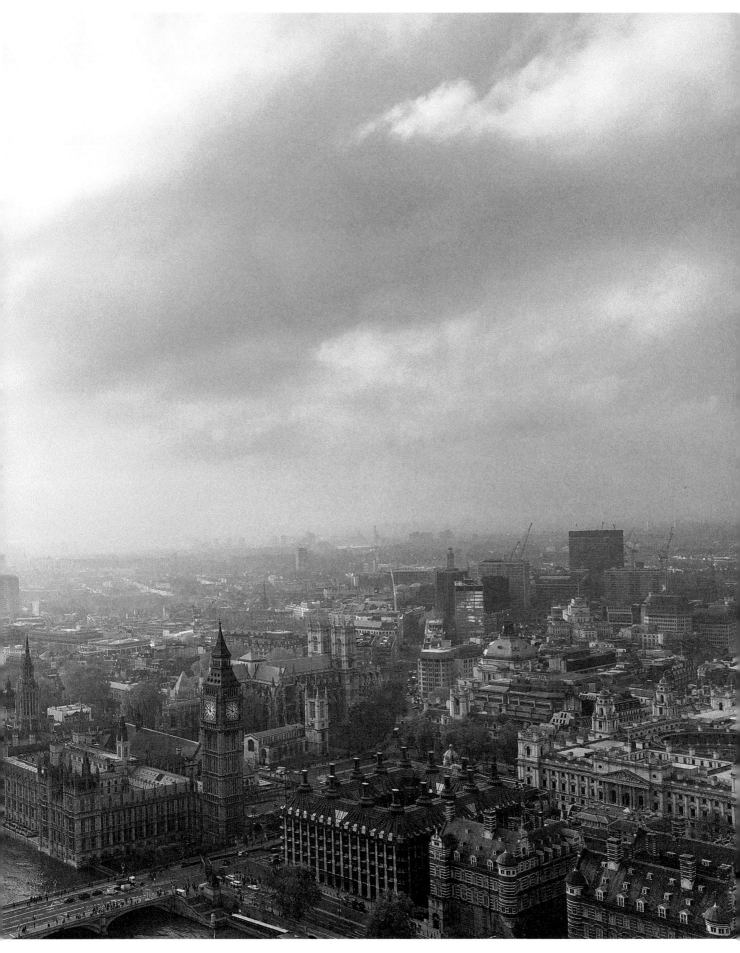

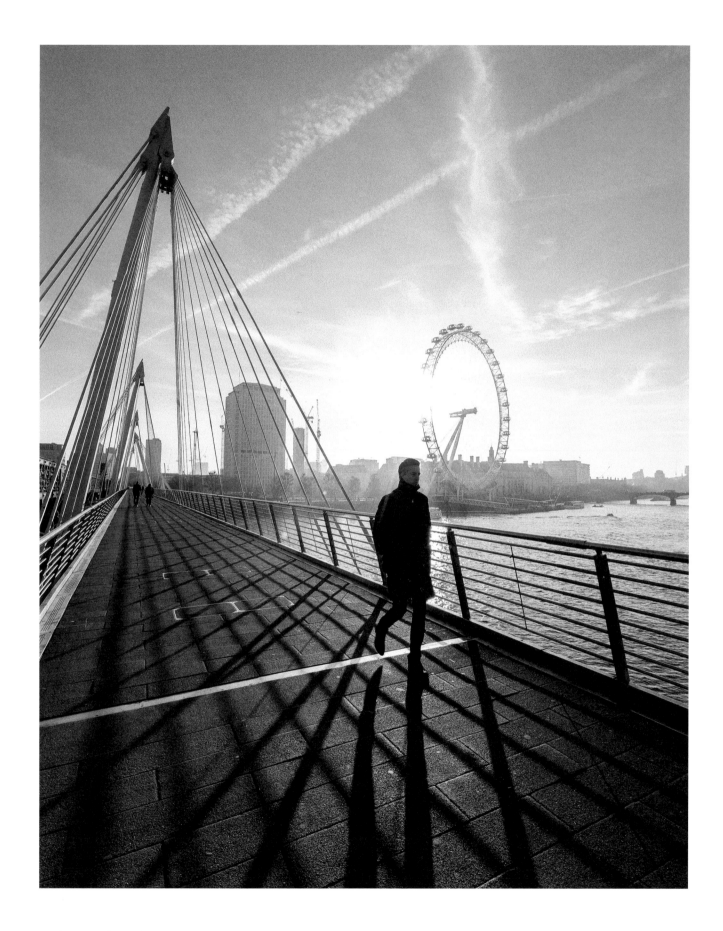

5 Above: View from Golden Jubilee Bridges, looking southeast
6 Right: Victoria Embankment south of the Royal Air Force Memorial, looking east

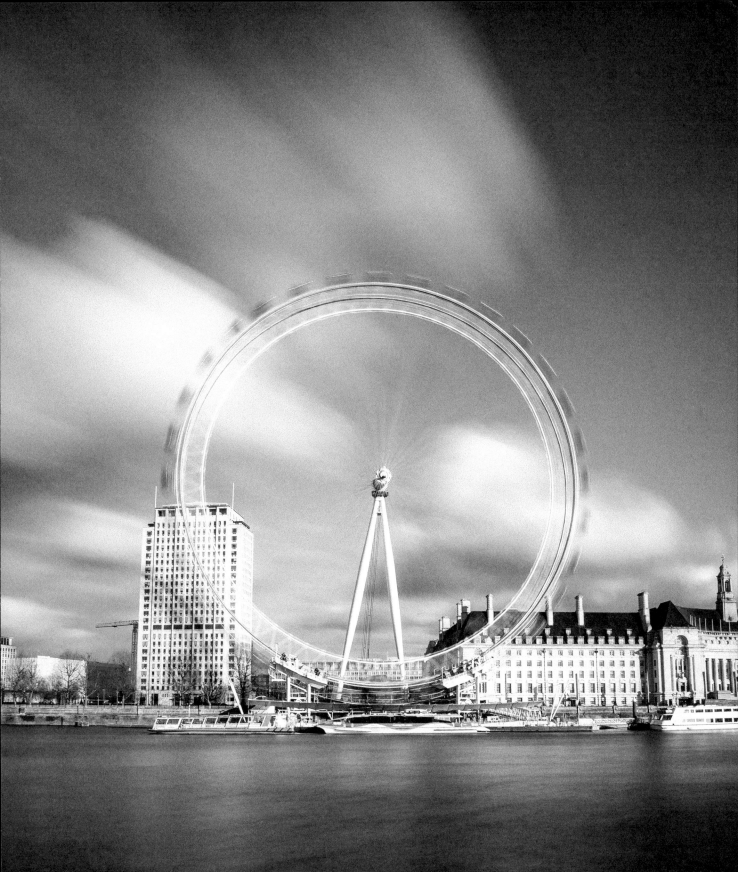

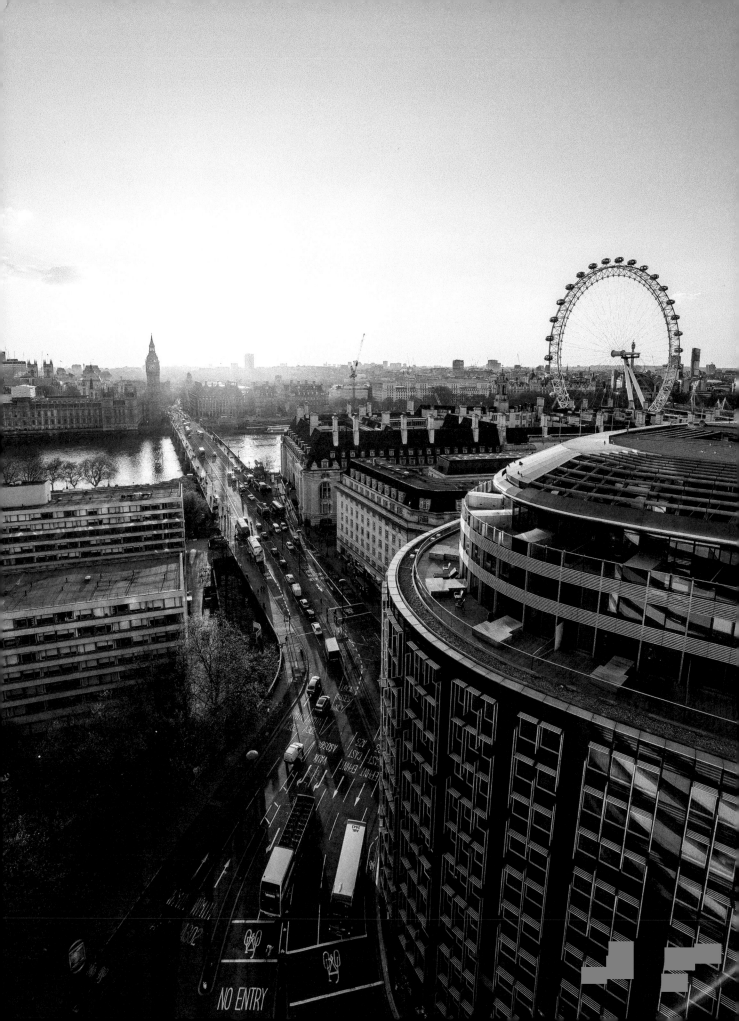

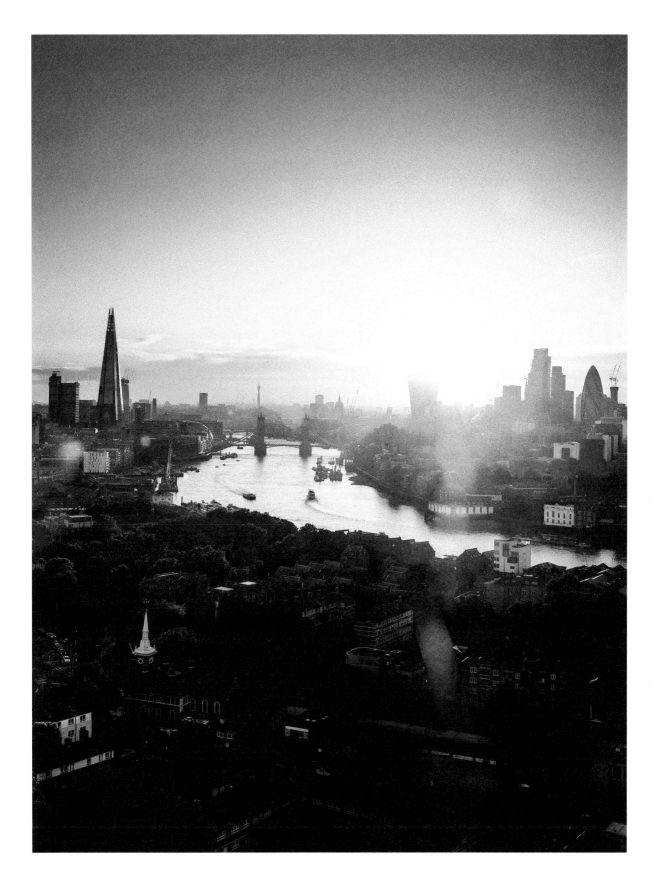

7　Left: Aerial view from Lambeth Palace and Westminster Bridge Roads, looking west

8　Above: View from Canada Water, looking west

9　Following Spread: View from the London Eye capsule, looking southwest

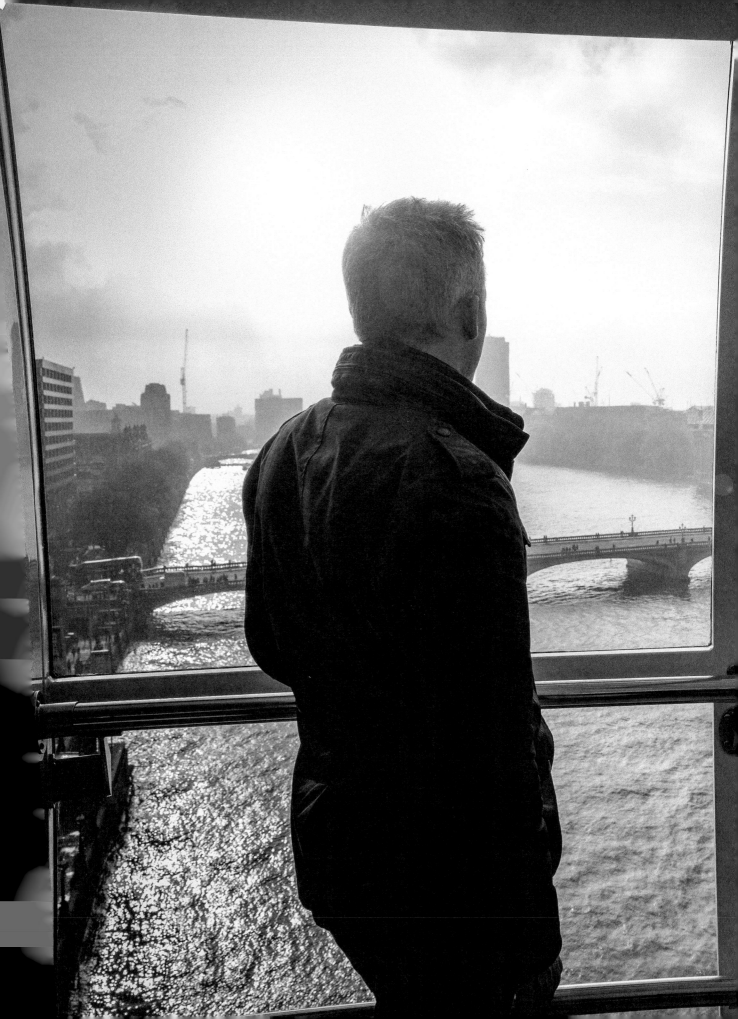

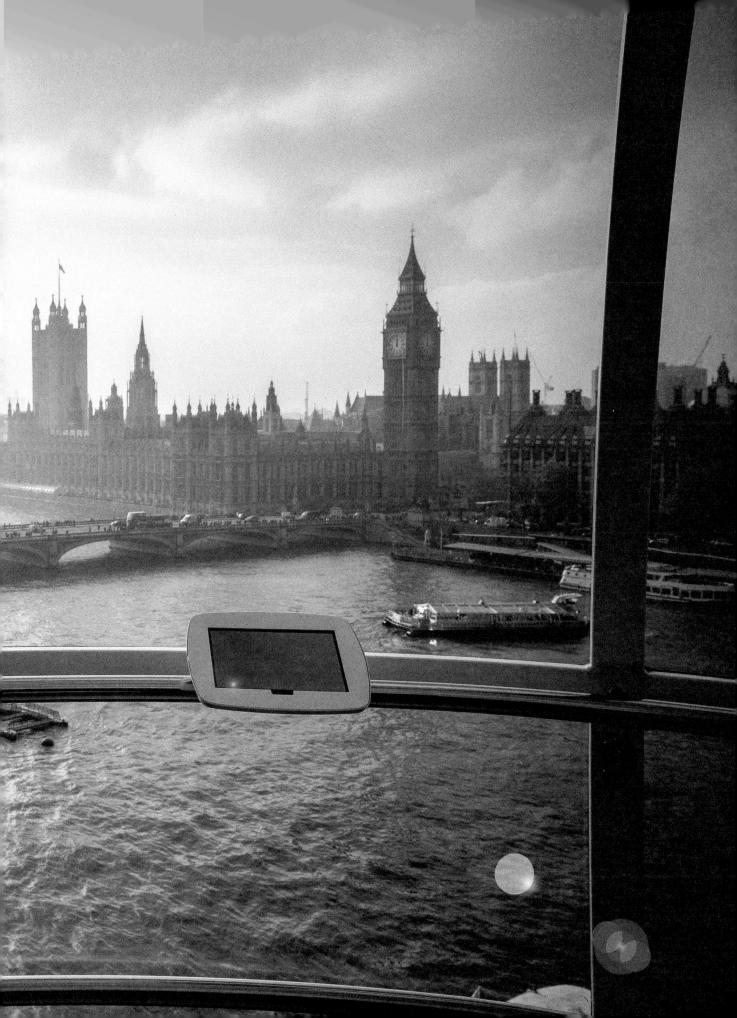

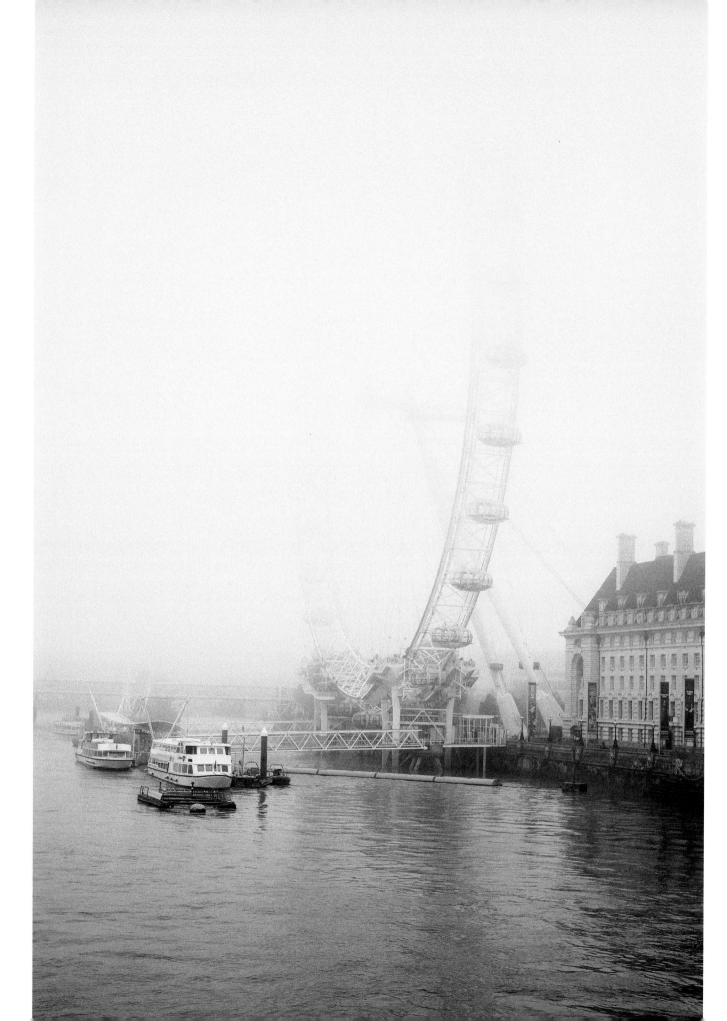

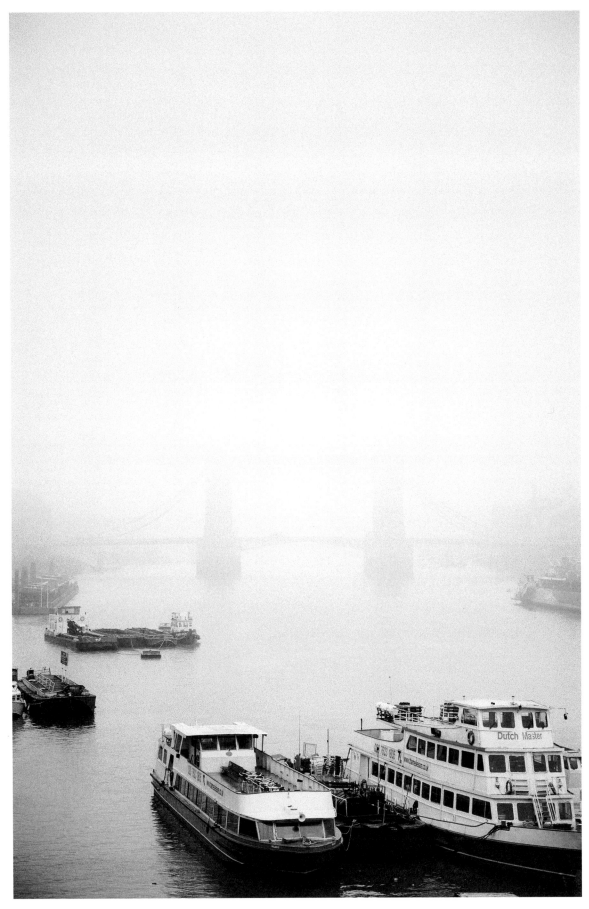

10 Left: View of the London Eye from Westminster Bridge, looking north

11 Above: View from London Bridge, looking east

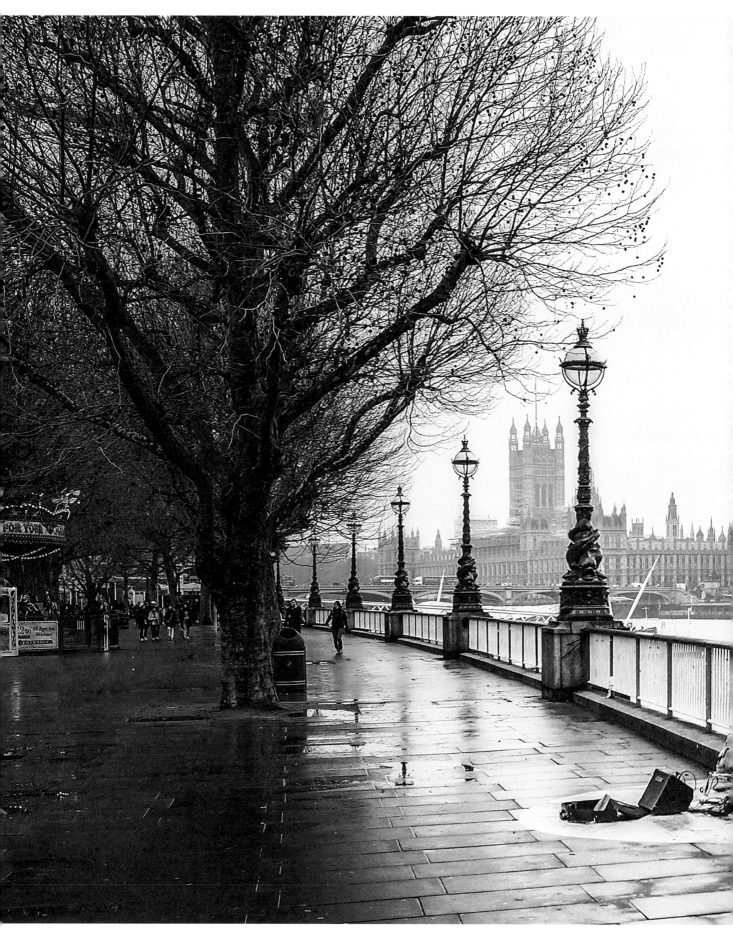

12 Above: South Bank at the Golden Jubilee Bridges, looking southwest
13 Following Spread: View from the London Eye capsule, looking southwest

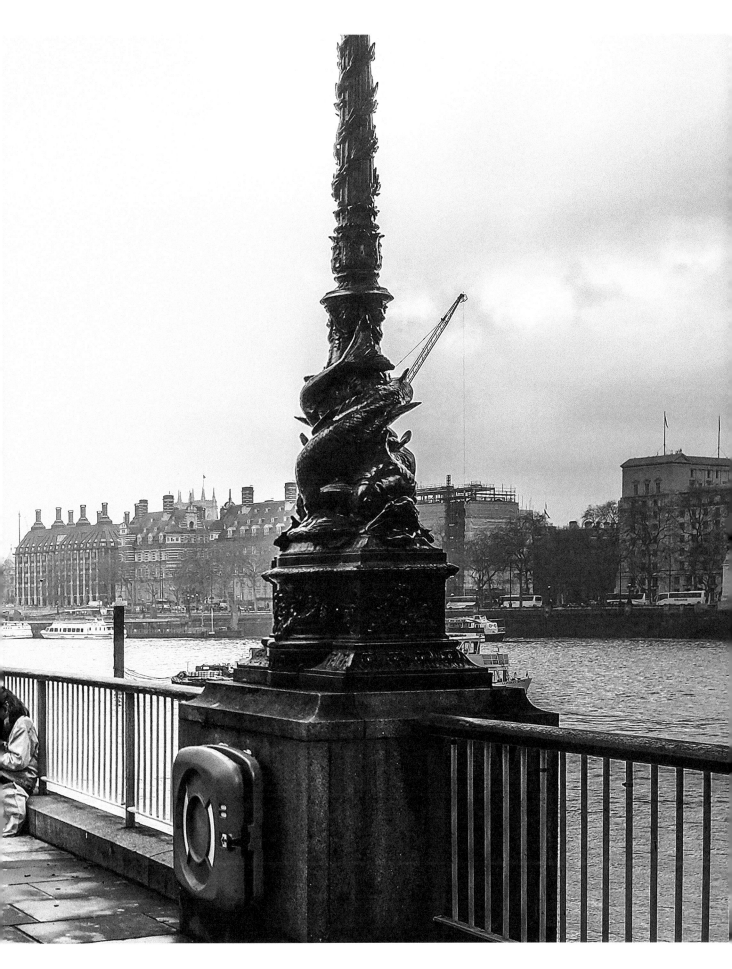

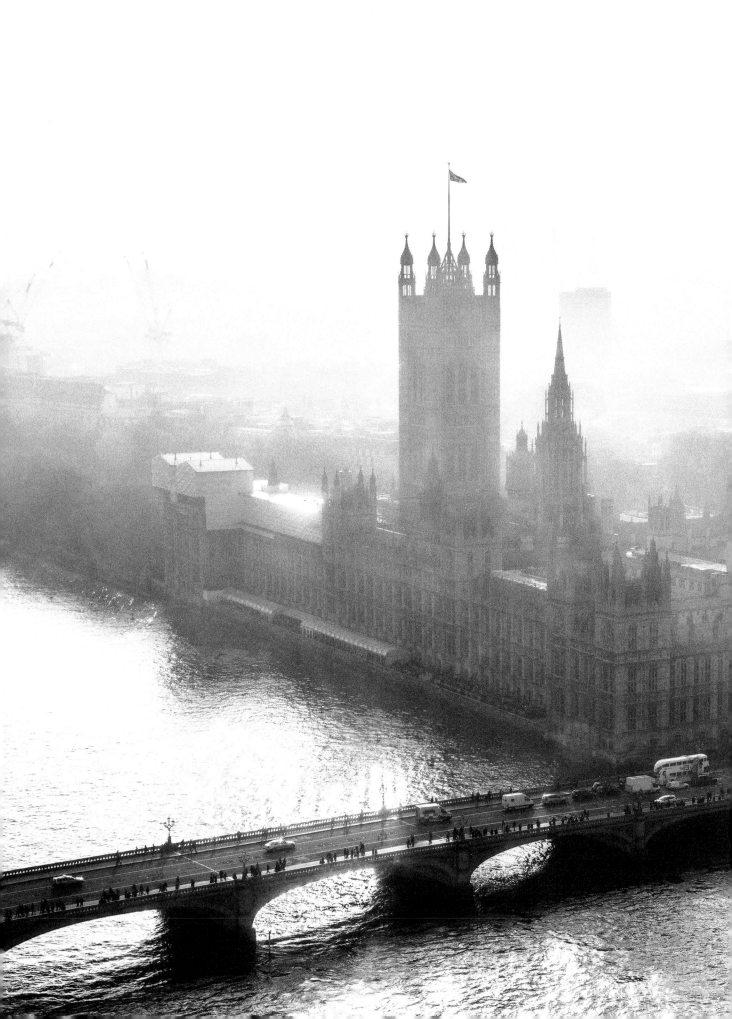

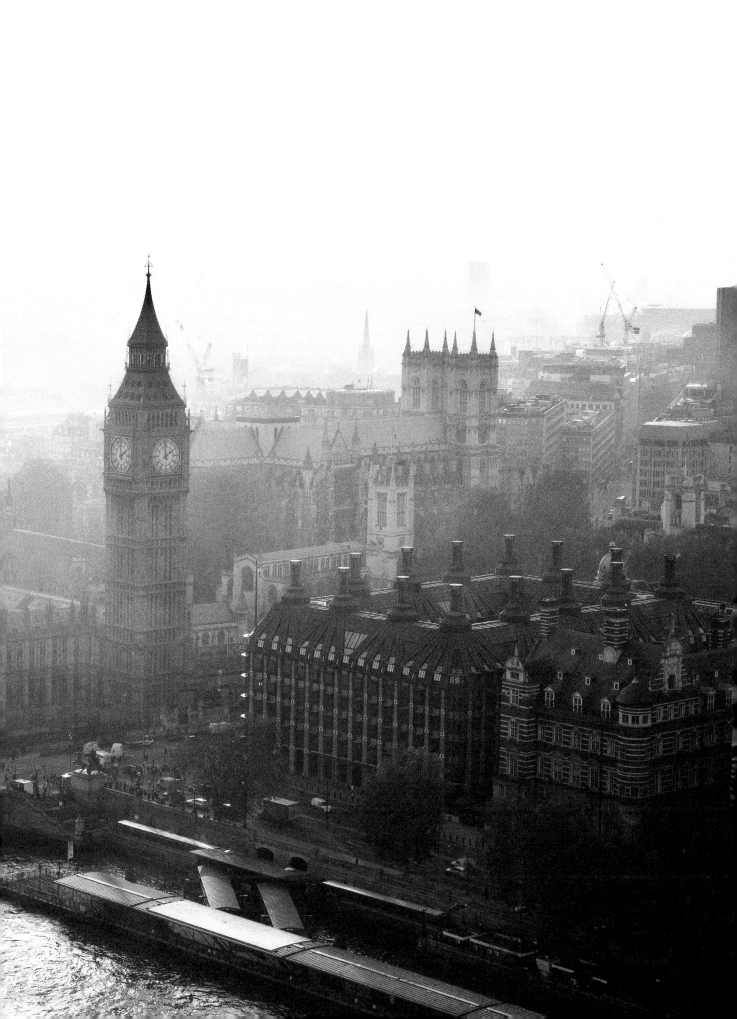

This melancholy London – I sometimes imagine that the souls of the lost are compelled to walk through its streets perpetually. One feels them passing like a whiff of air.

WILLIAM BUTLER YEATS

Poet

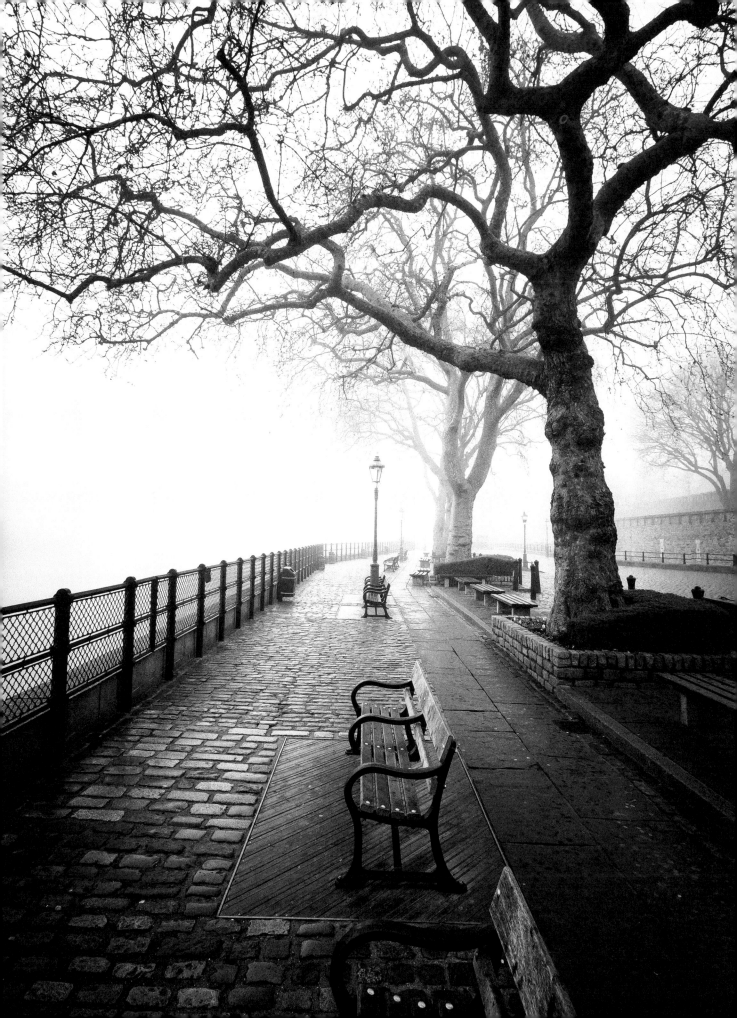

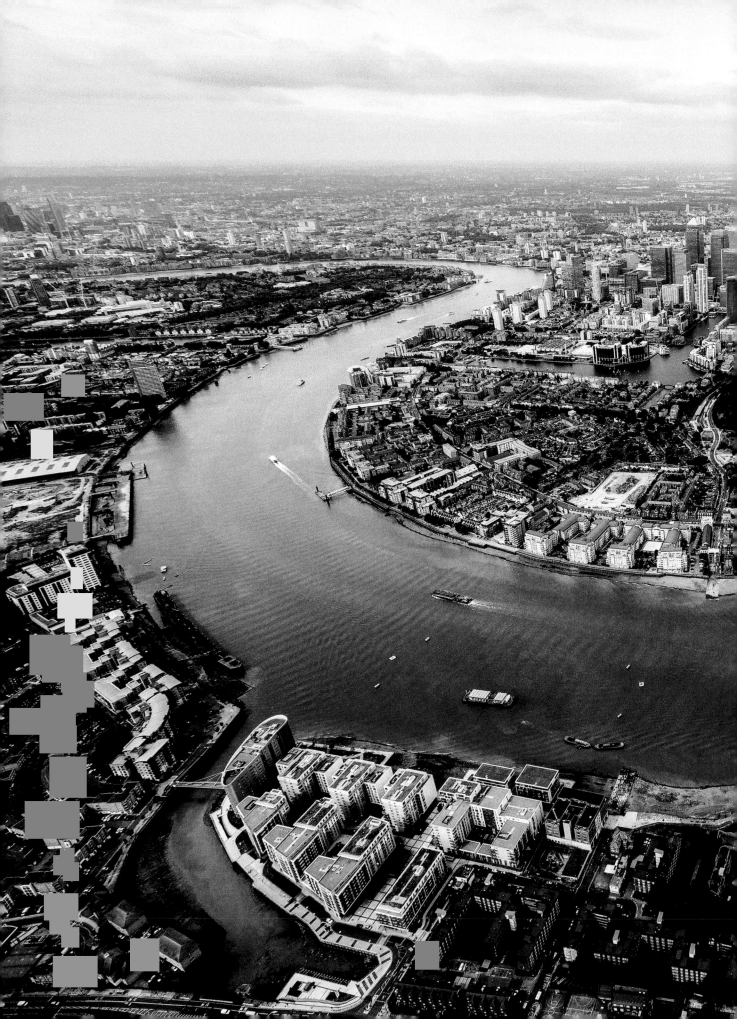

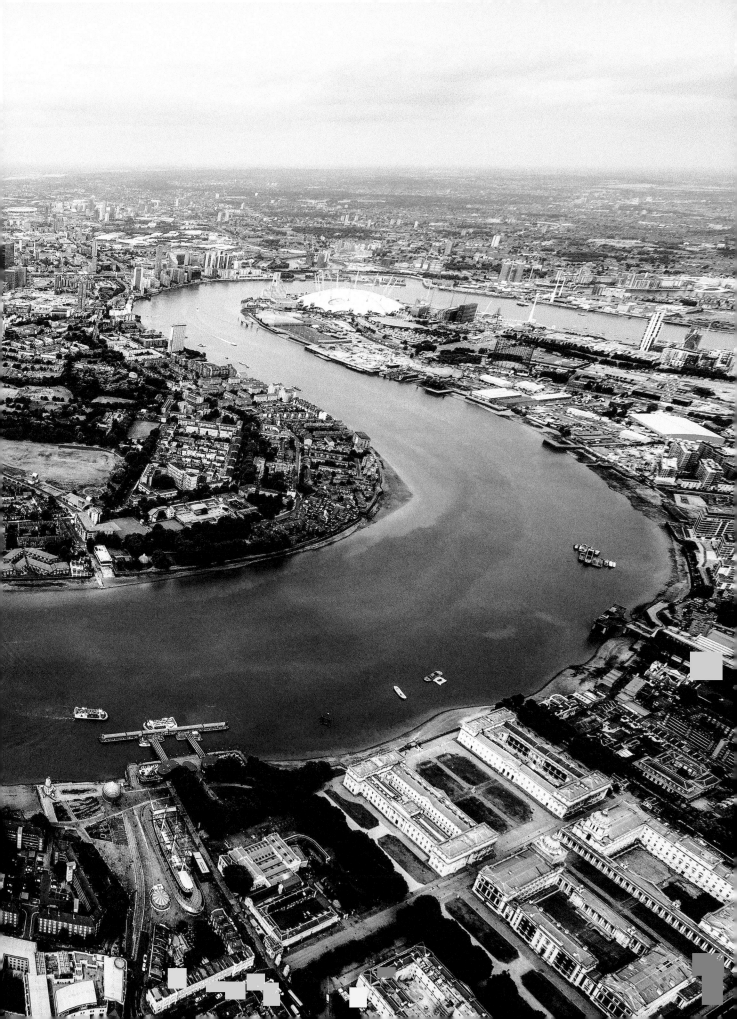

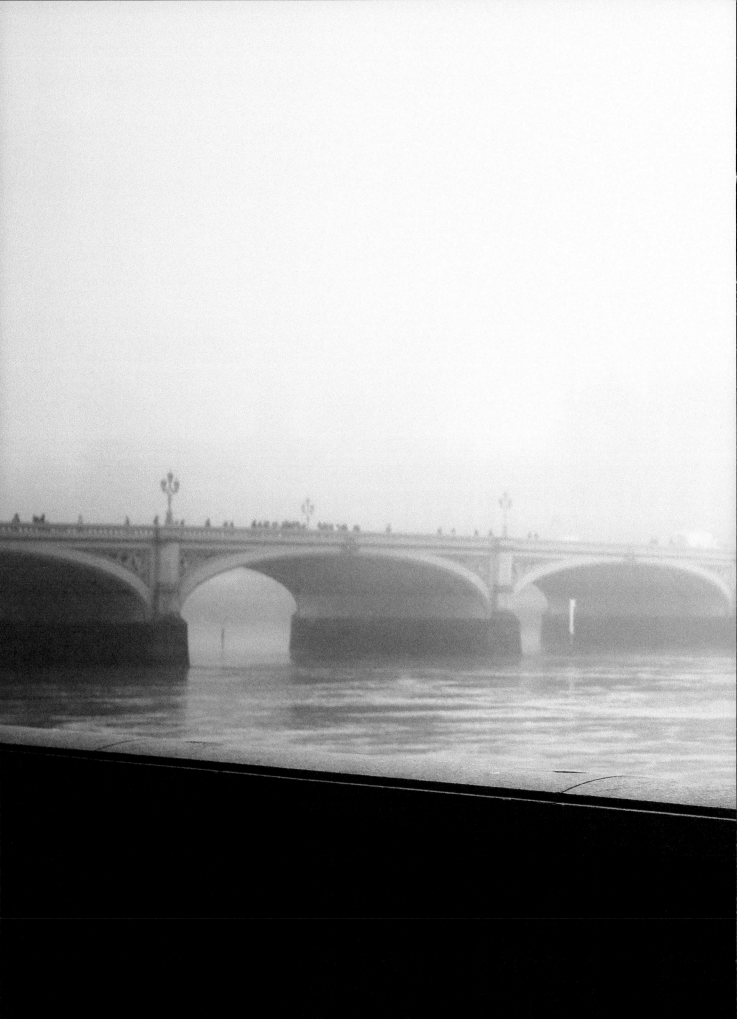

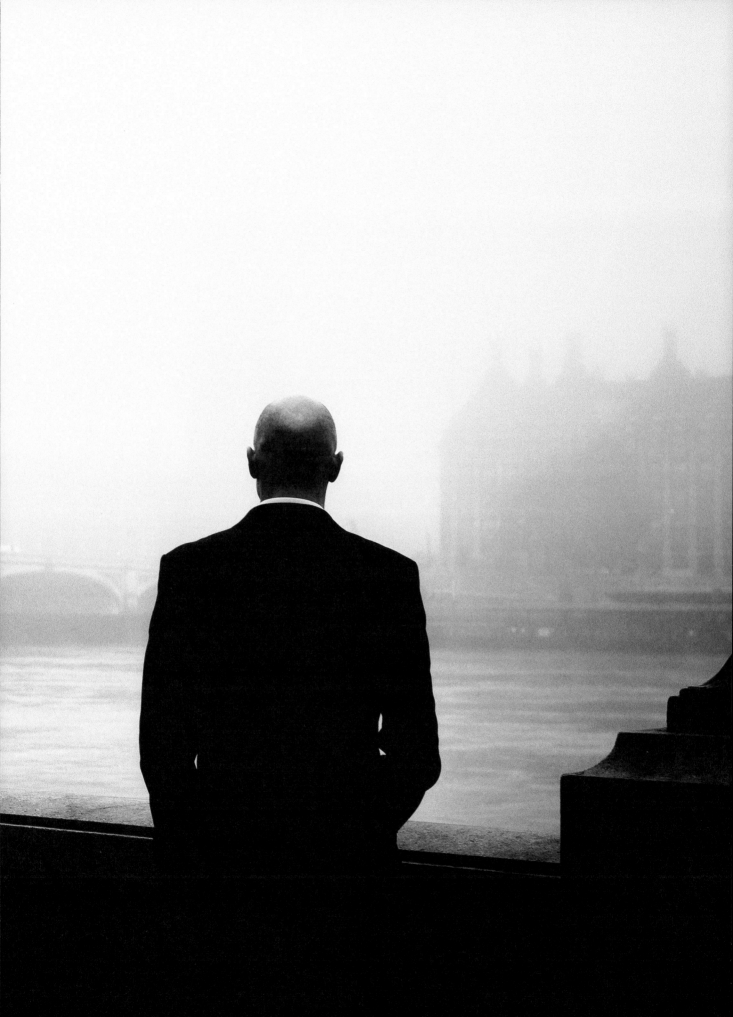

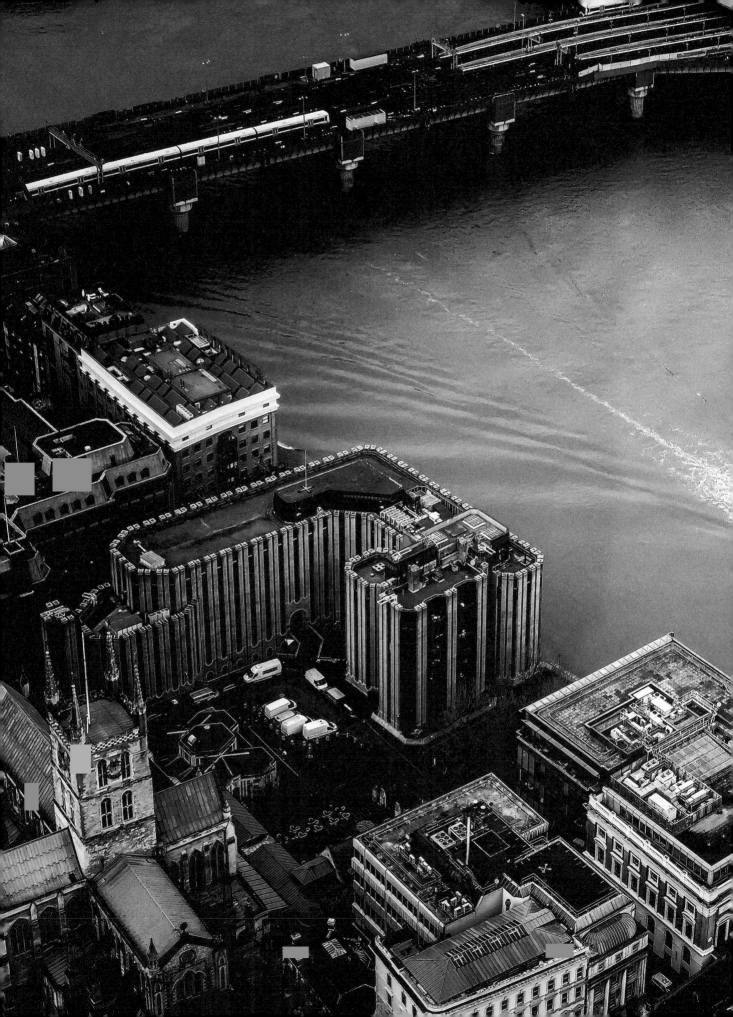

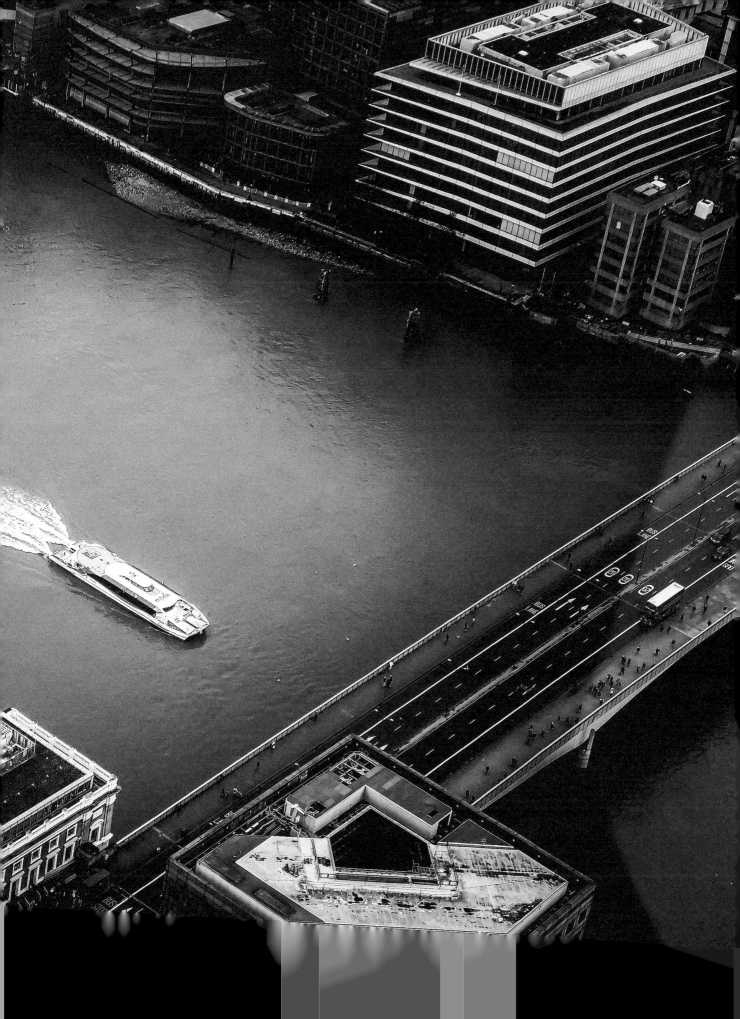

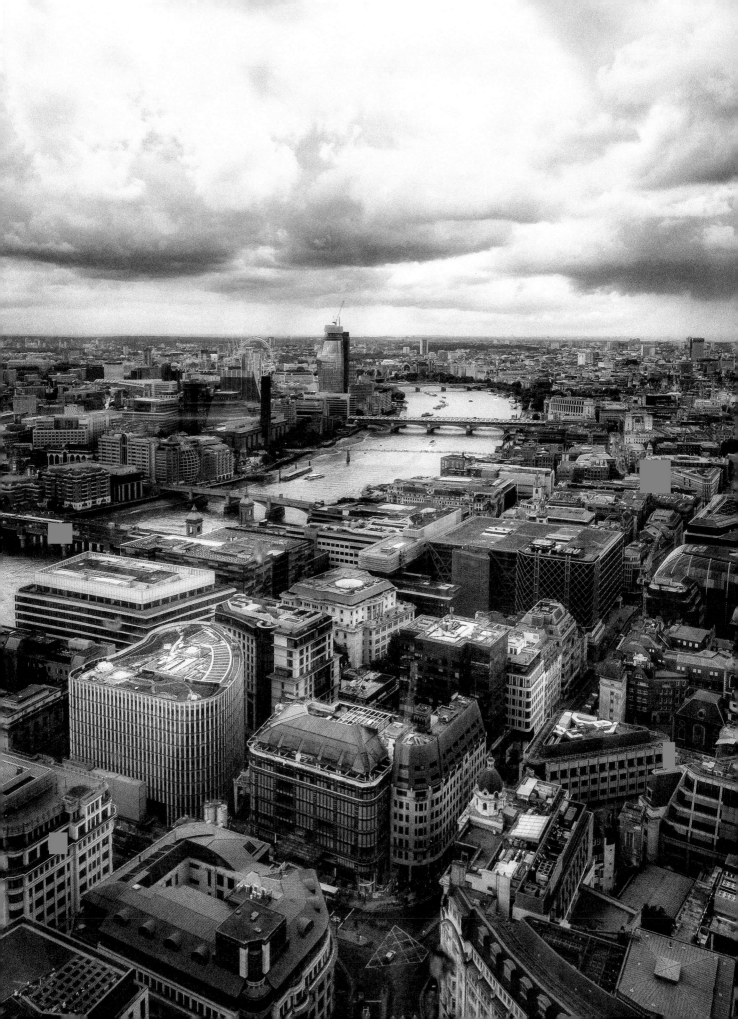

"There are little pockets of old time in London, where things and places stay the same, like bubbles in amber," she explained. "There's a lot of time in London, and it has to go somewhere— it doesn't all get used up at once,"

NEIL GAIMAN

Author

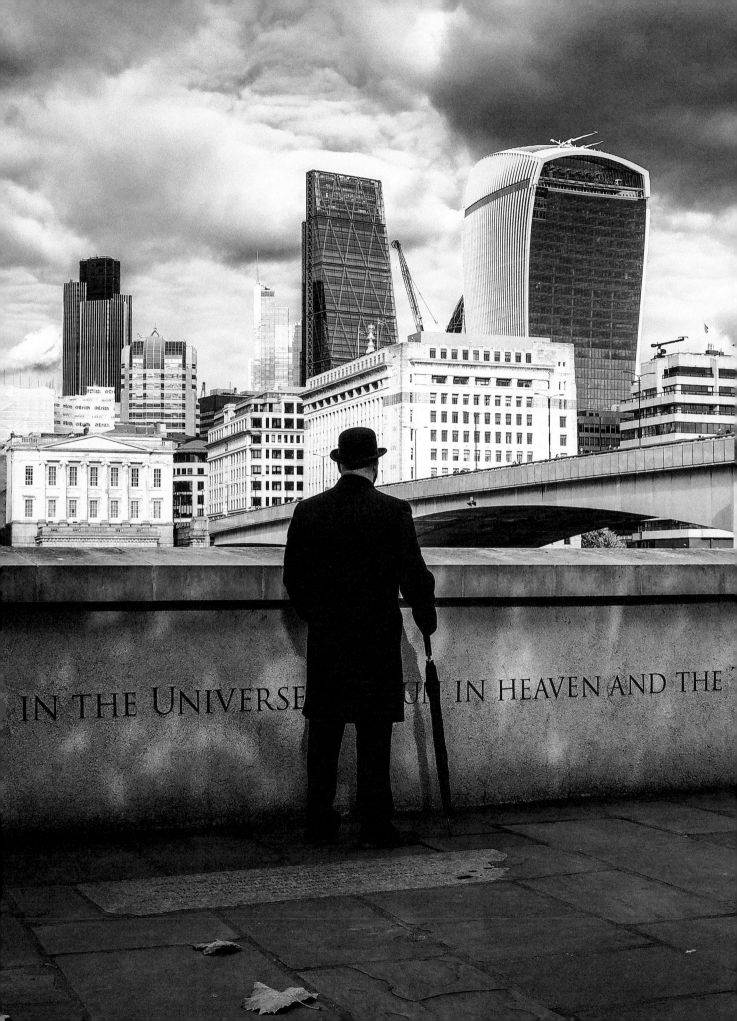

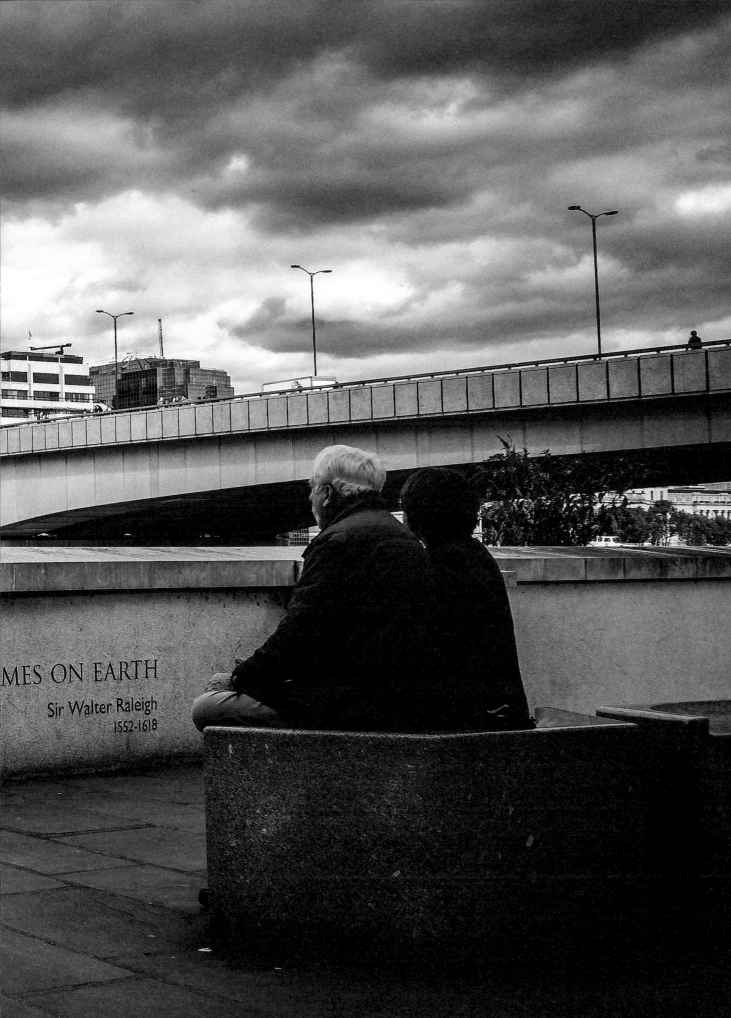

1

River Thames

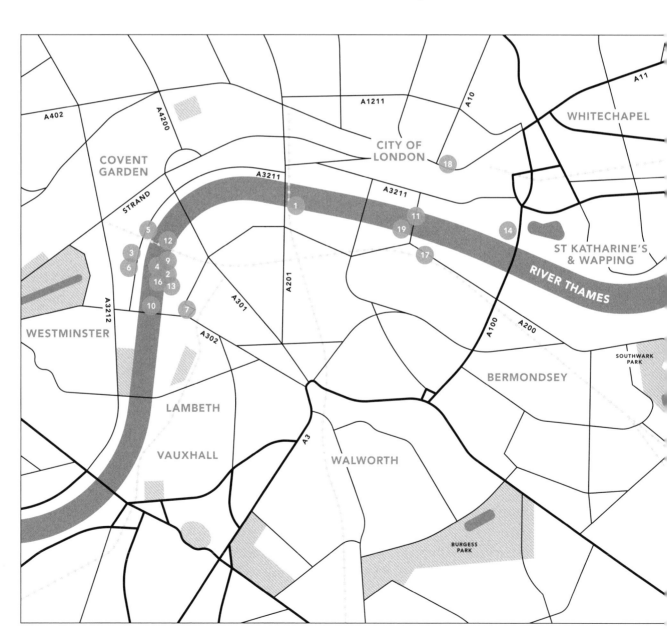

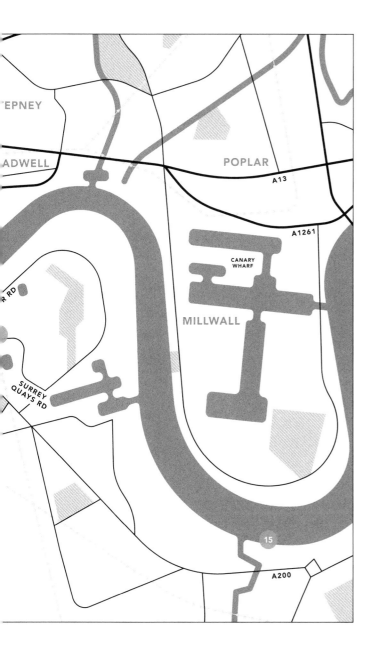

Street View

After the Great Fire of London in 1666 destroyed nearly a third of the capital, it was proposed that the city be rebuilt on a grid system. The plan was roundly rejected, paving the way for today's tangled maze of streets with their baffling tendency to change names or direction without much warning. ✚ No one understands this complex web better than London cabbies. To earn the right to sit behind the wheel of one of London's iconic black taxis, aspiring drivers must learn the 25,000 streets and 20,000 points of interest in central London, and the fastest routes between them. The test is called "The Knowledge" and is universally known as one of the hardest exams in the world. ✚ Also travelling the main arteries, nothing screams London more than the blazing red double-decker buses. The most recognised model, the Routemaster, was introduced in the 1950s. Famous for its open rear entrance, the industrial design masterpiece has been seen throughout the capital for more than half a century — becoming an international emblem of the city and a nostalgic trigger for even the most unsentimental Londoners.

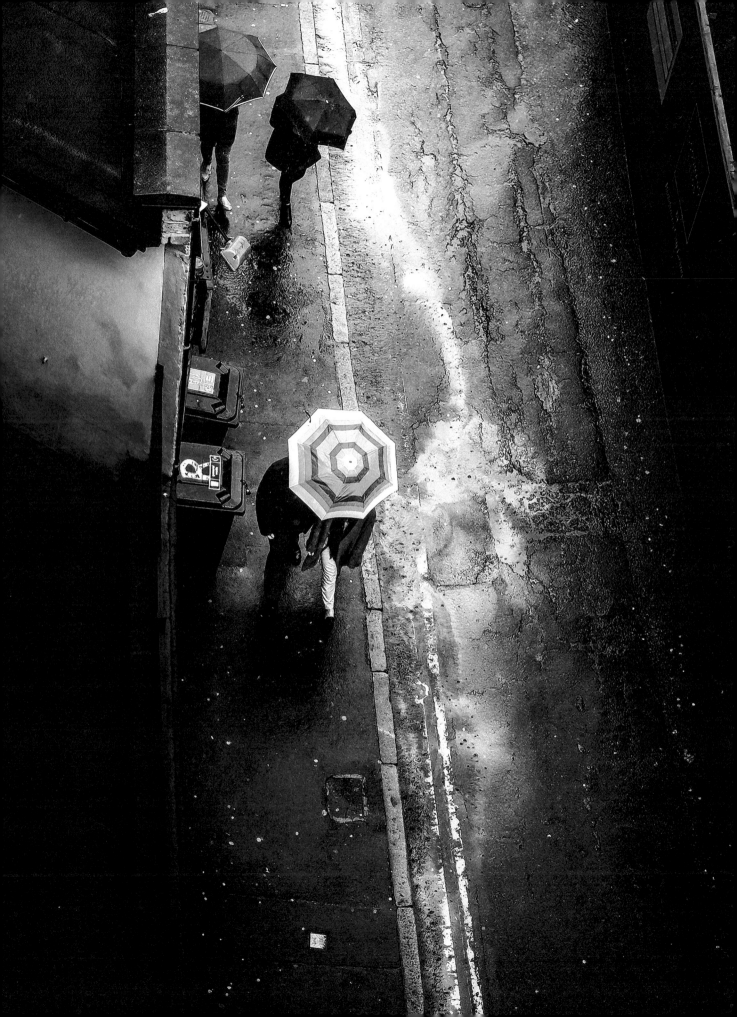

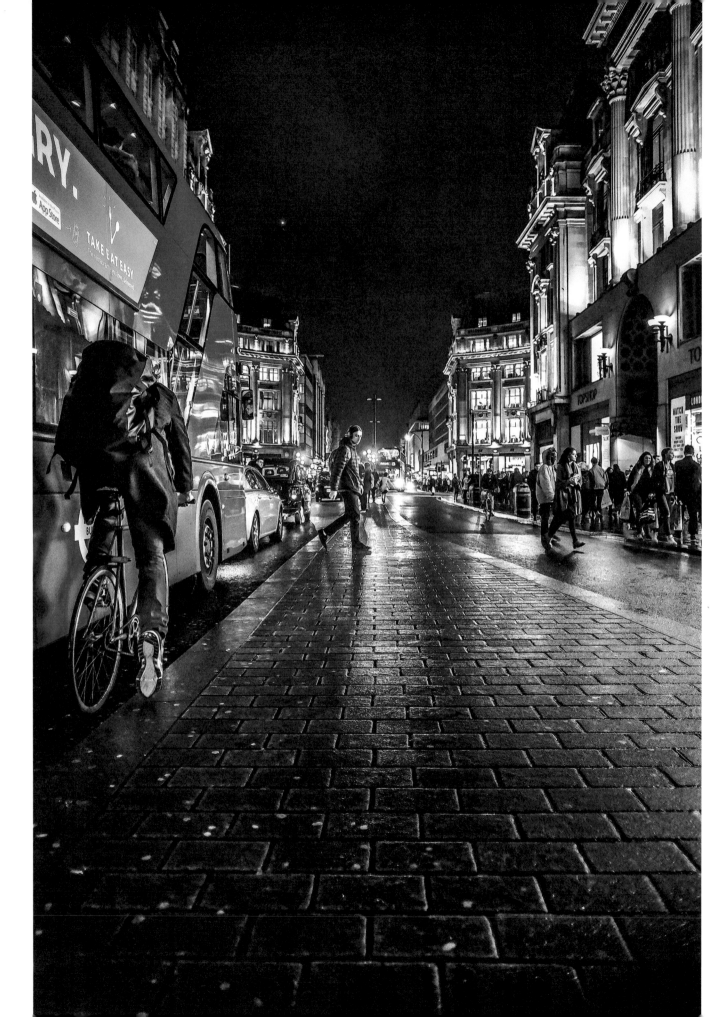

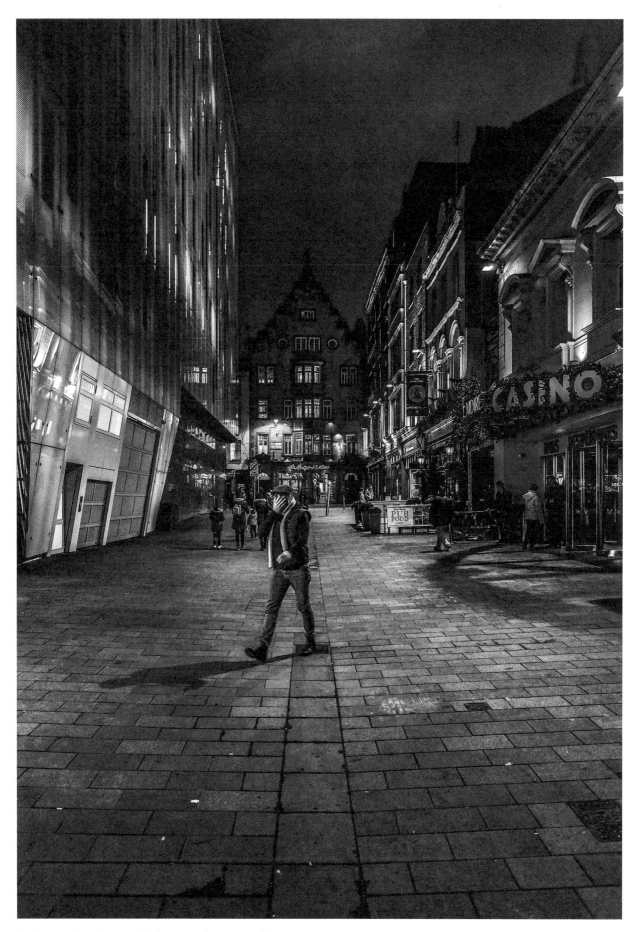

1 Previous Page: View over Alie Street near Canter Way, Aldgate
2 Left: Oxford and Argyll Streets, looking west
3 Above: Leicester Street, northwest corner of Leicester Square, looking north

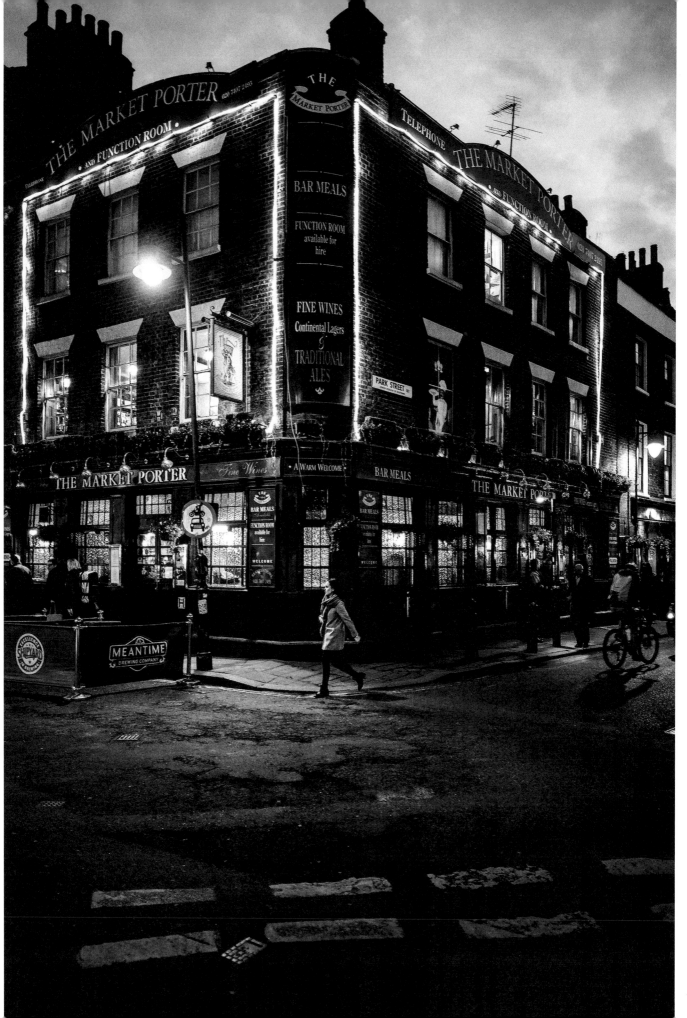

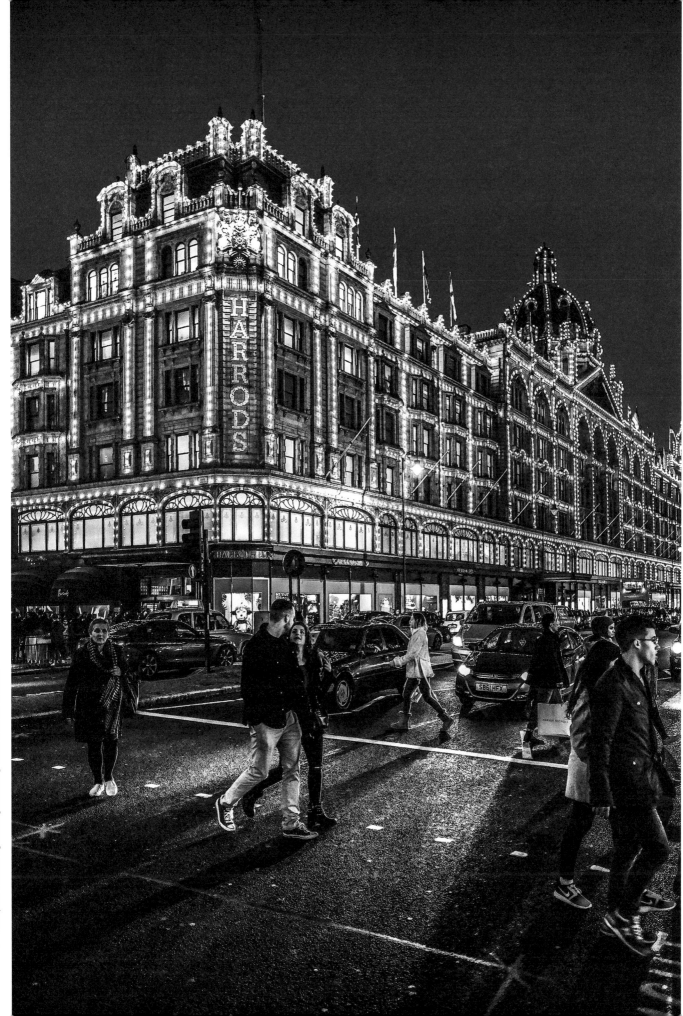

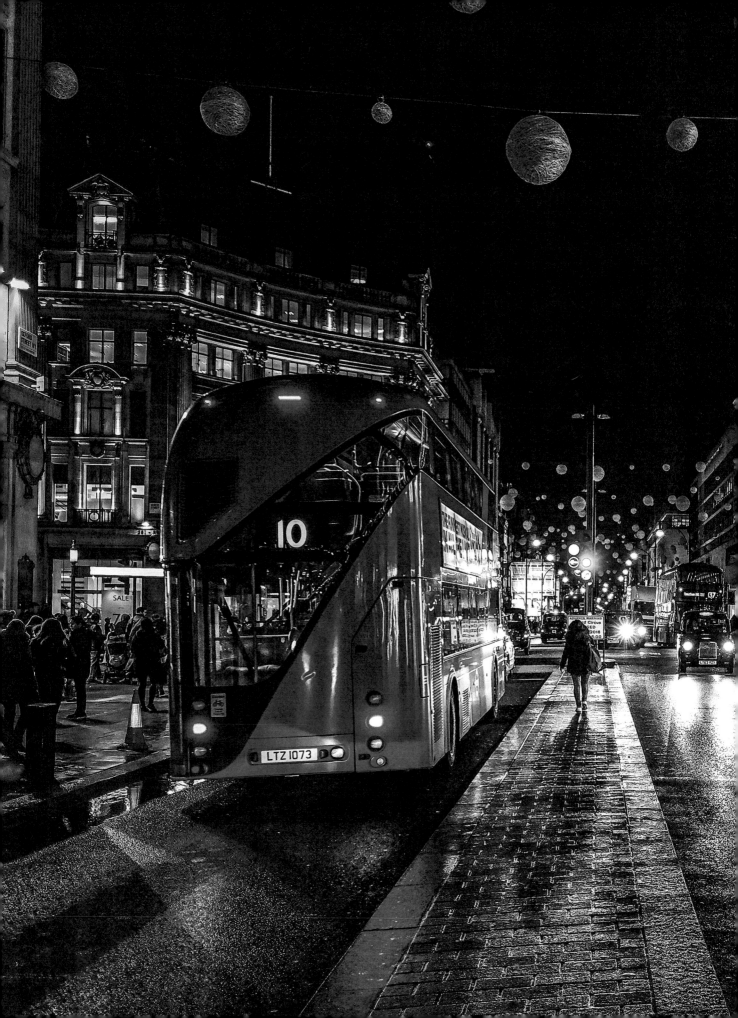

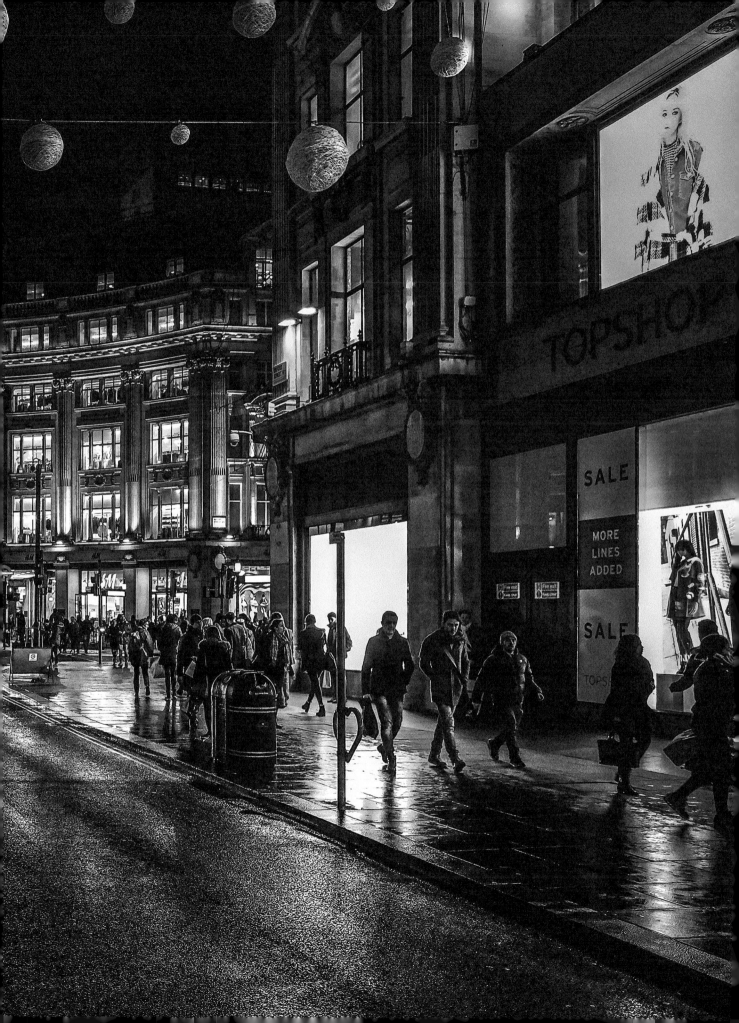

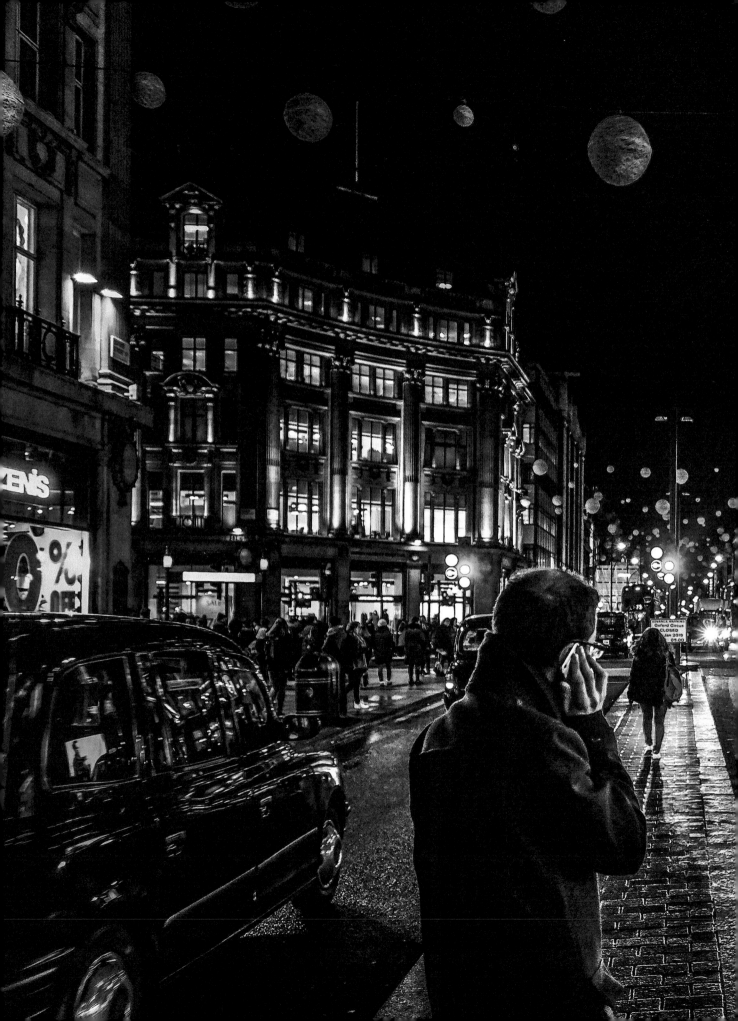

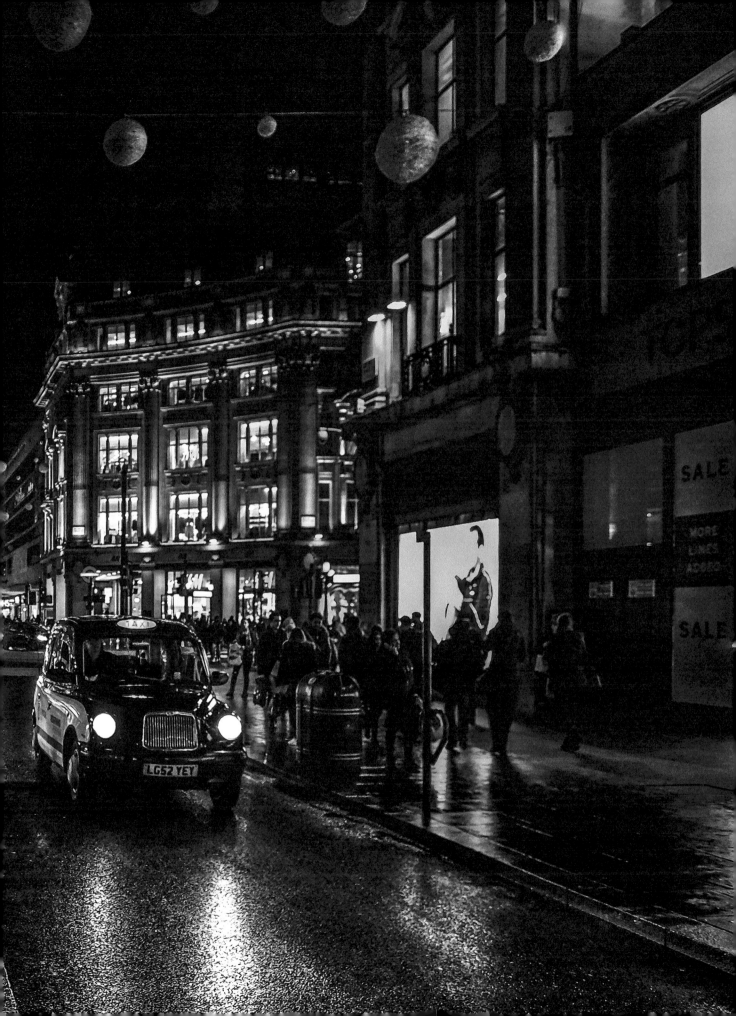

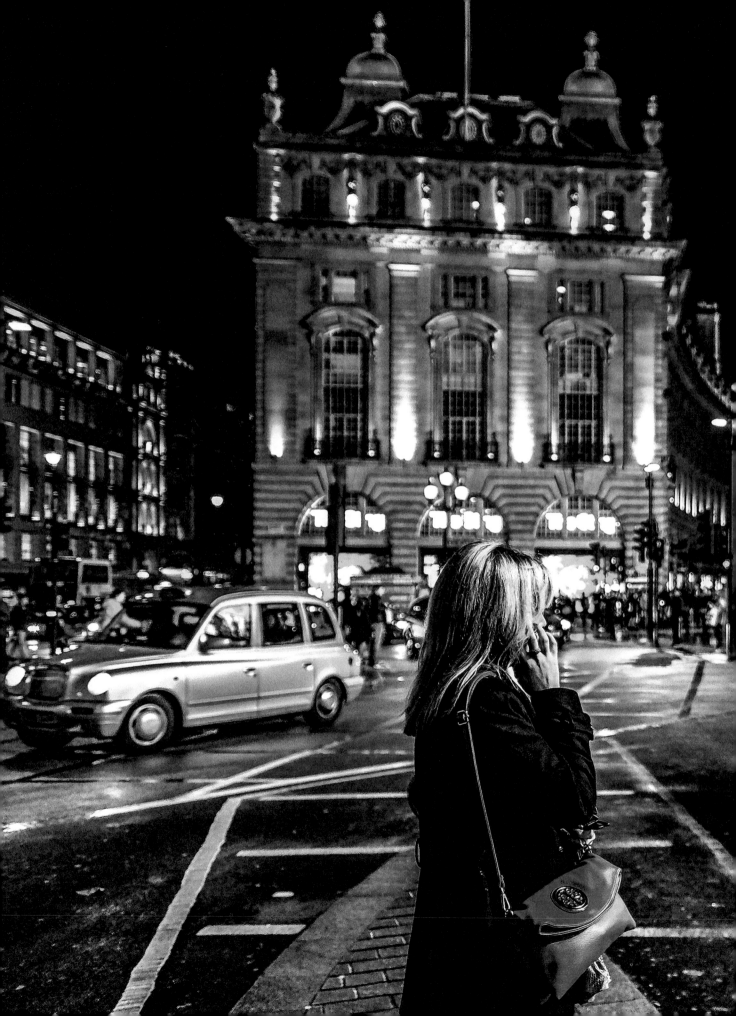

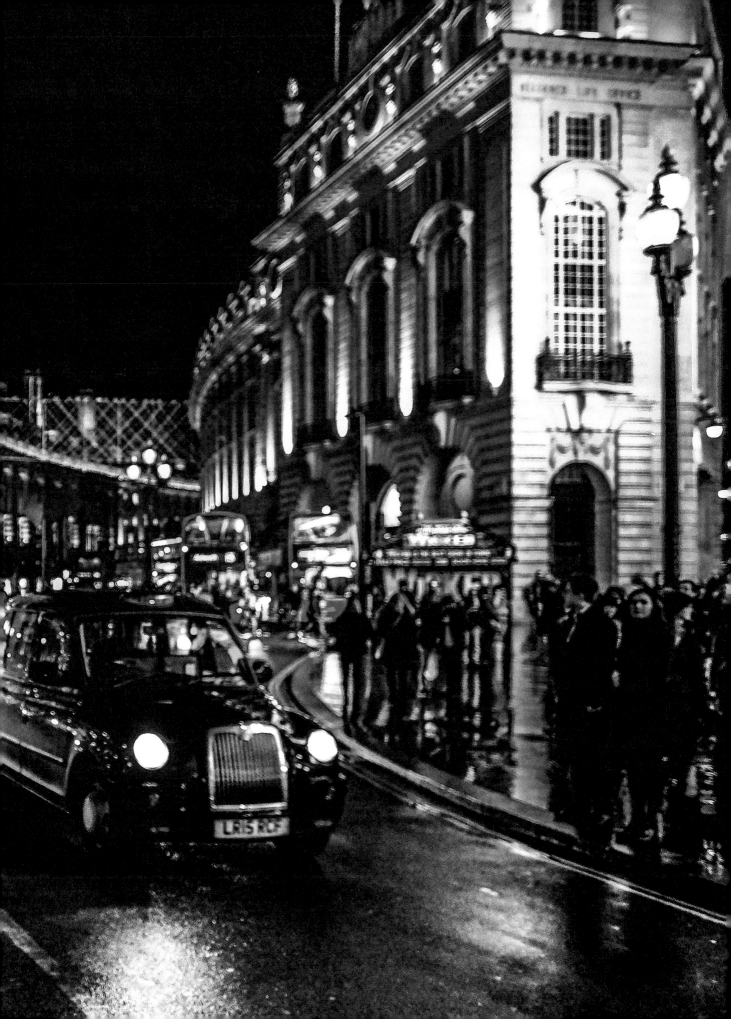

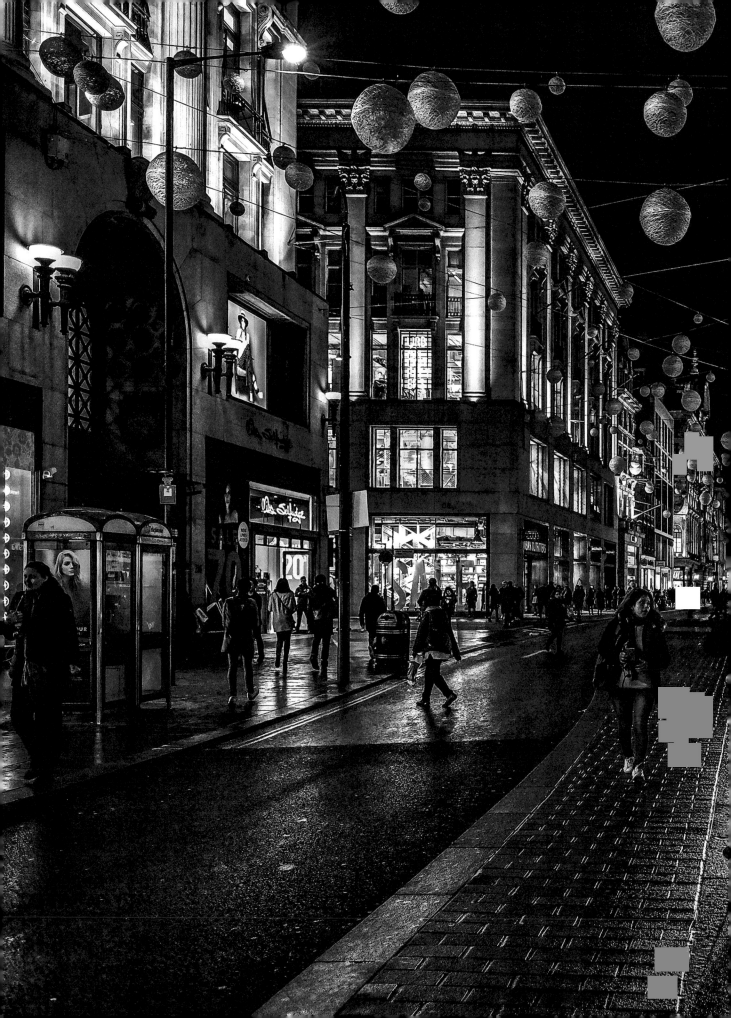

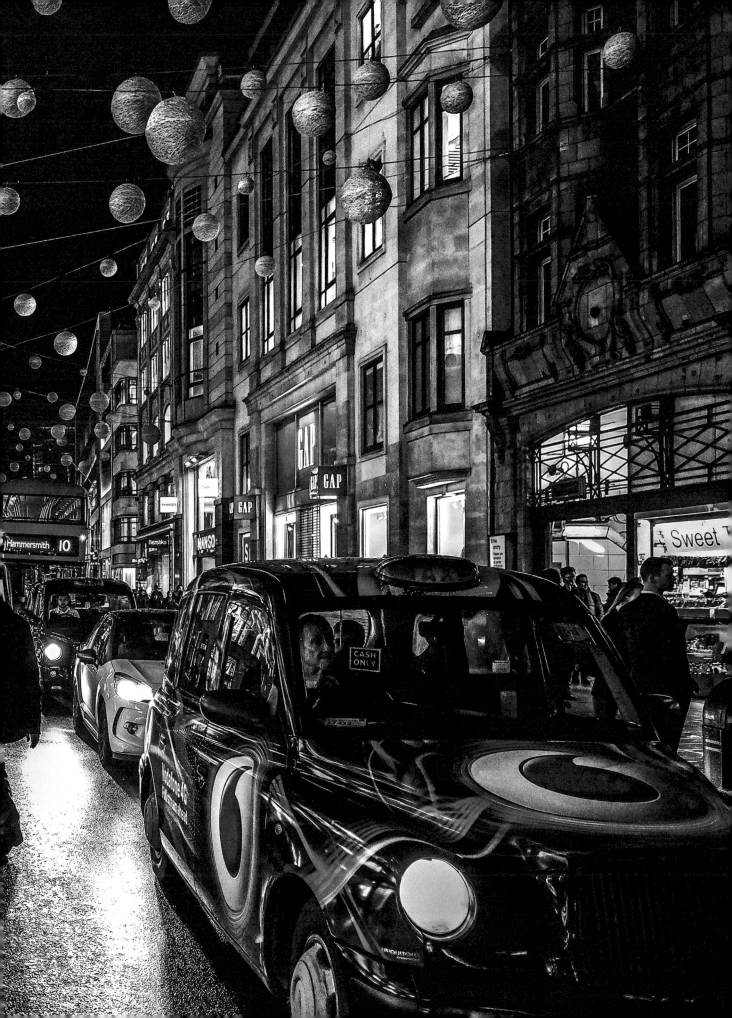

London is a roost for every bird.

BENJAMIN DISRAELI

Former British Prime Minister

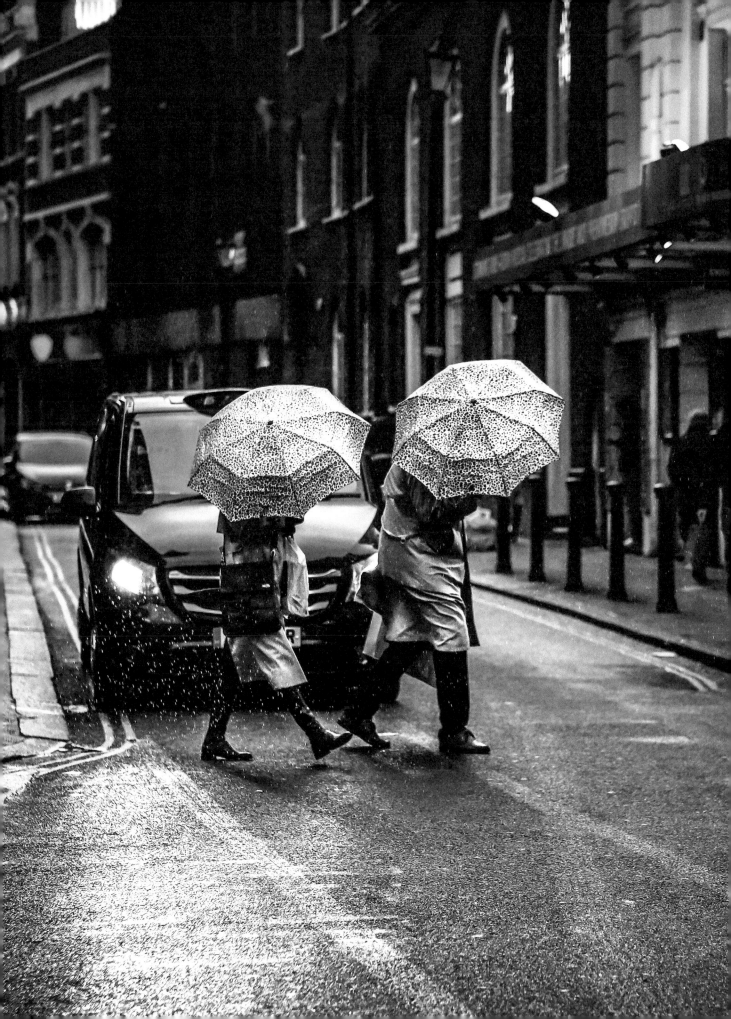

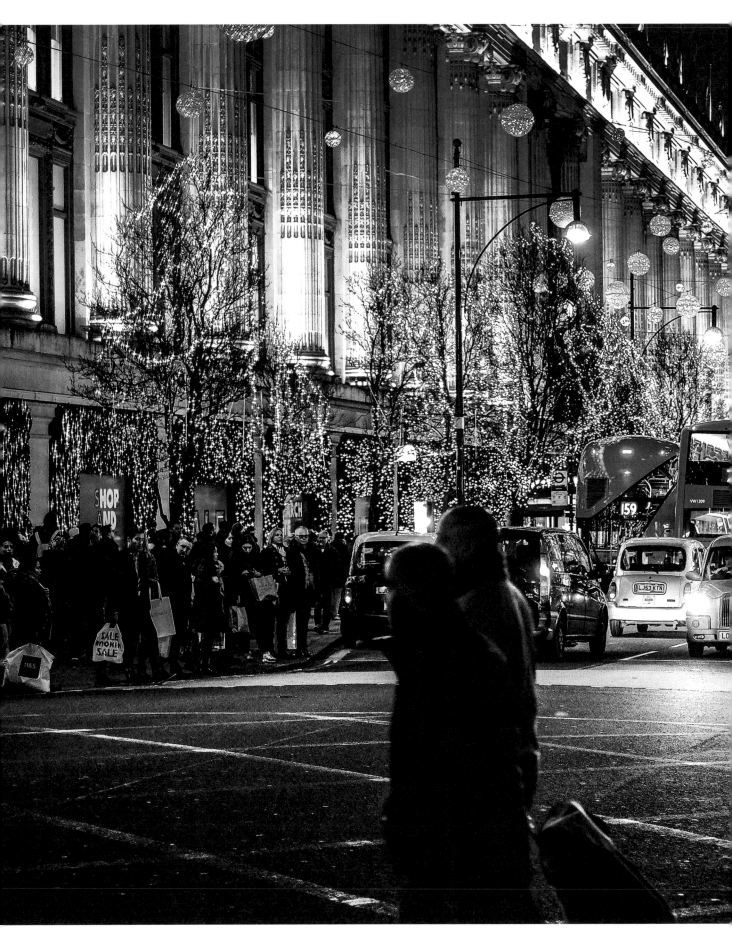

11 Oxford Street in front of Selfridges, looking east

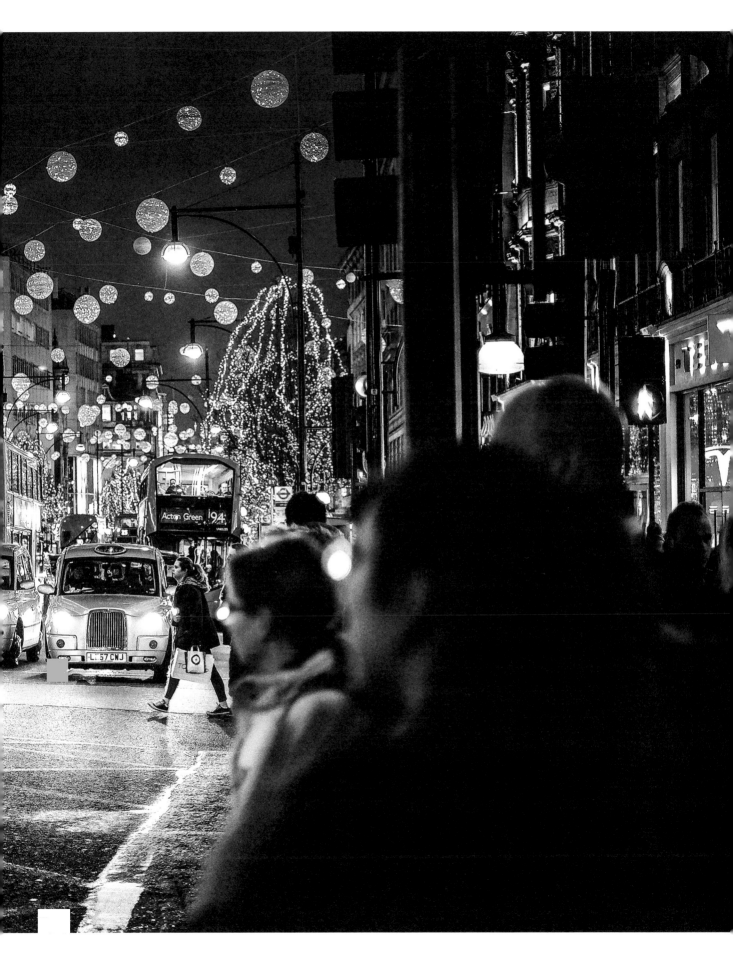

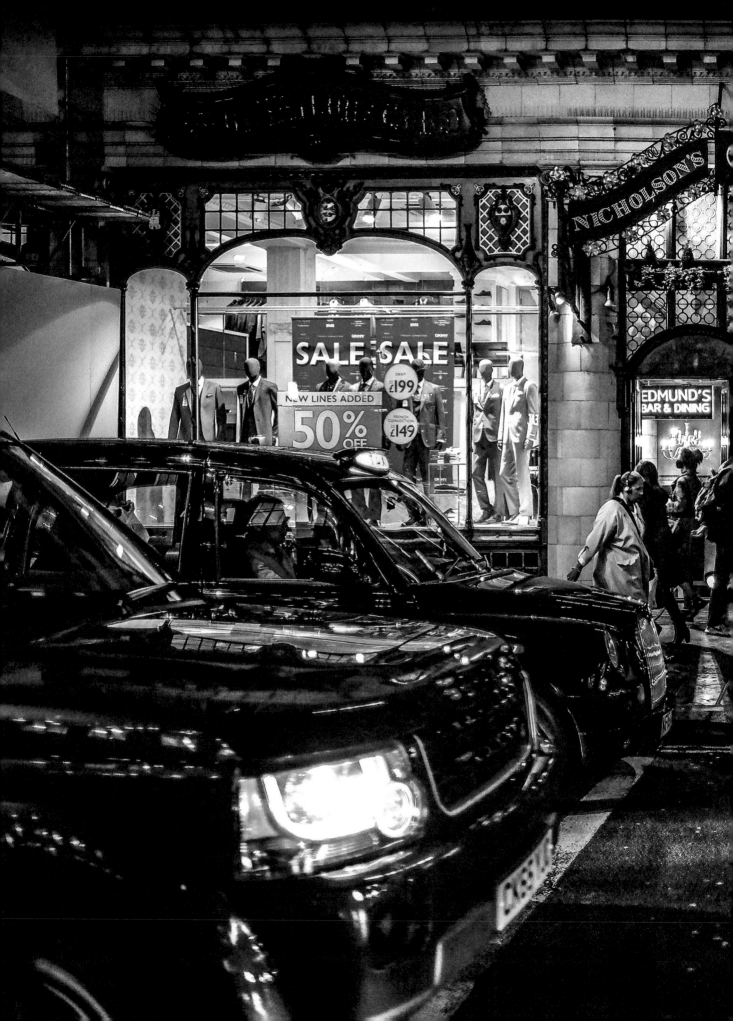

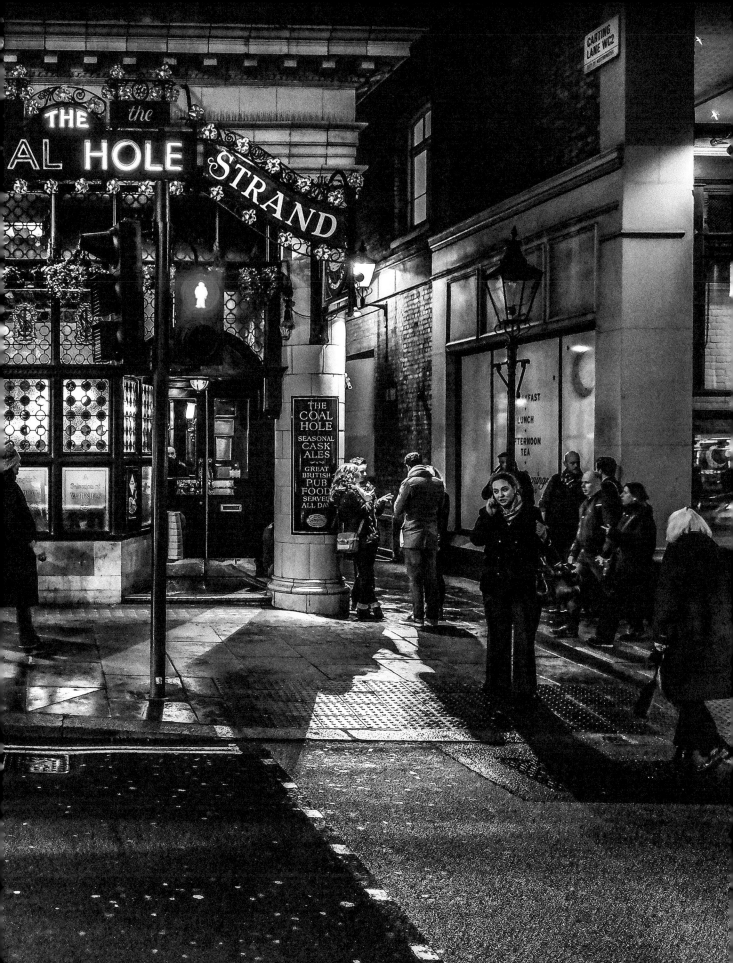

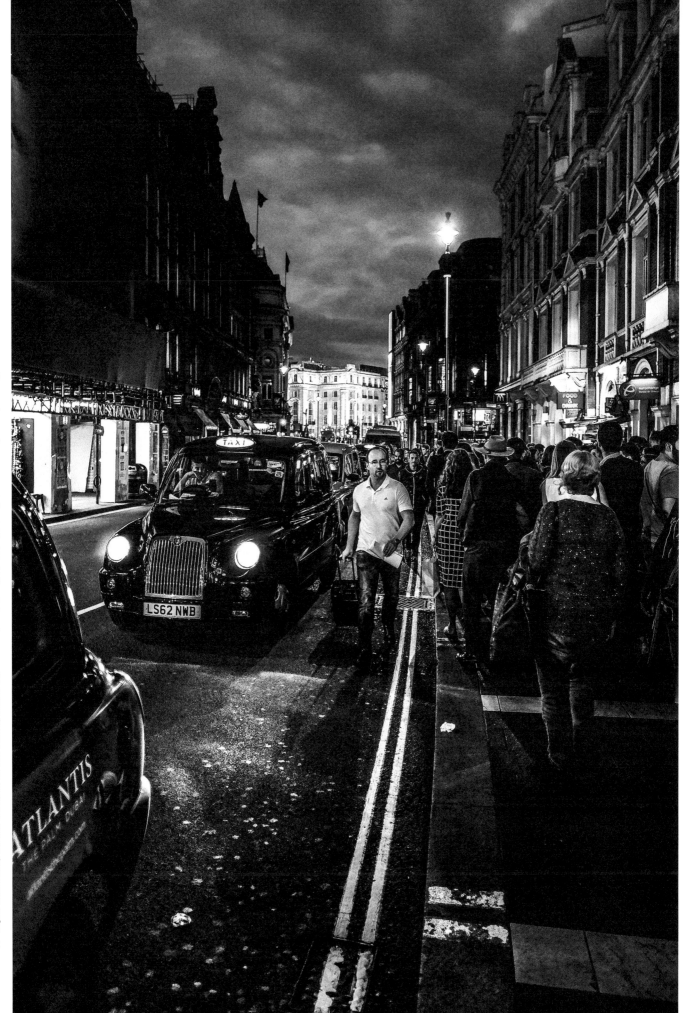

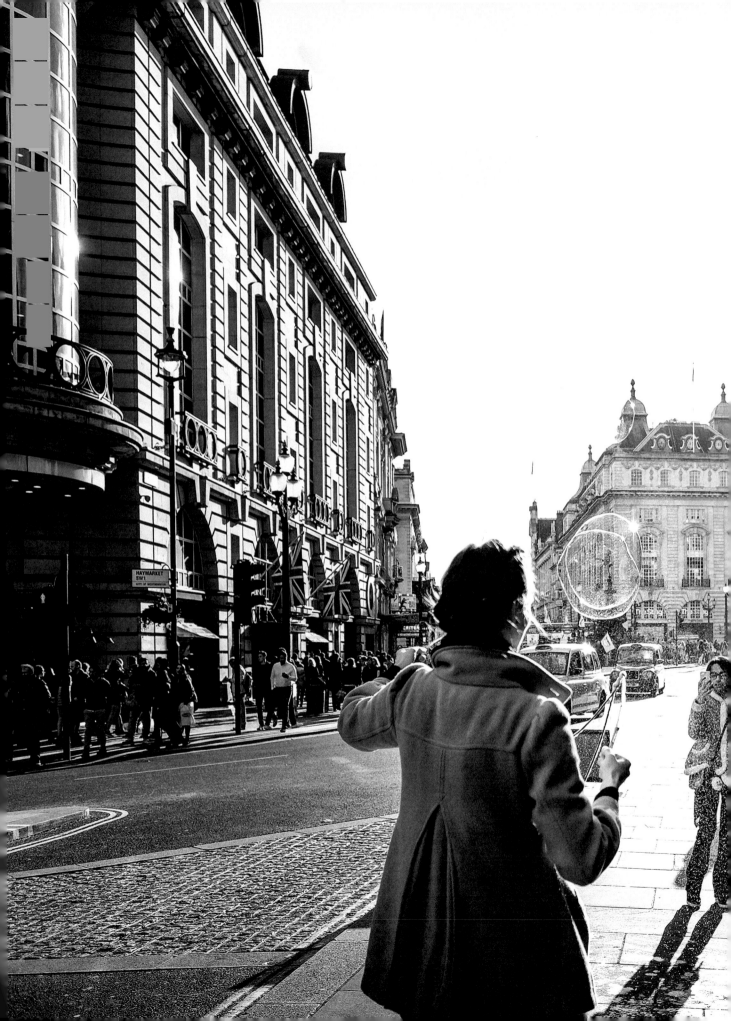

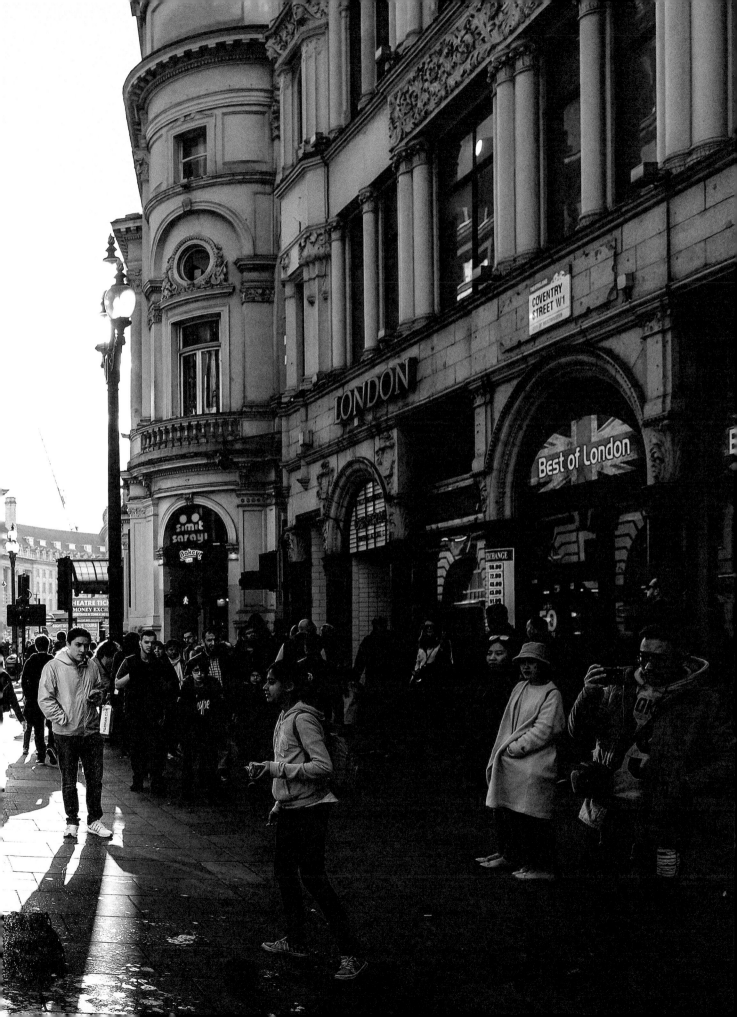

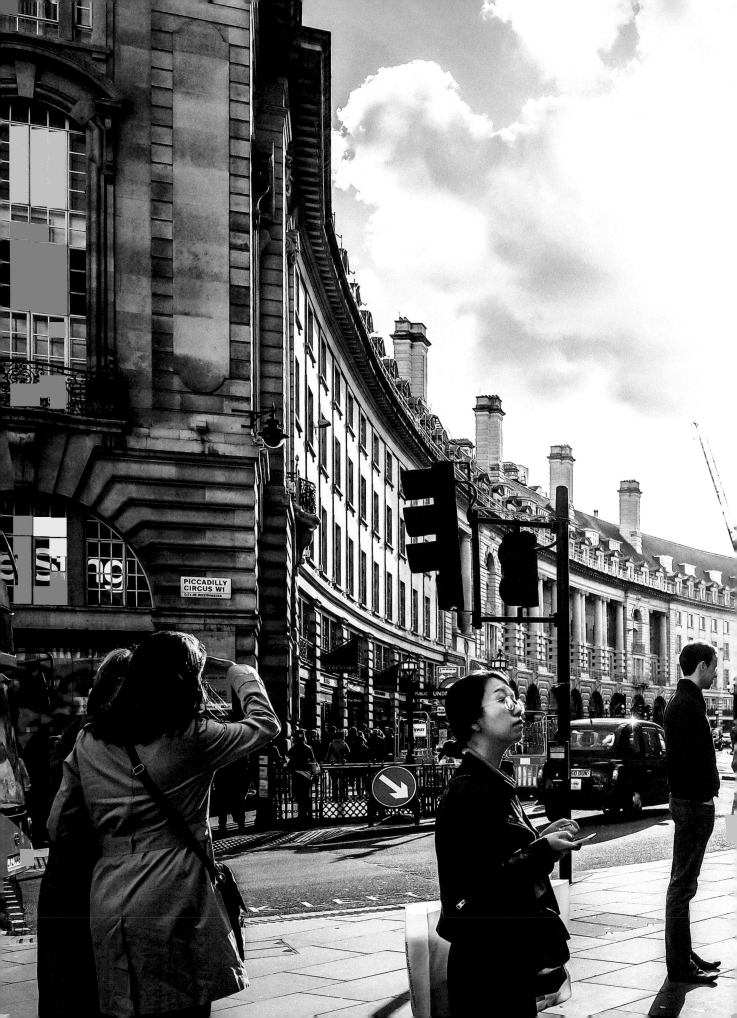

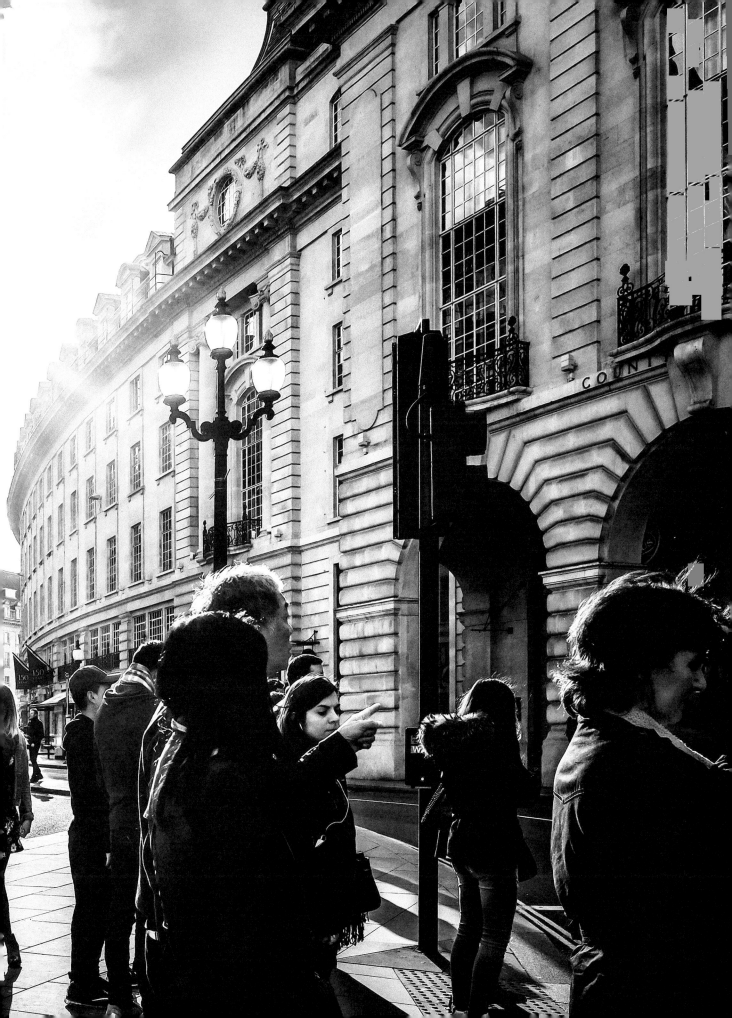

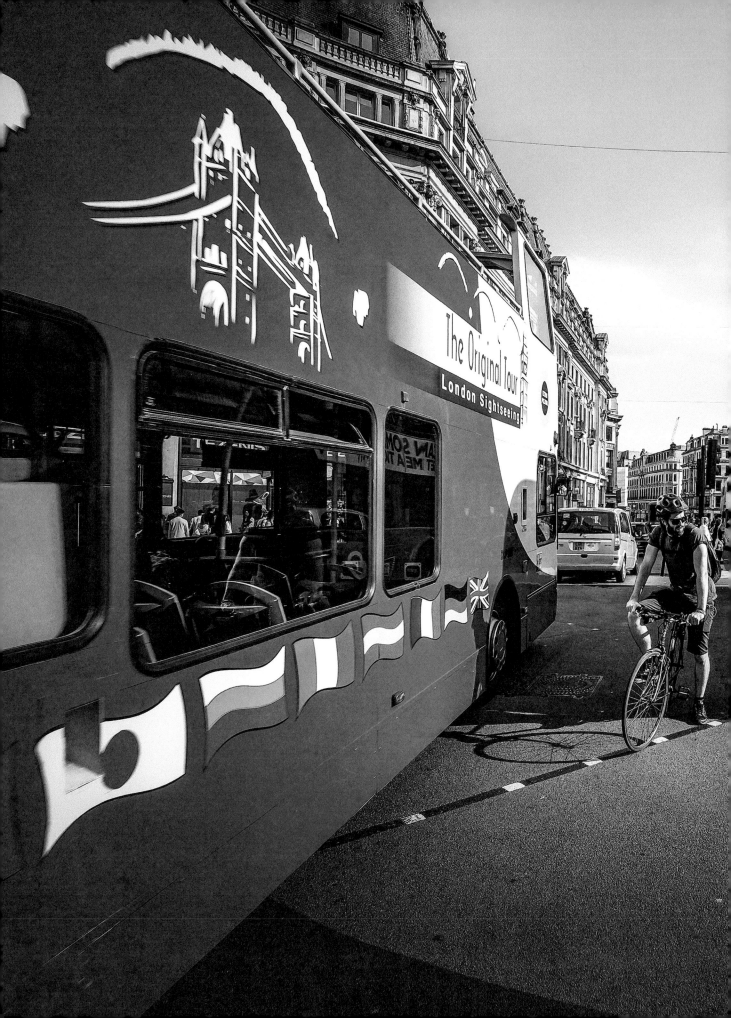

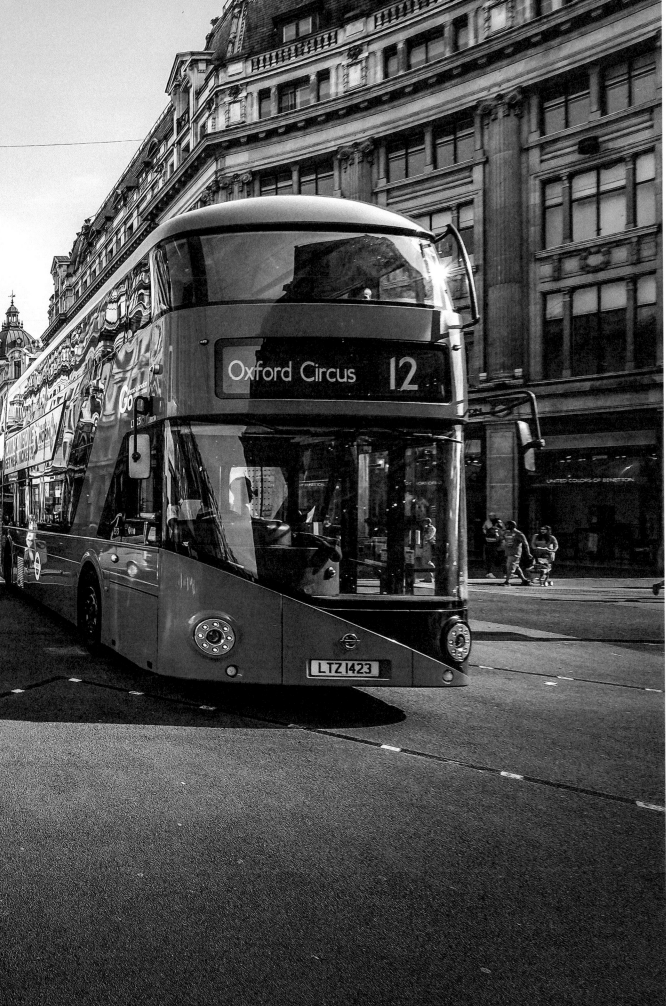

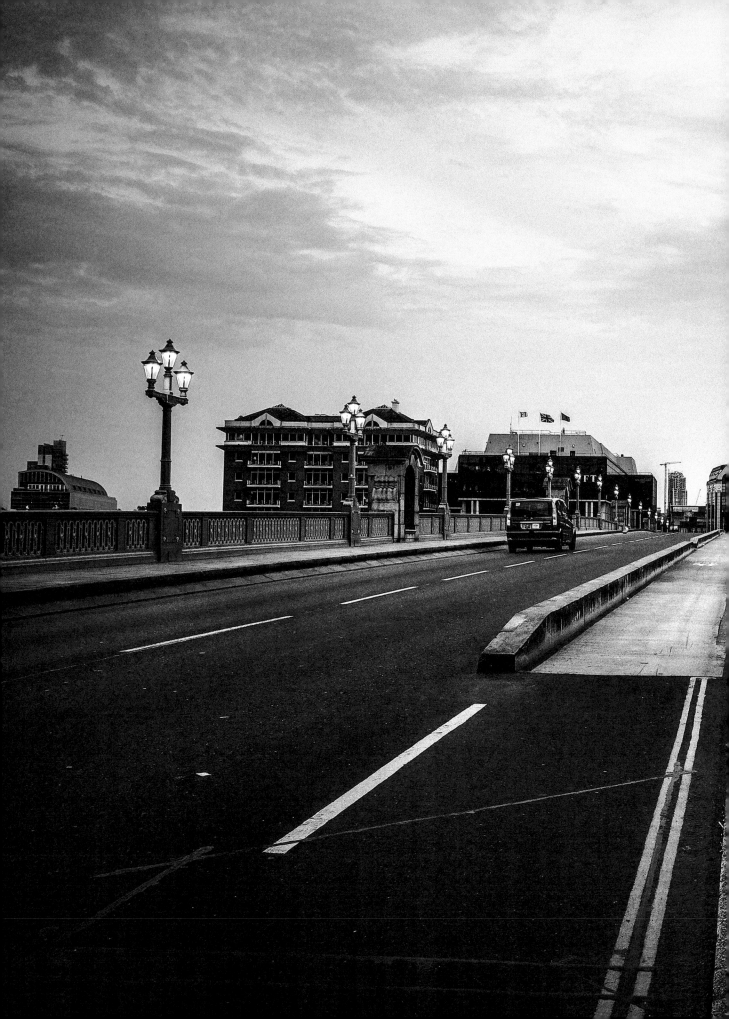

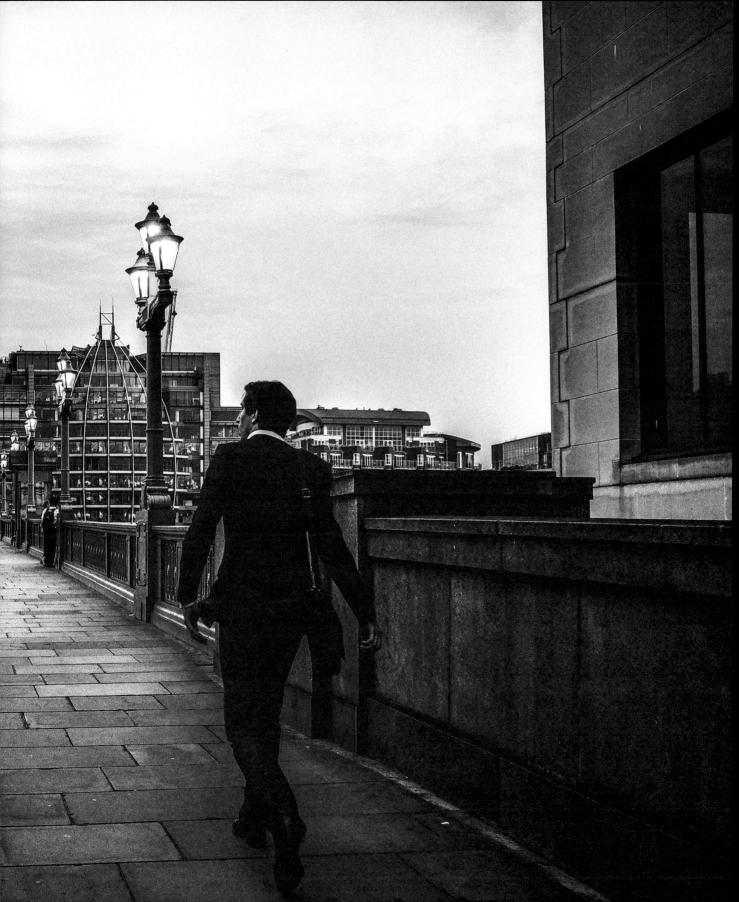

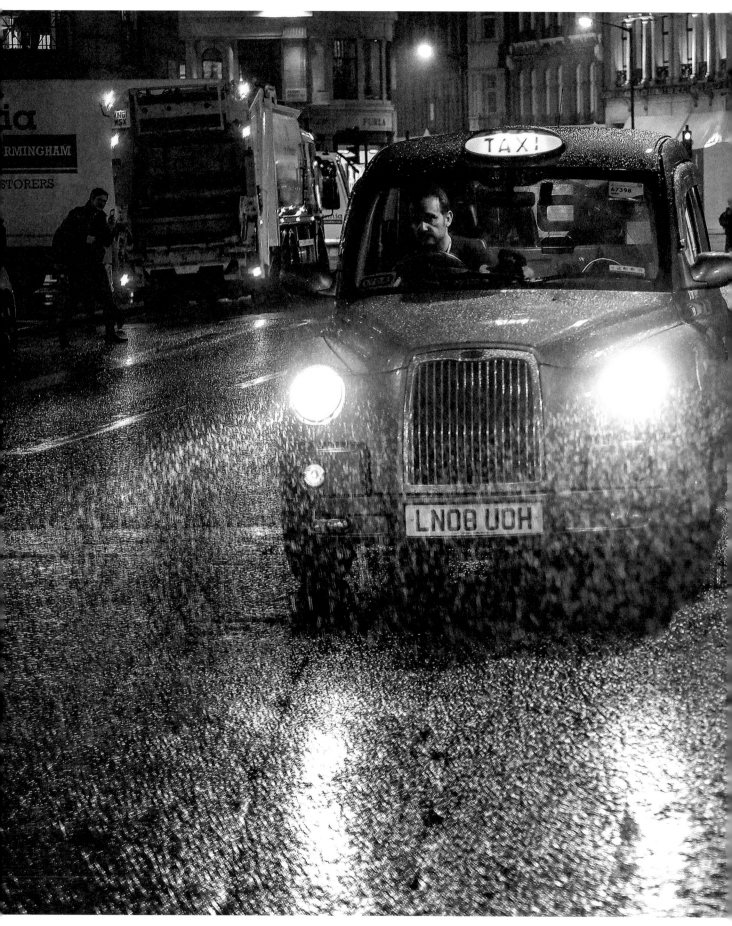

19 Argyll and Great Marlborough Streets, looking southwest

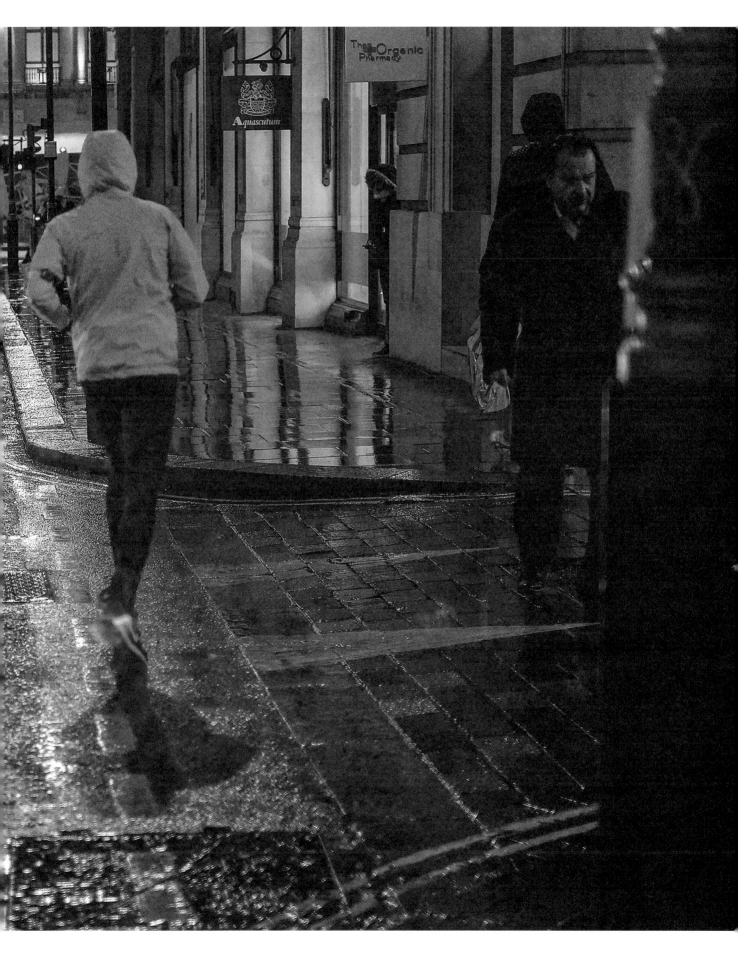

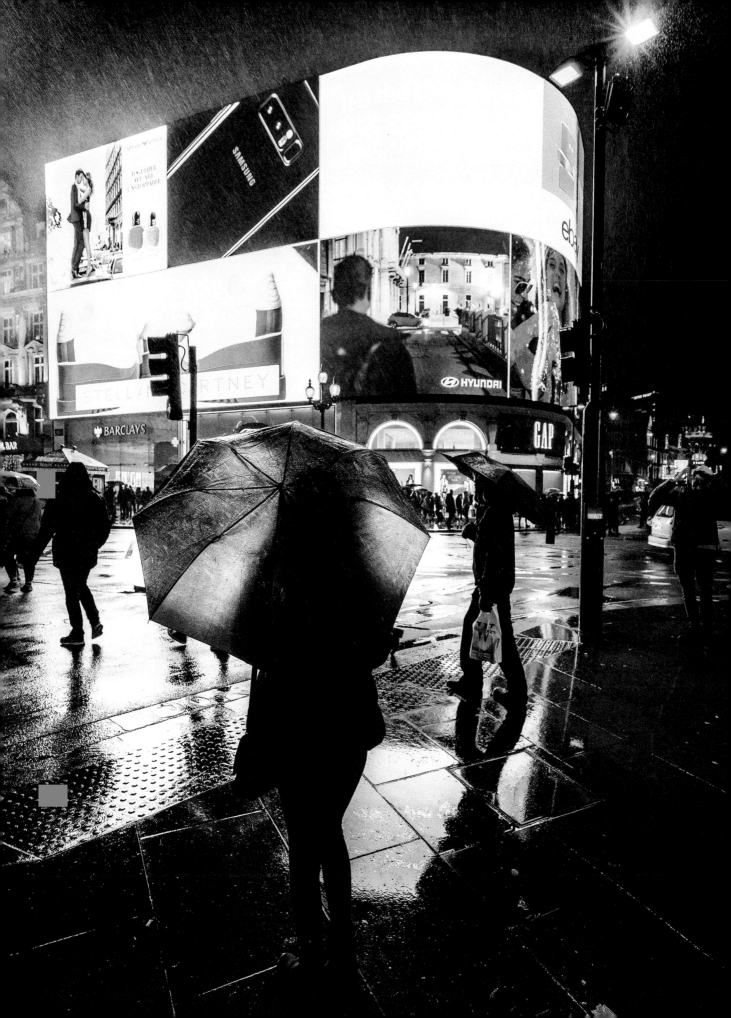

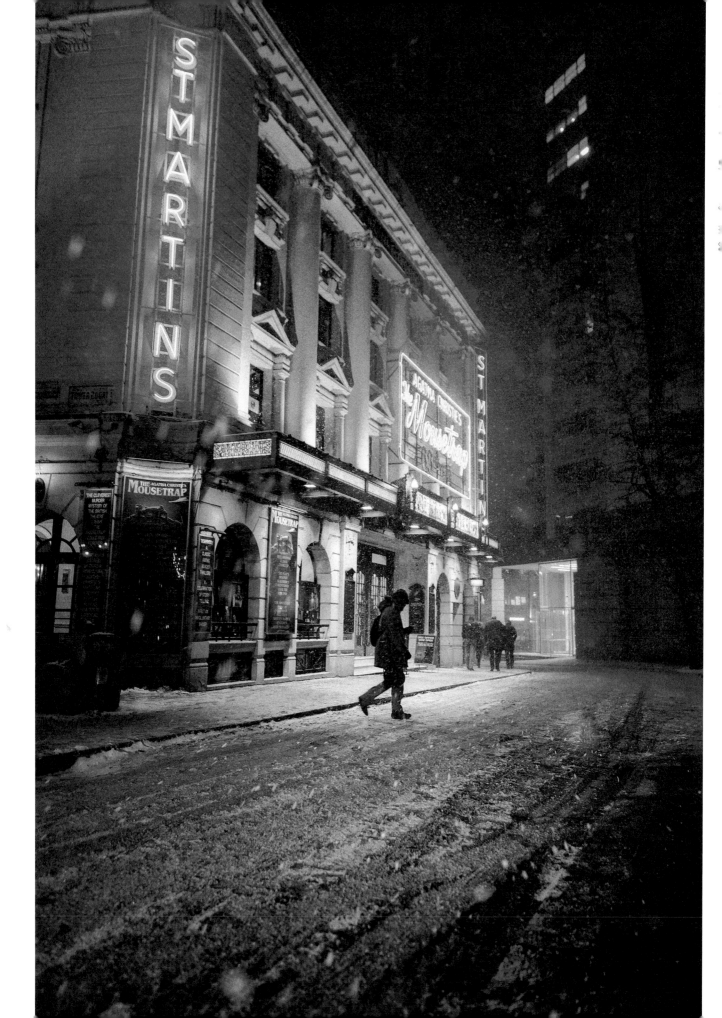

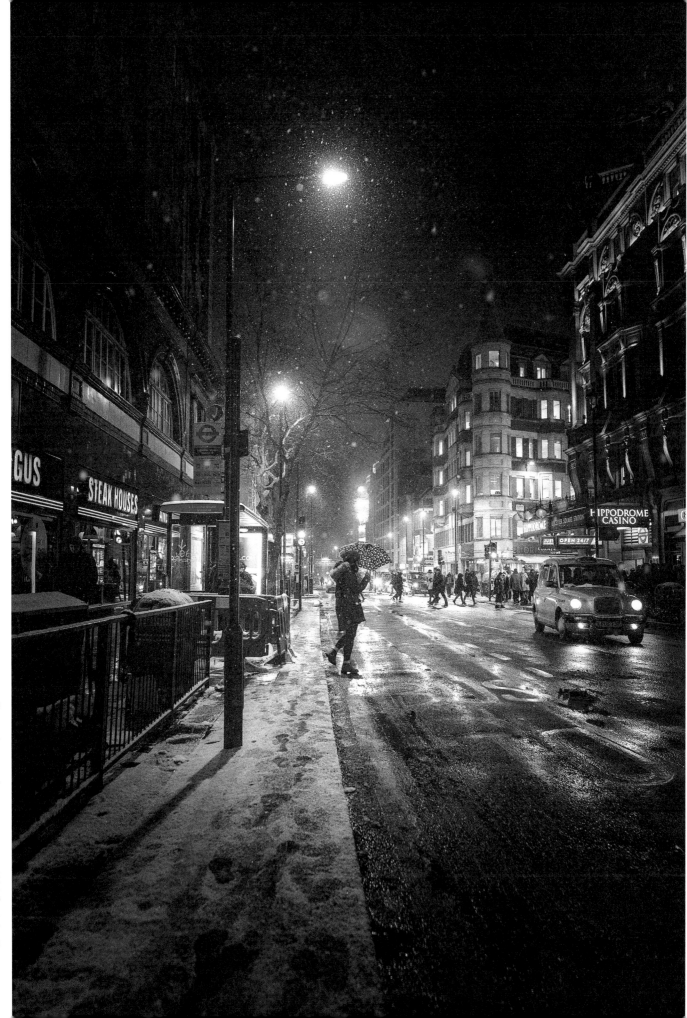

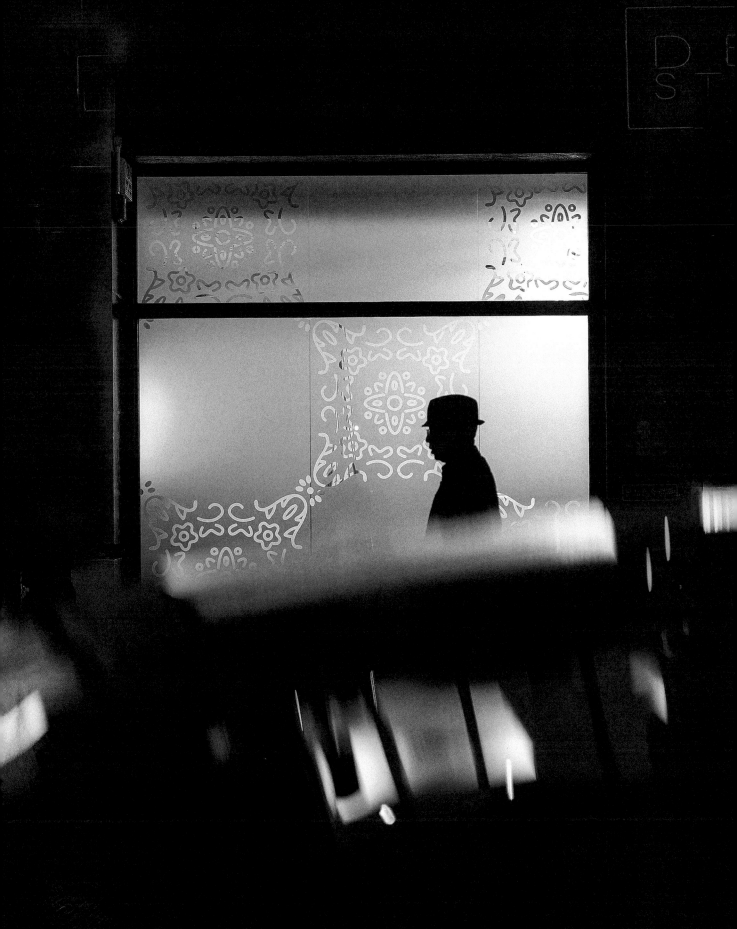

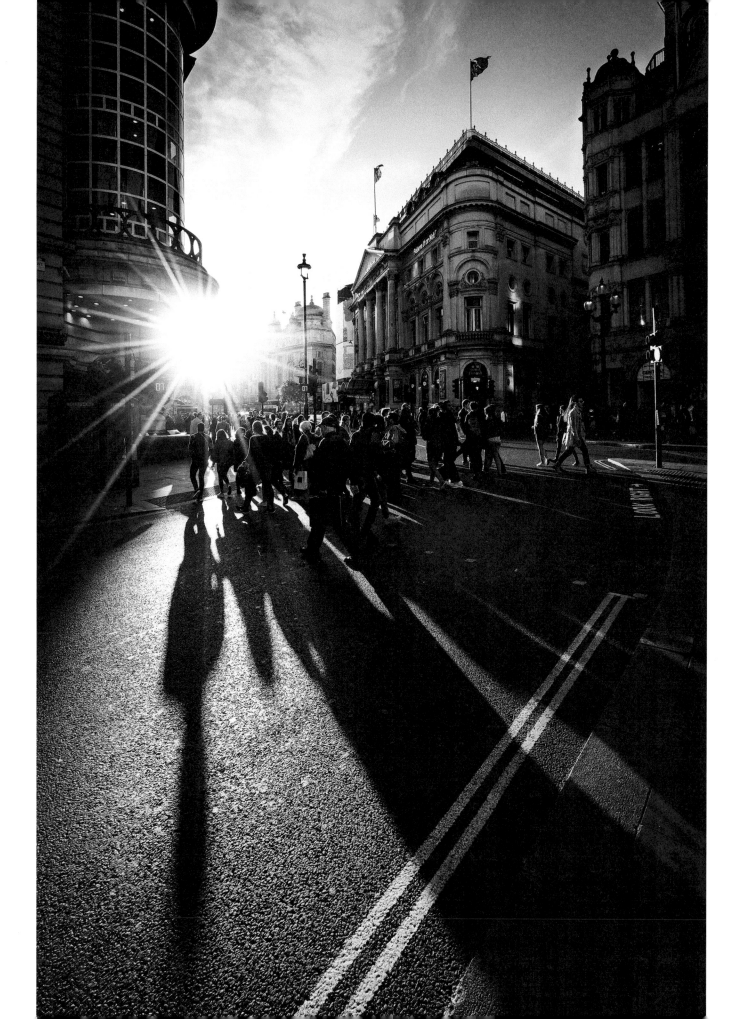

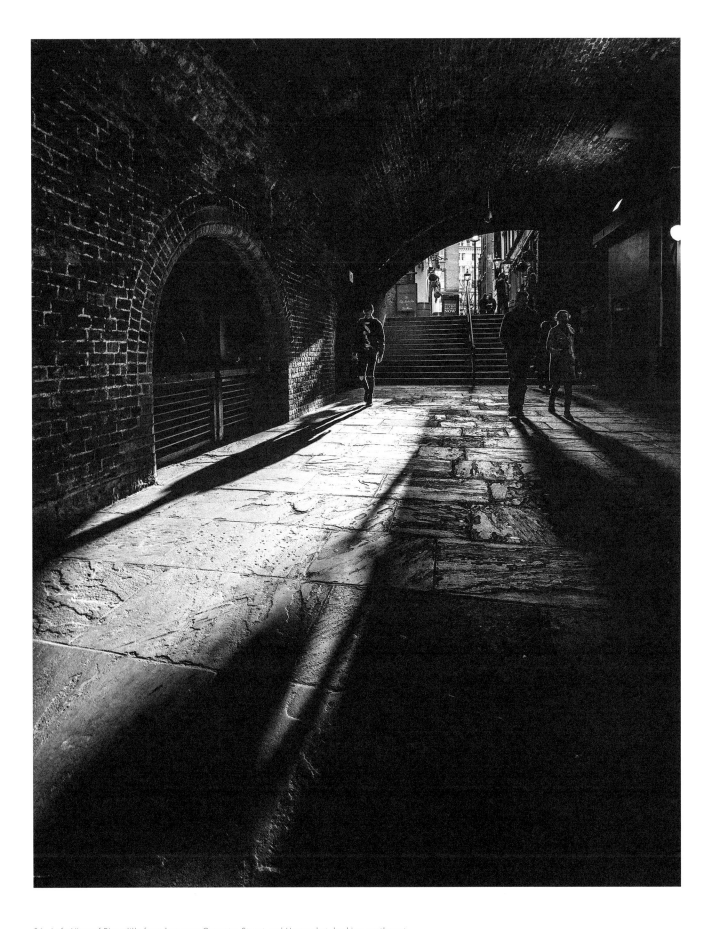

26 Left: View of Piccadilly from between Coventry Street and Haymarket, looking northwest

27 Above: Craven Passage, near Charing Cross Station

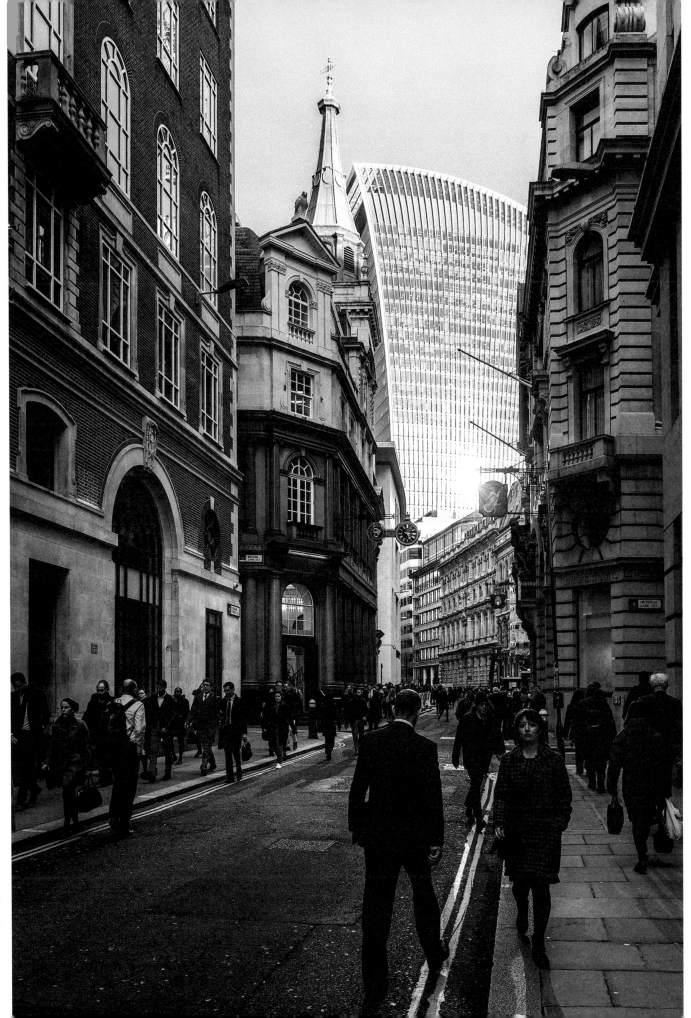

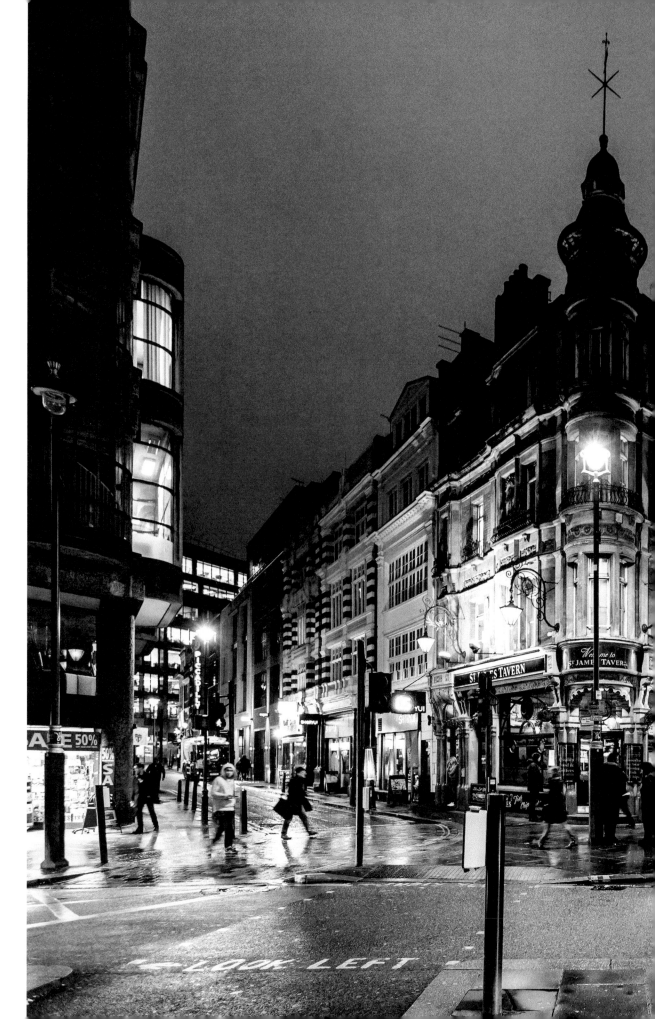

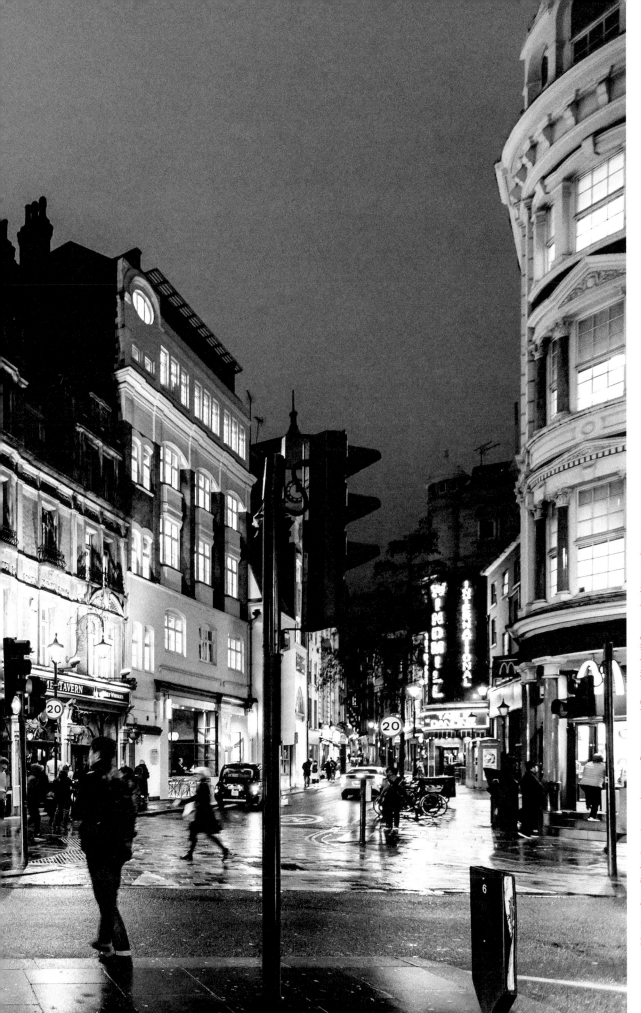

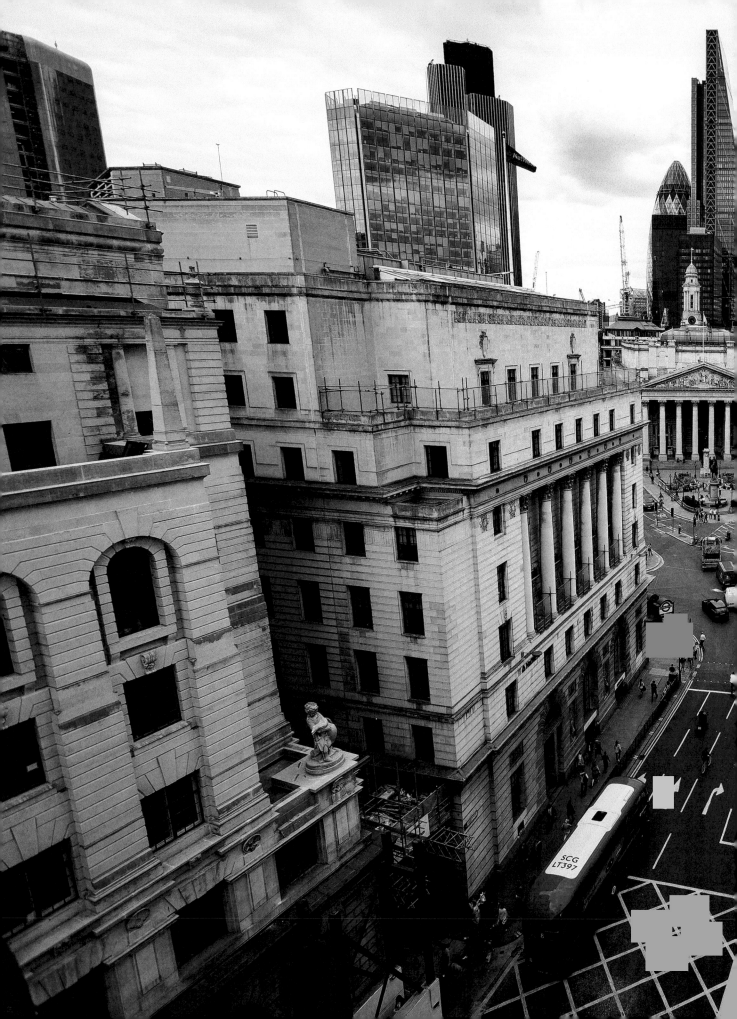

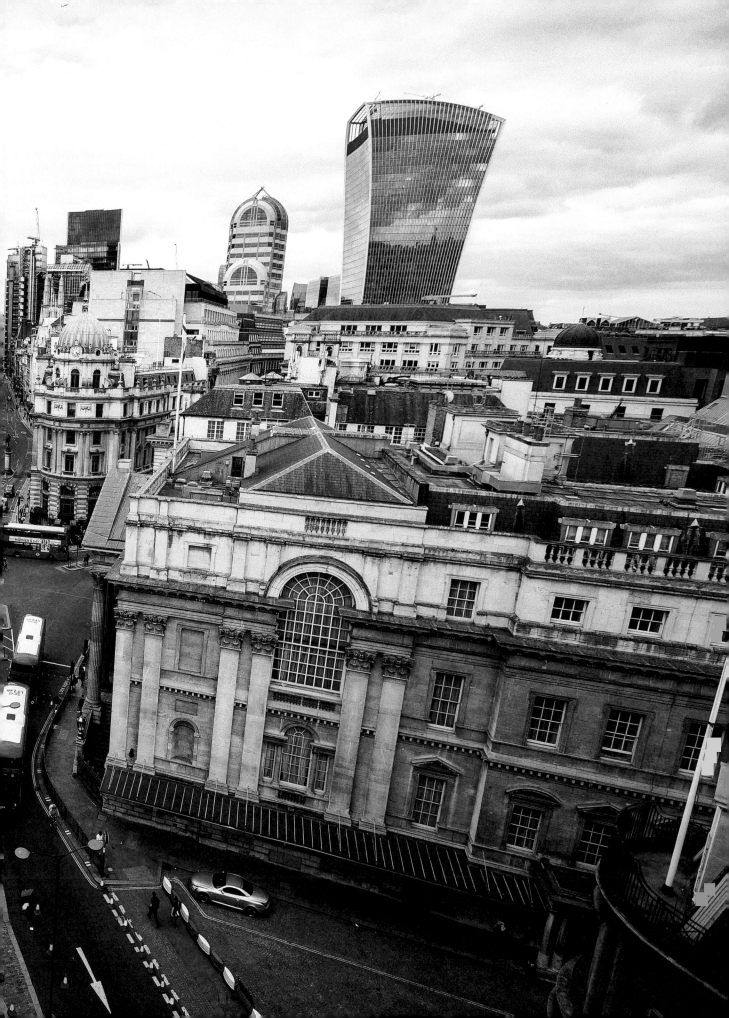

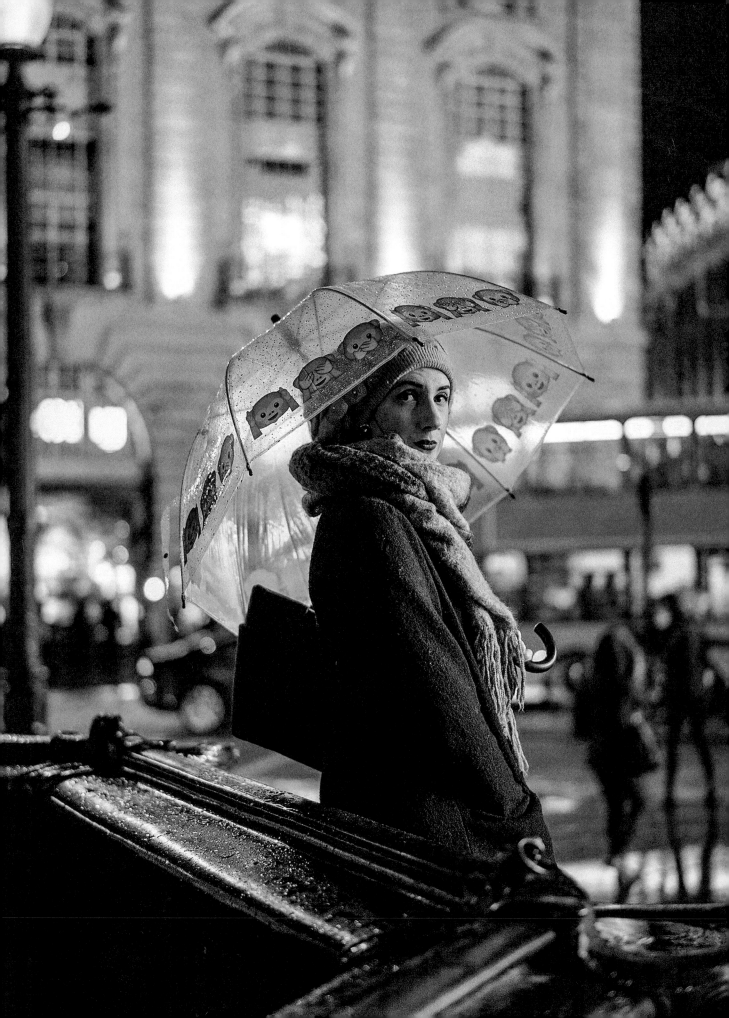

London opens to you like a novel itself...
It is divided into chapters, the chapters
into scenes, the scenes into sentences;
it opens to you like a series of rooms,
door, passage, door. Mayfair to Piccadilly
to Soho to the Strand.

ANNA QUINDLEN

Author and Journalist

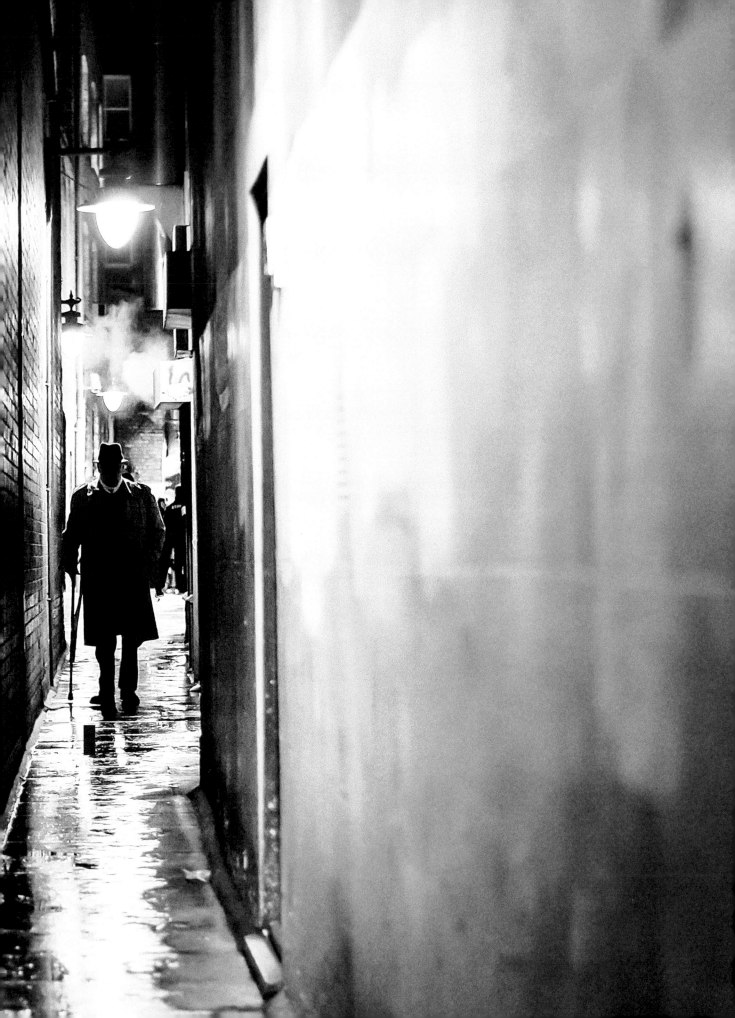

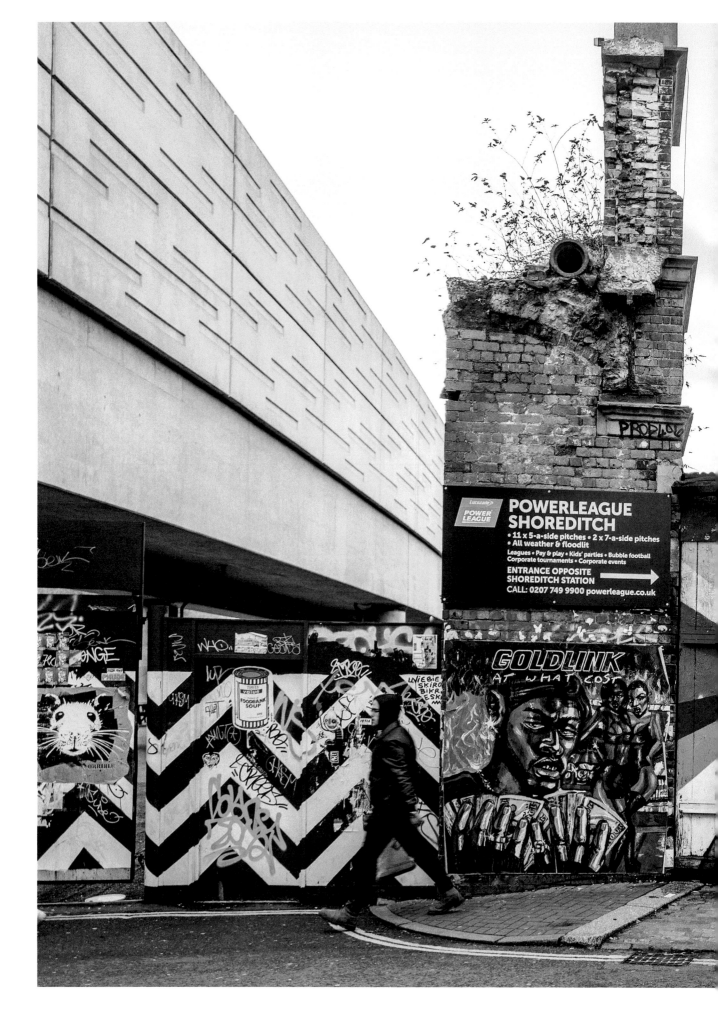

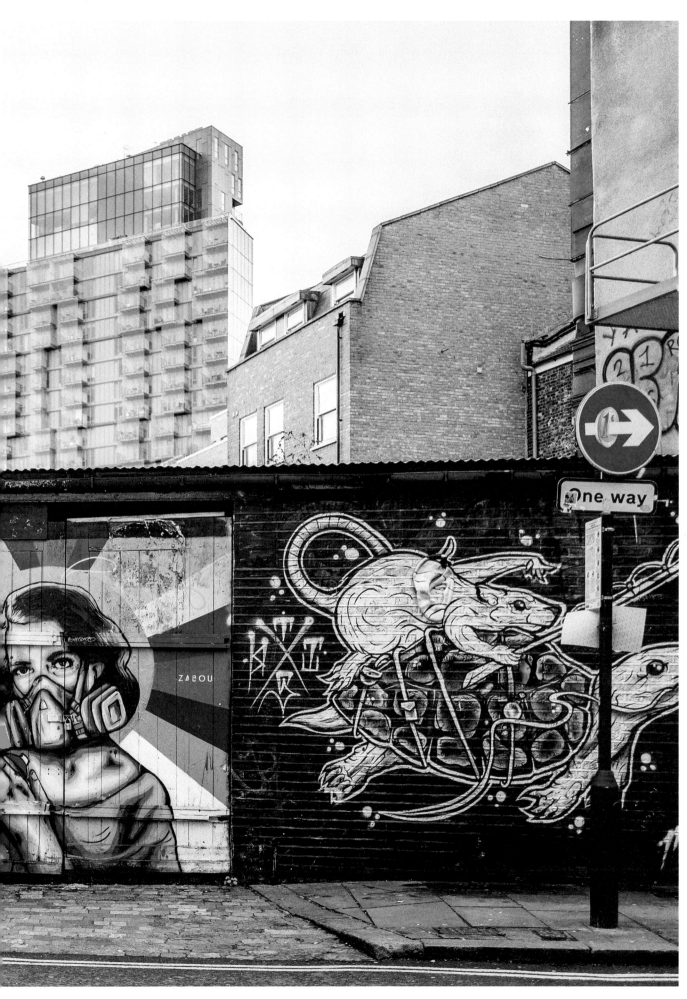

ZABOU

One way

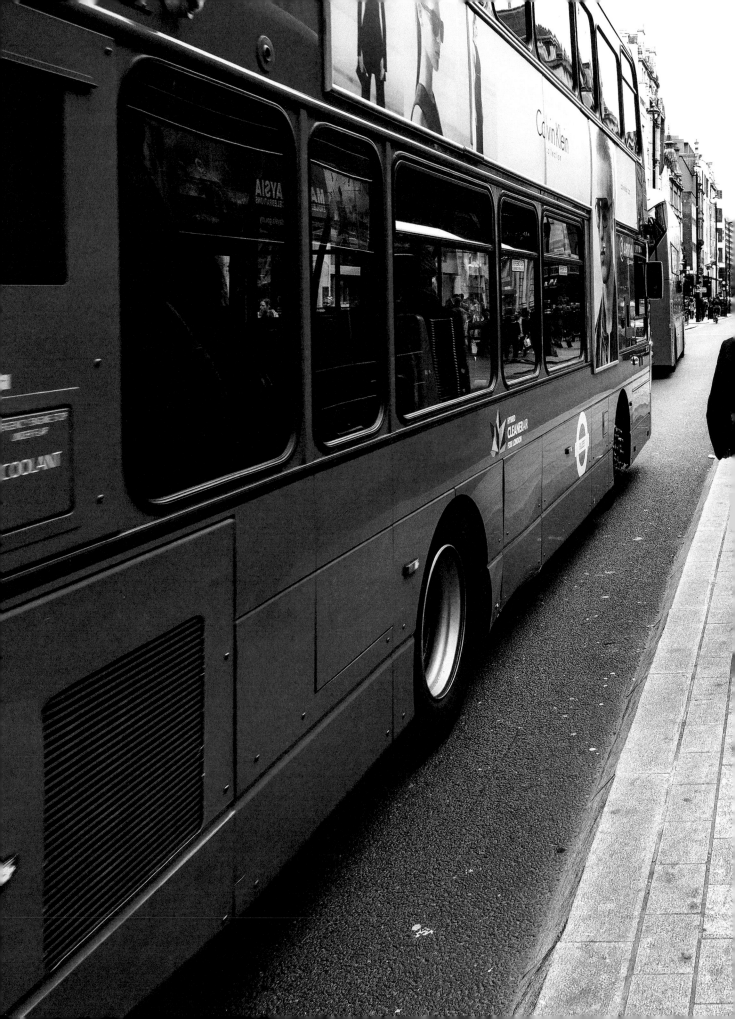

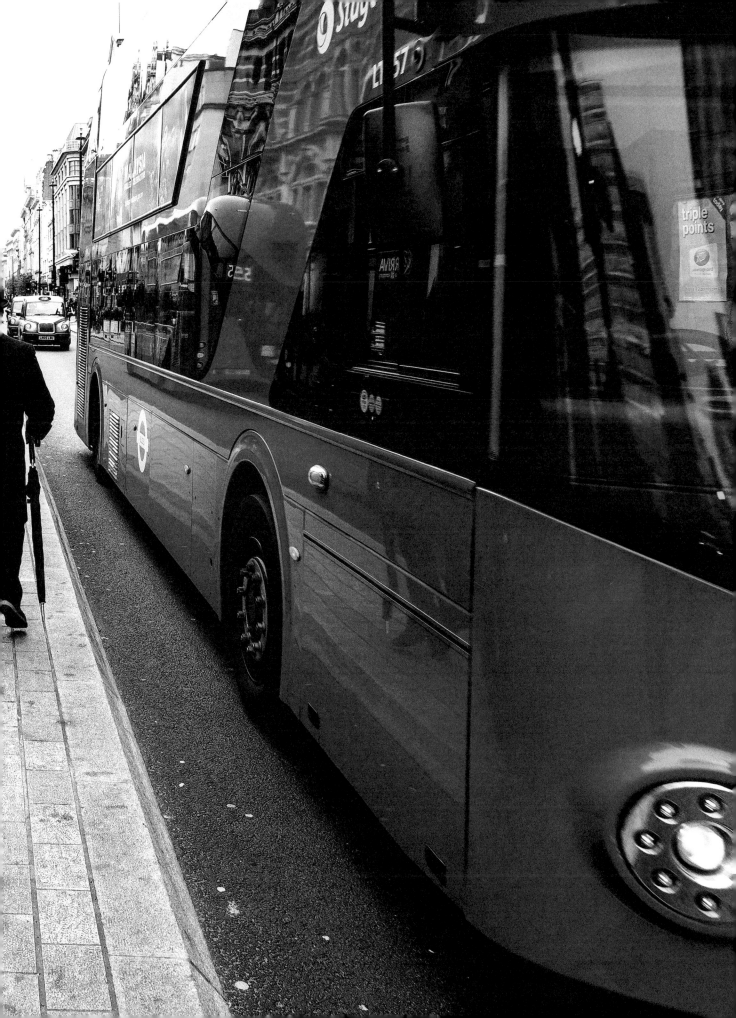

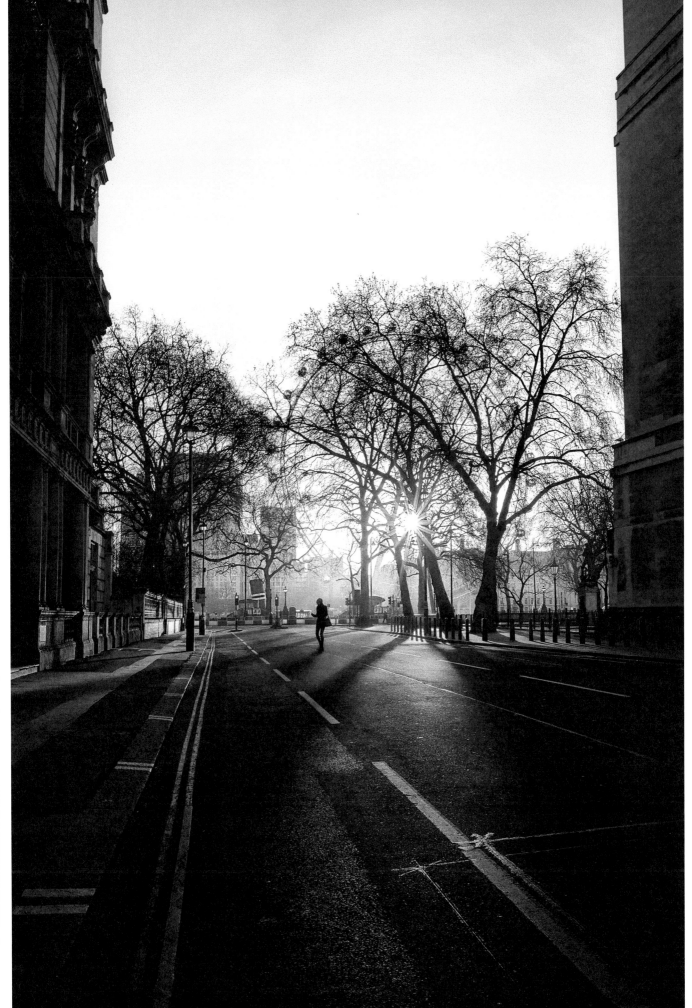

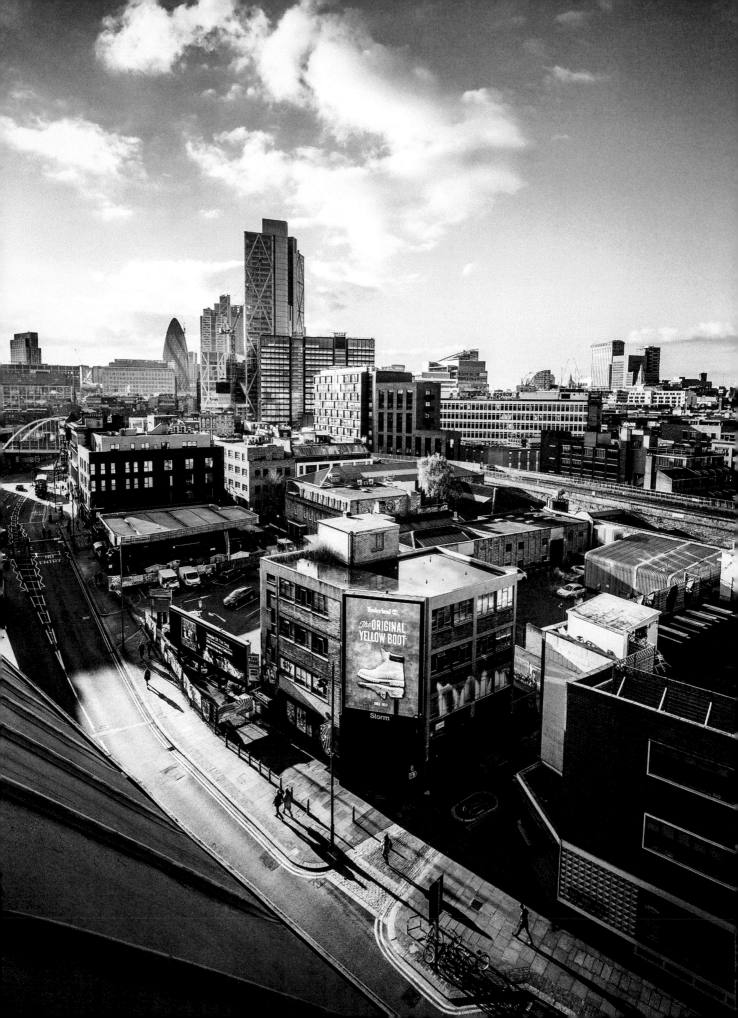

When a man is tired of London, he
is tired of life; for there is in London
all that life can afford.

SAMUEL JOHNSON

Writer

2

Street View

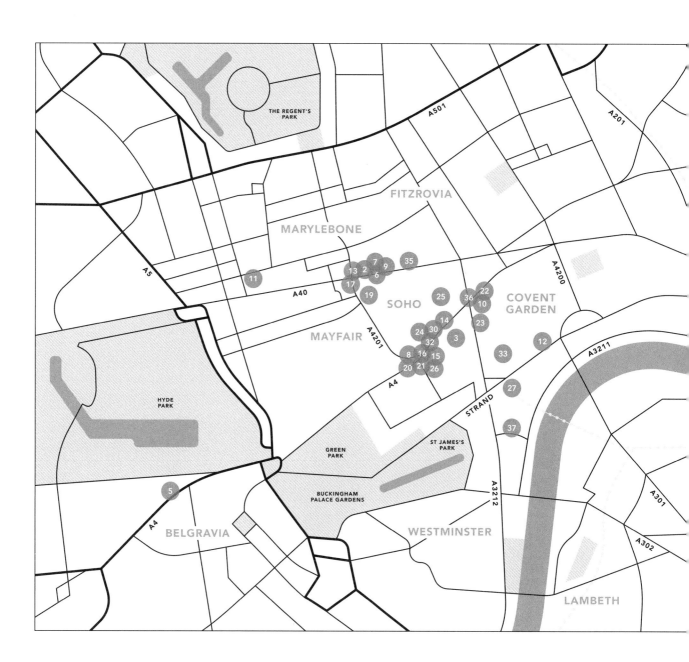

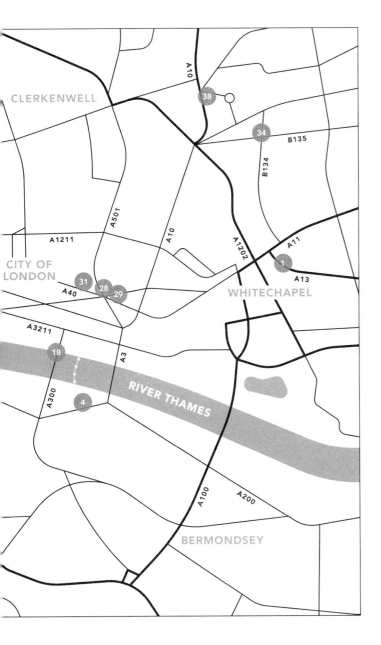

3

The Gherkin

Standing 41 storeys tall at 30 St Mary Axe, the Gherkin is one of the most instantly recognisable towers in the London skyline and, quite possibly, the world. Designed by architect Norman Foster and completed in 2003, the iconic building architecturally, technically, socially and spatially defies the norm. Its curvaceous form is a response to the constraints of the site, widening in profile as it rises from the ground and then tapering to its peak – maximising square footage while appearing more slender than a rectangular tower of equal size.
✛ The diagonally-braced structure is a striking contrast to the stark vertical lines around it, but the swirling design is not just for looks. As London's first ecological tall tower, it allows for column-free space within, opening each floor to uninterrupted light and views.

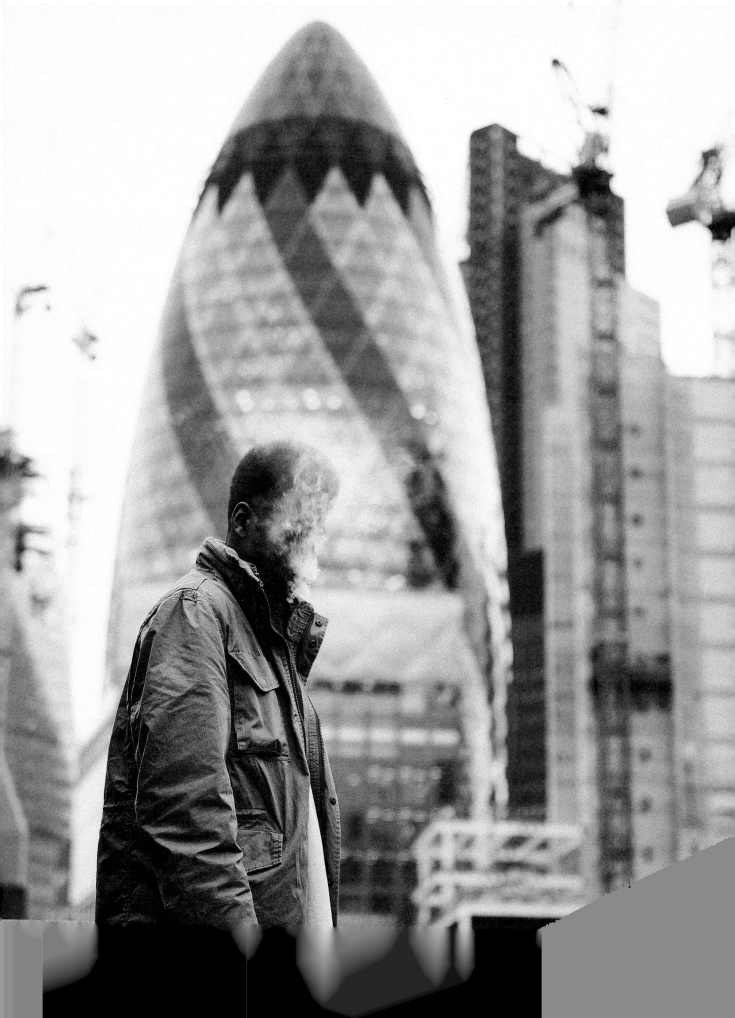

The English mist is always at work
like a subtle painter, and London is
a vast canvas prepared for the mist
to work on.

ARTHUR SYMONS

Poet, Critic and Editor

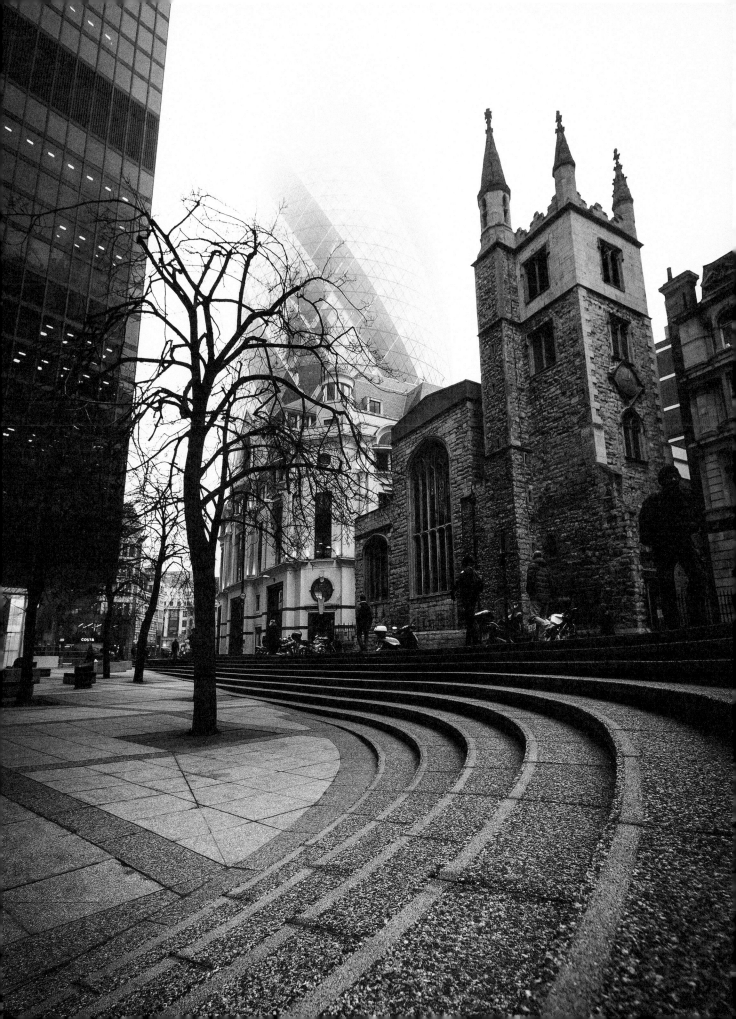

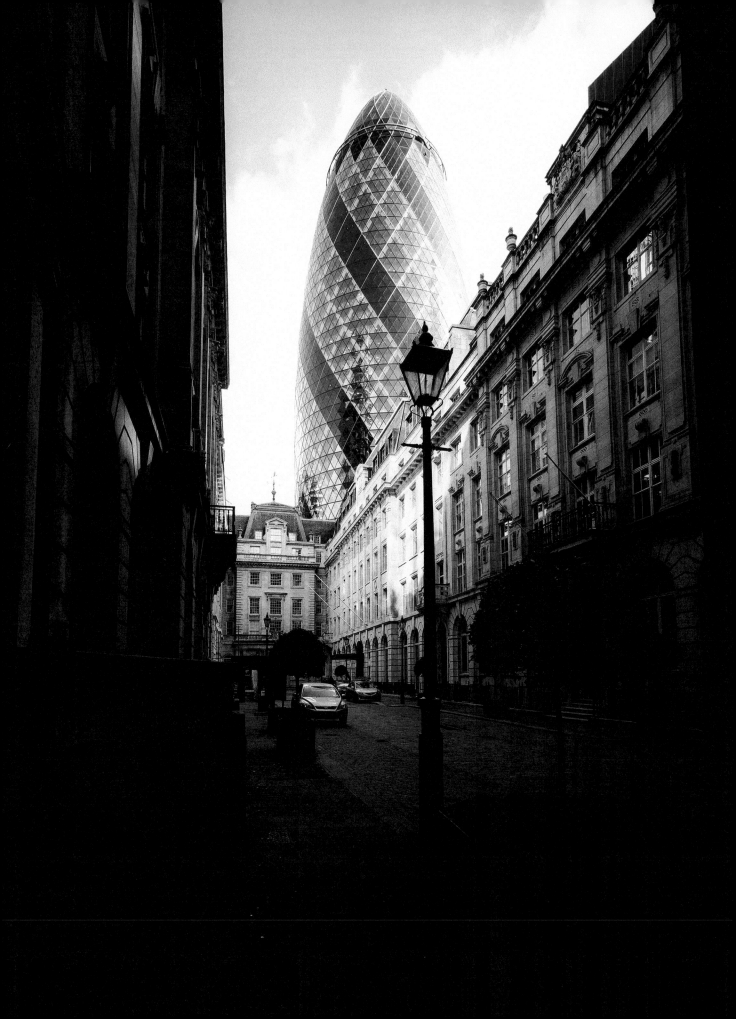

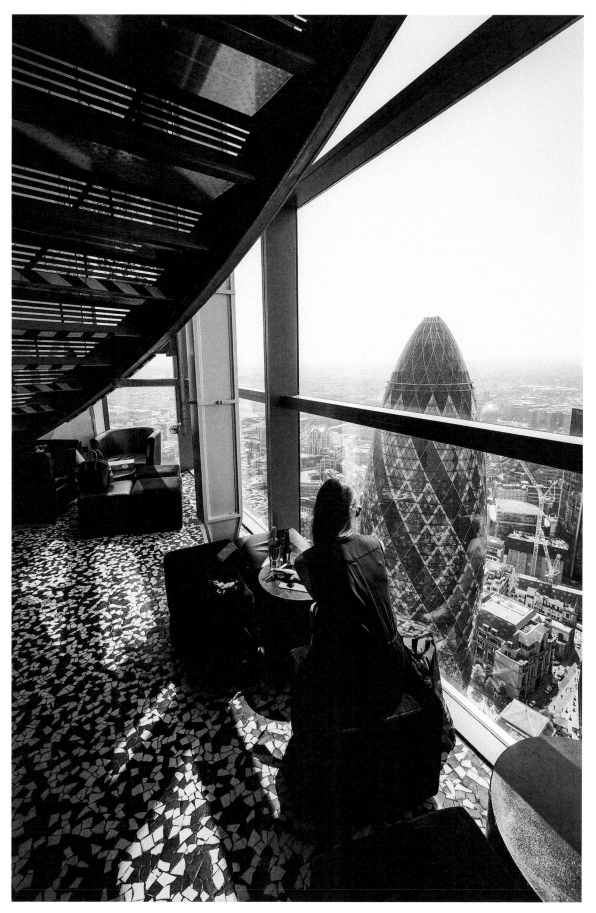

5 Above: View from Heron Tower, looking south
6 Right: View from Tower 42, looking southeast

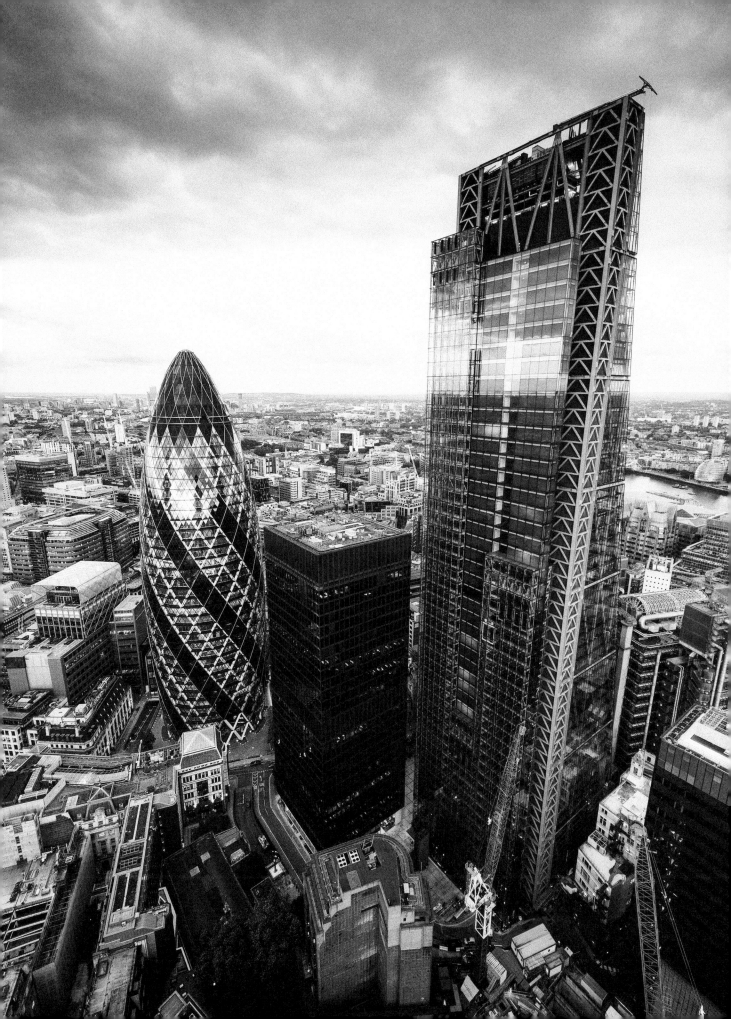

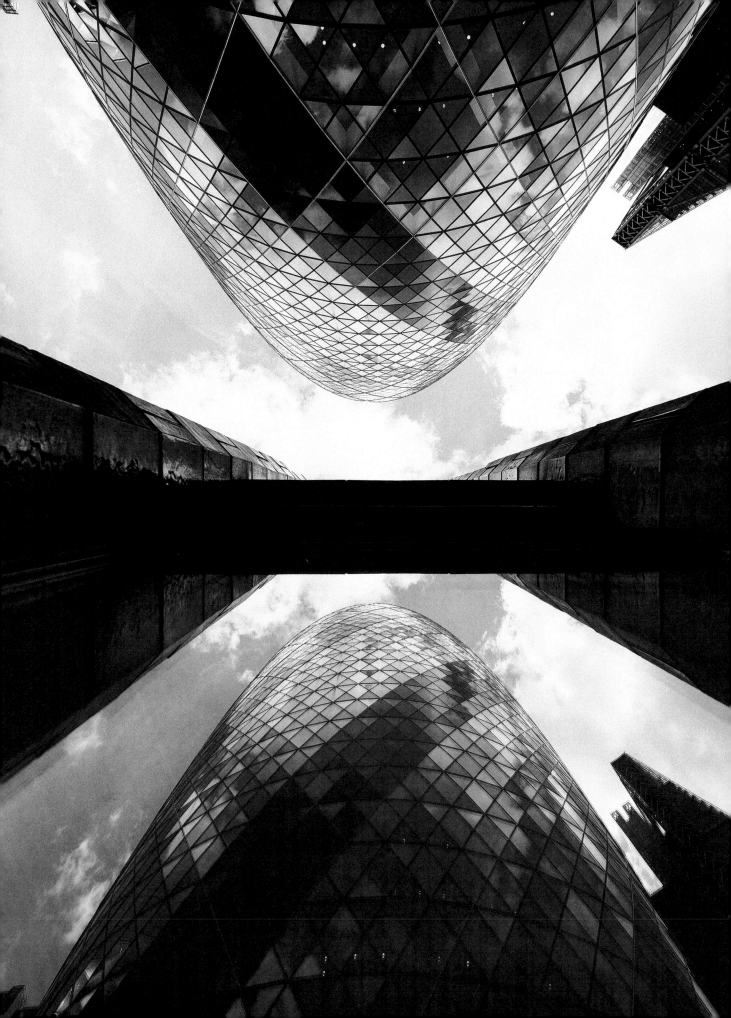

London is a chaotic patchwork of history, architecture, style, as disorganised as any dream, and like any dream possessing an underlying logic, but one that we can't quite make sense of, though we know it's there. A shoved-together city cobbled from centuries of distinct aesthetics disrespectfully clotted in a magnificent triumph of architectural philistinism.

CHINA MIÉVILLE

Author

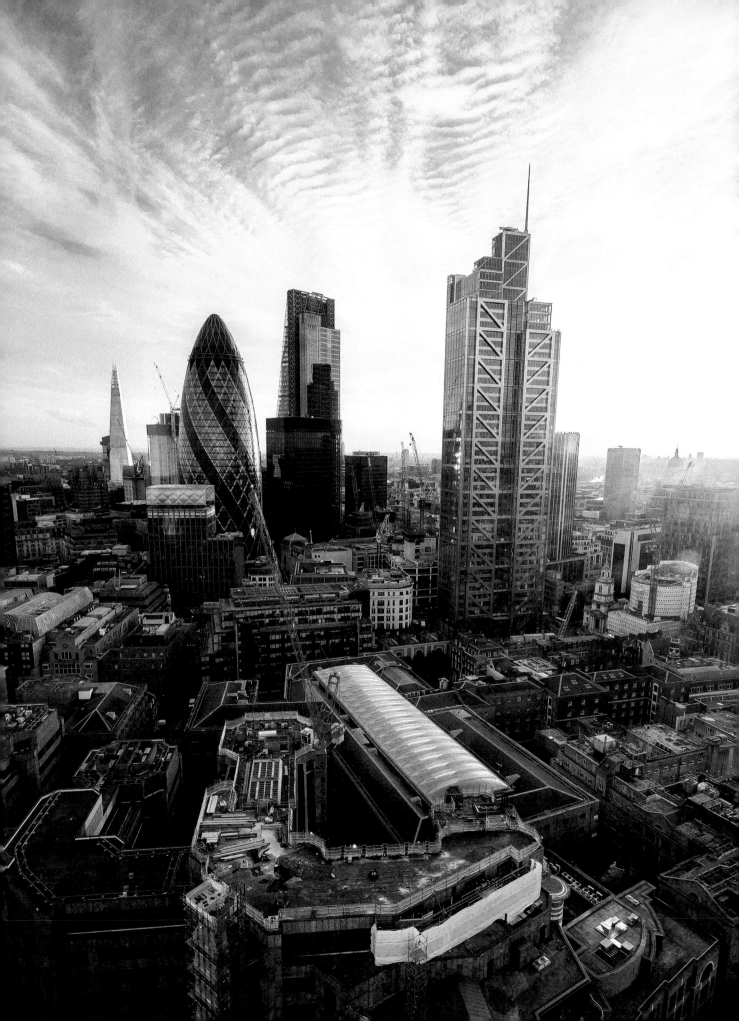

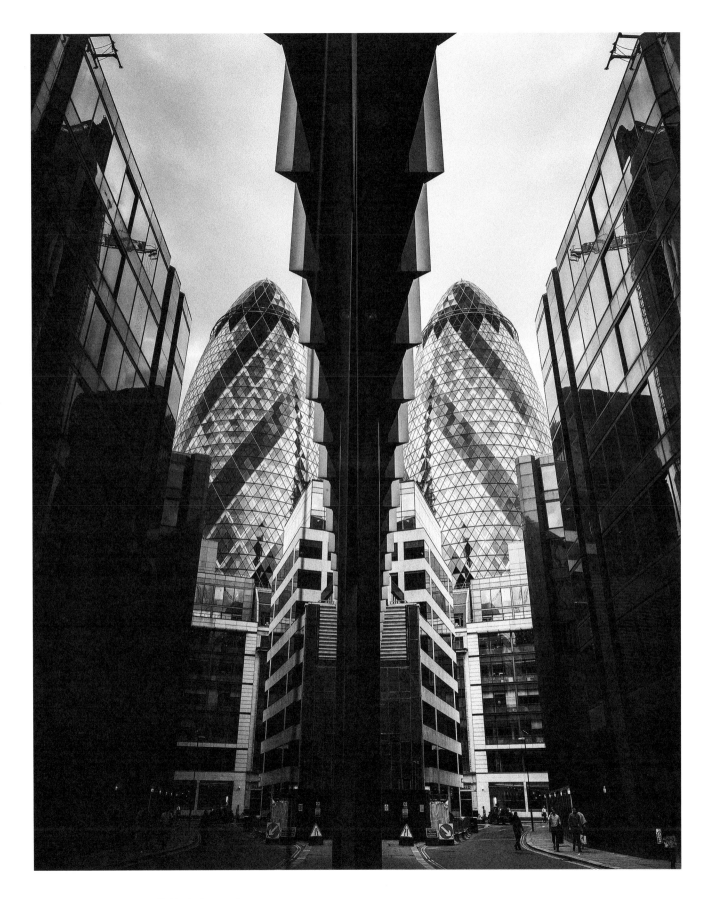

8 Left: Aerial view over Spitalfields, looking southwest
9 Above: View from Billiter Street

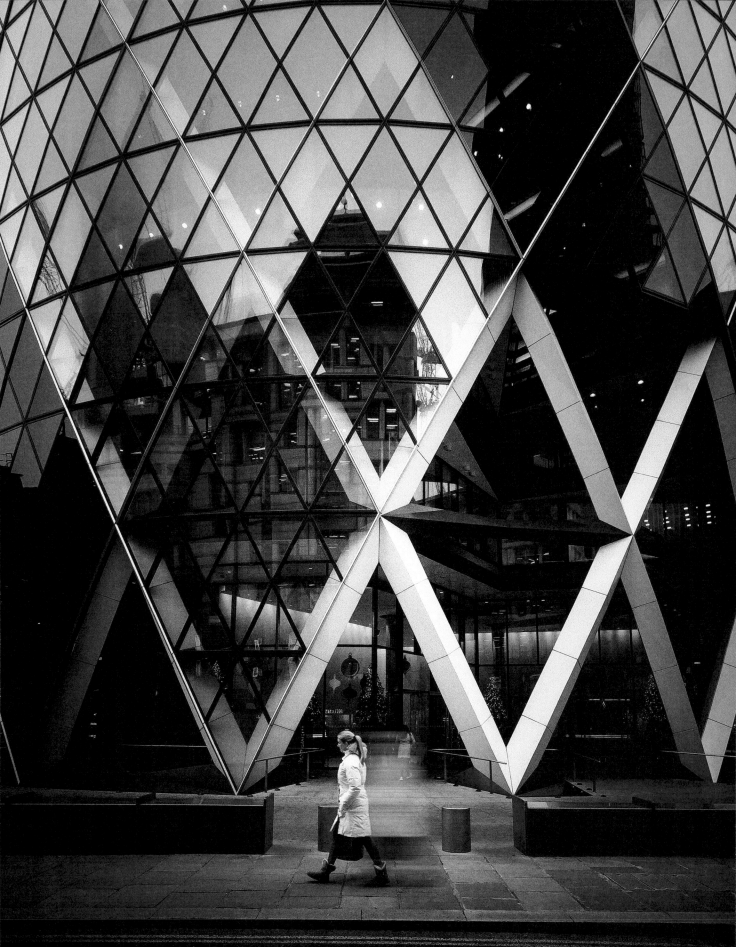

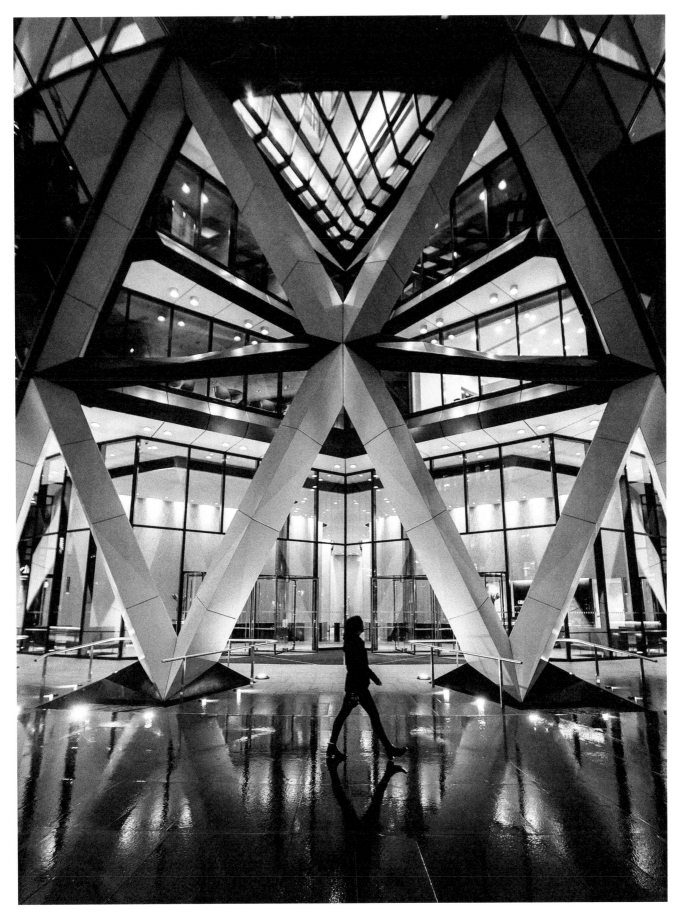

10 + 11 At street level, St Mary Axe

It is difficult to speak adequately or justly of London. It is not a pleasant place; it is not agreeable, or cheerful, or easy, or exempt from reproach. It is only magnificent.

HENRY JAMES

Author

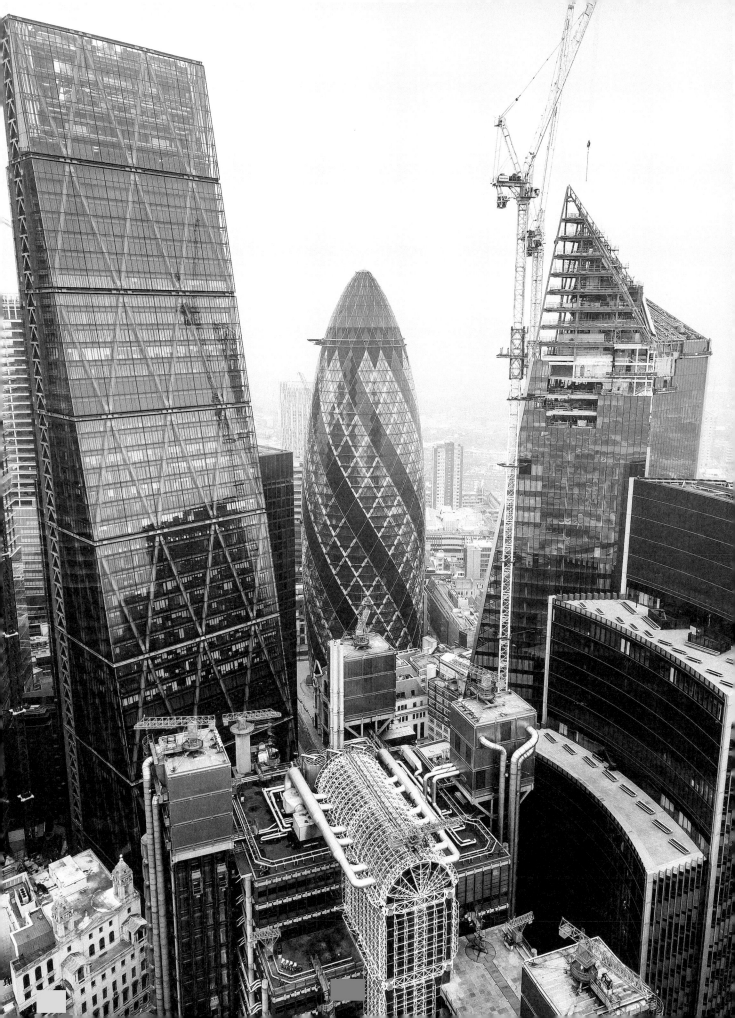

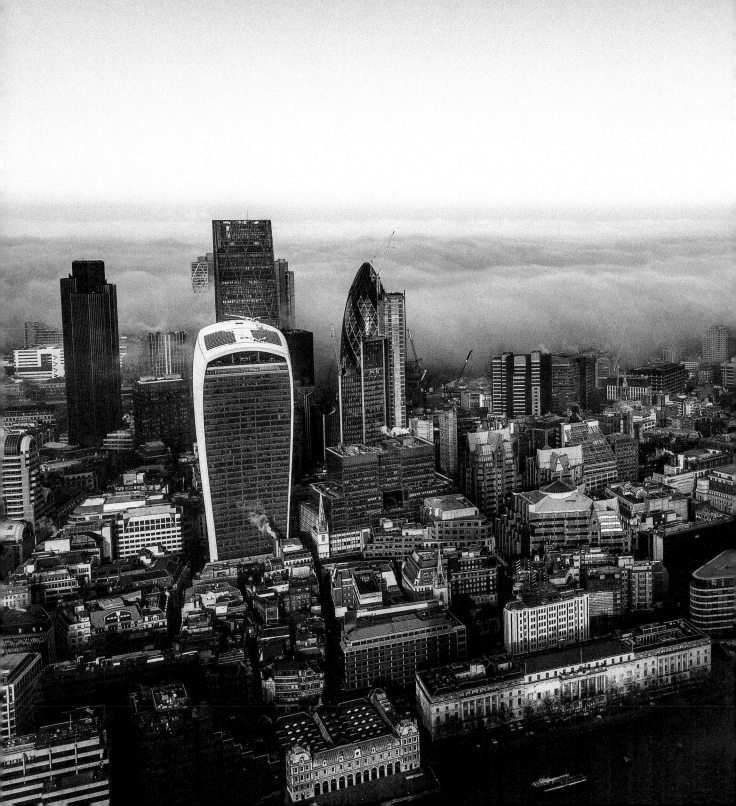

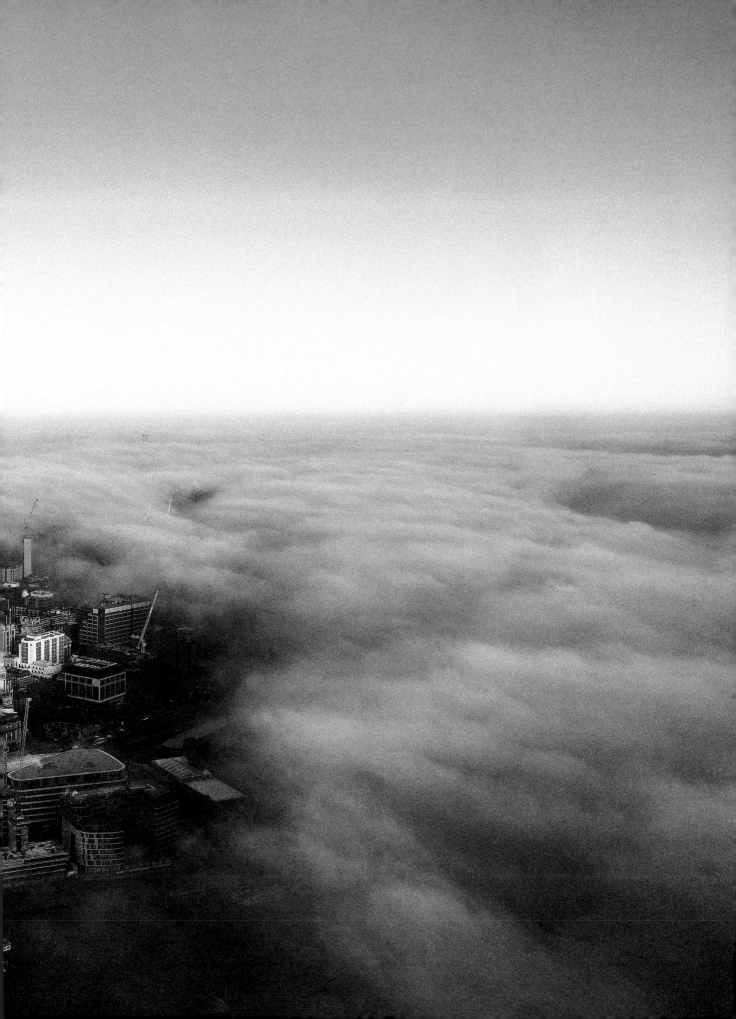

3

The Gherkin

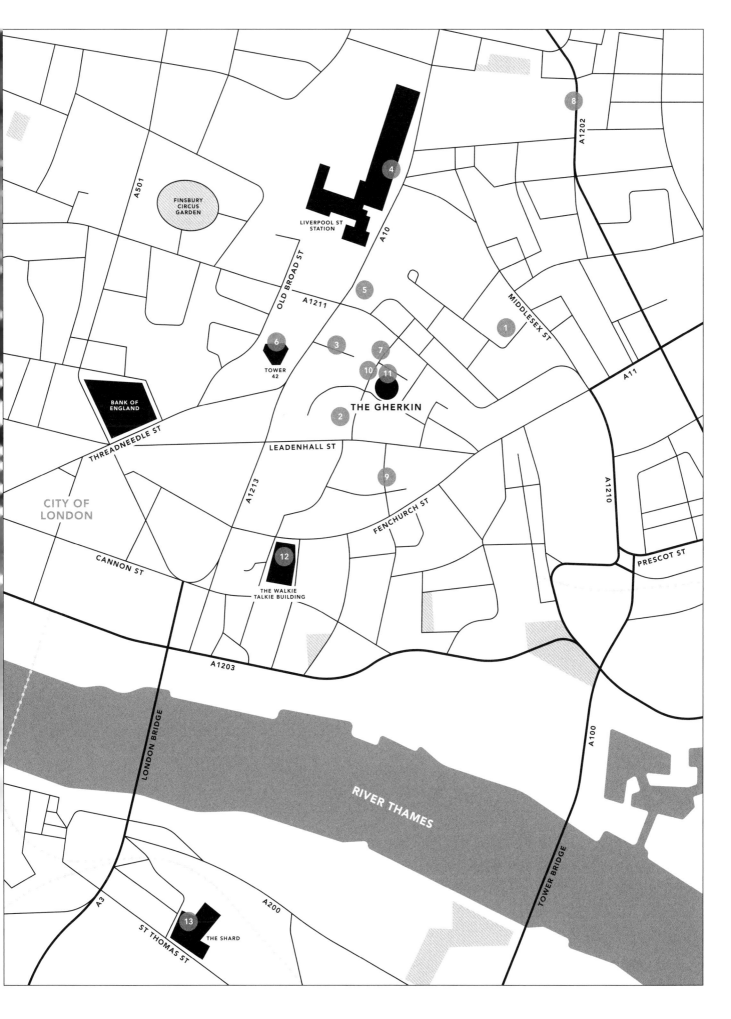

4

The Shard

A 95-storey glass pyramid that disappears into the sky, The Shard was a polarising addition to the London skyline in 2012. Designed by master Italian architect Renzo Piano, who historically viewed high rises as "arrogant and aggressive," The Shard was intentionally built to be different – light, airy and elegant, unlike the heavy towers of yore. ✚ Eleven thousand extra white glass panels line the exterior, creating a façade that changes with the weather and the seasons. It was built to reflect the skyline, not disturb it, although some would disagree. ✚ Conceived as a "vertical city" by developer Irvine Seller, the building's tall tapered structure is not only striking from the outside but a purposeful invitation for mixed uses within. From the bottom up, offices occupy the lowest floors with the largest footprints. Then, restaurants, bars and a hotel stack up, one on top of the other, with apartments residing on the storeys narrow enough to show views on all four sides. Floors 68, 69 and 72 hold the highest viewing areas in all of the UK, boasting 360-degree sights and 40 miles of visibility on a clear day. The final 23 cloud-piercing floors complete the spire-like sculpture rising up from the River Thames.

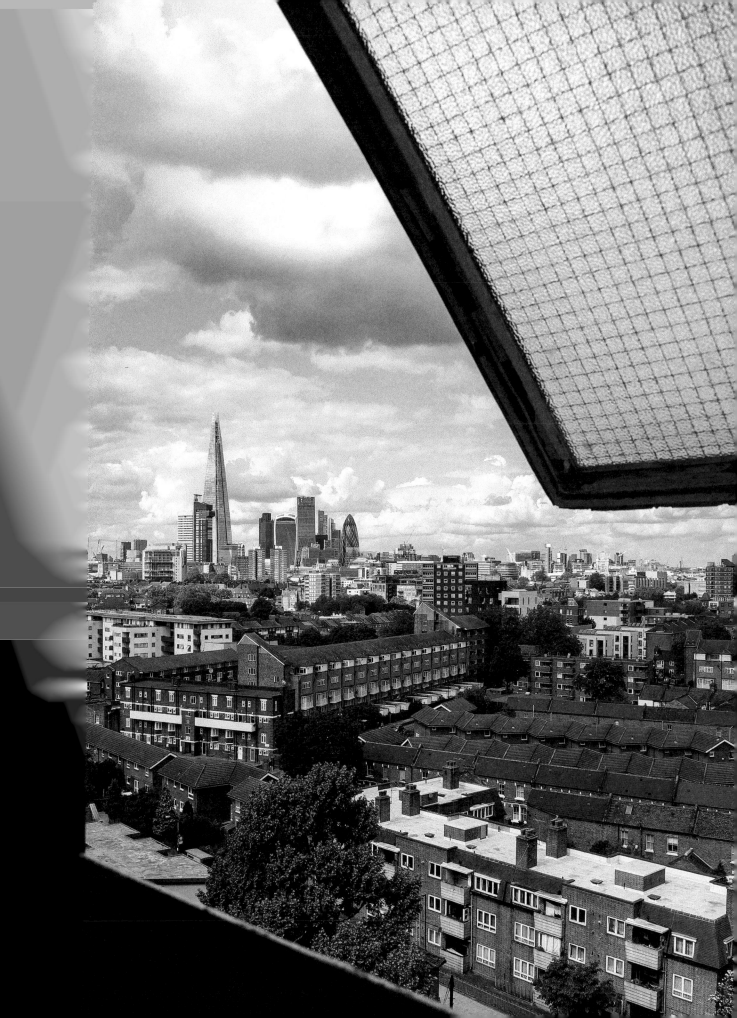

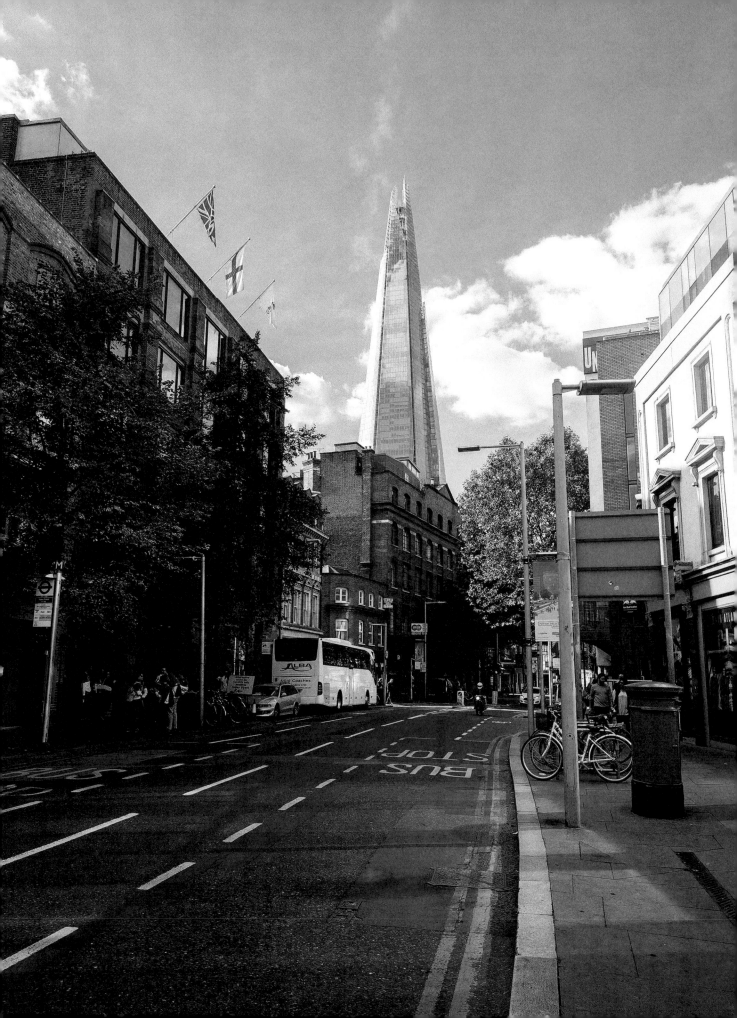

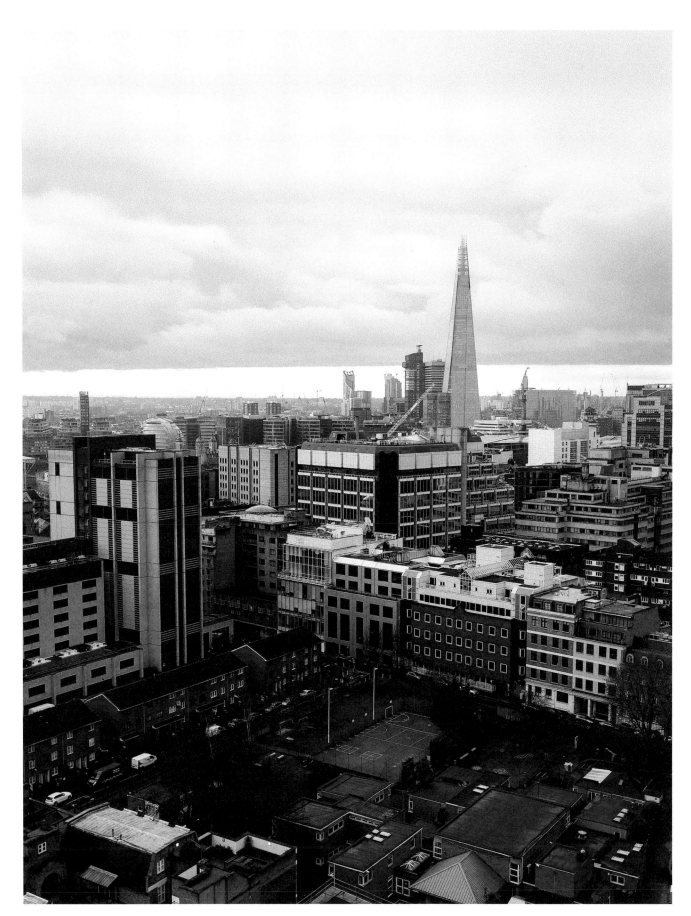

1 Previous Page: View from East and Flint Streets, Walworth, looking north
2 Left: View along Tooley Street at Barnham Street, looking northwest
3 Above: Aerial view over Whitechapel, looking southwest

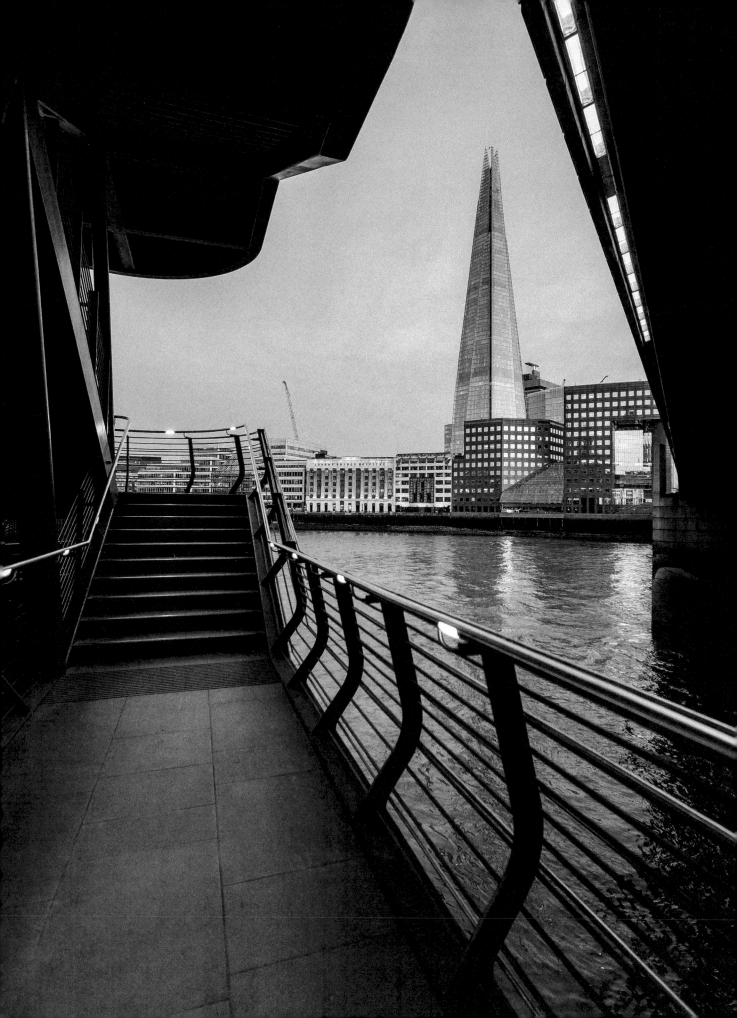

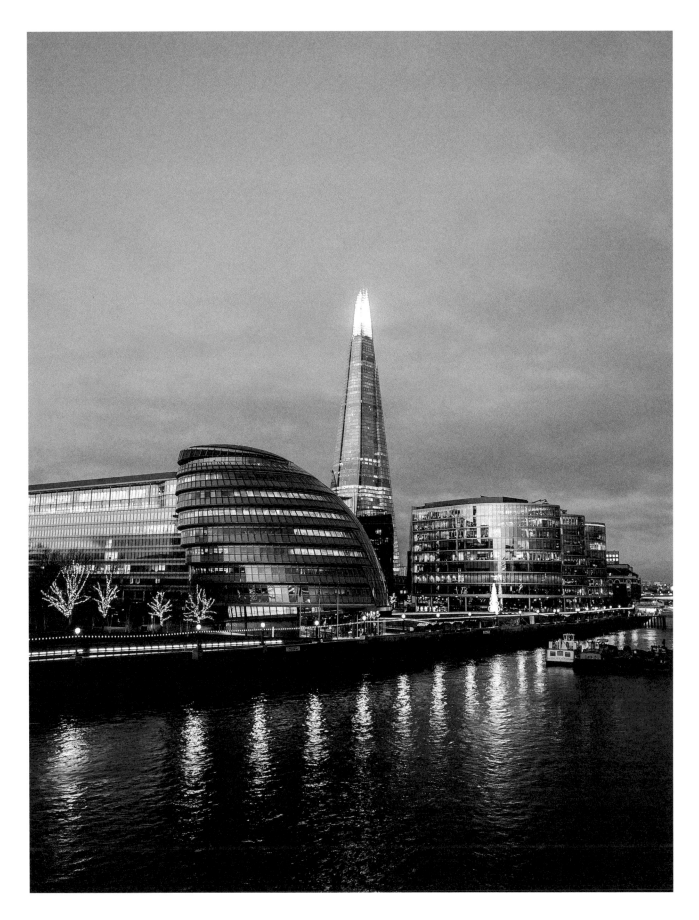

4 Left: Under London Bridge, looking south

5 Above: View from Tower Bridge, looking west

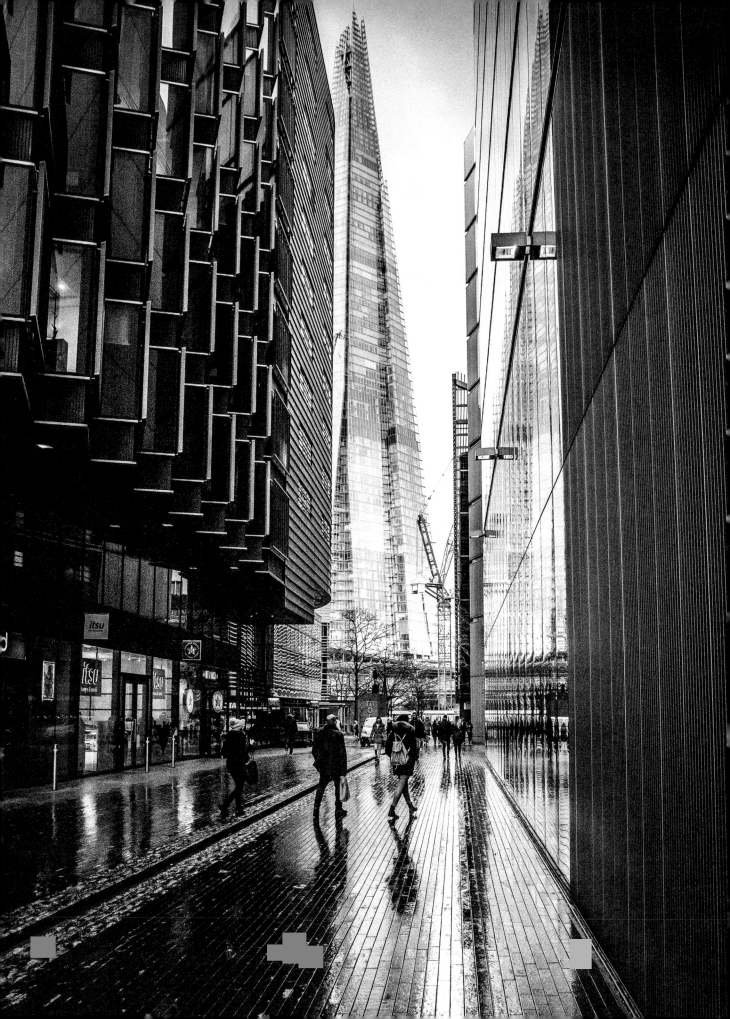

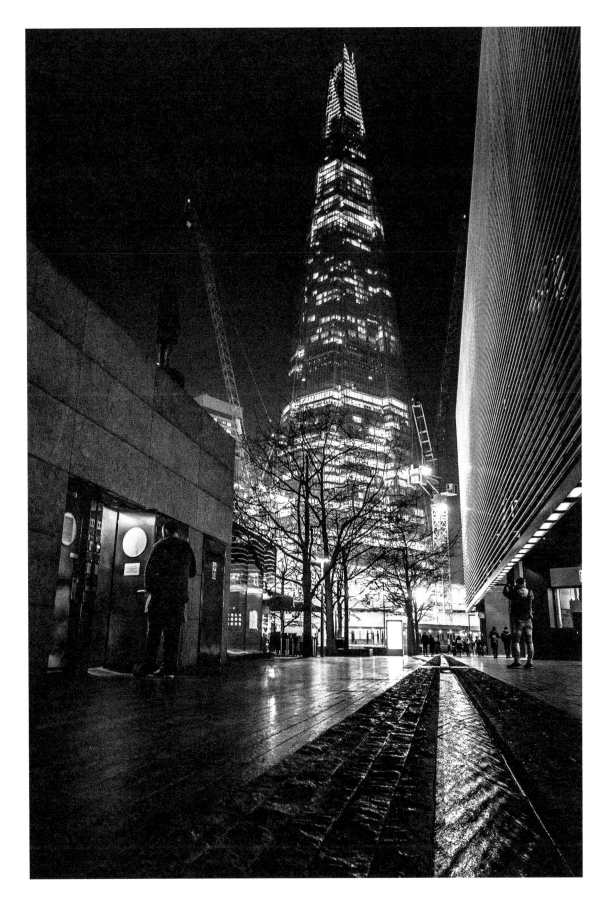

6 Left: View from More London Riverside walkway, looking west

7 Above: View from More London Riverside walkway, looking west

8 Following Spread: View from Tower 42, looking south

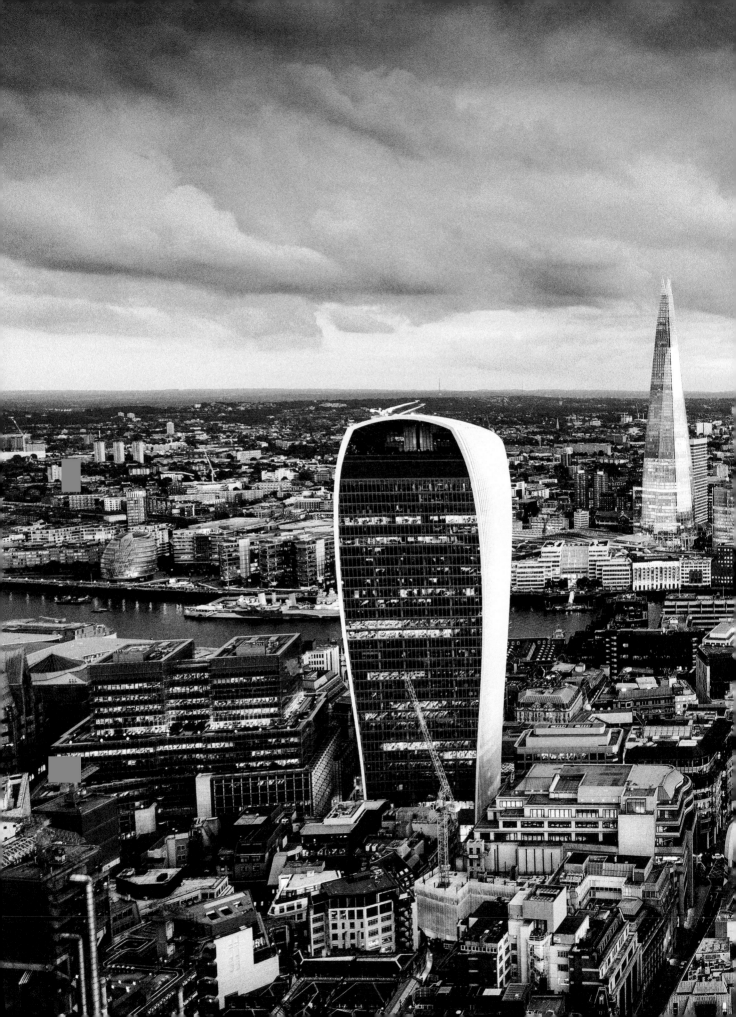

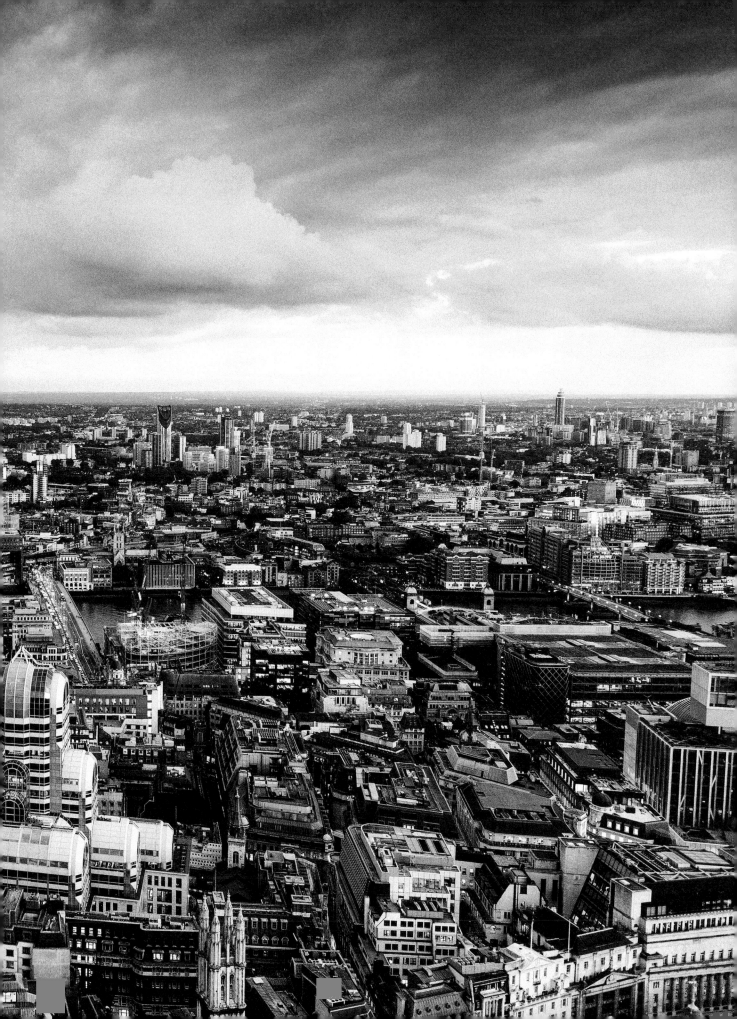

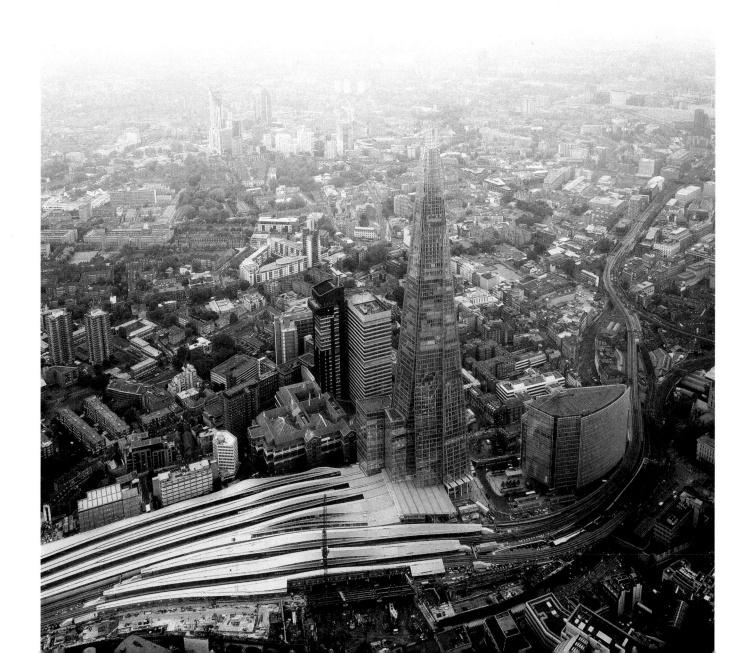

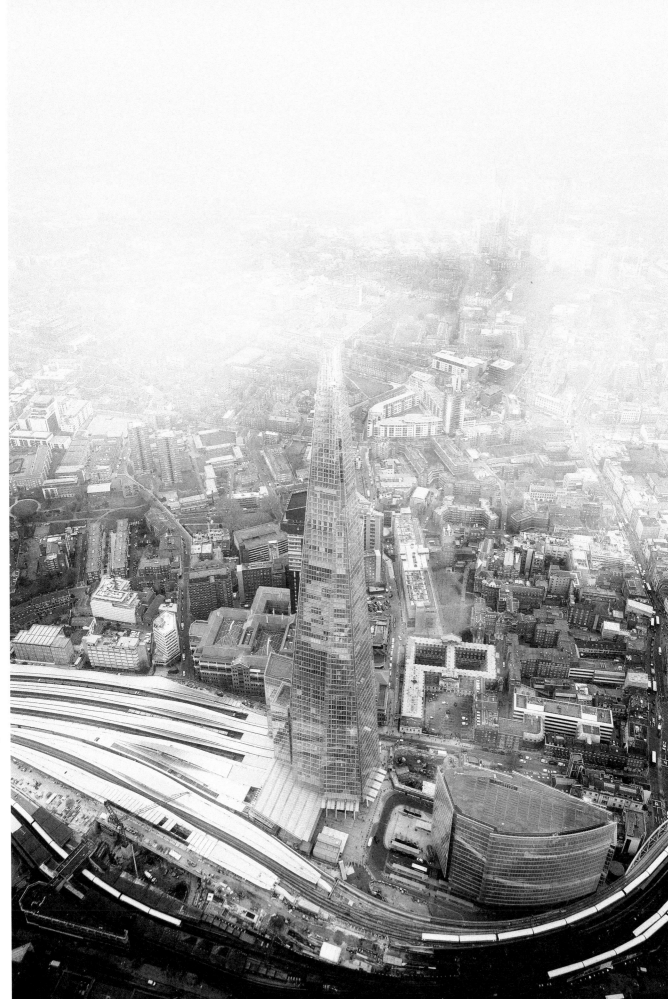

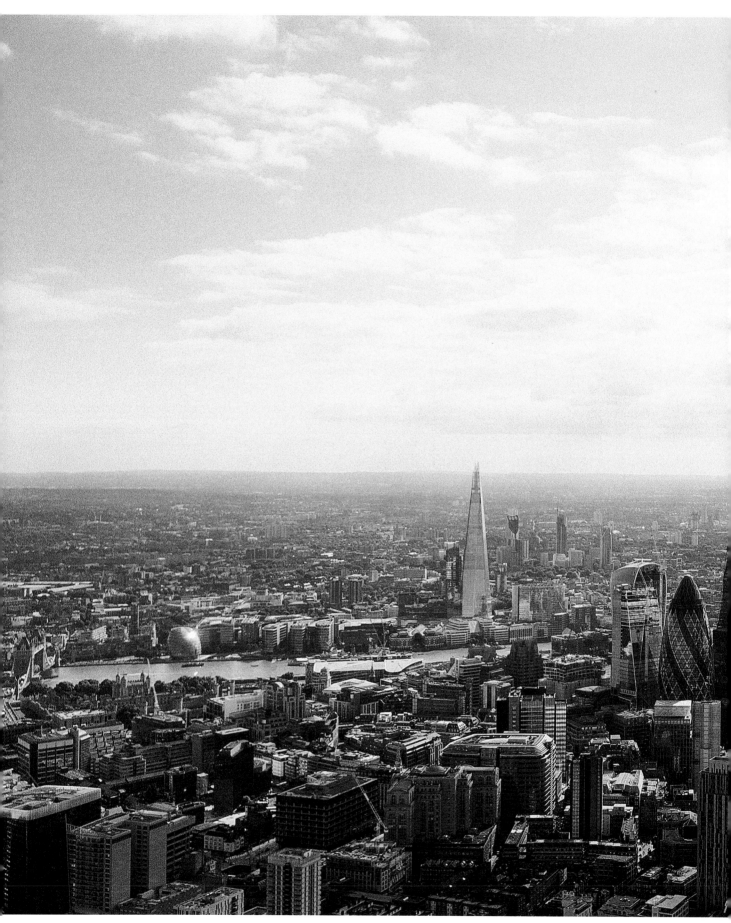

11 Above Allen Gardens, looking southwest

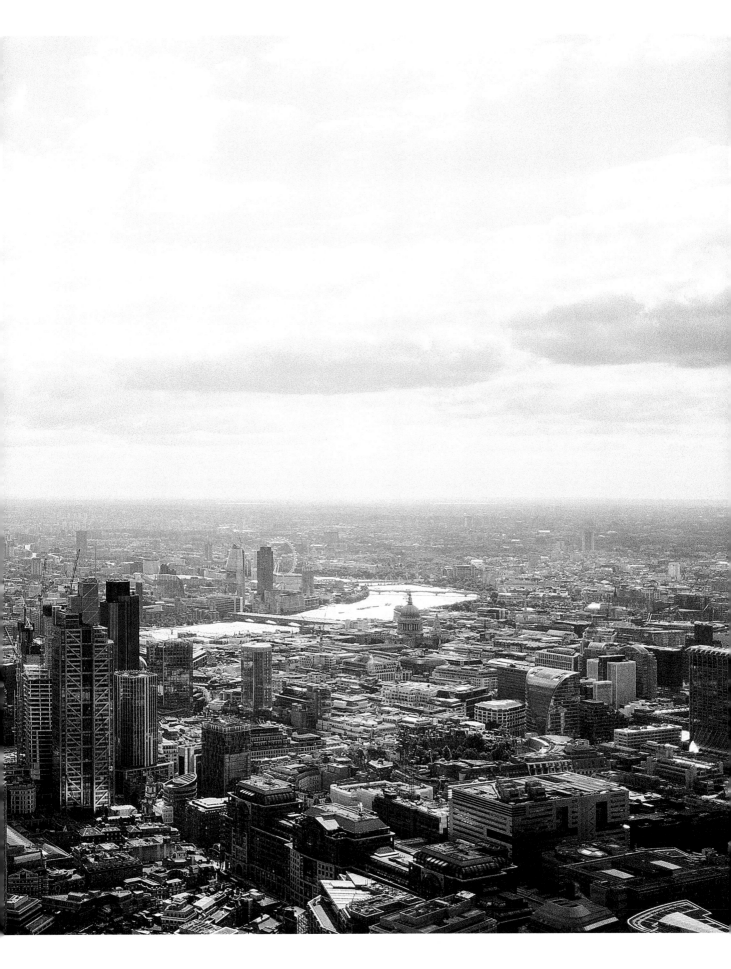

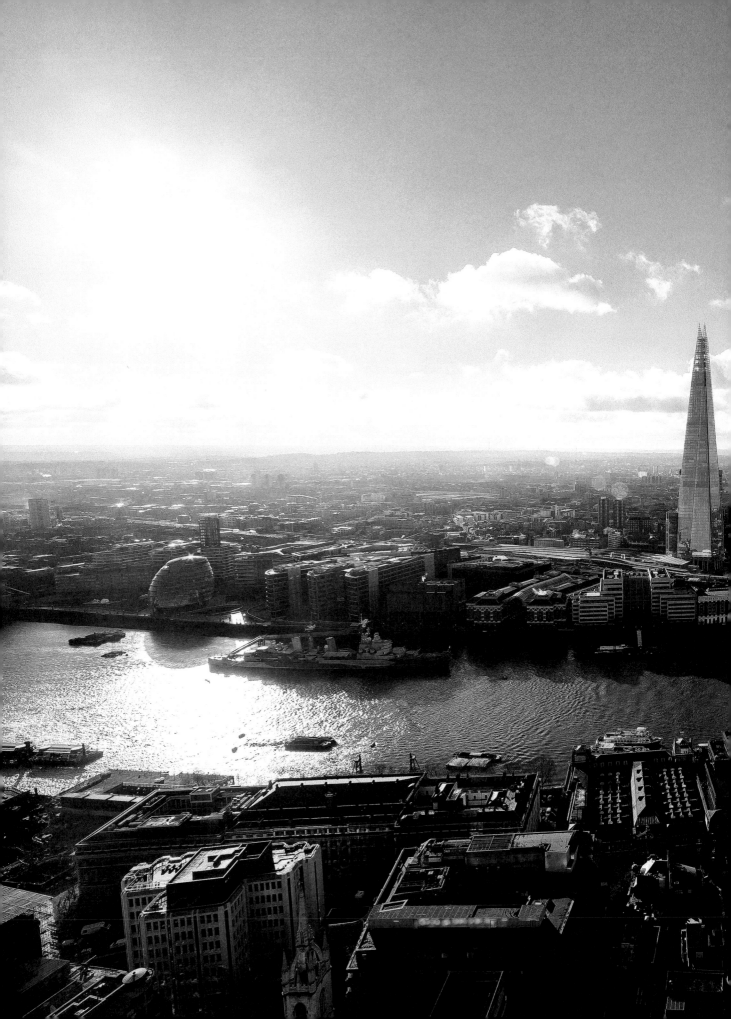

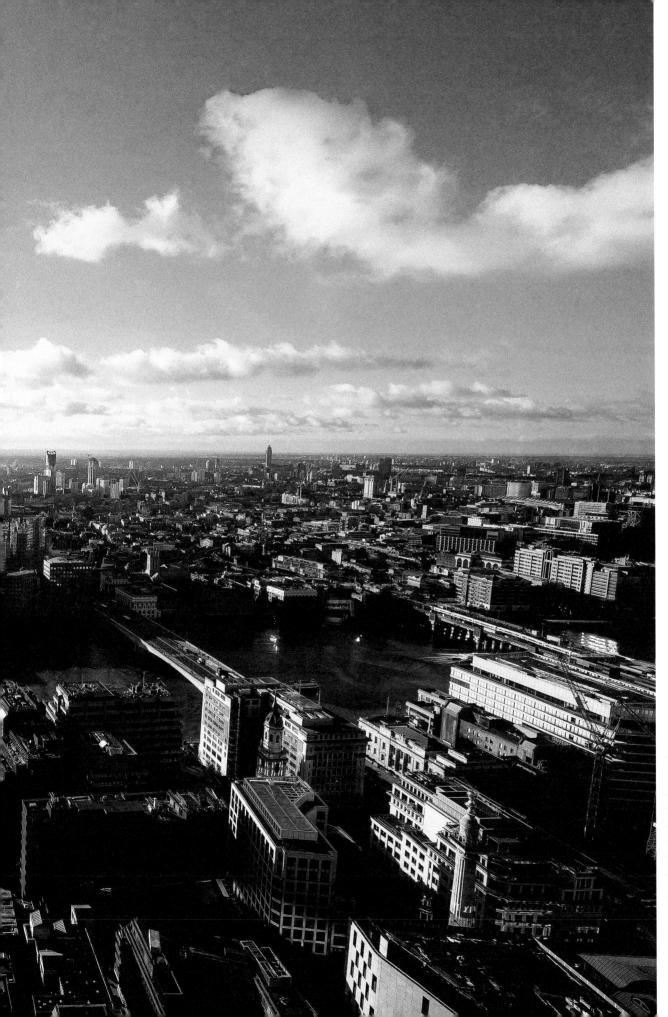

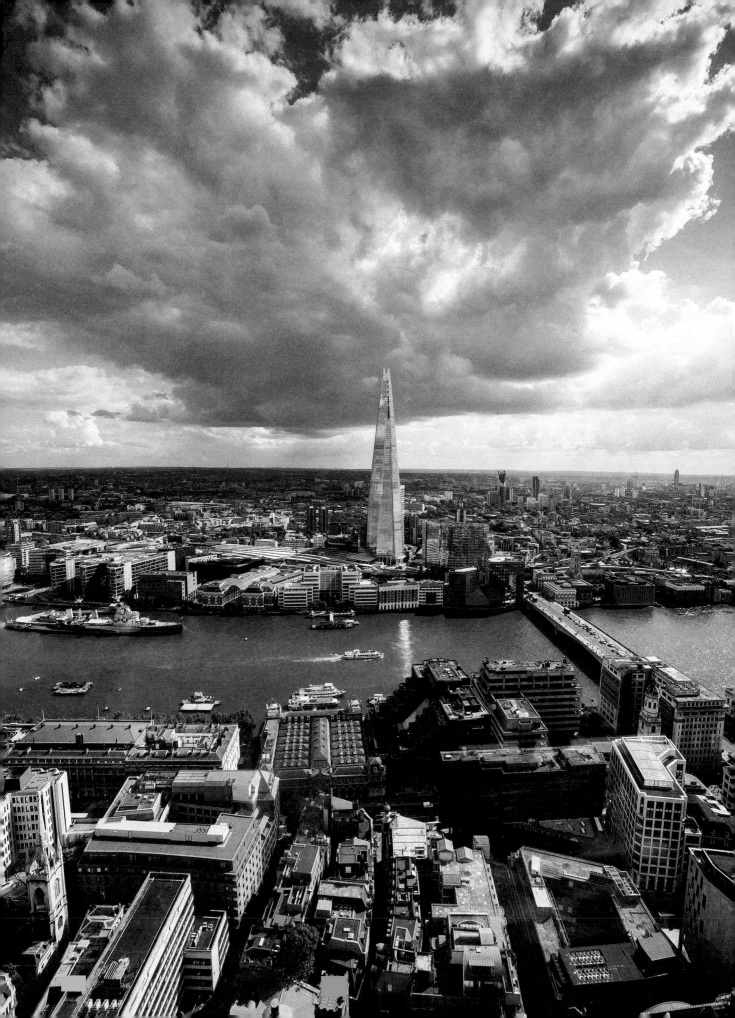

Cities are beautiful because they are created slowly; they are made by time. A city is born from a tangle of monuments and infrastructures, culture and market, national history and everyday stories.

RENZO PIANO

Architect

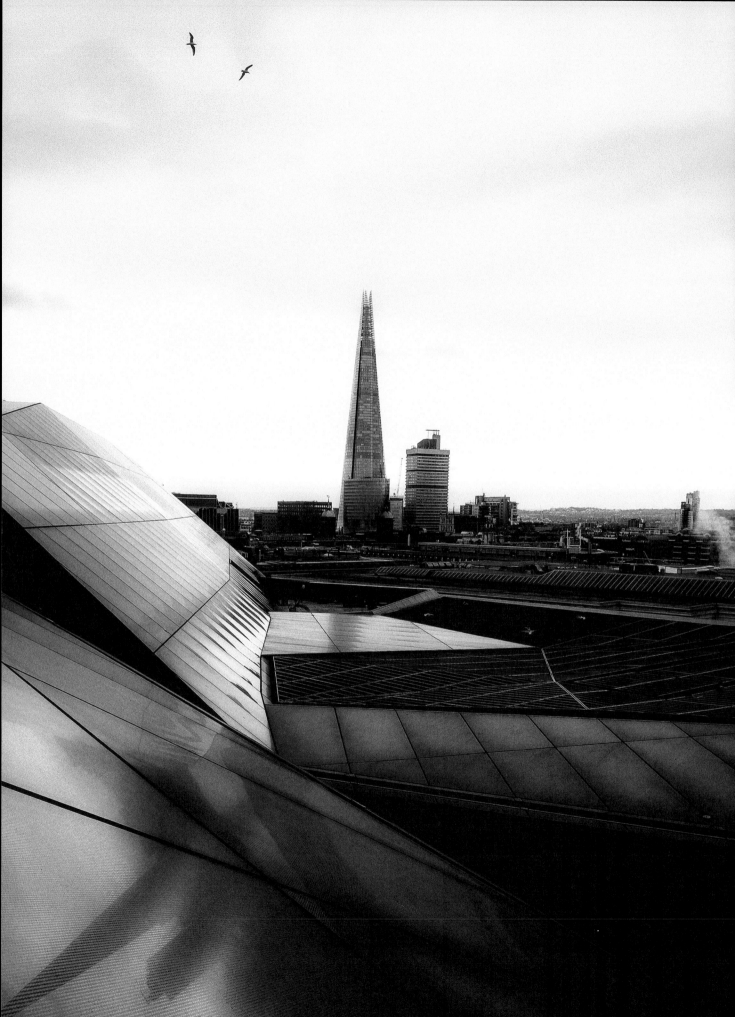

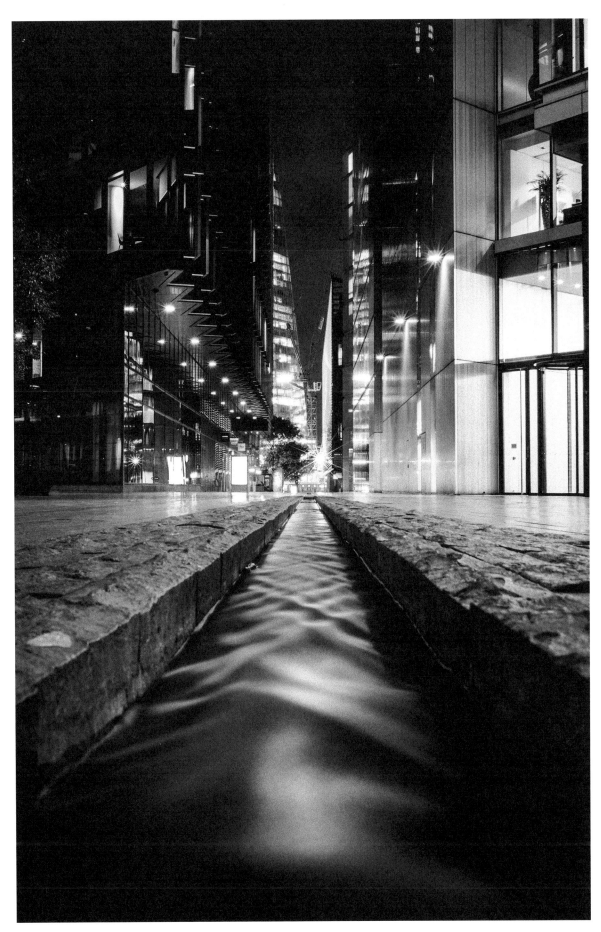

14 Left: View from One New Change terrace, looking south
15 Above: View from More London Riverside walkway, looking west

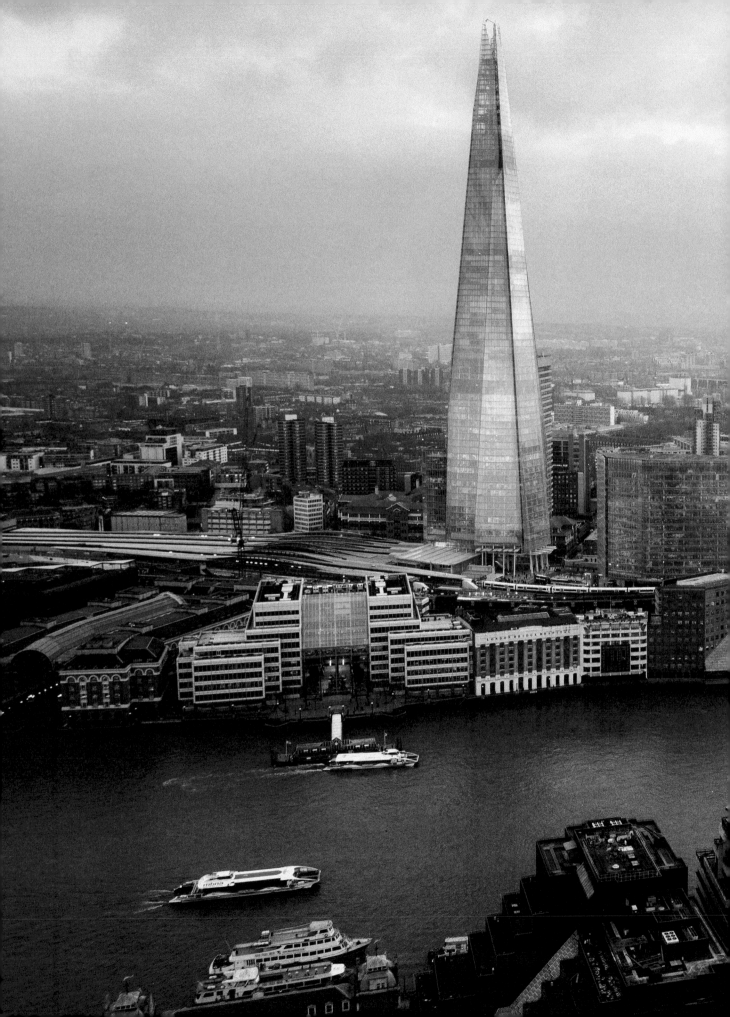

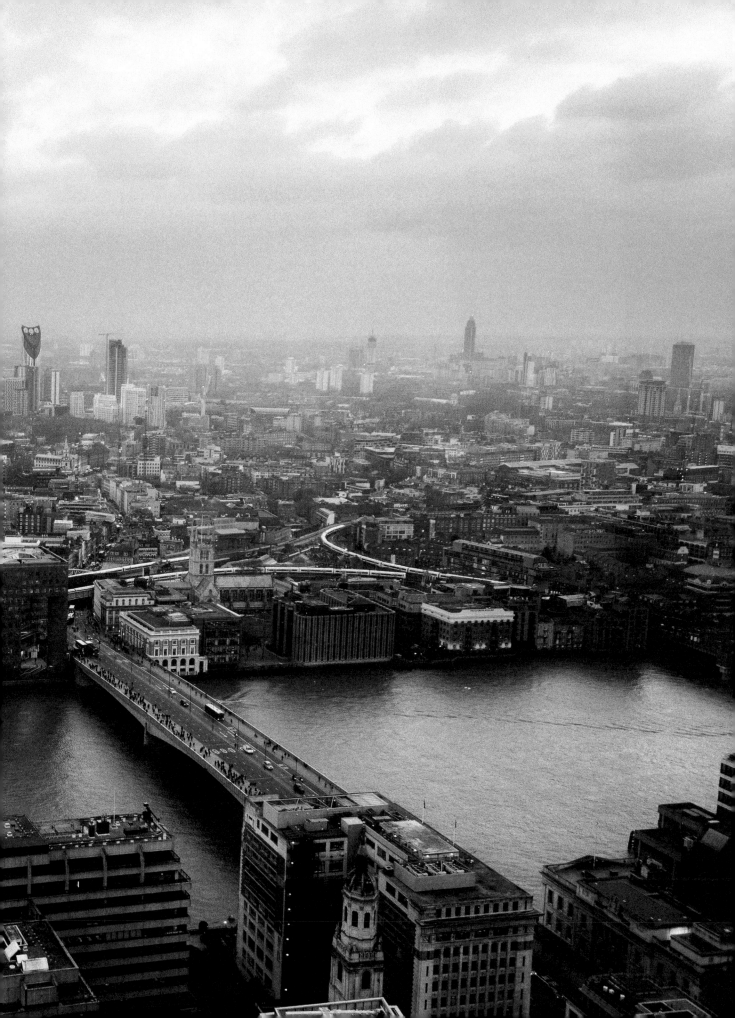

London is like a smoky pearl
set in a circle of emeralds.

WILLIAM HENRY RIDING

Writer

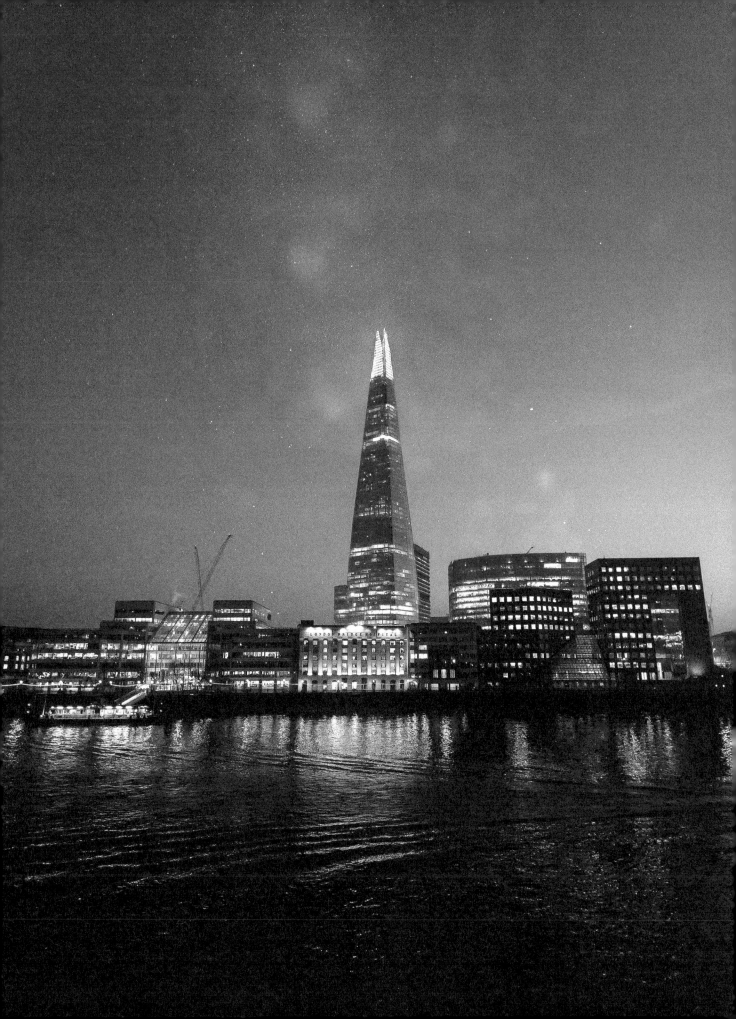

4

The Shard

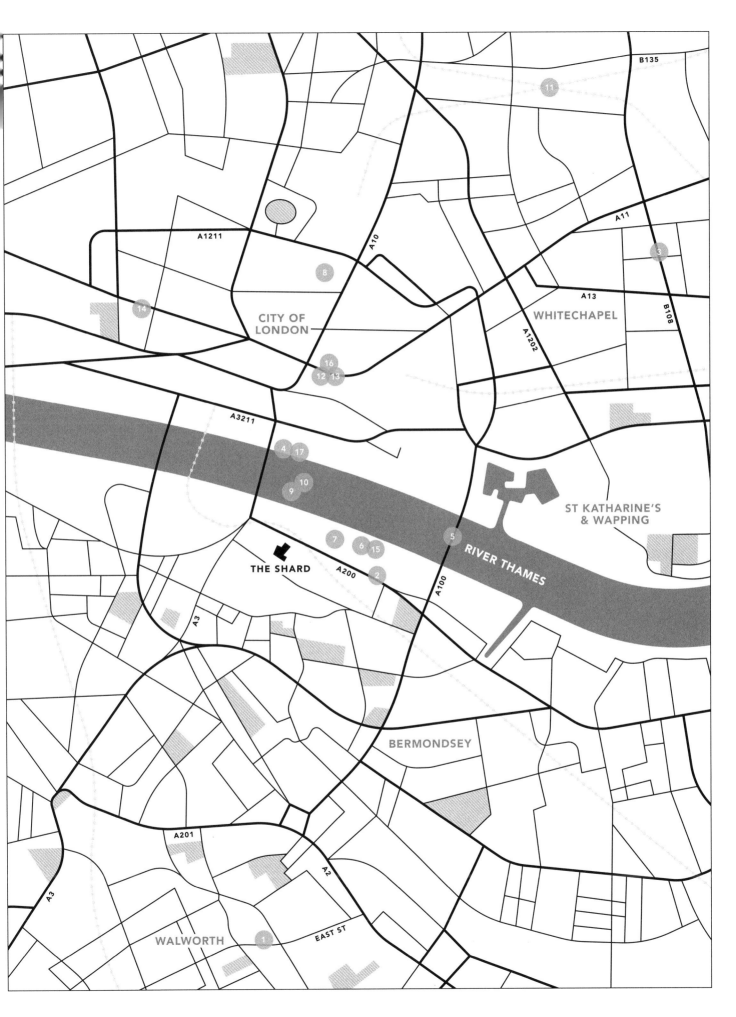

Spaces & Places

London is an amalgamation of history and progress. With precious stone structures standing metres from modern architectural marvels, the layout creates a rich and beautiful tension that demands acknowledgement of the city's past and respect for its incessant forward movement. ✦ From 1939 to 1945, bombing destroyed over 70,000 buildings and damaged another 1.7 million, devastating the city. In an effort to determine which structures were historically and culturally important enough to be salvaged, the Town and Country Planning Act of 1947 created a three-level grading system. The listing classifications are still used to identify and preserve buildings of special interest, and ensure no more of the city's vital history is lost. ✦ London has become one of the world's most important centres of design. Its creativity and innovation play out everywhere: in museums, government buildings, markets and even Tube stations. A quick look upward – at not only the city's skyline but its ceilings – is to be reminded of the capital's architectural genius.

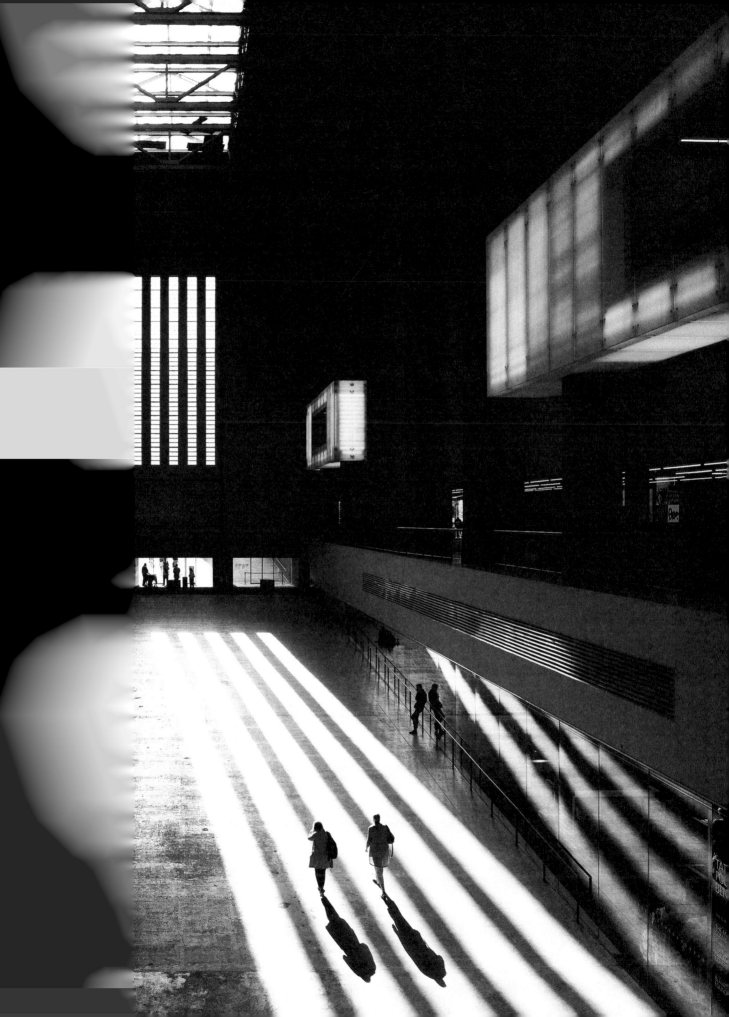

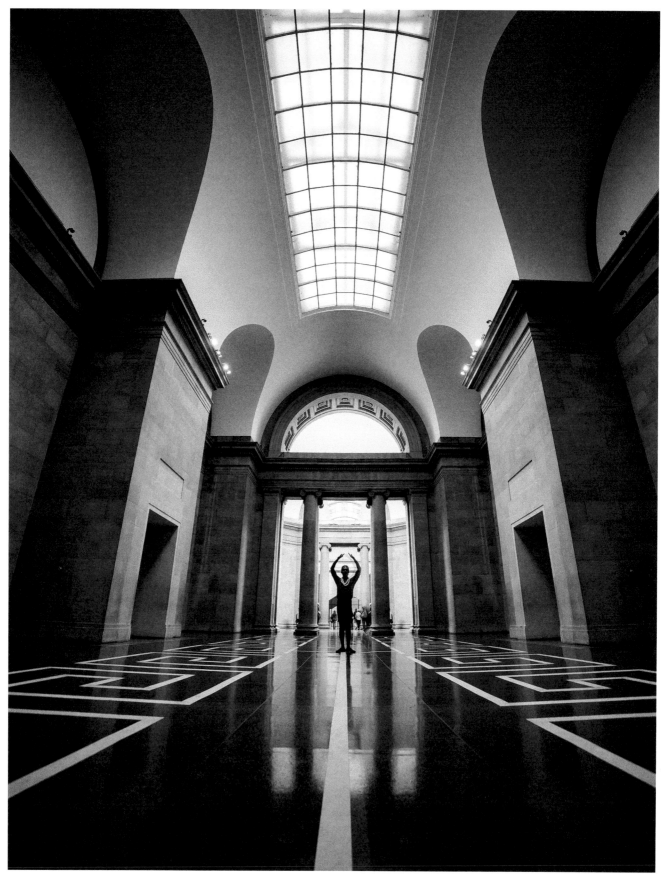

1 Previous Page: Turbine Hall, Tate Modern
2 Above: Interior hallway, Victoria & Albert Museum
3 Right: Atrium roof, Imperial War Museum

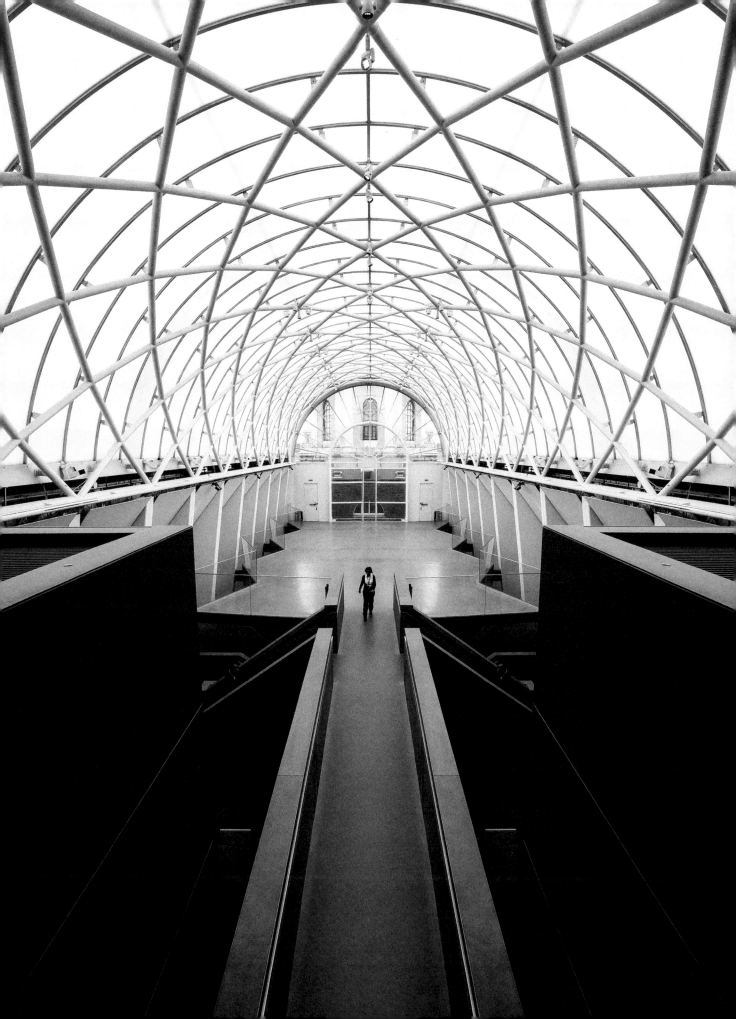

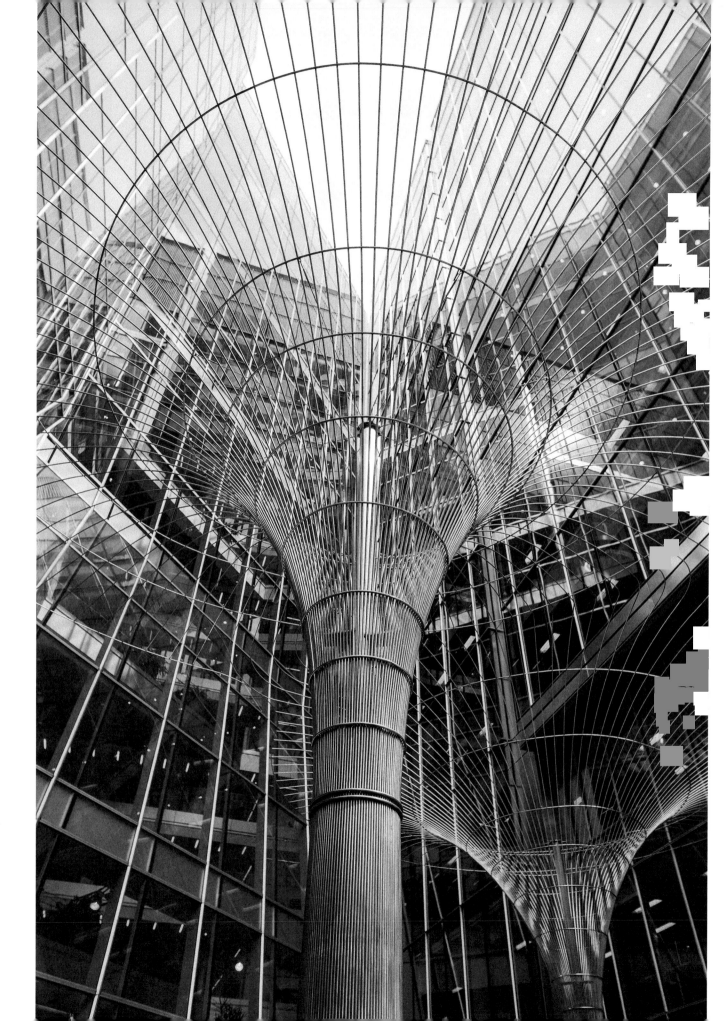

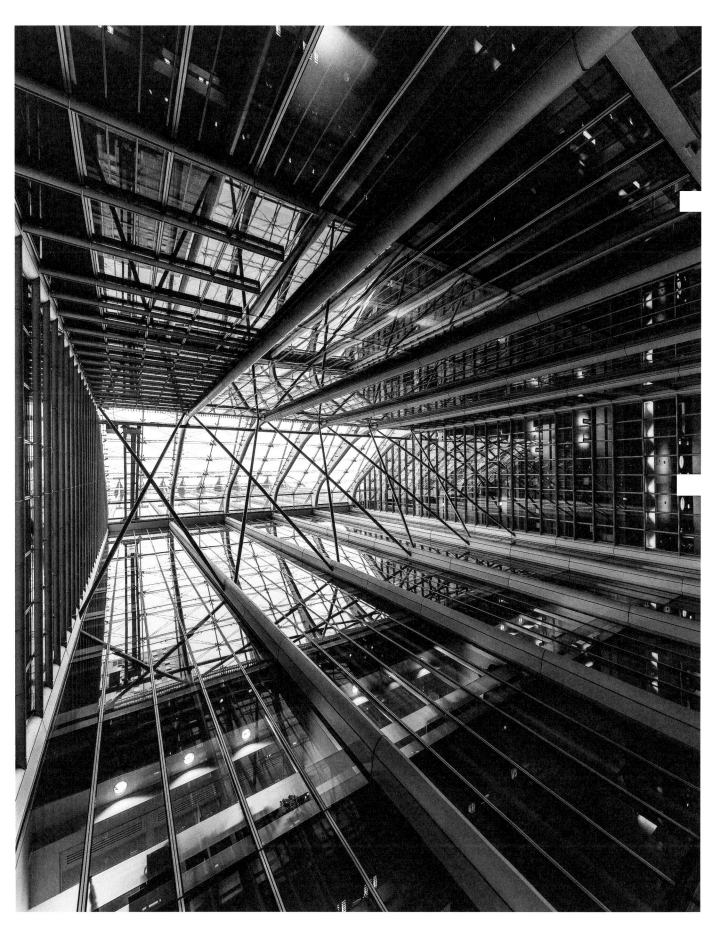

4 Left: North Colonnade, between Upper Bank and Montgomery Streets
5 Above: View of atrium, 1 Ropemaker Street
6 Following Spread: Victoria & Albert Museum entrance hall

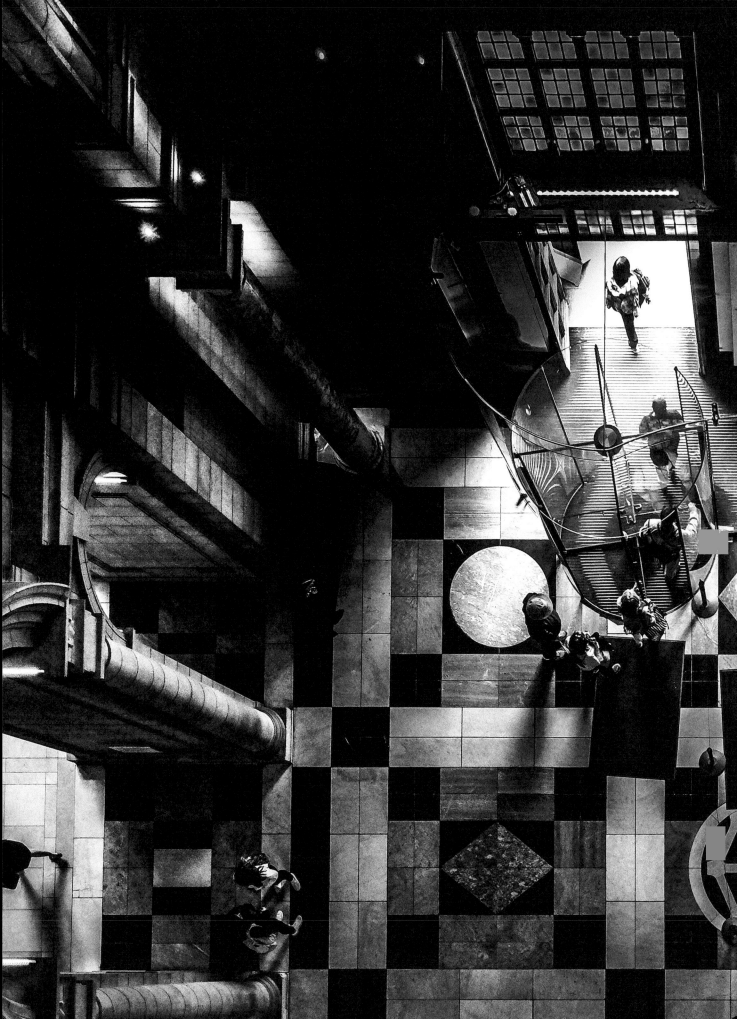

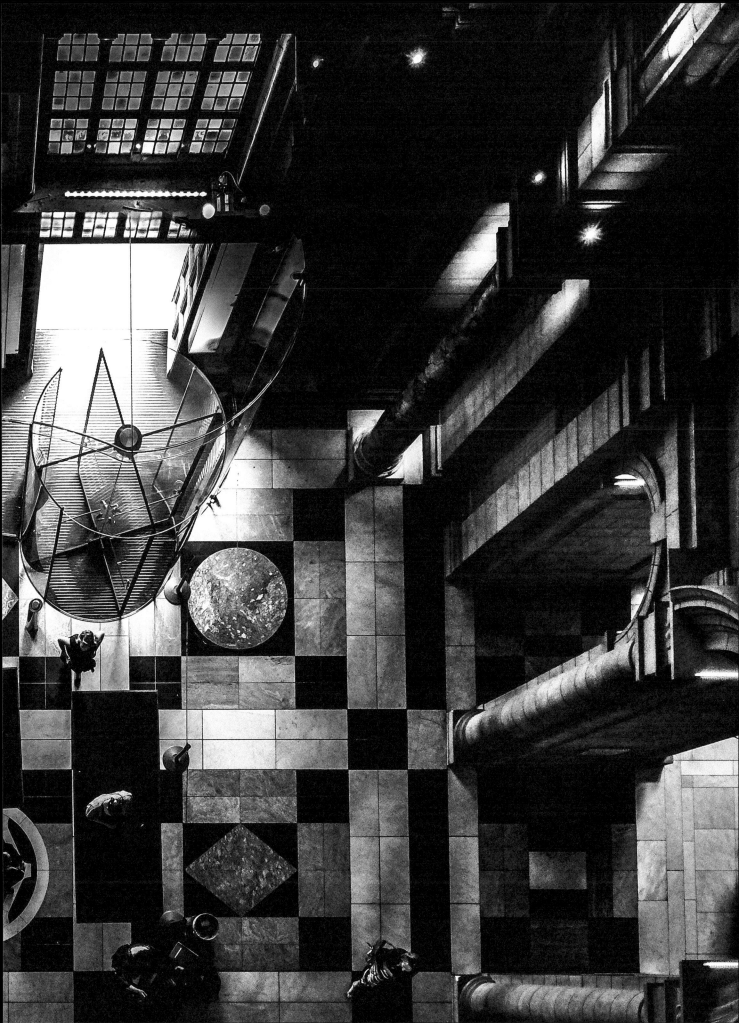

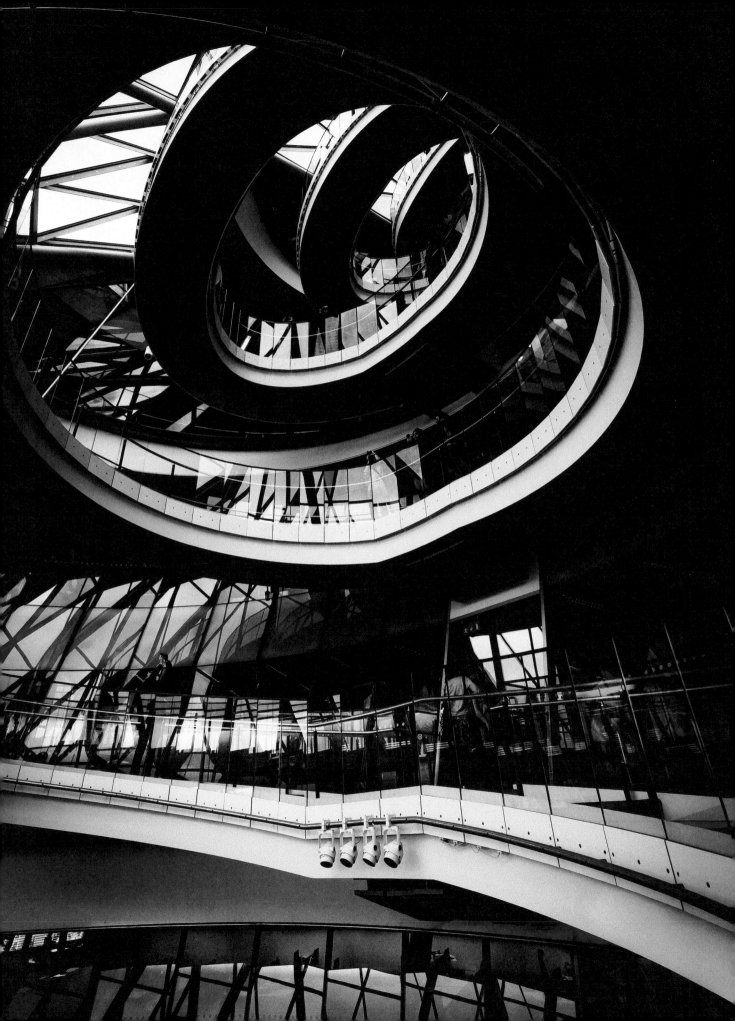

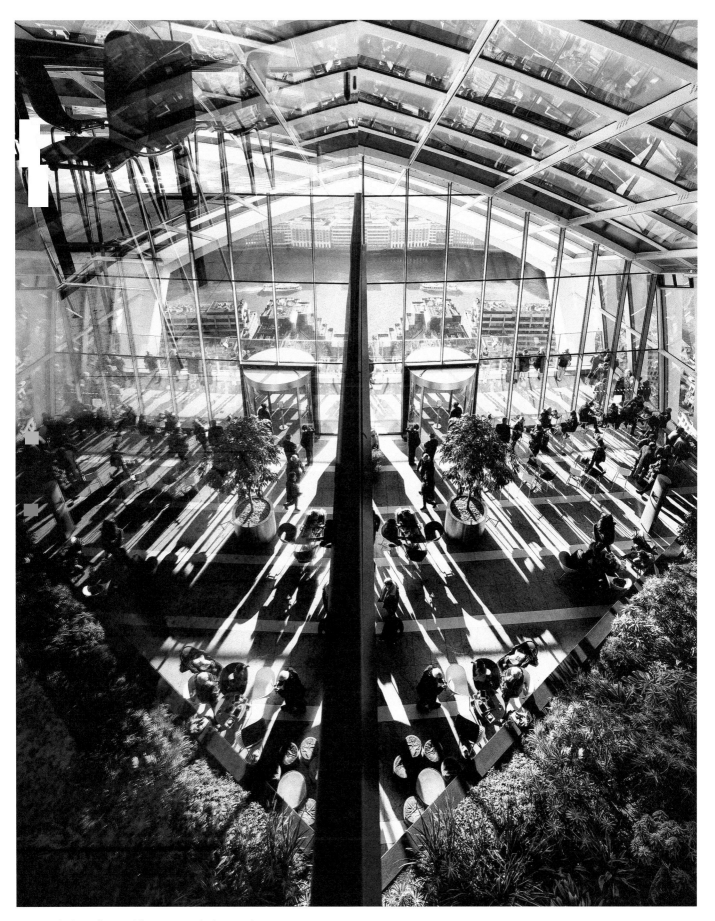

7 Left: City Hall, second floor staircase, looking south
8 Above: View from the Sky Garden, looking south

London goes beyond any boundary
or convention. It contains every wish
or word ever spoken, every action or
gesture ever made, every harsh or
noble statement ever expressed.
It is illimitable. It is Infinite London.

PETER ACKROYD

Biographer, Novelist and Critic

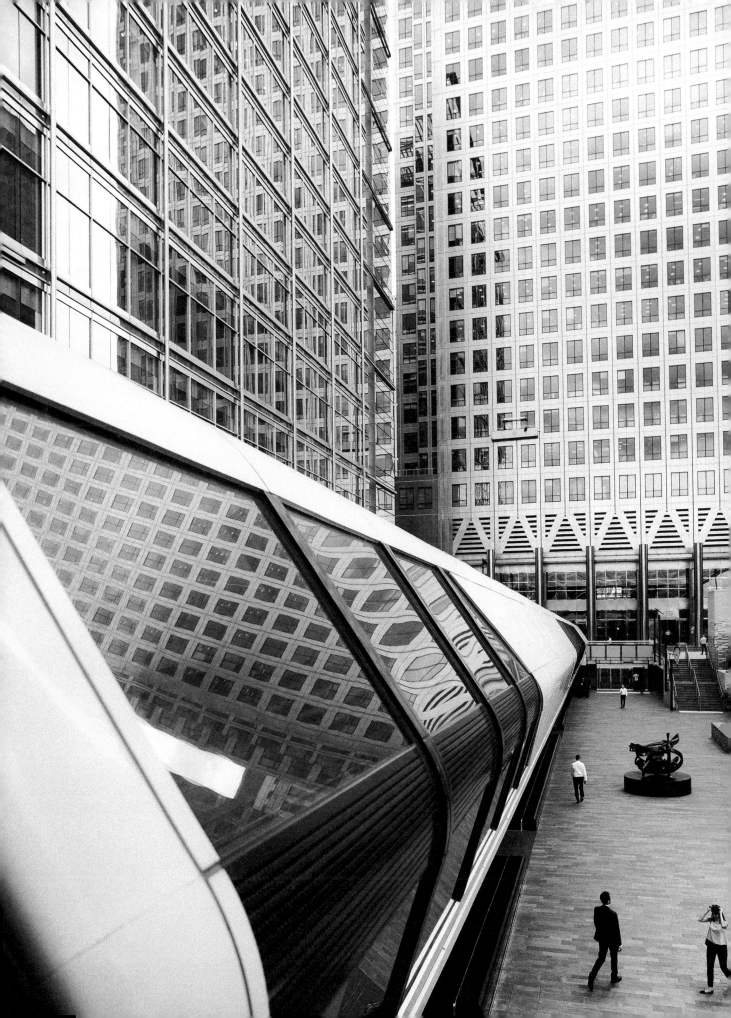

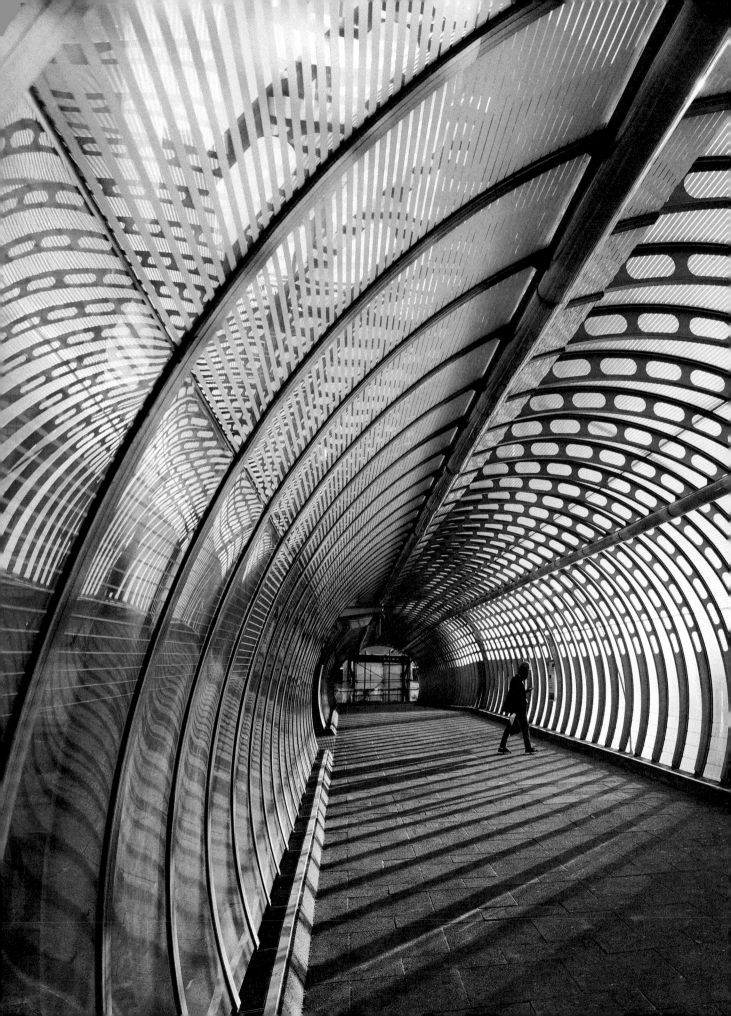

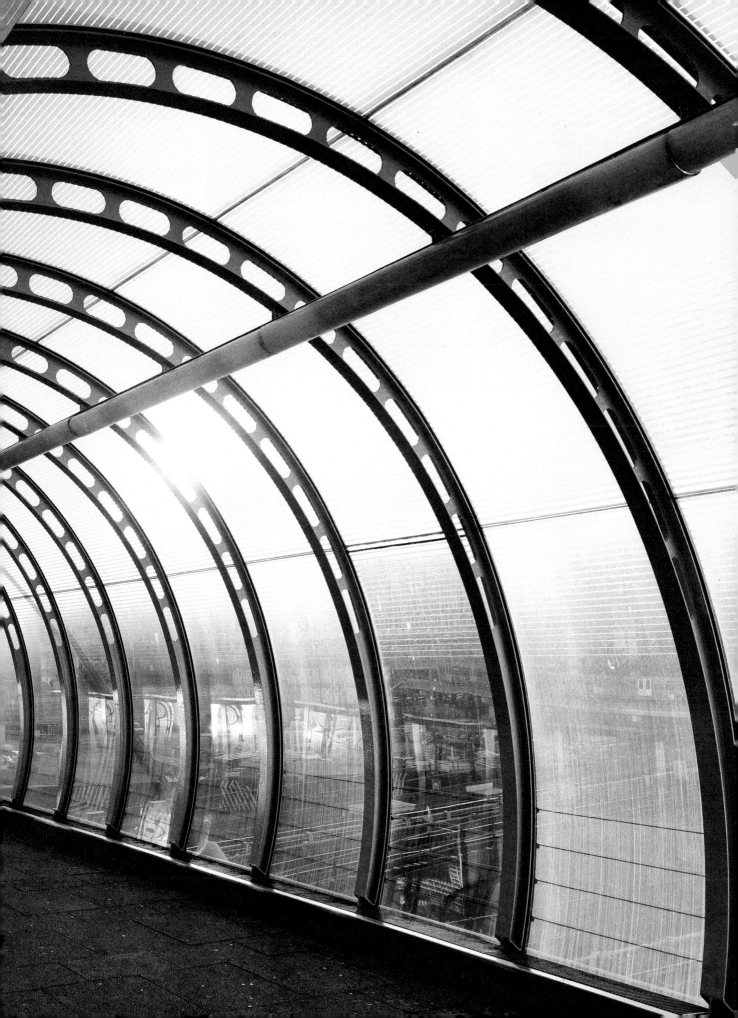

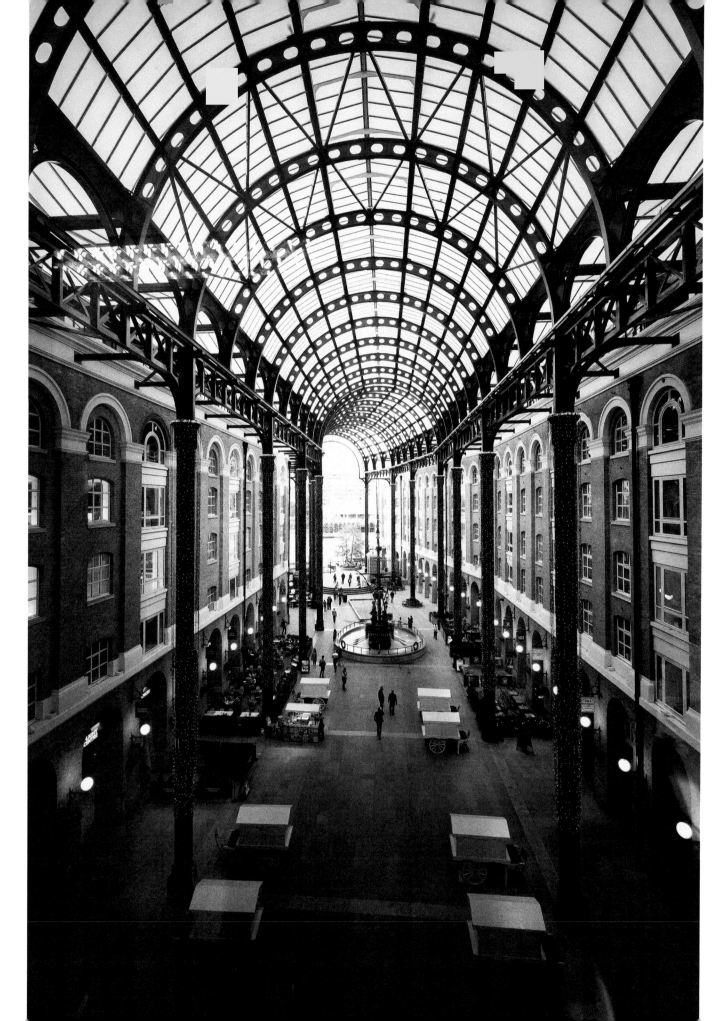

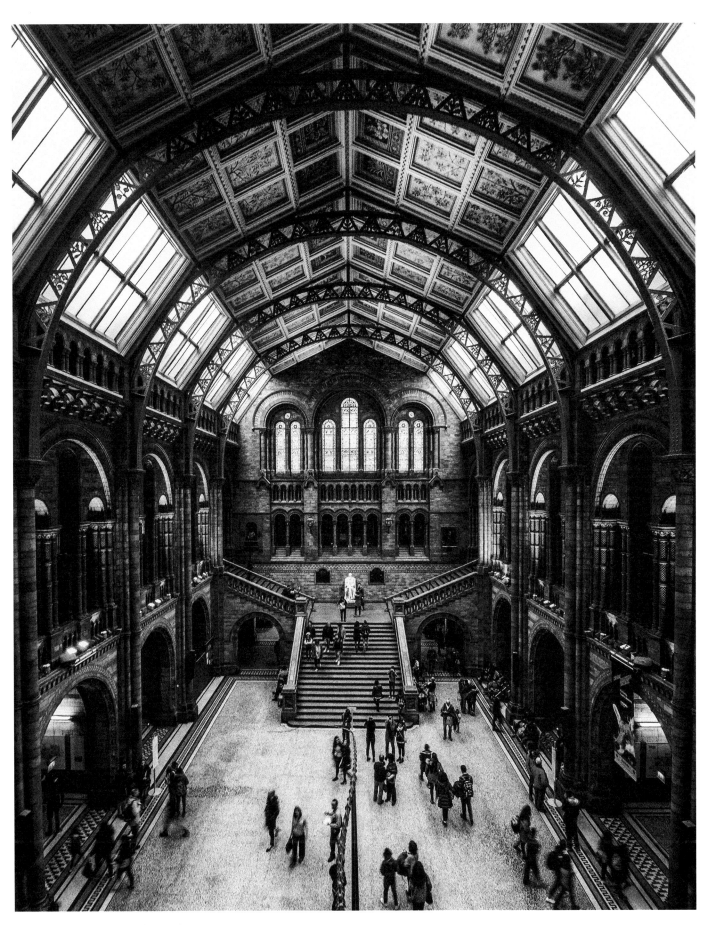

11 Left: Hay's Galleria, looking north
12 Above: Hintze Hall, Natural History Museum

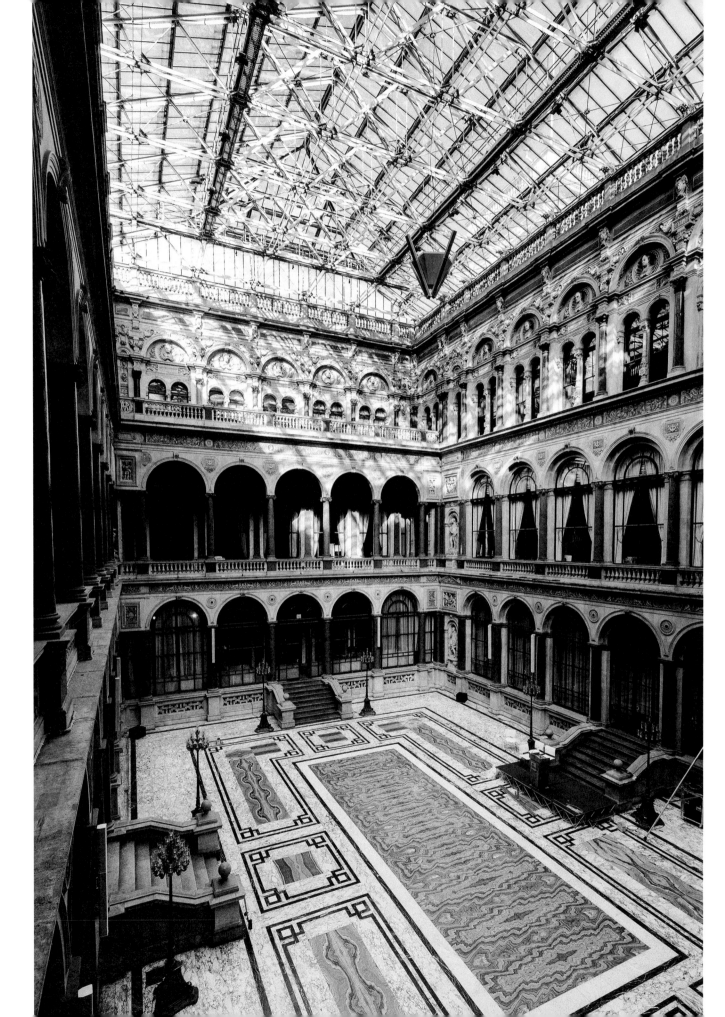

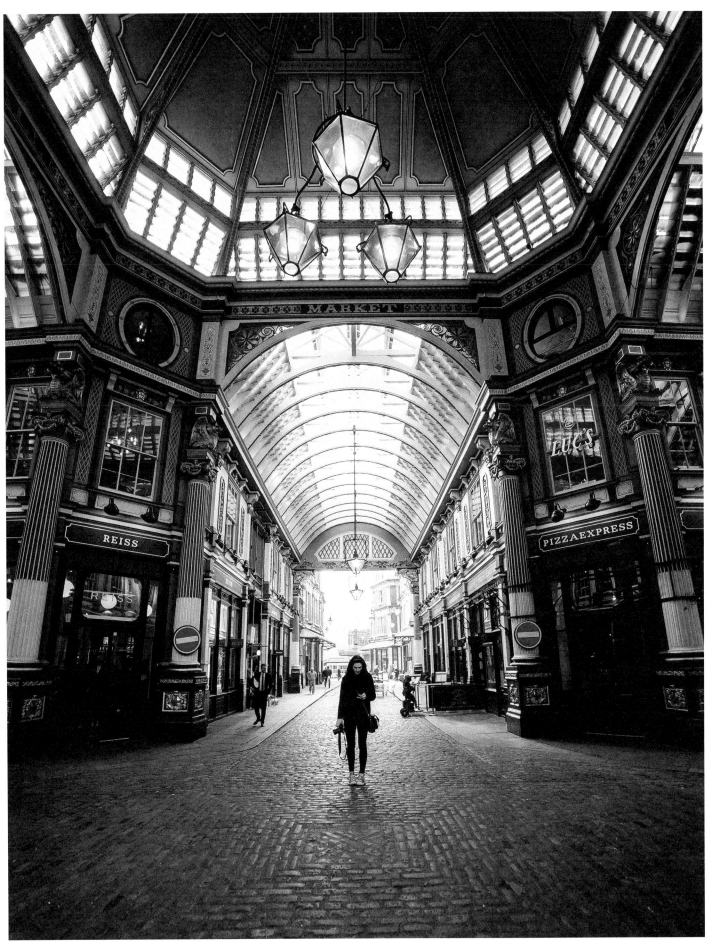

13 Left: Durbar Court, Foreign and Commonwealth Office
14 Above: Central junction, Leadenhall Market, looking south

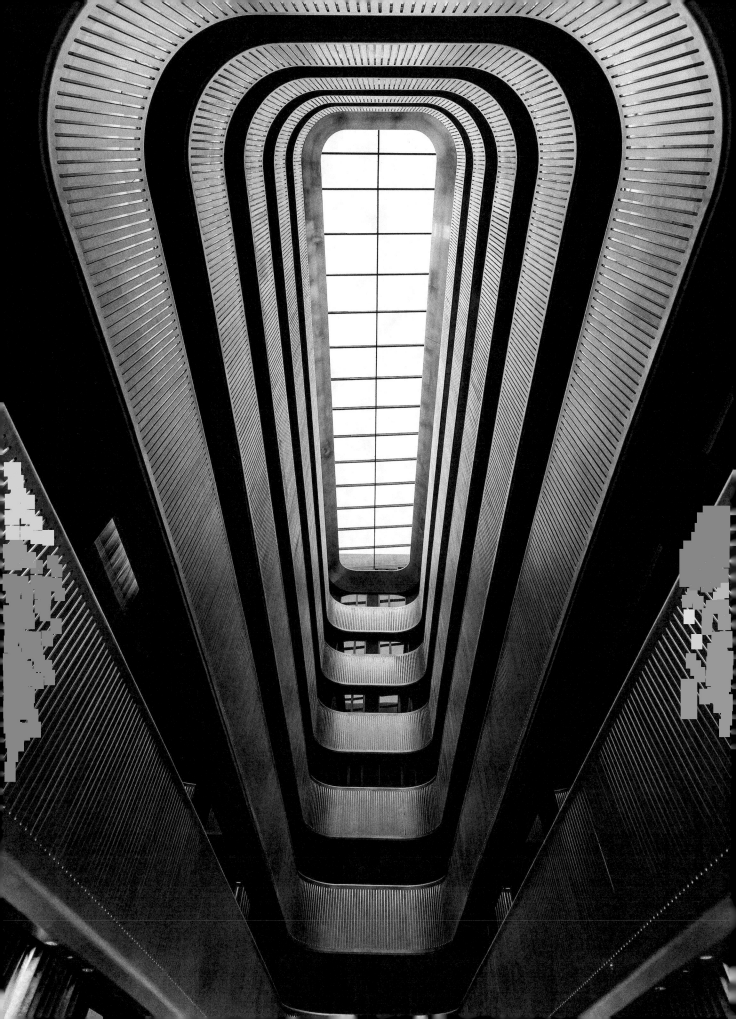

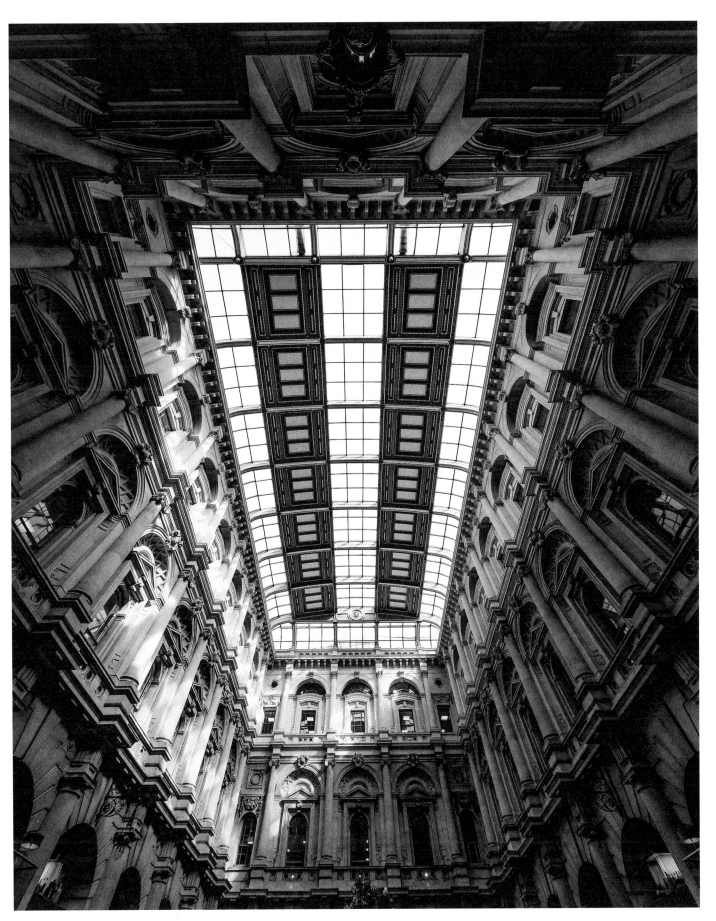

15　Left: Atrium, Dorsett Hotel, Shepherd's Bush
16　Above: Atrium, Royal Exchange

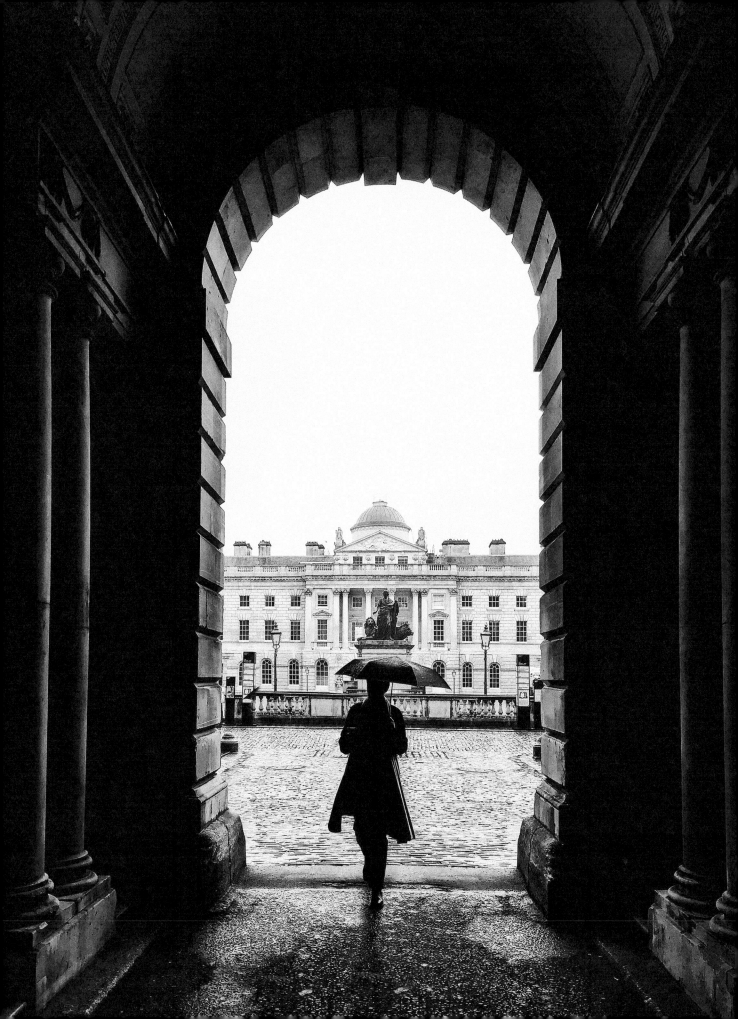

It is not the walls that make the city,
but the people who live within them.
The walls of London may be battered,
but the spirit of the Londoner stands
resolute and undismayed.

KING GEORGE VI

King of the United Kingdom and Dominions of the British Commonwealth

5

Spaces & Places

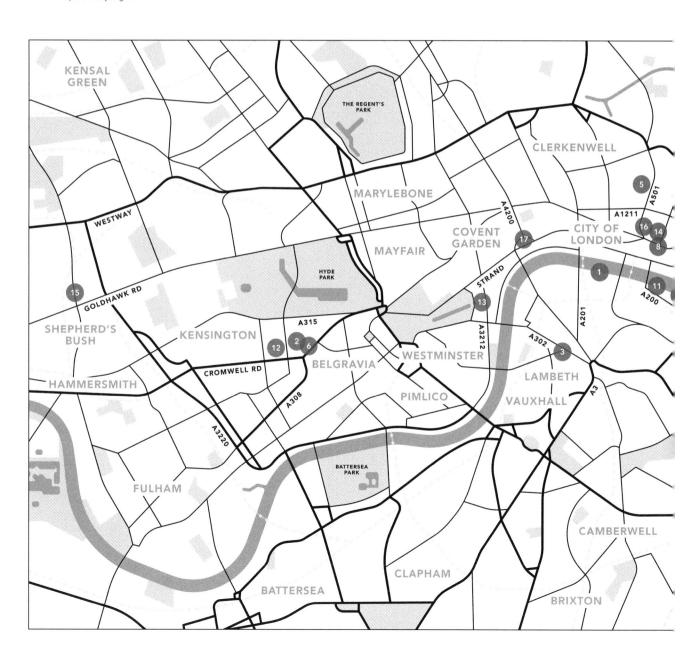

WHITECHAPEL

A11

POPLAR

A13

10

9

4

A1261

CANARY
WHARF

KHAM

Tower Bridge

One glimpse and the viewer is instantly transported back in time to when England was the most powerful seafaring nation and London was the busiest port in the world. Designed by Horace Jones and completed in 1894, the Tower Bridge was the answer to London's growing traffic problem – serving as a much-needed conduit to the east side of the city while still allowing tall ships to come into port up to 30 times a day. ✚ The Tower Bridge's genius lay in its hydraulic lifting mechanism, hidden in the two neo-Gothic towers, that could lift both 1,000-ton bascules, drawbridge-style, in minutes. Eighty people were needed to maintain the engines and keep the bridge working until the system switched from steam power to electricity in 1974. ✚ Two high-level walkways stretch between the pinnacle towers, 42 metres above the River Thames. In 2014, glass panels were installed in the walkways – giving visitors not only a full panorama of the city from above, but a breathtaking and unrivalled view of the River Thames below.

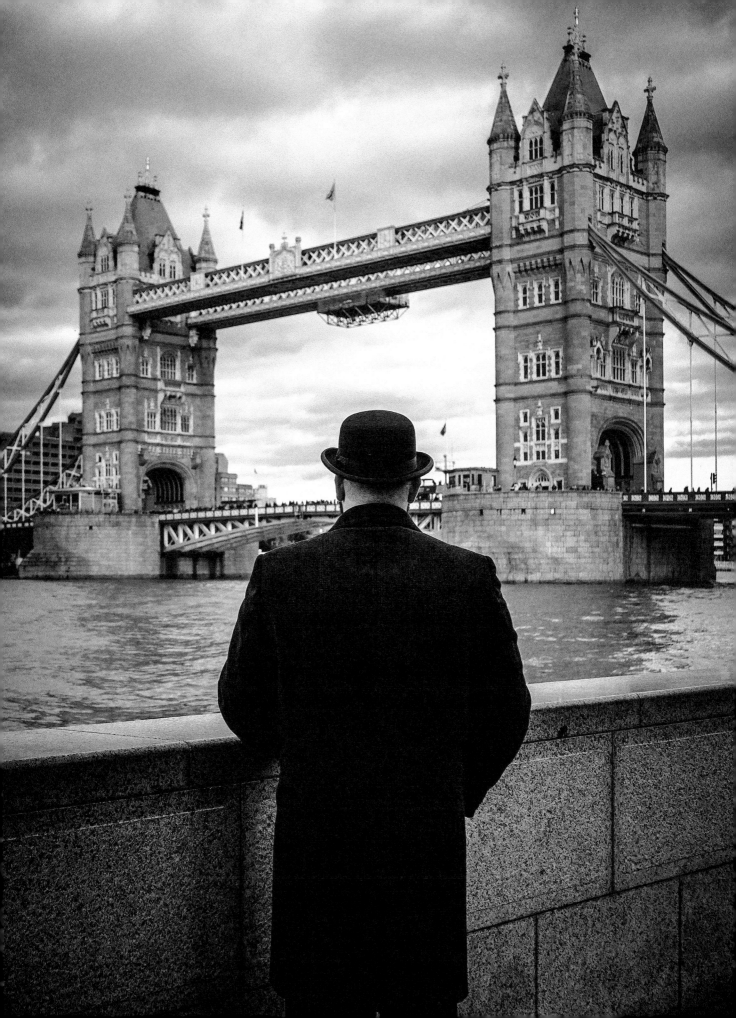

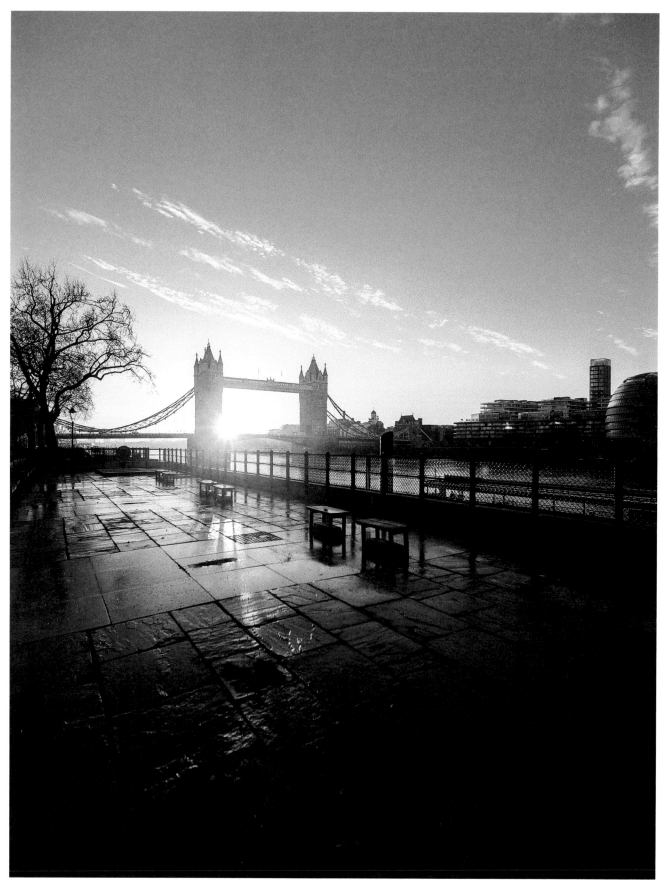

1 Previous Page: View from outside City Hall, looking northeast

2 Above: Footpath west of Traitor's Gate, looking east

3 Right: Footpath east of Traitor's Gate, looking east

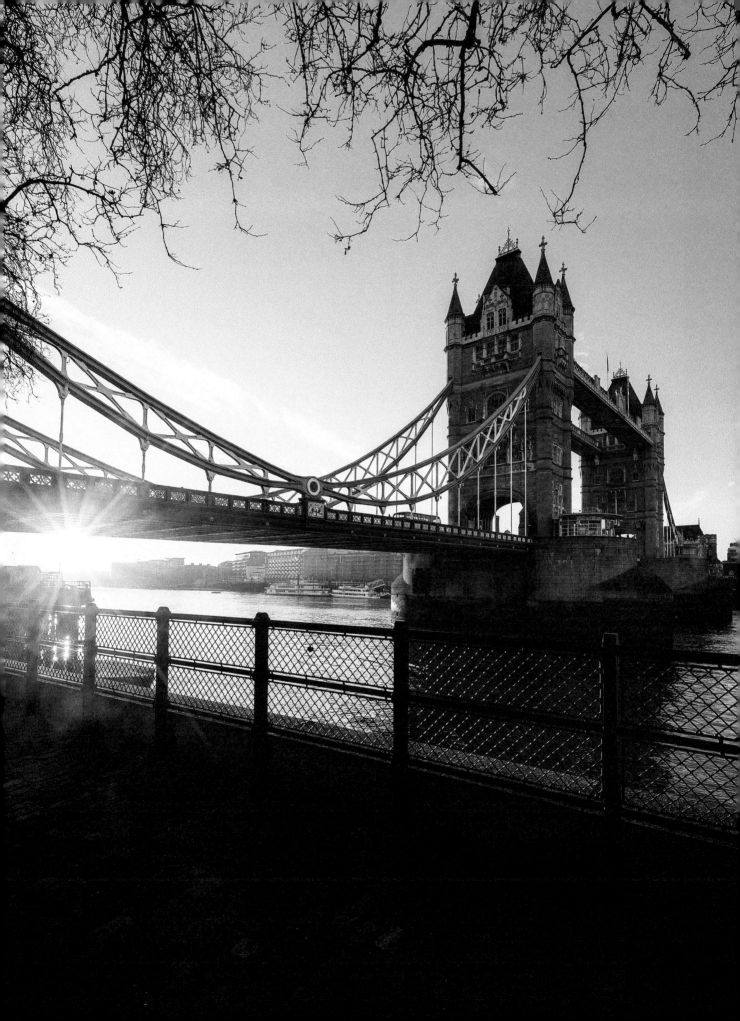

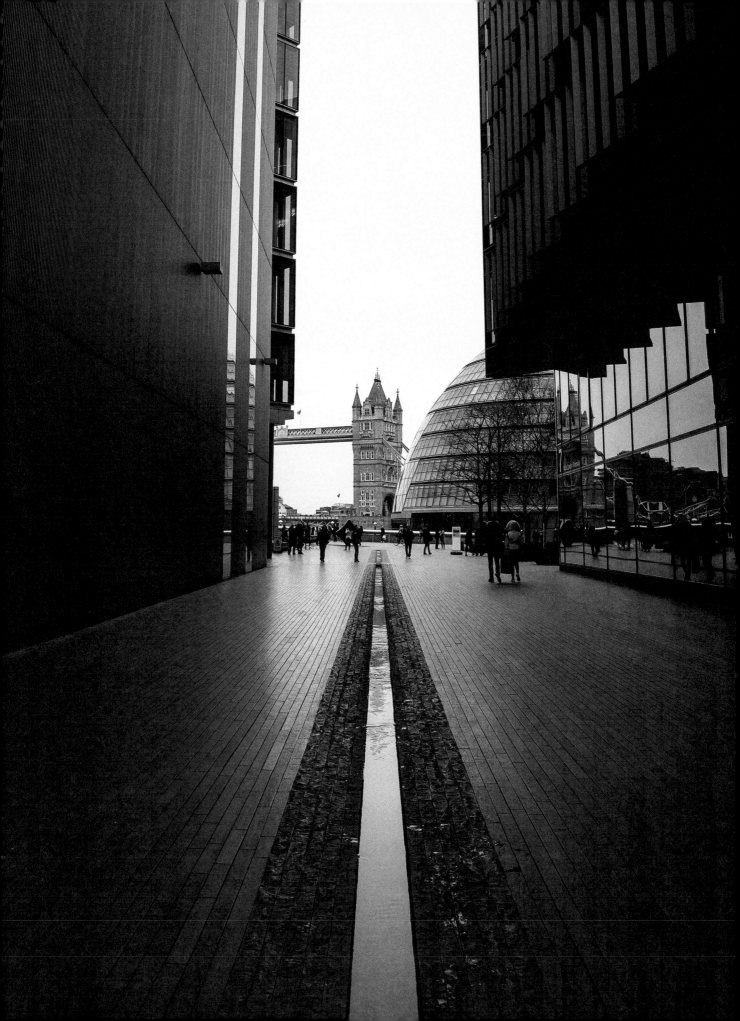

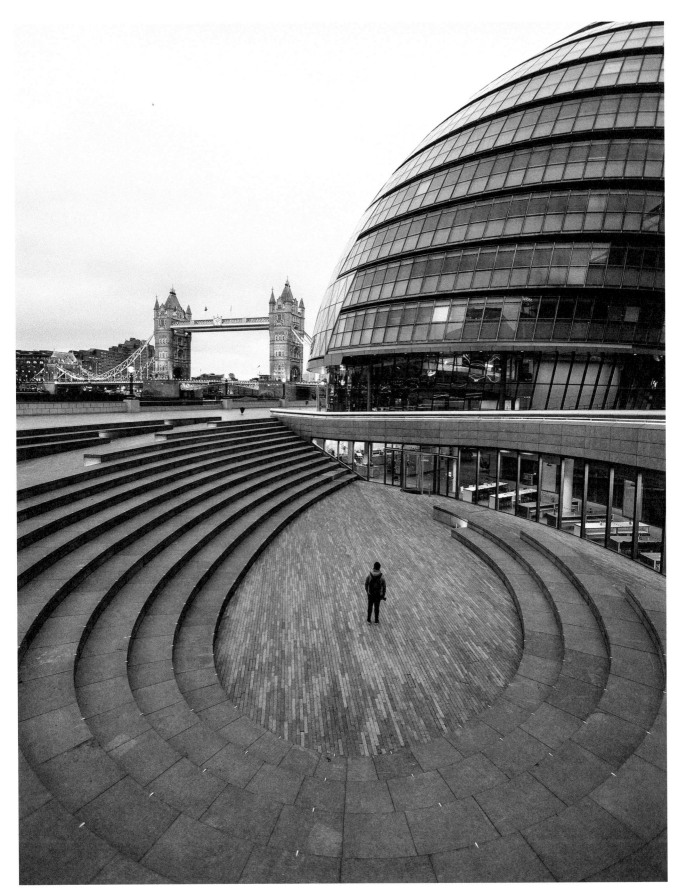

4 Left: View from More London Riverside walkway, looking east

5 Above: View from the top of the Scoop, looking east

6 Following Spread, Left: View across Tower Bridge, looking north

7 Following Spread, Right: Aerial view of Tower Bridge

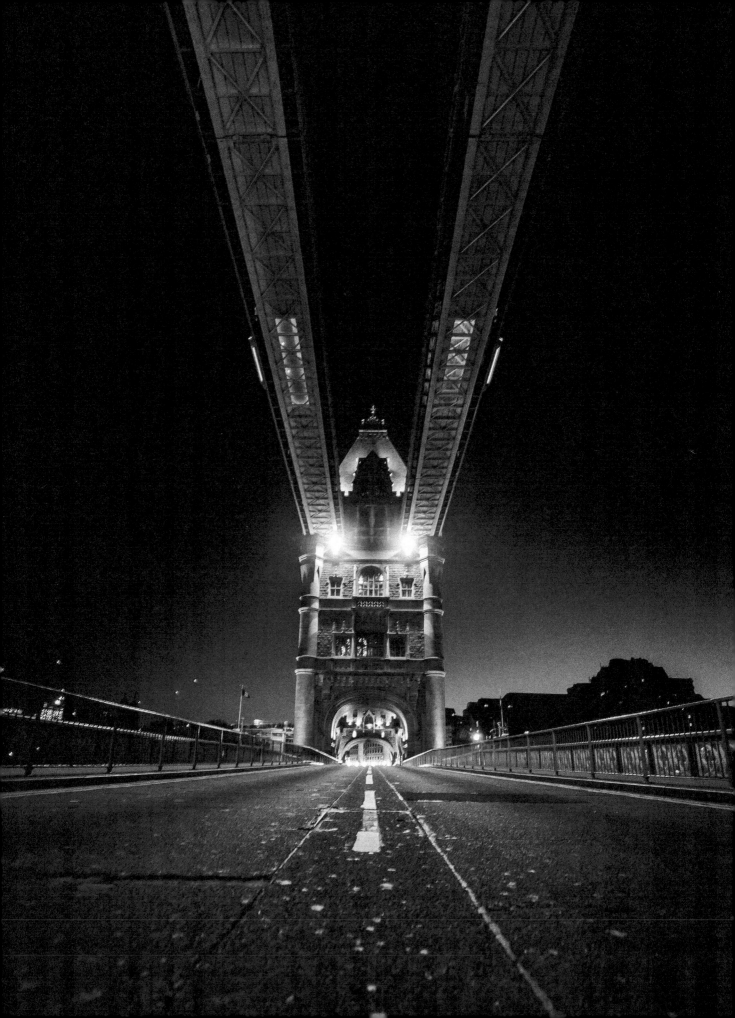

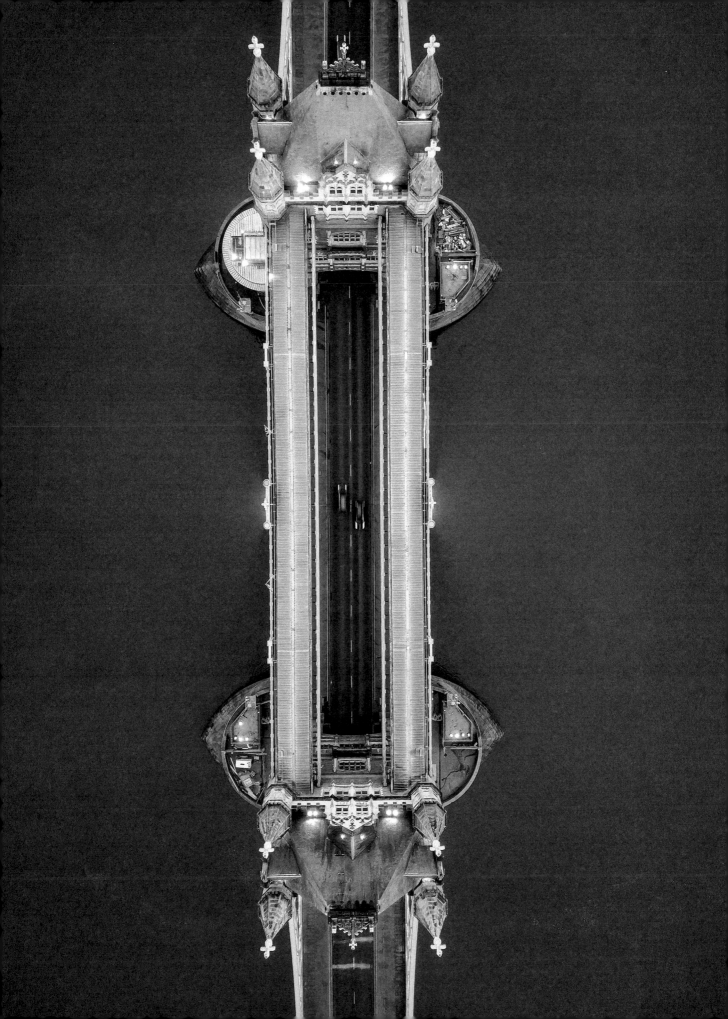

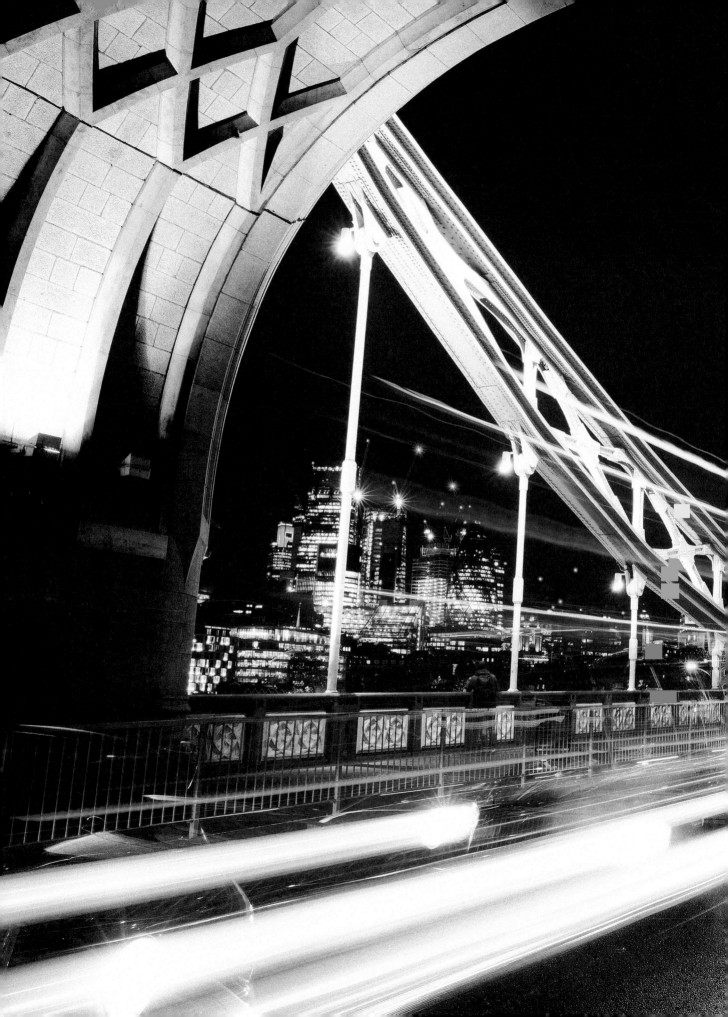

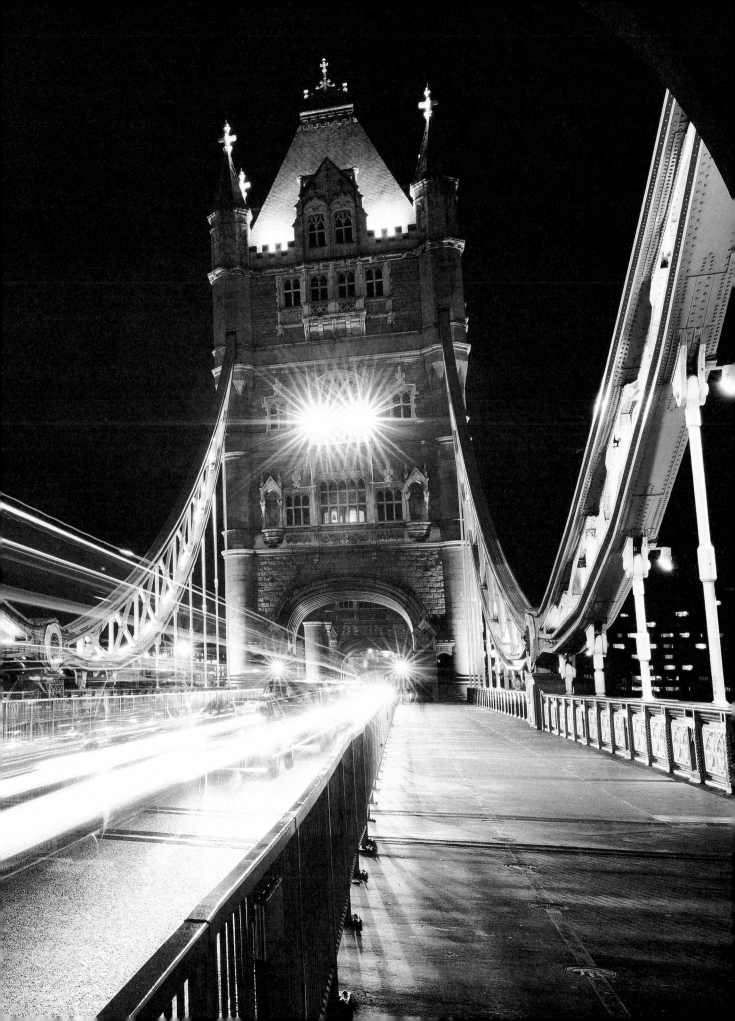

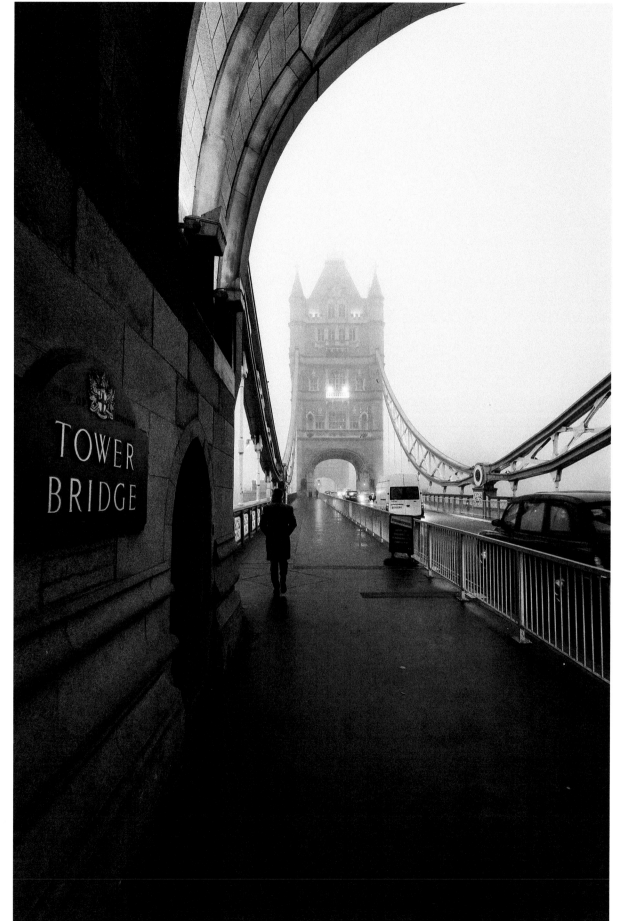

8　Previous Spread: View across Tower Bridge, looking north　　9　Left: View from south entrance to Tower Bridge, looking north

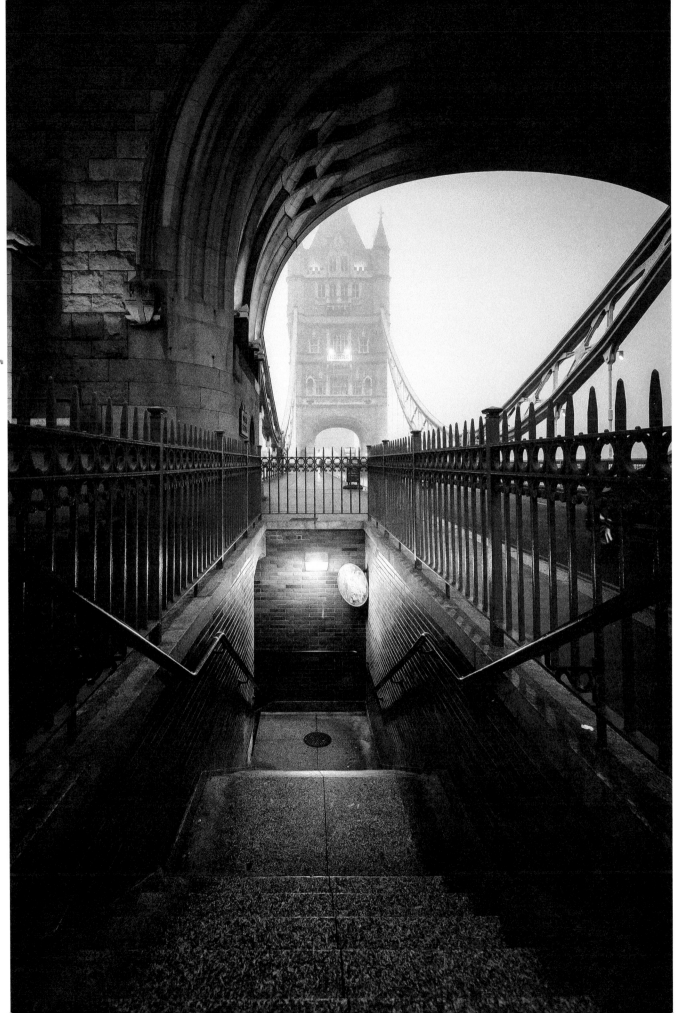

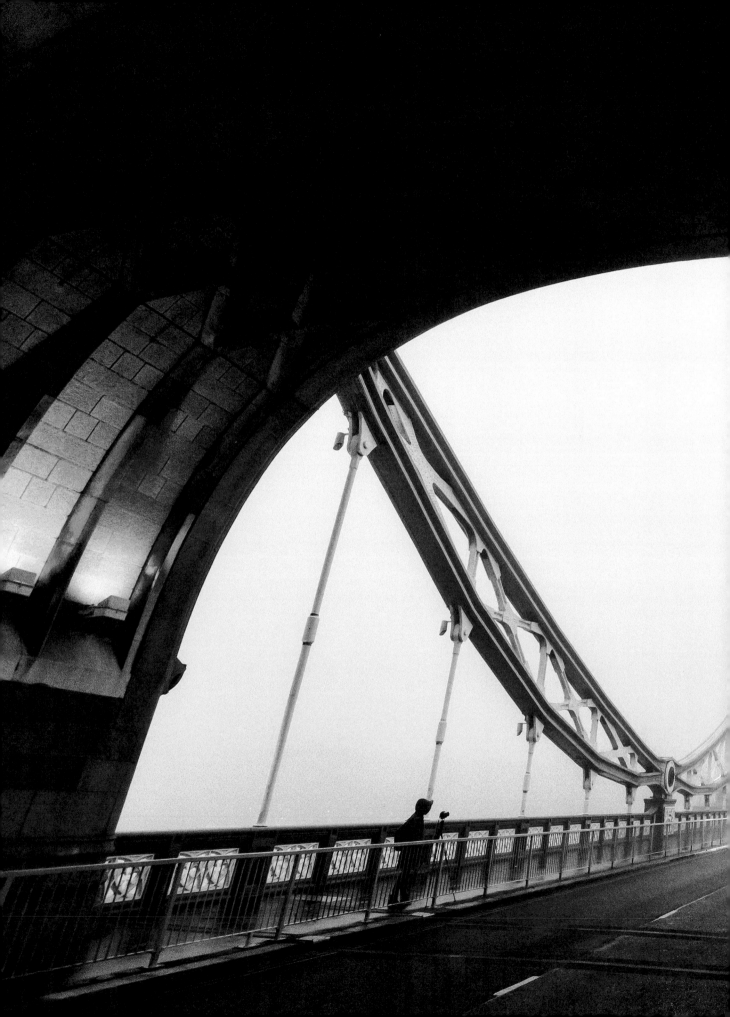

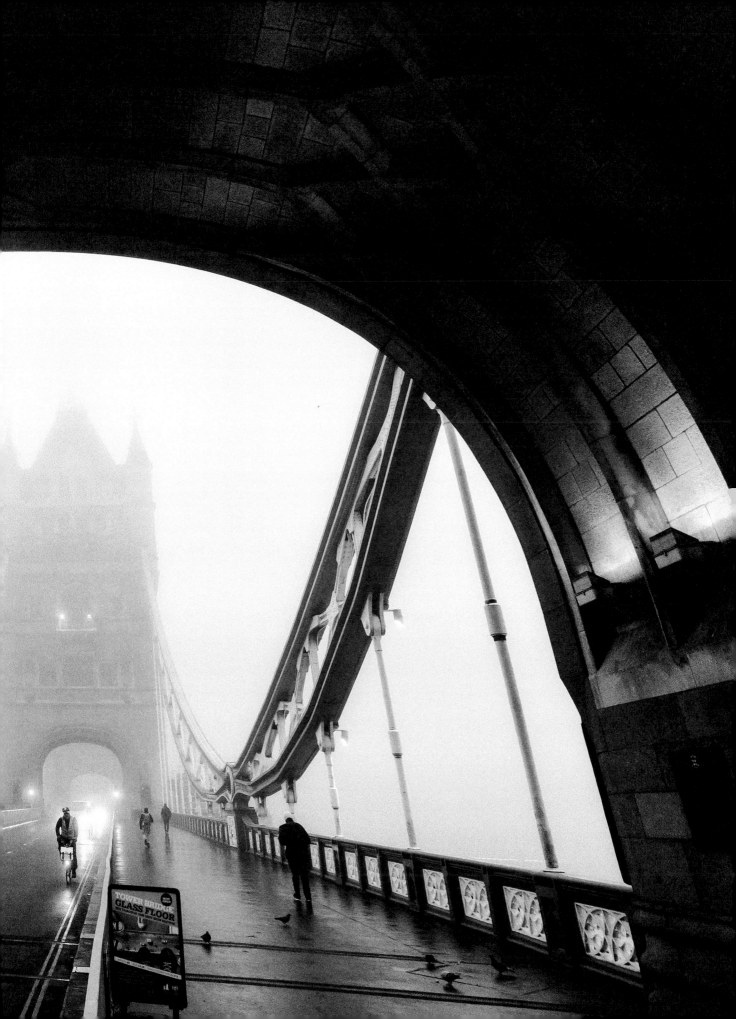

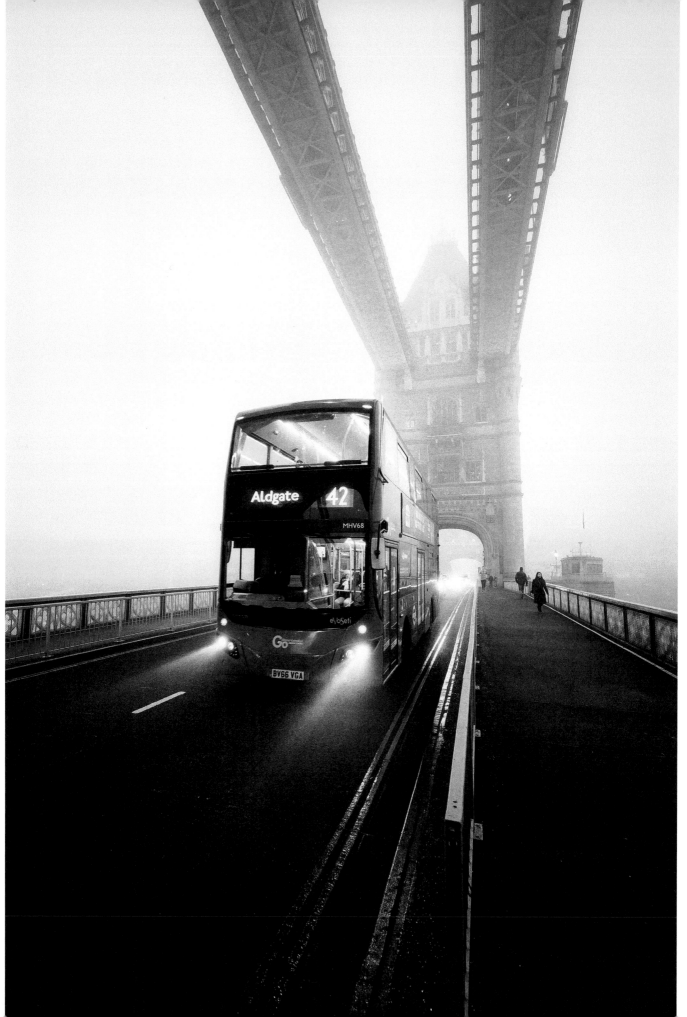

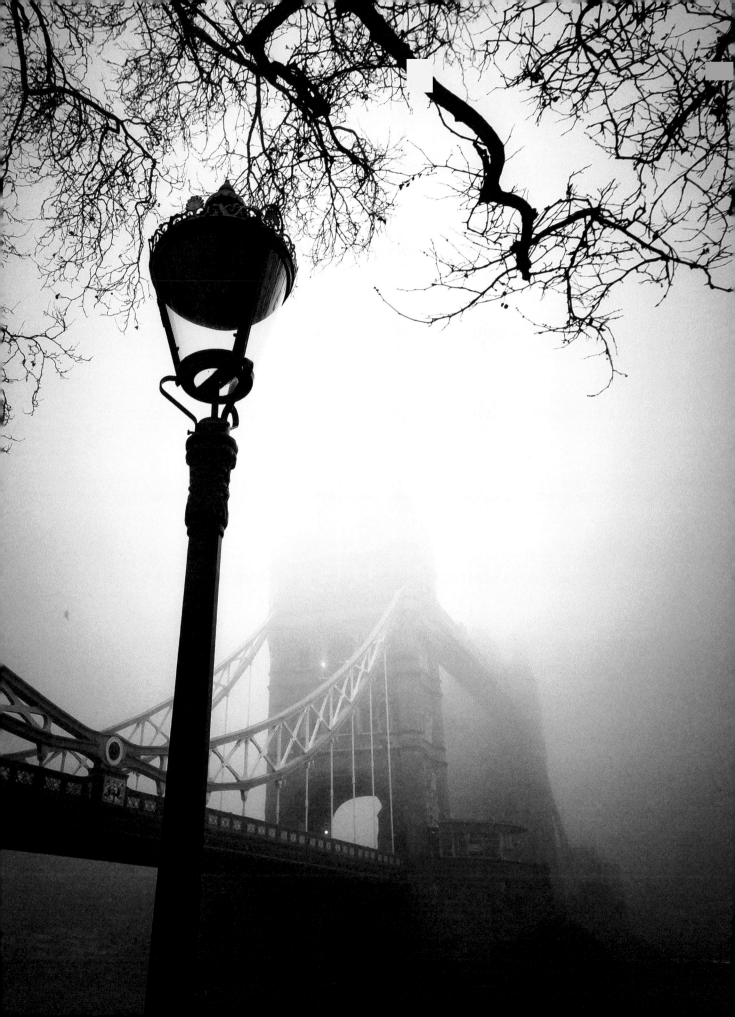

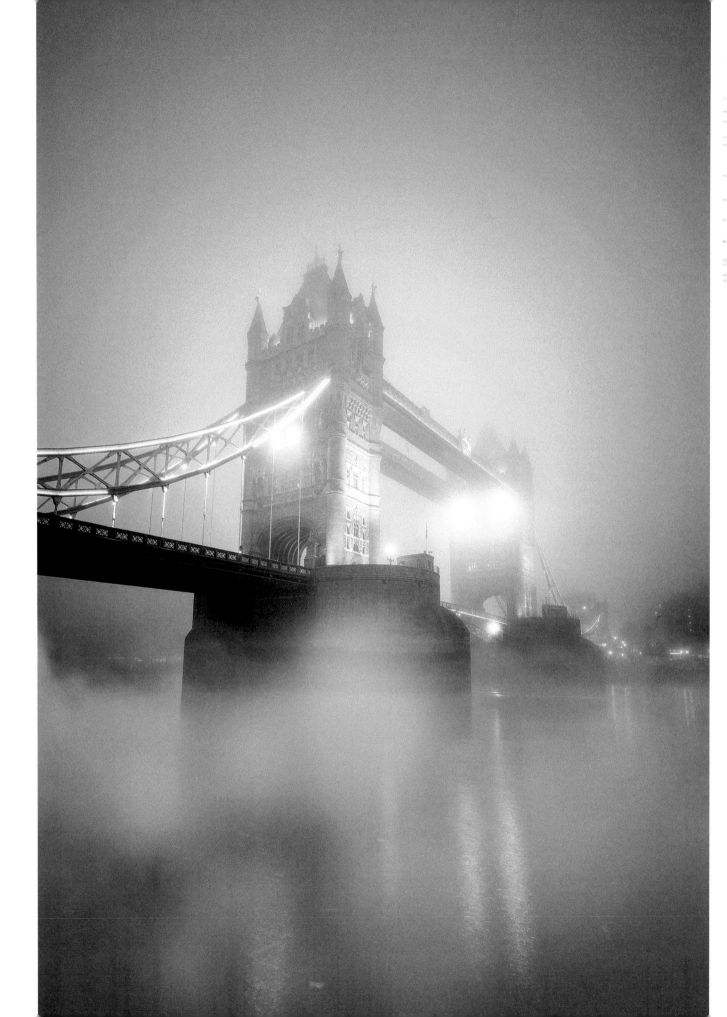

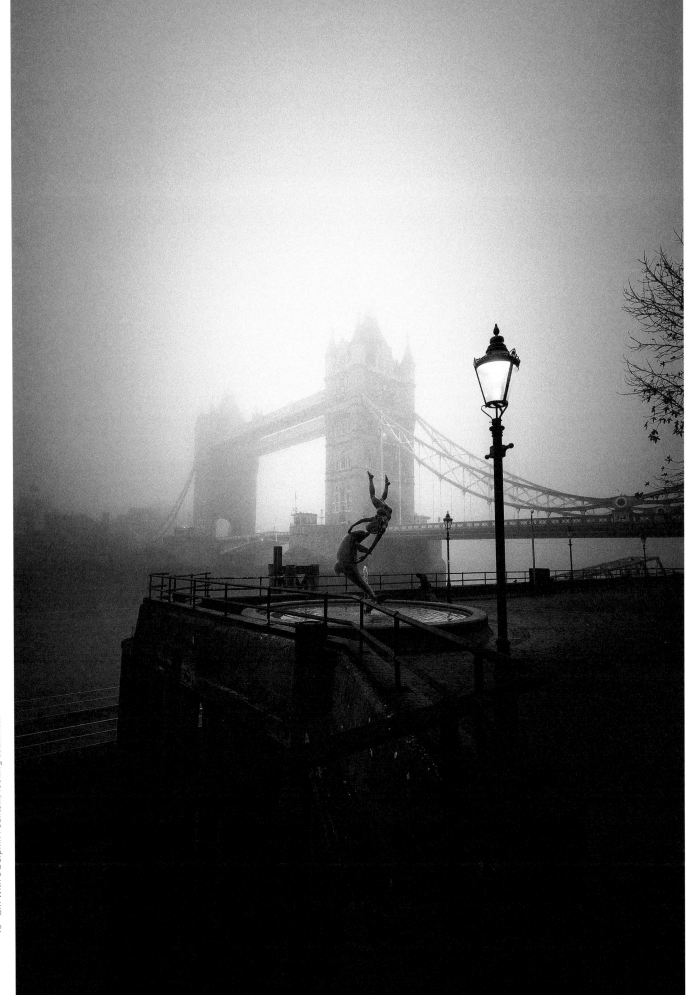

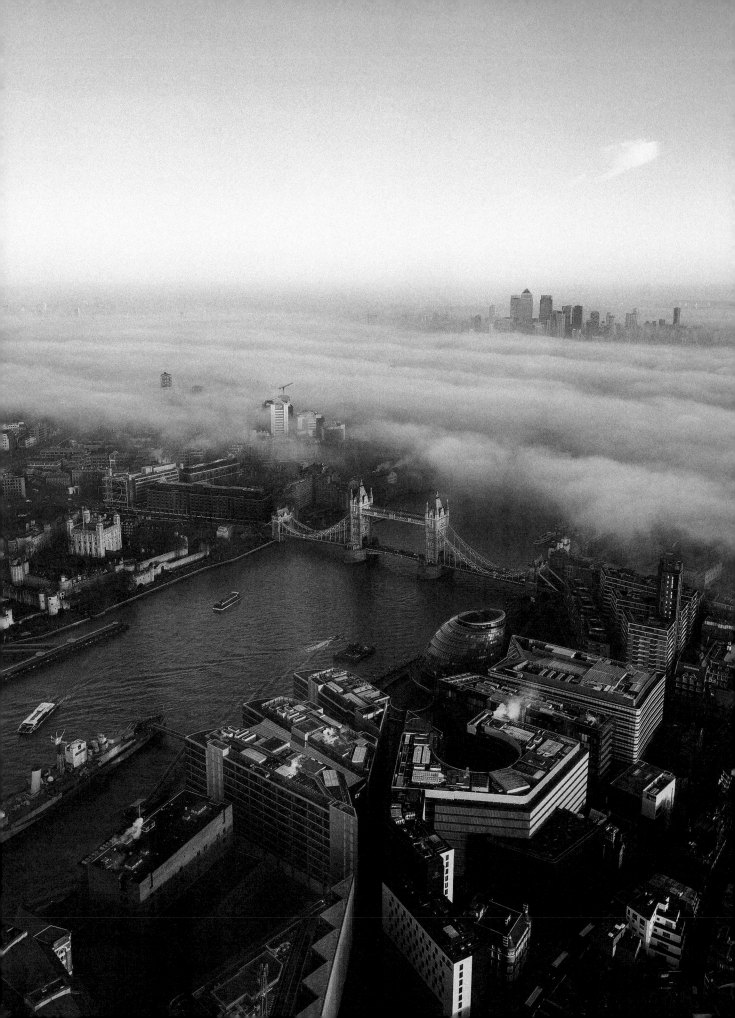

Go where we may, rest where we will,
Eternal London haunts us still.

THOMAS MOORE

Poet

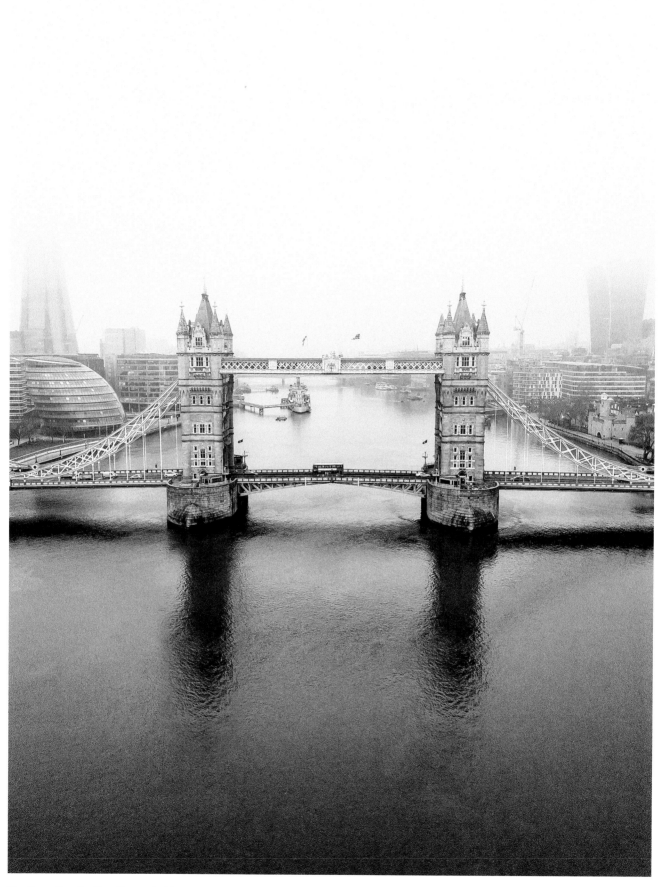

17 Above: Over the River Thames, looking west
18 Right: Aerial view of City Hall and Tower Bridge, looking east
19 Following Spread: Above St Katharine Docks, looking southwest

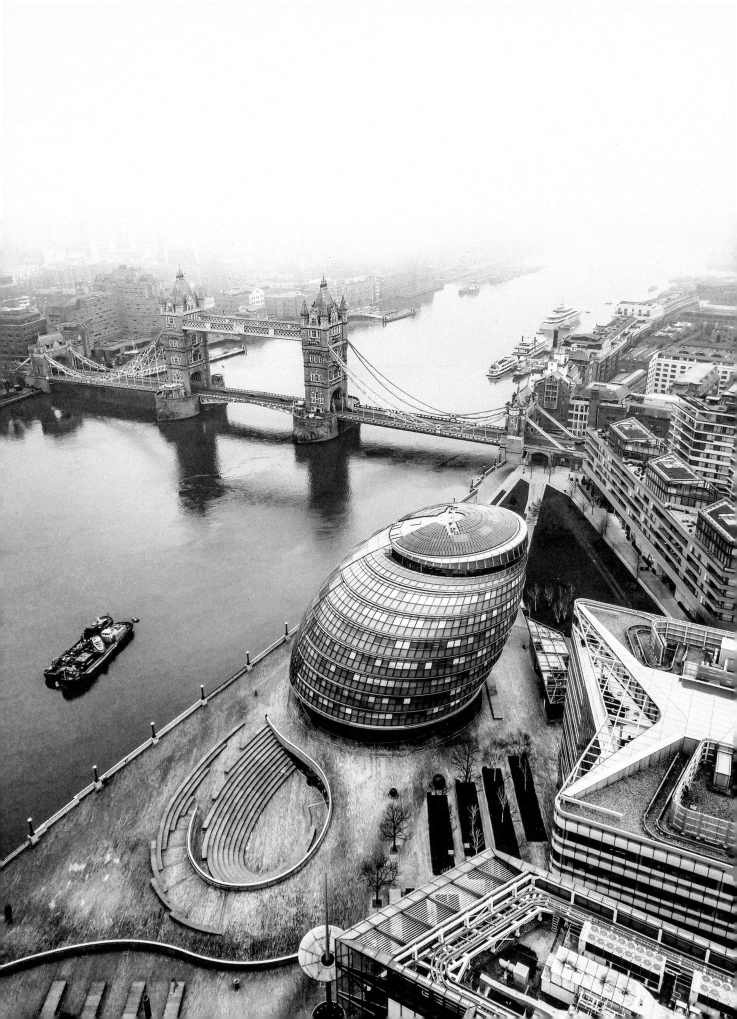

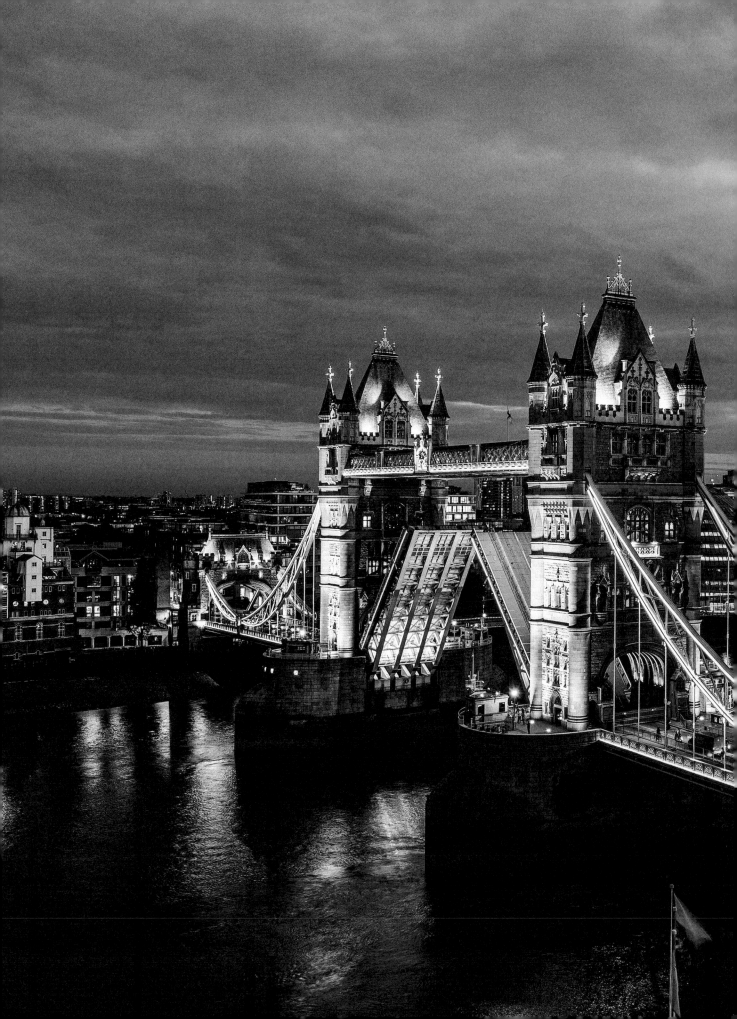

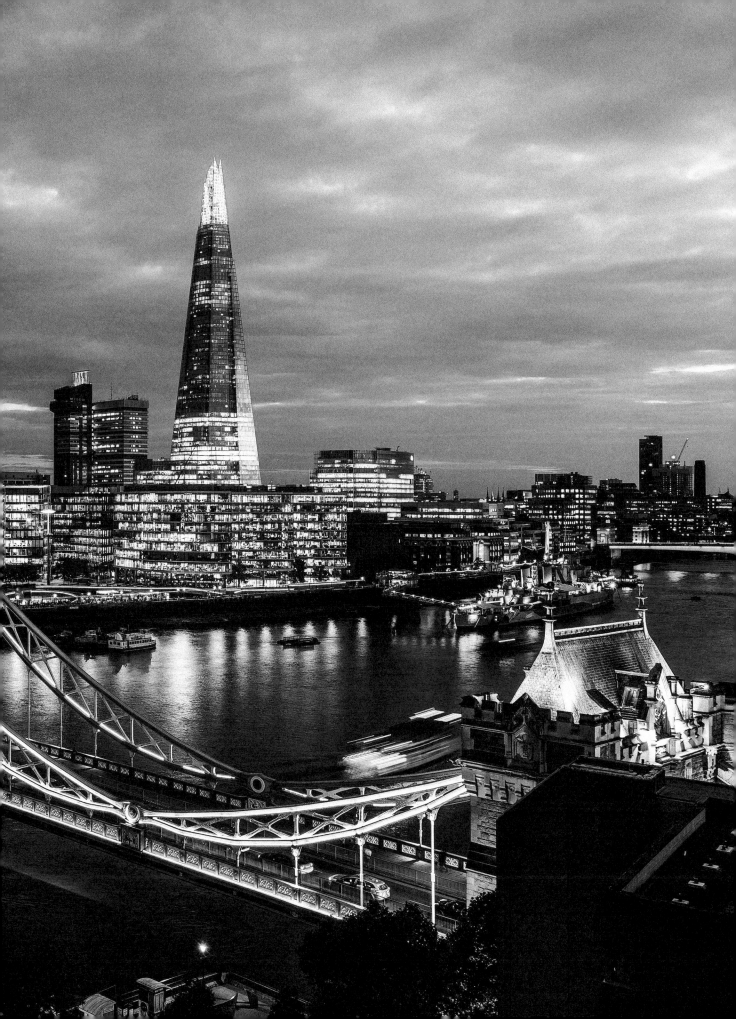

6

Tower Bridge

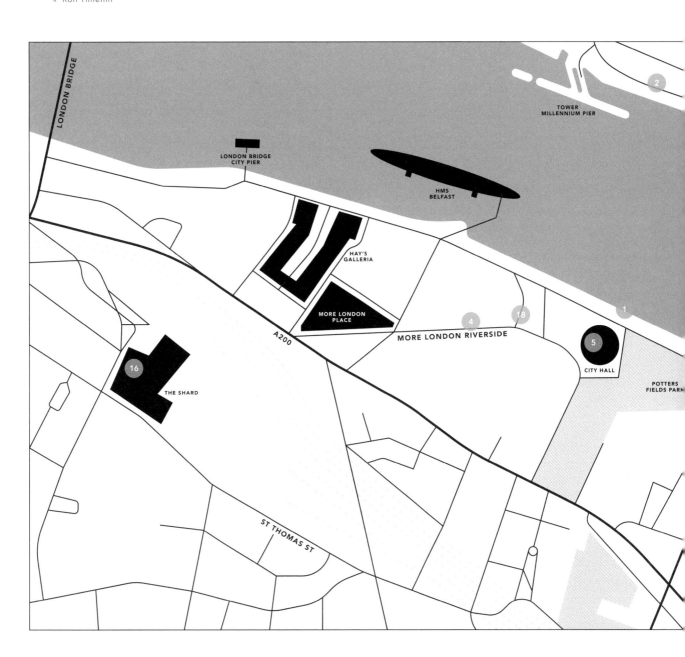

18 Aerial view of City Hall and Tower Bridge, looking east
 « Tobi Shinobi

19 Above St Katharine Docks, looking southwest « Max Leitner

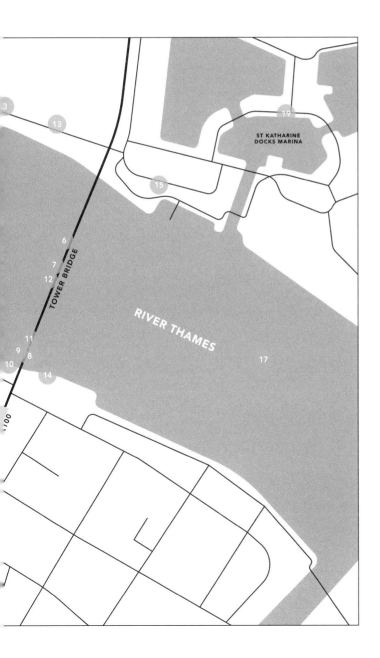

St Paul's Cathedral

With 21st-century skyscrapers rising up around it, St Paul's Cathedral stands undiminished as the symbol of London's resilience and renewal. ✚ Built on the highest point in the City – the original heart of London and today's bustling financial district – the present cathedral is at least the fourth of its name to stand in that very spot. The first two were destroyed by the elements, and the third was destroyed by the Great Fire of London in 1666. Architect Sir Christopher Wren set to work soon after, building the now iconic English Baroque masterpiece with its triumphant 365-foot dome. ✚ Three hundred years later, the house of prayer once again came under fire, this time from German bombers during World War II. Amid the Blitz attack on 29 December 1940, Prime Minister Winston Churchill sent word that "St Paul's must be saved at all costs." And it was, thanks to local volunteers who risked their lives putting out the blaze on its dome, standing firm as huge swathes of the city burned down around it. ✚ There's a single word inscribed in the pediment above the south door: *RESURGAM*, Latin for "I shall rise again." A fitting reminder of the cathedral's tumultuous past and a quiet nod to Londoners' survivalist spirit.

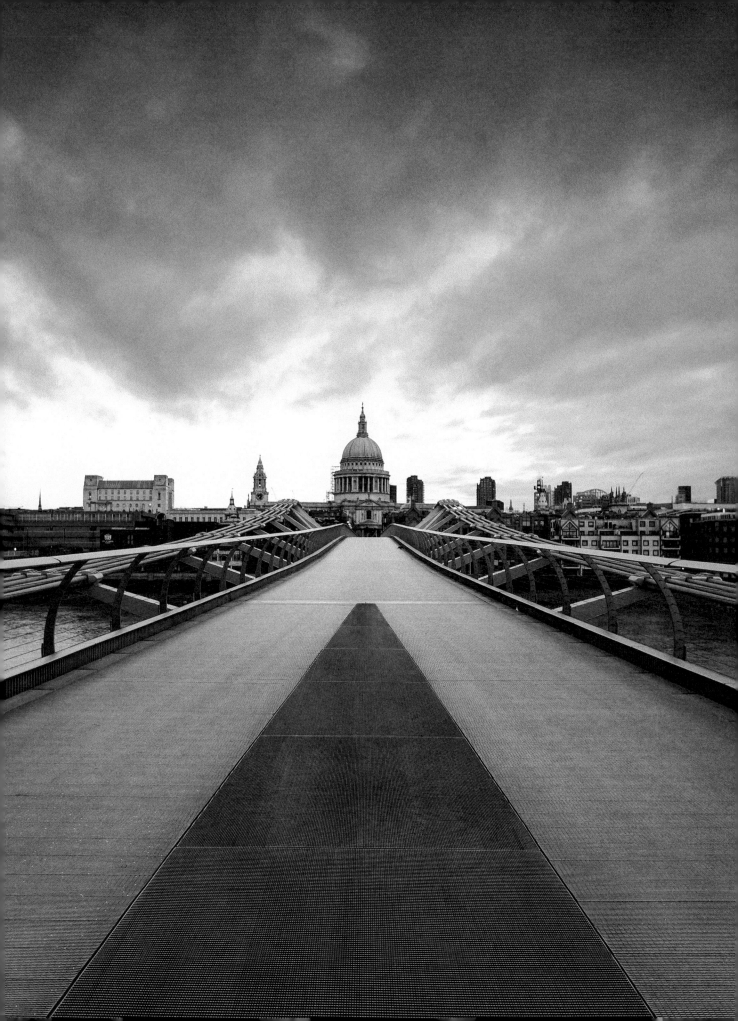

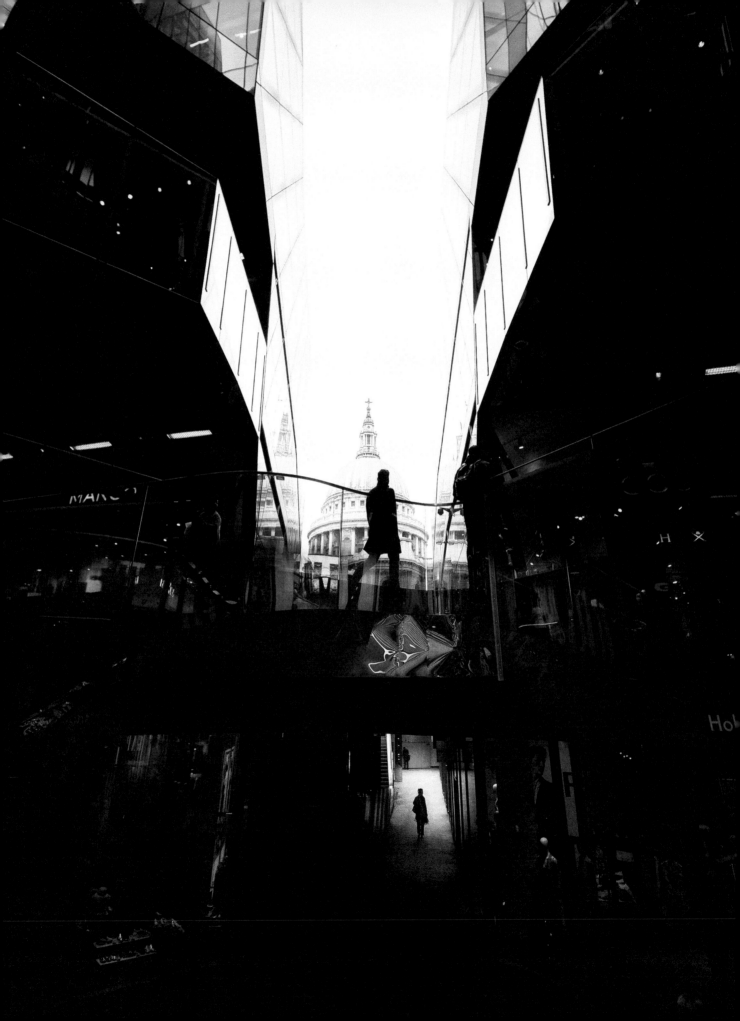

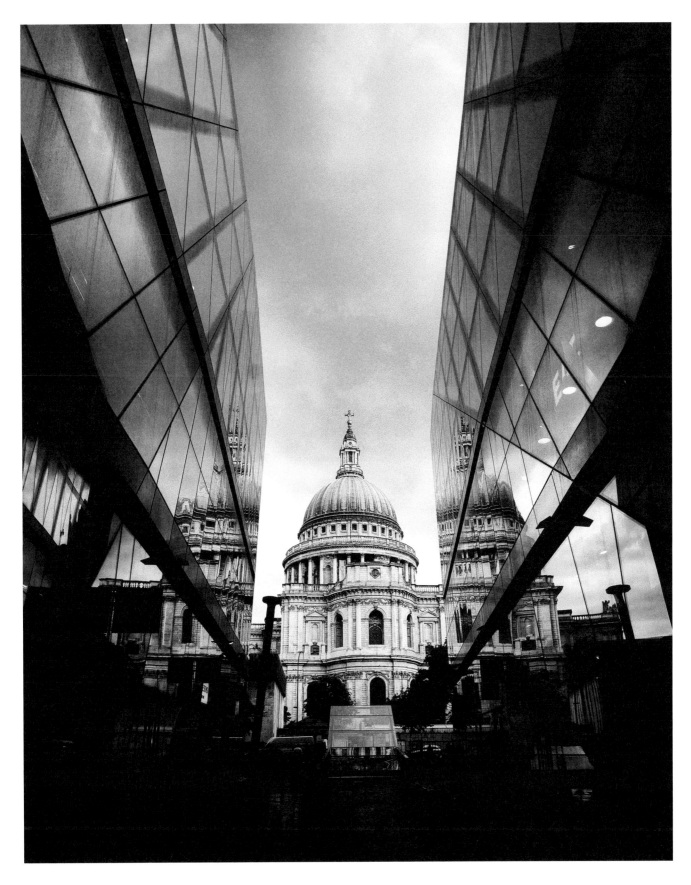

1 Previous Page: View from Millennium Bridge, looking north

2 Left: View from One New Change, looking west

3 Above: View from One New Change, looking west

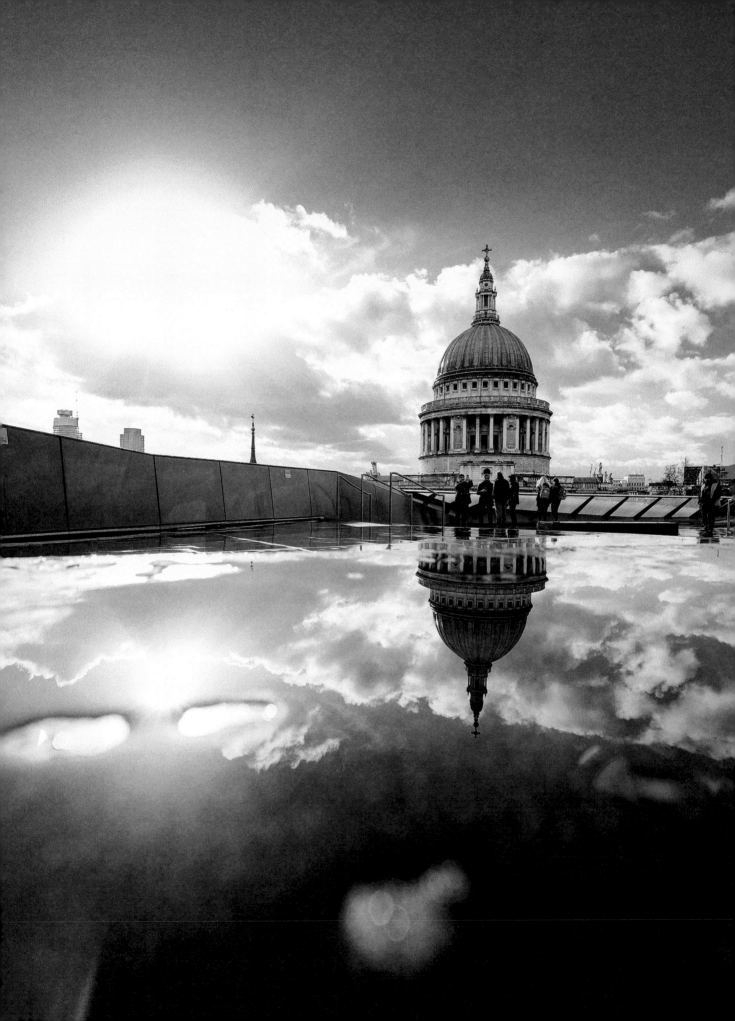

Architecture aims at eternity.

SIR CHRISTOPHER WREN

Architect

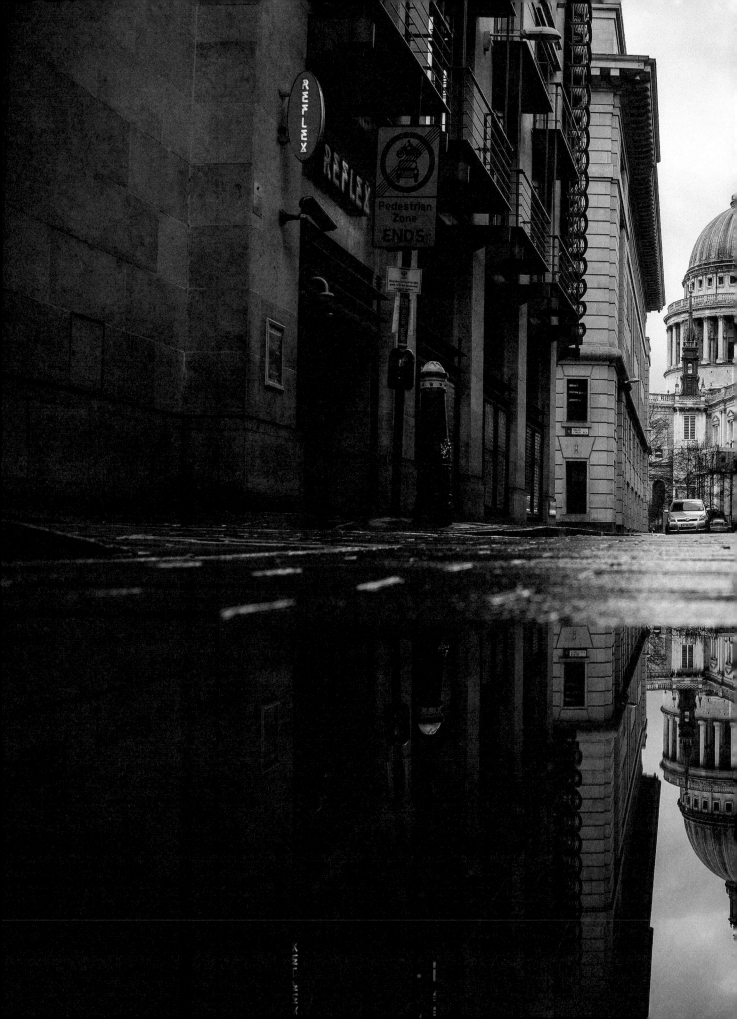

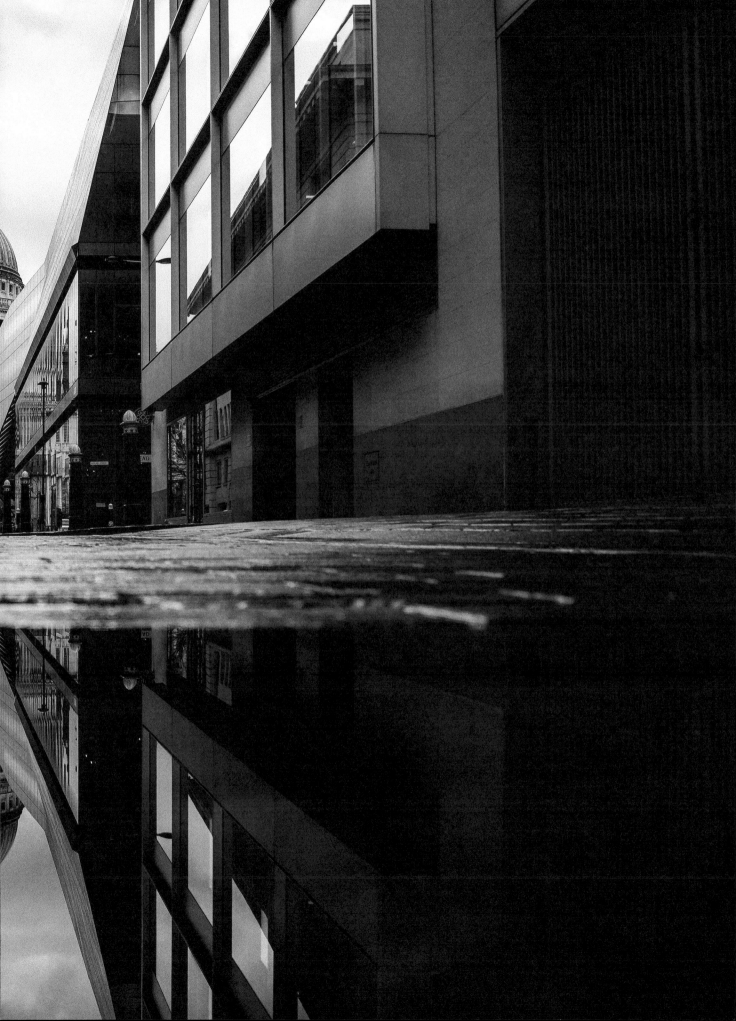

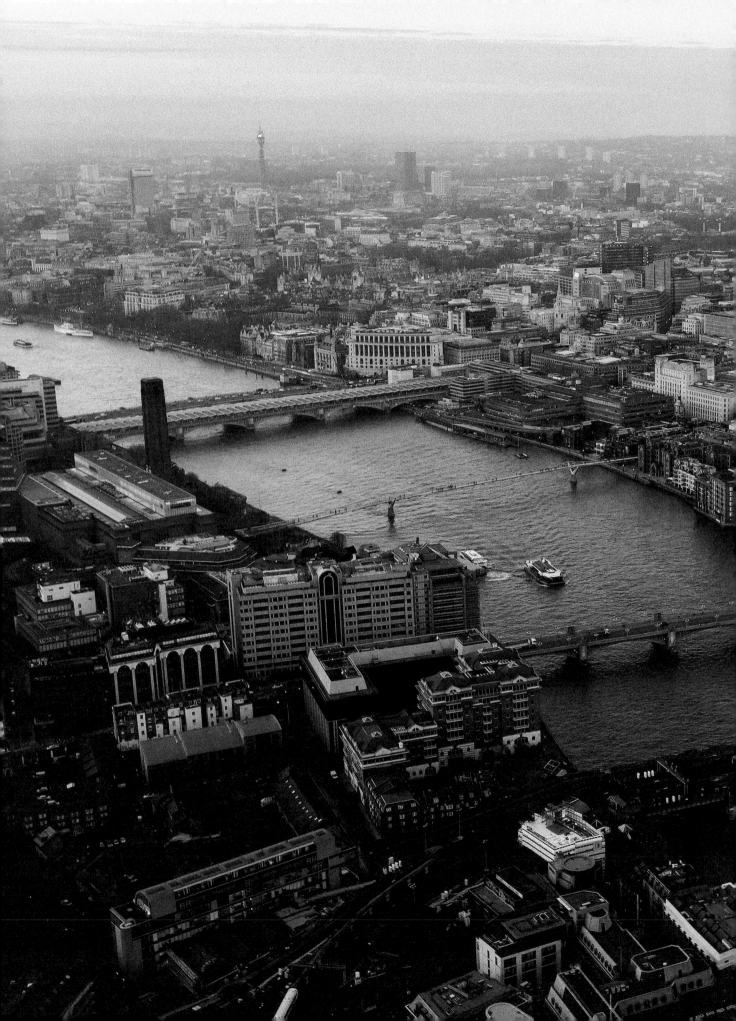

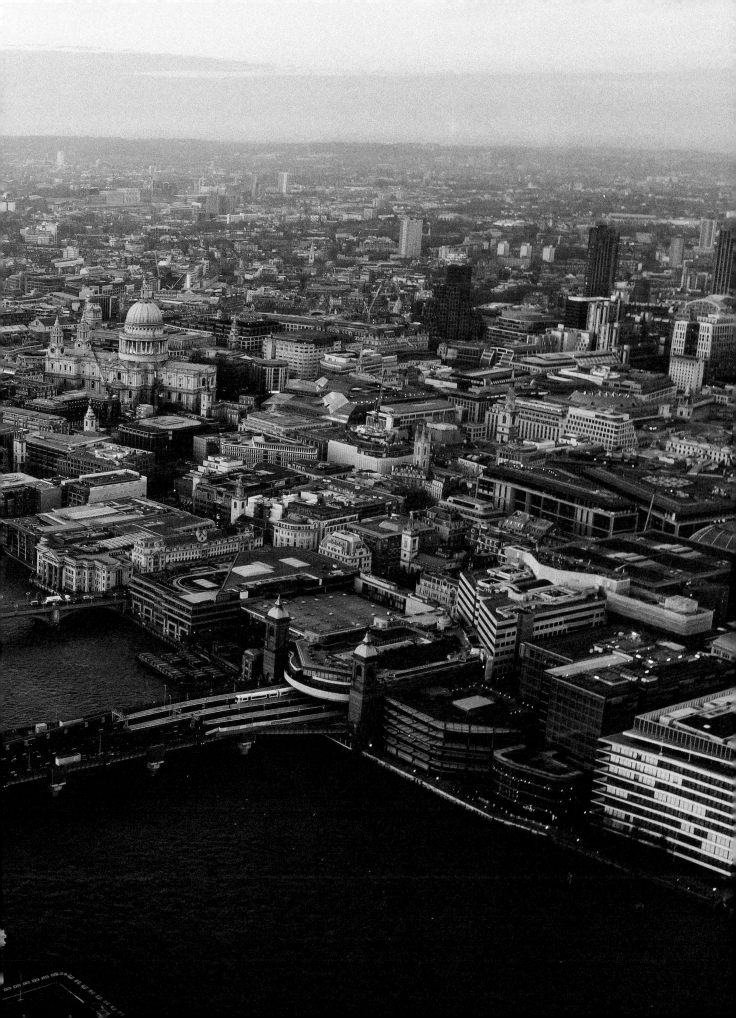

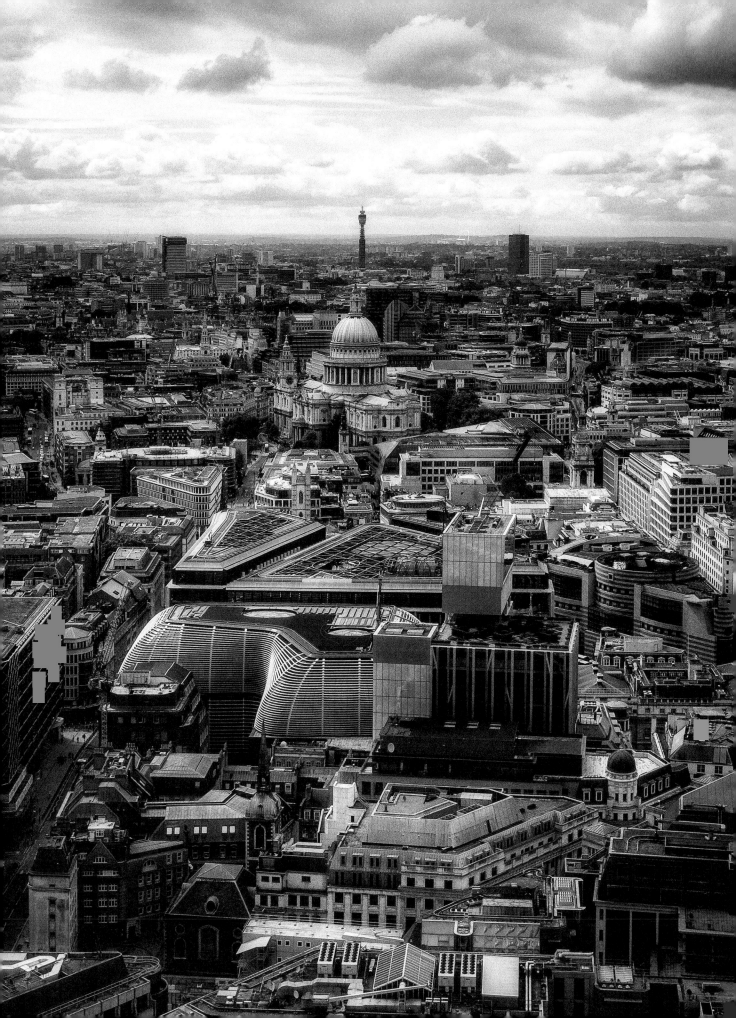

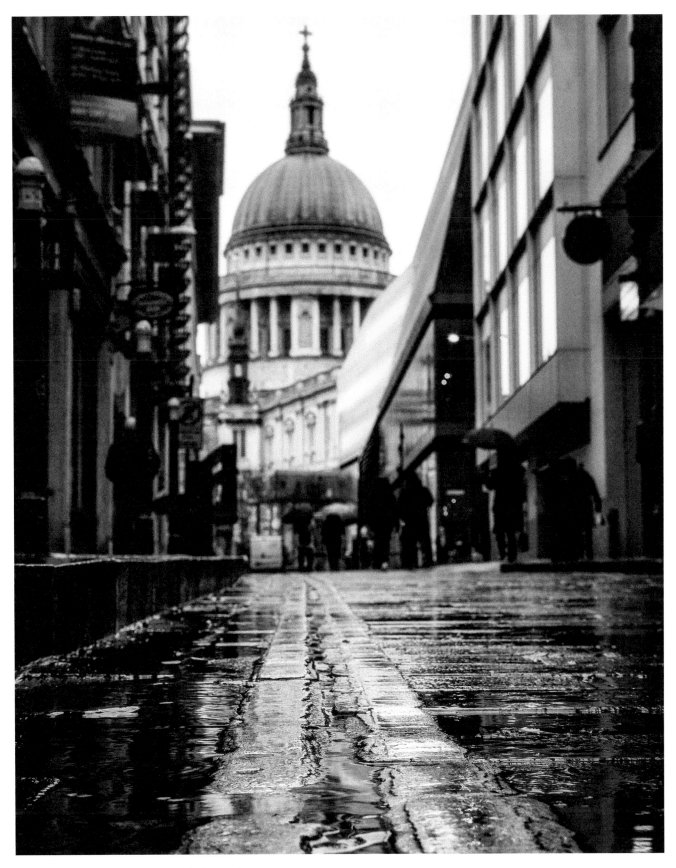

6 Previous Spread: View from The Shard, looking northwest

7 Left: View from the Sky Garden, looking west

8 Above: View from Watling Street, looking west

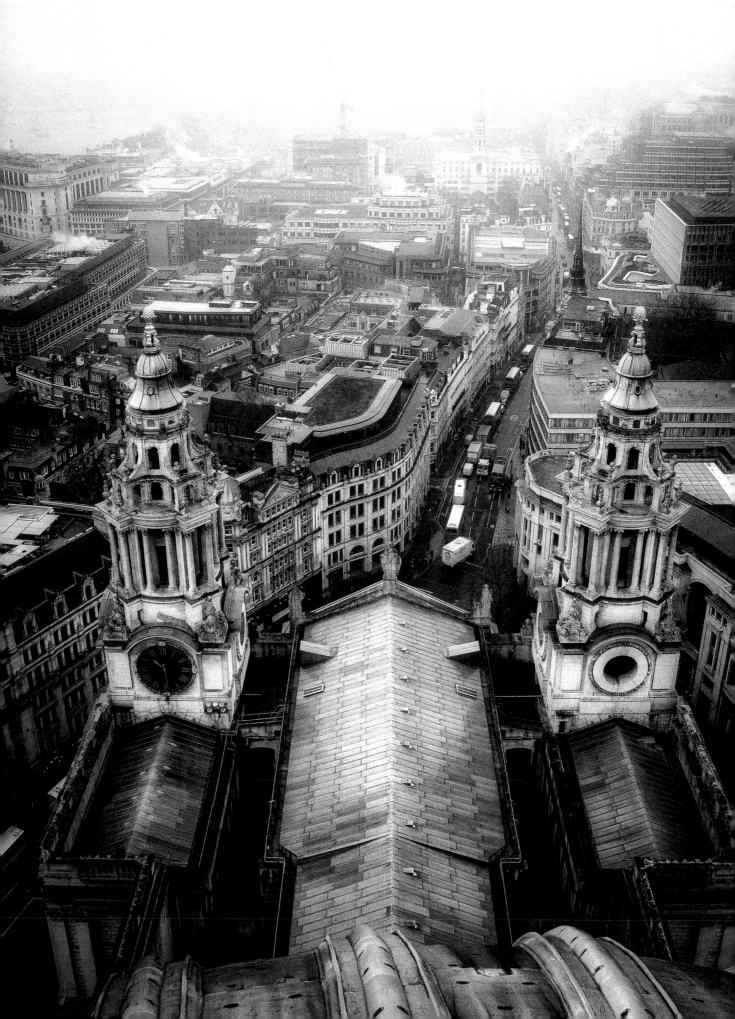

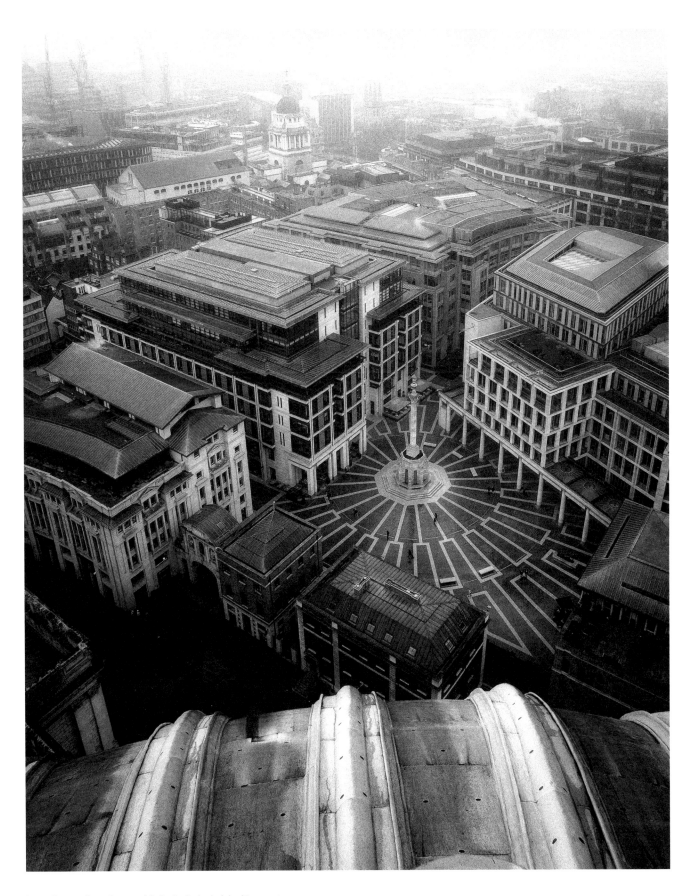

9 Left: View from the top of St Paul's Cathedral, looking west
10 Above: View from the top of St Paul's Cathedral, looking northwest

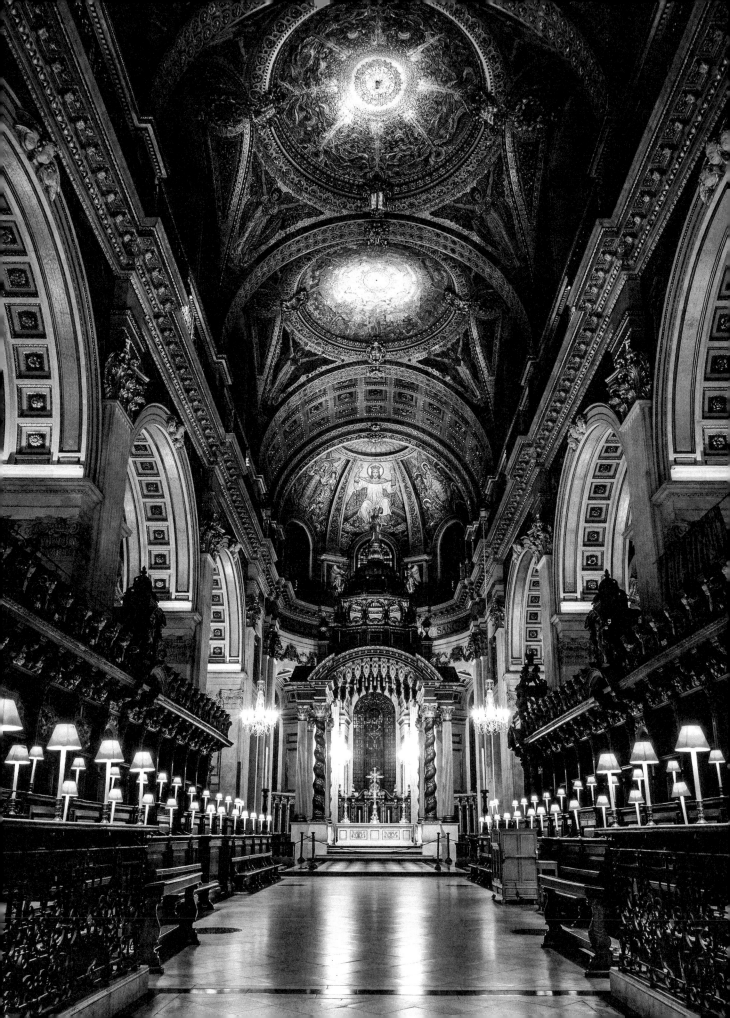

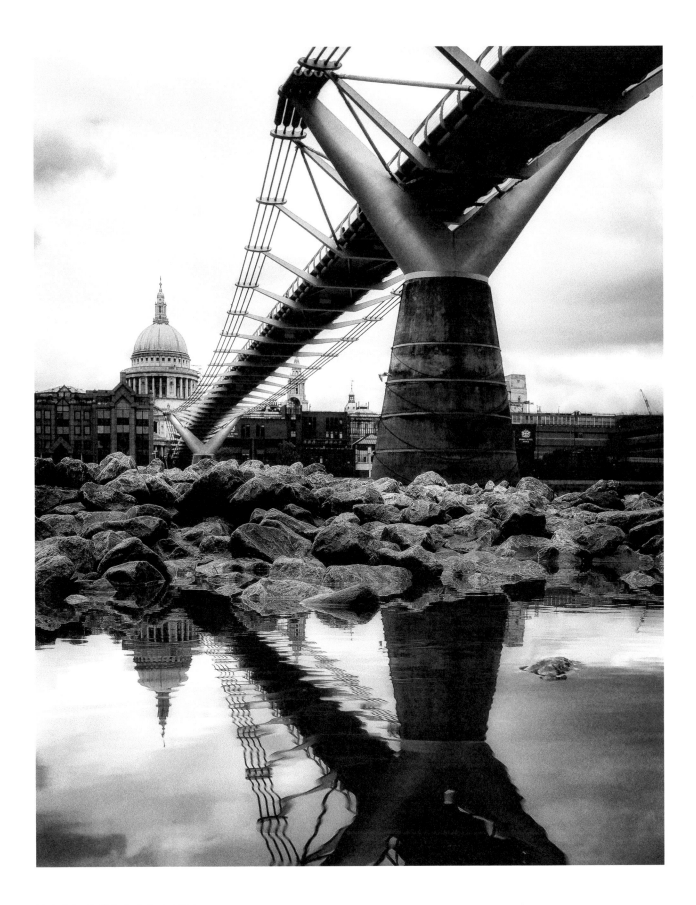

11 Left: Inside St Paul's Cathedral Choir
12 Above: View from the foot of Millennium Bridge, looking north

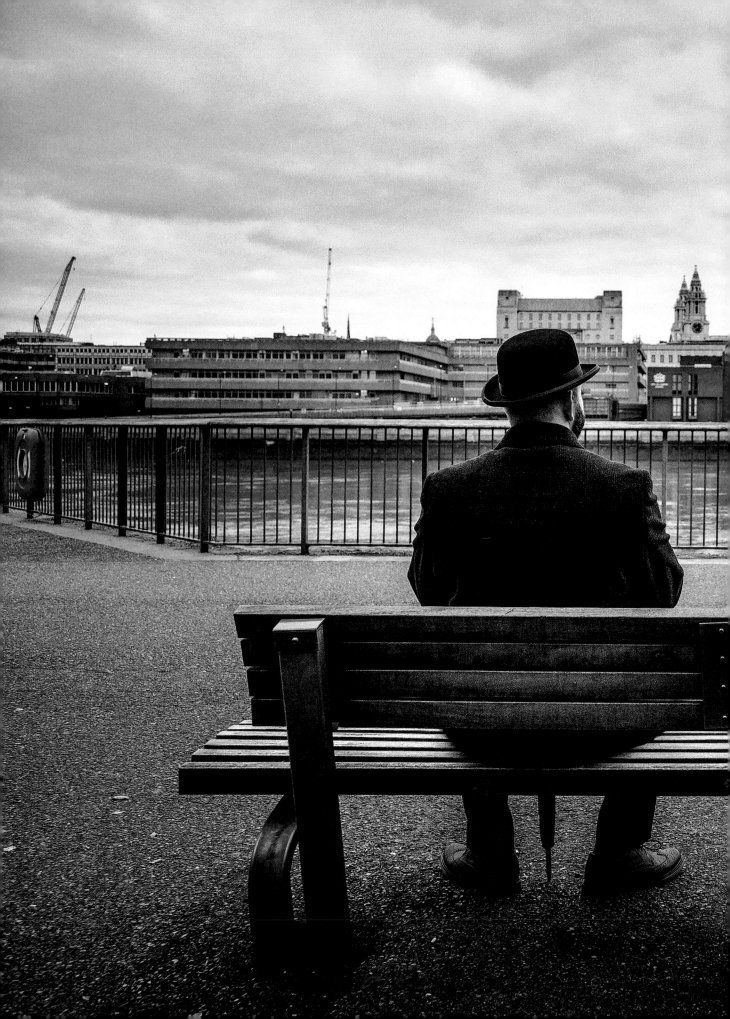

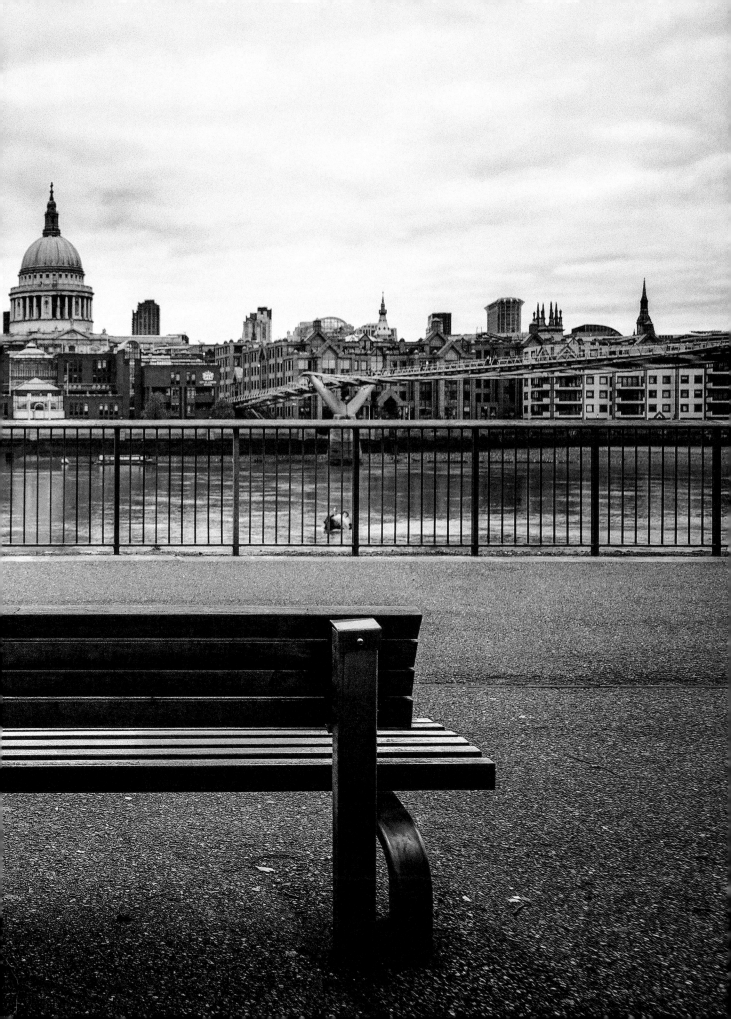

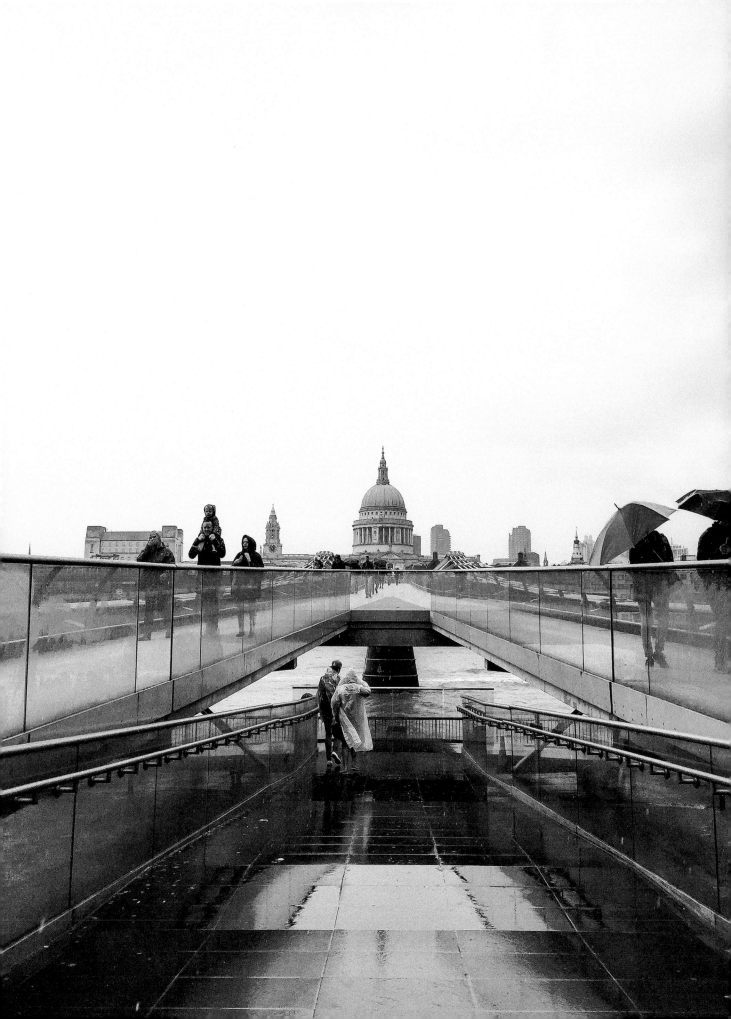

London has the trick of making its past,
its long indelible past, always a part of its
present. And for that reason it will always
have meaning for the future, because of all
it can teach about disaster, survival, and
redemption. It is all there in the streets.
It is all there in the books."

ANNA QUINDLEN

Author and Journalist

7

St Paul's Cathedral

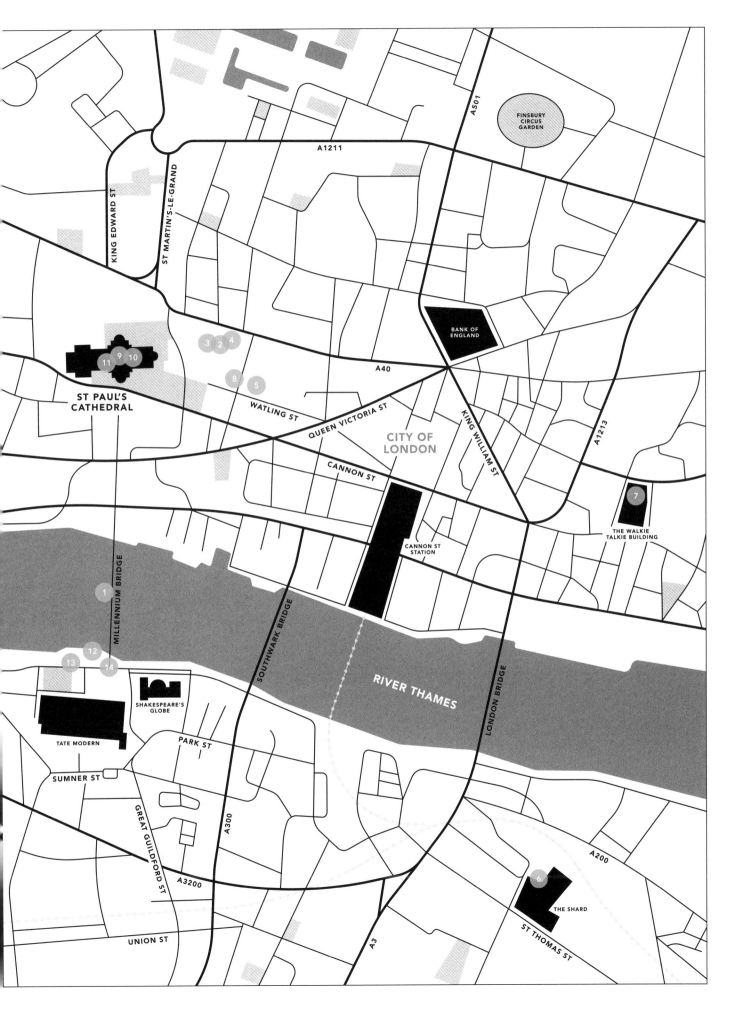

Big Ben

A universal misnomer for the most famous feature of the Houses of Parliament, "Big Ben" is used by Londoners and visitors alike to describe the 100-metre tower at the northern end of the palace. But, the name is actually that of the 13.7-tonne bell that hangs inside. ✚ Designed by architect Sir Charles Barry after the Palace of Westminster was destroyed by fire, the Clock Tower (as it was originally named) was completed in 1859. The bell, likely called "Ben" after Sir Benjamin Hall, the First Commissioner of Works, rang for the first time on 11 July of that year. Despite a few early cracking issues, a silent period during World War I, occasional maintenance, and a large renovation project that began in 2017, Big Ben has rung on the hour through the reign of six monarchs. ✚ The tower's four-faced Great Clock is London's most important and accurate timepiece. Typically exact within the second, the clock's pendulum has been regulated by a stack of old pennies since the beginning. Adding or removing a single pre-decimal penny has the power to alter the time two-fifths of a second per day. ✚ In 2012, the Clock Tower was formally renamed the Elizabeth Tower in honor of Queen Elizabeth II's Diamond Jubilee, but if time is any indication, the landmark's slightly inaccurate nickname is here to stay.

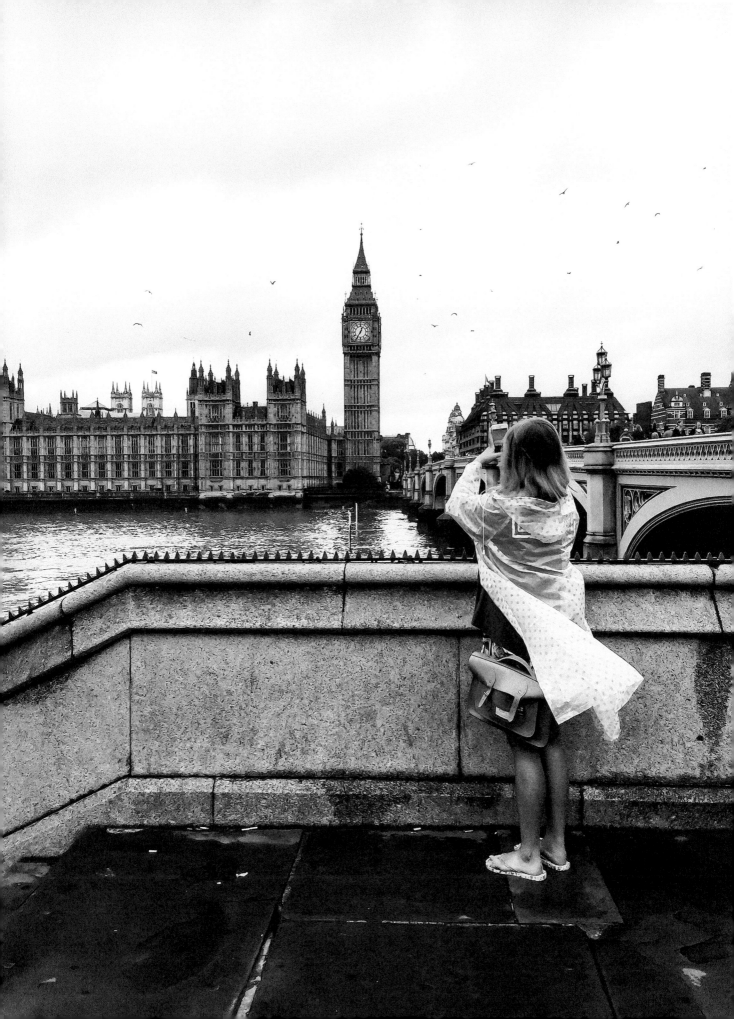

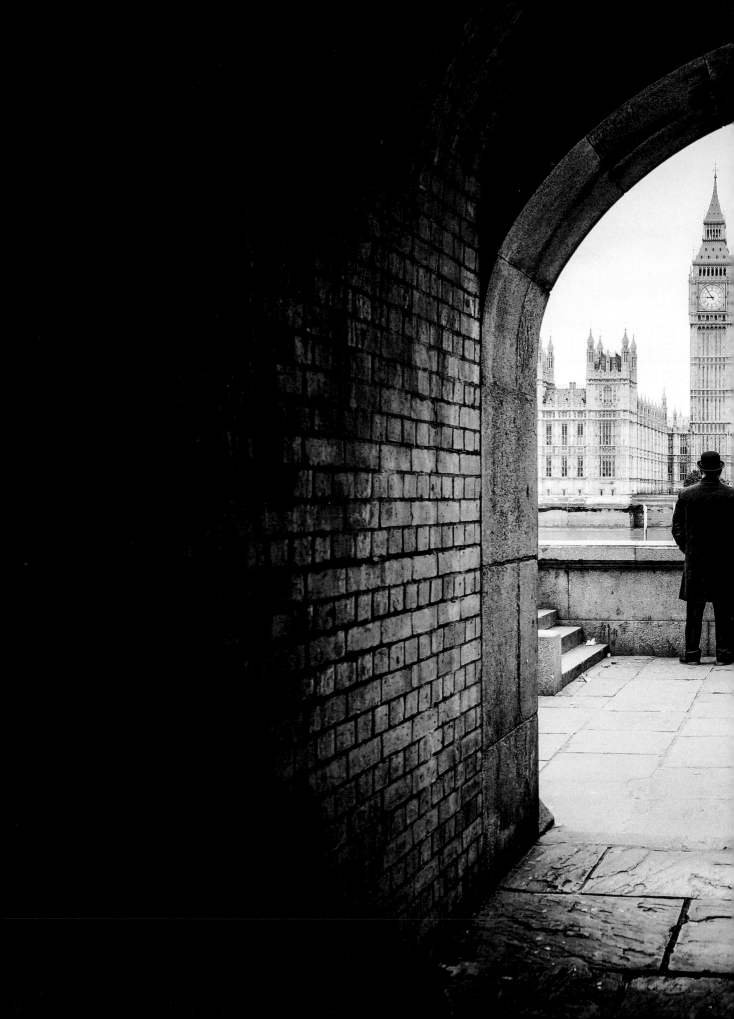

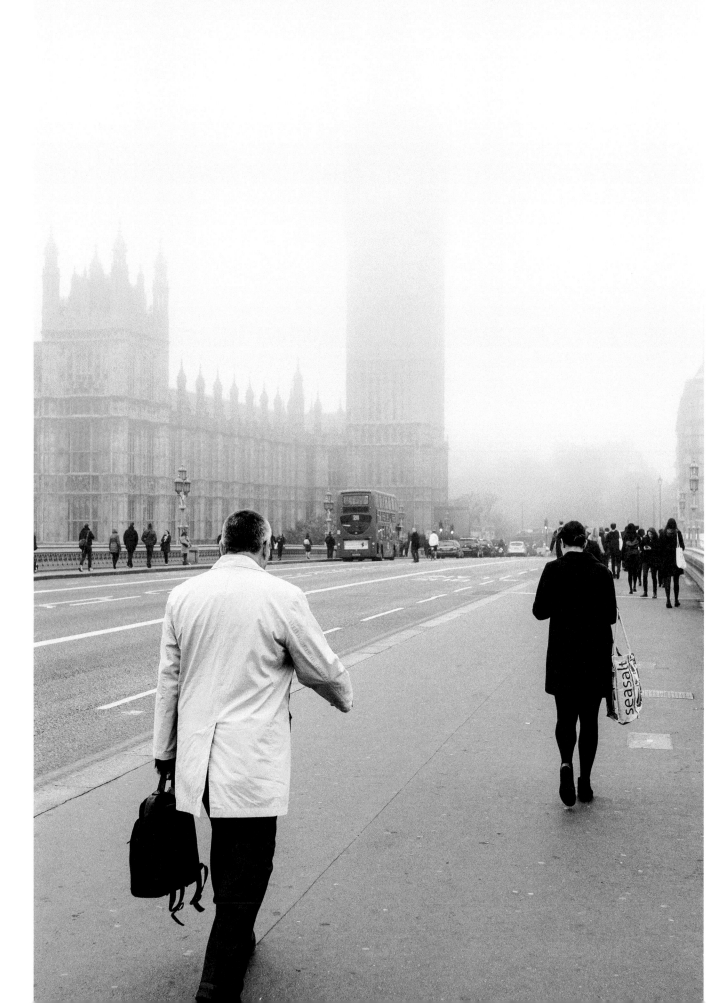

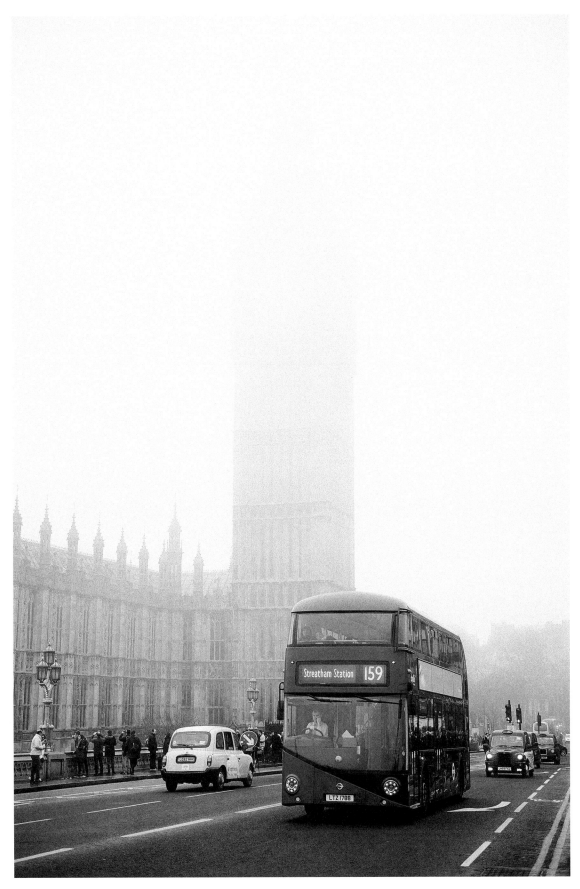

1 Opening Page: View from Thames Path at St Thomas' Hospital Gardens, looking west
2 Previous Spread: View over the River Thames from the foot of Westminster Bridge, looking west
3 Left: View from Westminster Bridge, looking west
4 Above: View from Westminster Bridge, looking west

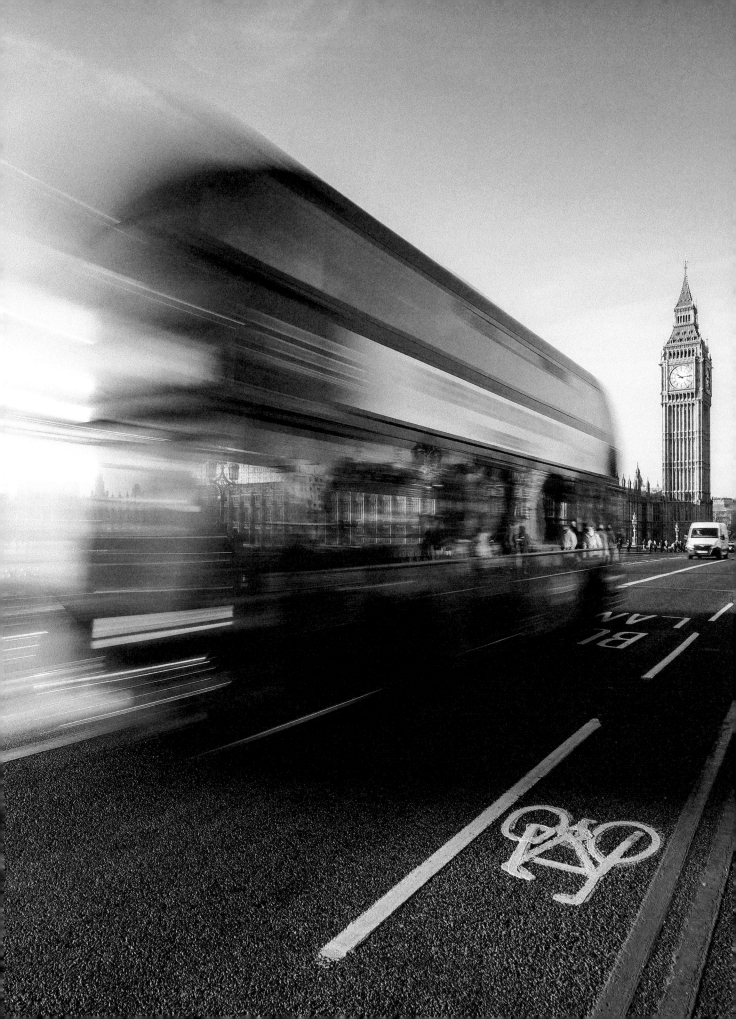

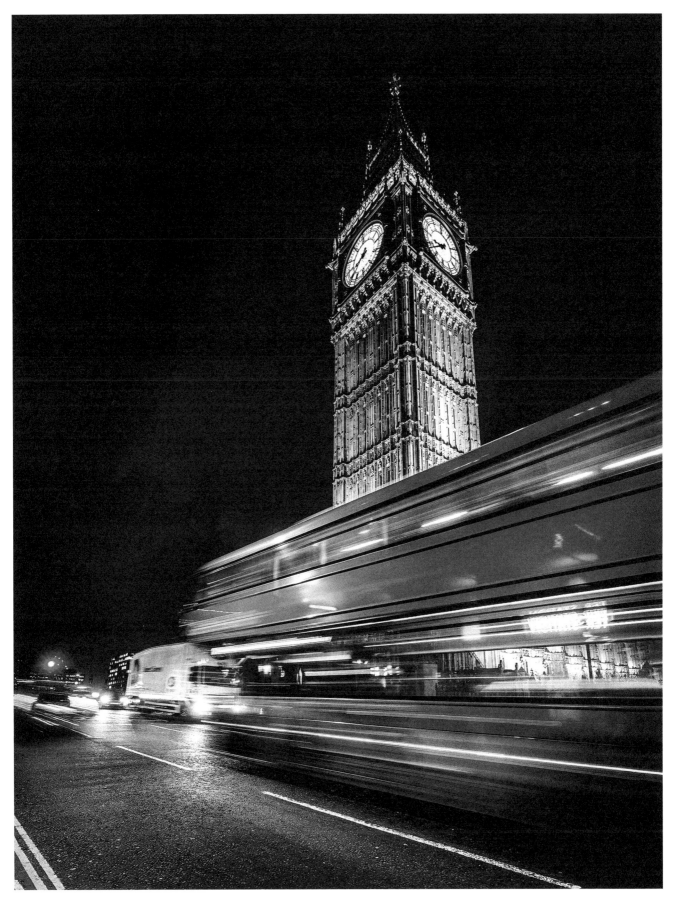

5 Left: View from Westminster Bridge, looking west
6 Above: View from outside Westminster Station, looking southeast

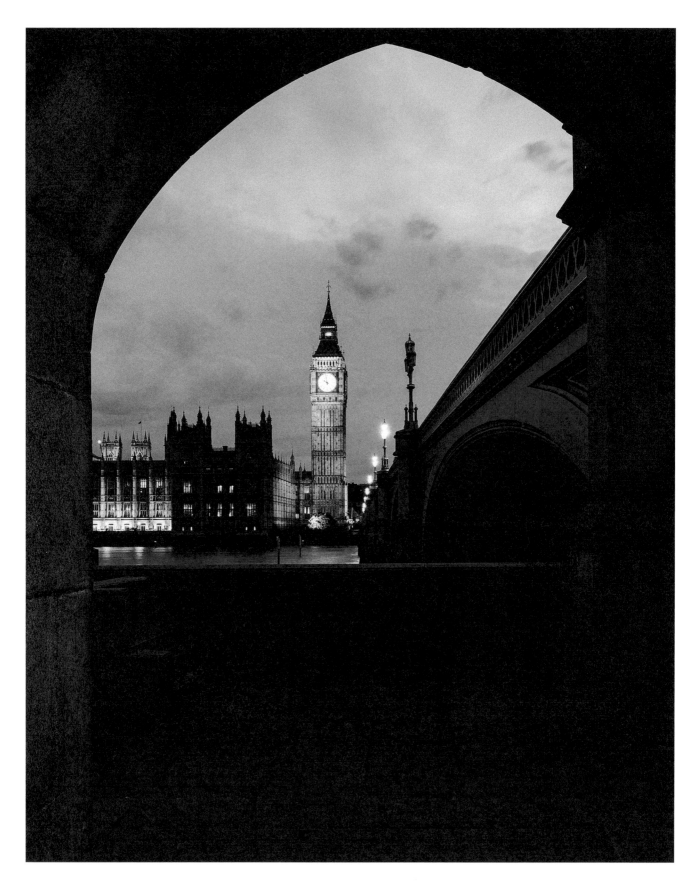

7 Above: View over the River Thames from the foot of Westminster Bridge, looking west
8 Right: Aerial view along Westminster Bridge, looking west

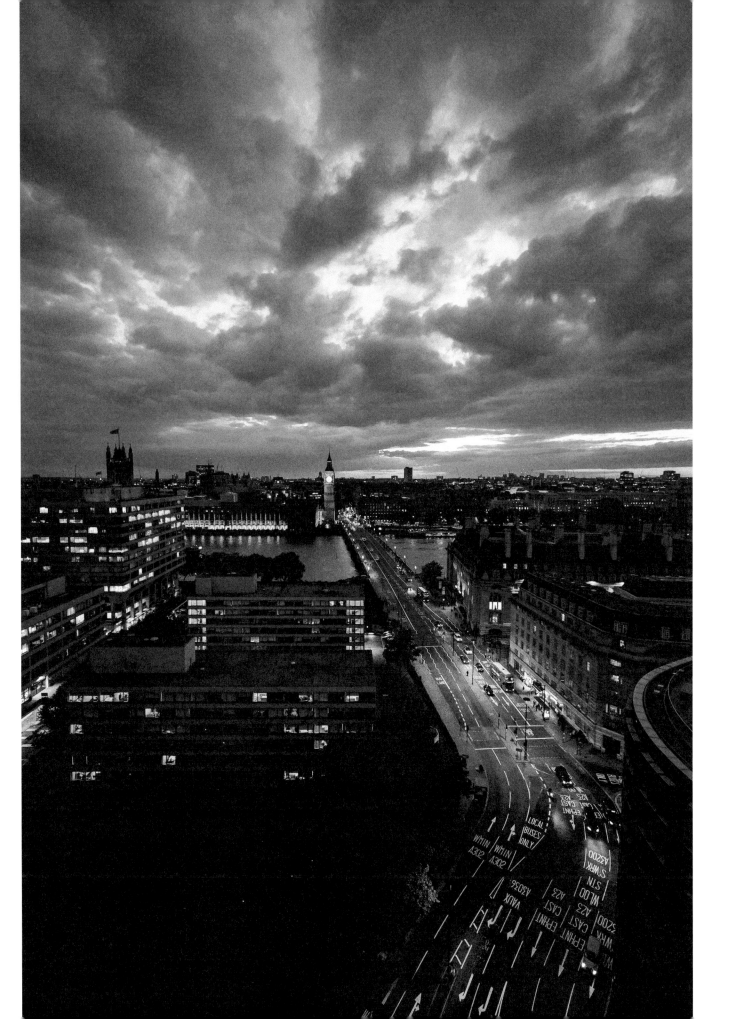

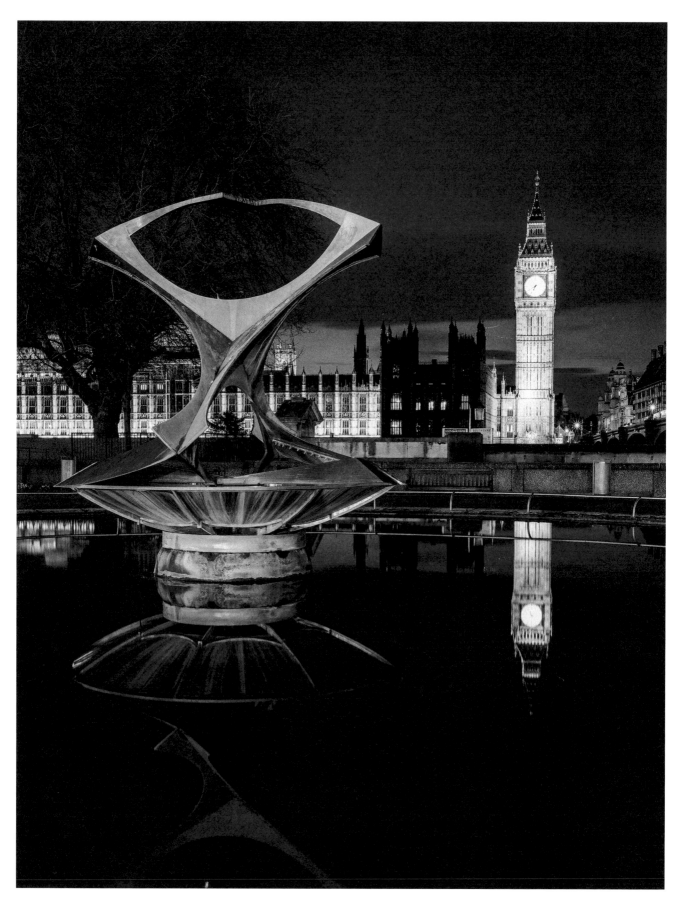

9 Above: View from St Thomas' Hospital Gardens, looking west
10 Right: View from Queen's Walk south of the London Eye, looking southwest

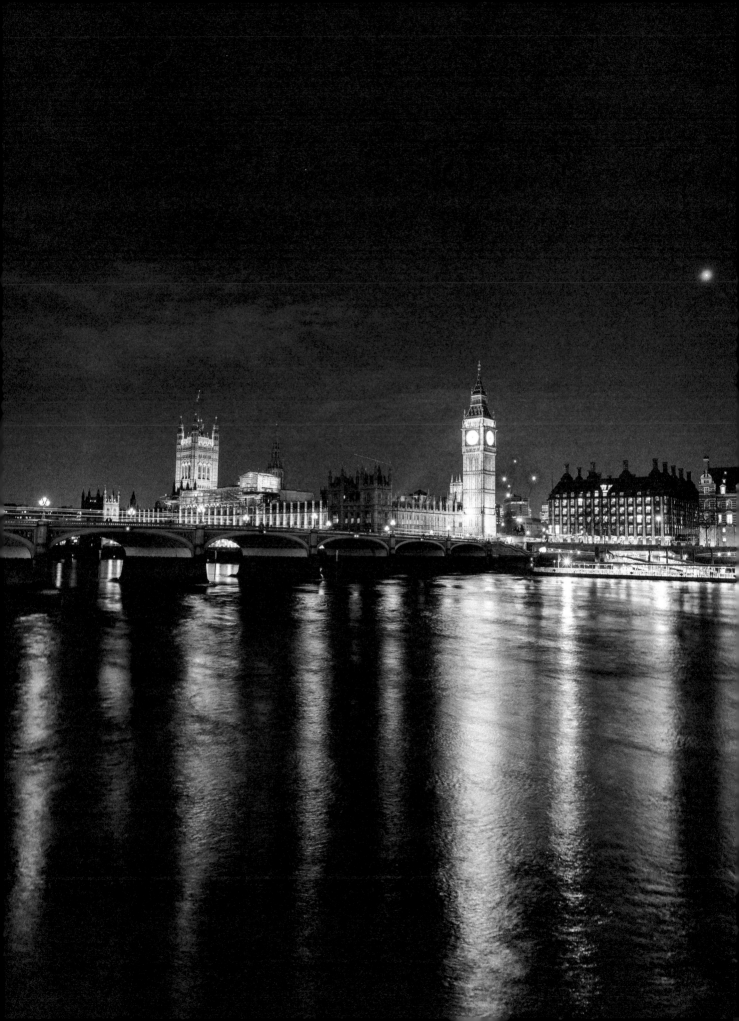

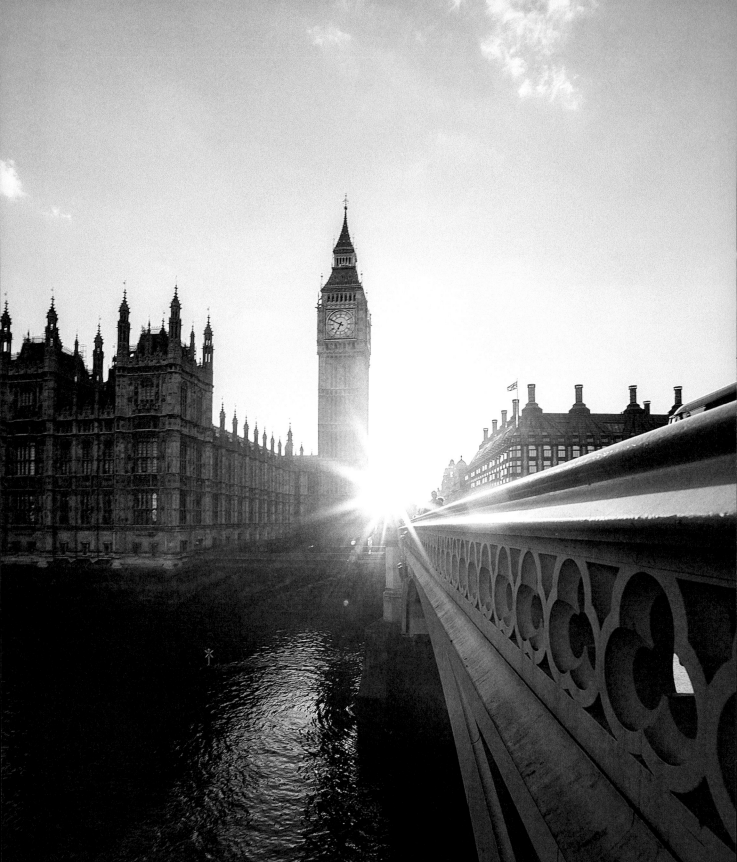

We shape our buildings;
thereafter they shape us.

SIR WINSTON CHURCHILL

Former British Prime Minister

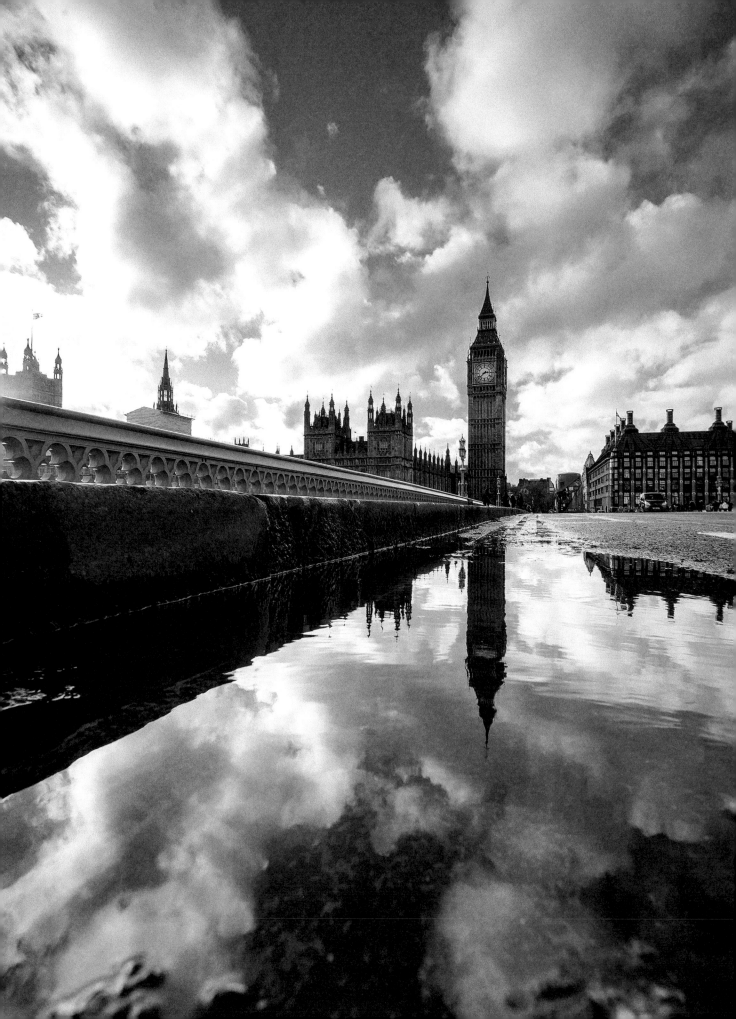

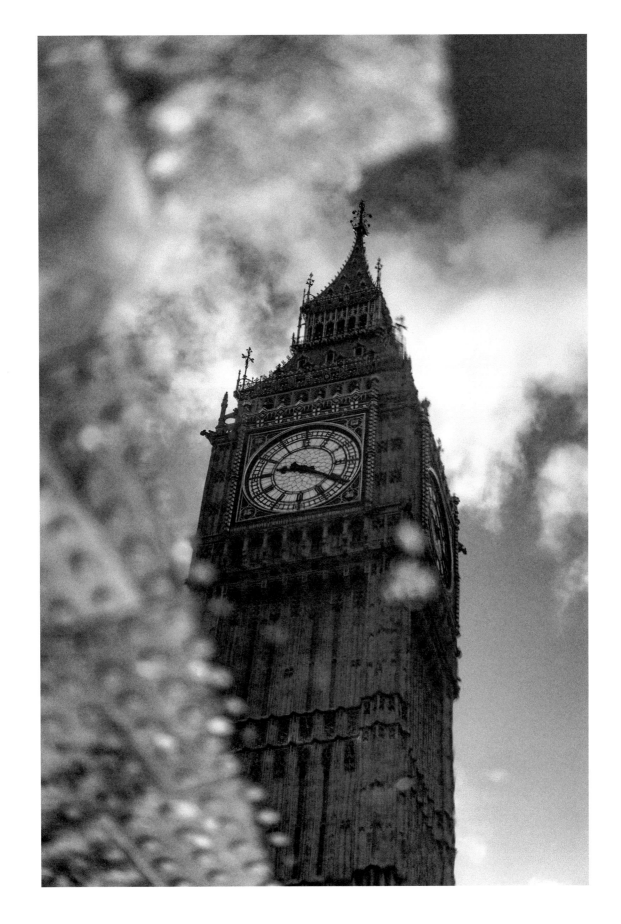

12 Left: View from Westminster Bridge, looking west
13 Above: Reflection of Big Ben from Bridge Street

8

Big Ben

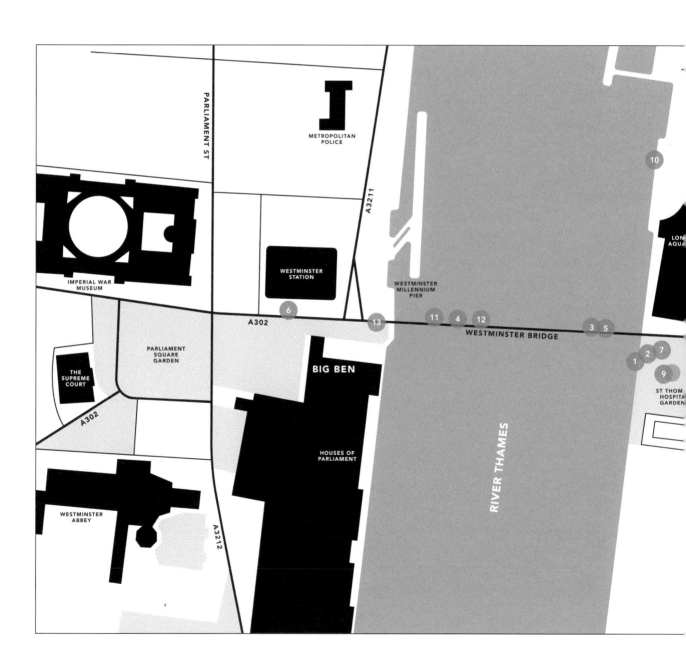

LONDON
DUNGEON

BELVEDERE RD

A3200

YORK RD

WATERLOO
STATION

8

LOWER MARSH

A3036

UPPER MARSH

A302

ROYAL ST

Tube & Rail

In 1863, a six-kilometre underground railway between Paddington and Farringdon changed the way people in London navigated their city. A global feat of engineering and ingenuity, the tunnel was the first section of the London Underground (or, more affectionately, "The Tube") and is still a functioning part of the sprawling 402-kilometre network that shuffles around well over a billion people each year. ✚ In 1908, at the stop now known as St James's Park, a simple red circle bisected by a blue bar was introduced to clearly identify the station name – against a sea of billboards and adverts that lined the platform walls – so riders knew when to get off. Today, that same pragmatic logo, with slight tweaks over the last century, marks every one of the Underground's trains and stations, and has become a powerful symbol of the capital all over the world. ✚ With less than half of its tracks actually below street level, the London Underground is not to be confused with the London Overground. Established in 2007, the "Ginger line" was the unification and renovation of six different, previously abandoned railways to create an orbital network around the capital. Today, the Overground serves 23 boroughs and in true London form, runs beneath Tube lines at Whitechapel and a few other stops throughout the city.

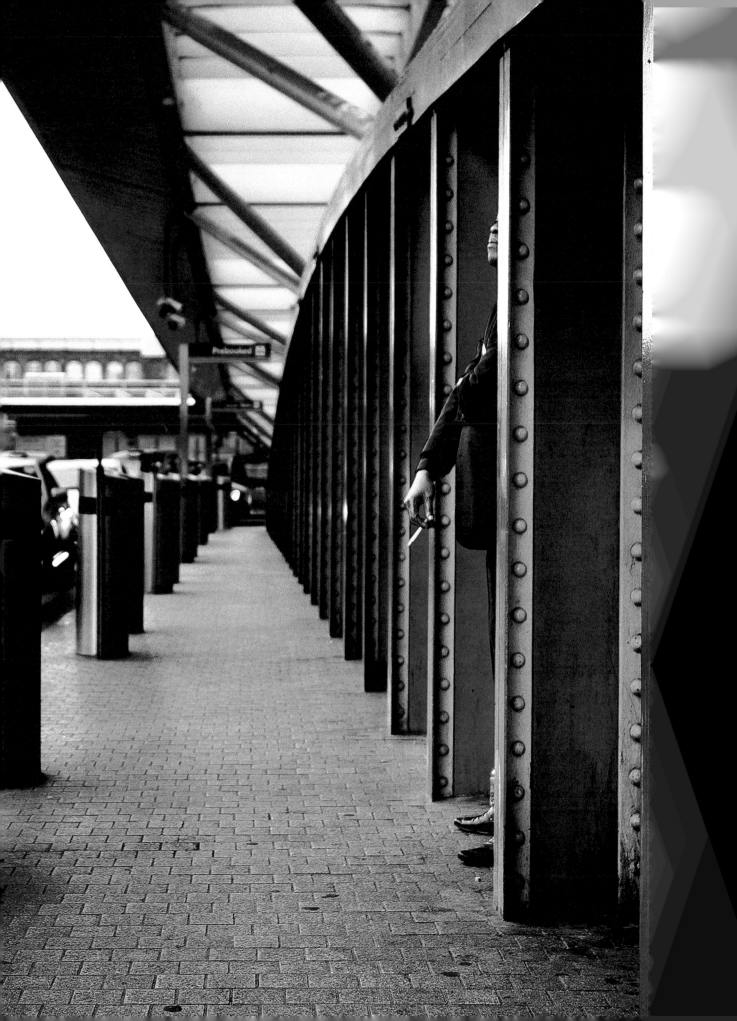

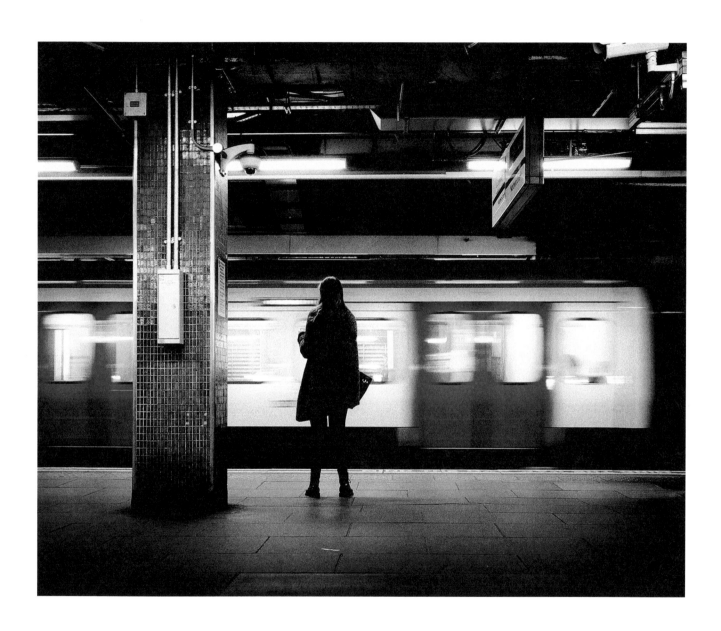

1 Previous Page: Sheldon Square, Paddington Station interchange
2 Above: Moorgate Station, Metropolitan westbound platform
3 Right: Rooftop view, Heron Quays DLR bridge

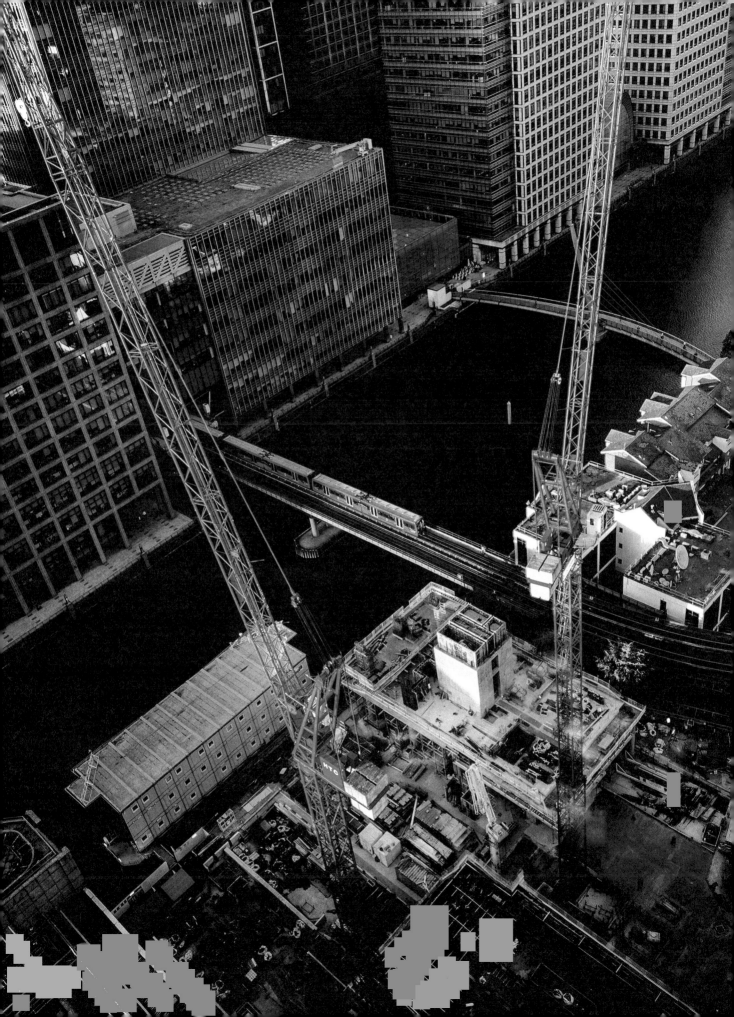

4 Above: Side view, train at Oxford Circus Station

5 Right: Borough Market entrance, London Bridge Station

6 Following Spread: Center platform, Clapham Common Station

CAUTION!!! FLOOR SURFACES MAY BE
SLIPPERY DUE TO THE WET WEATHER.

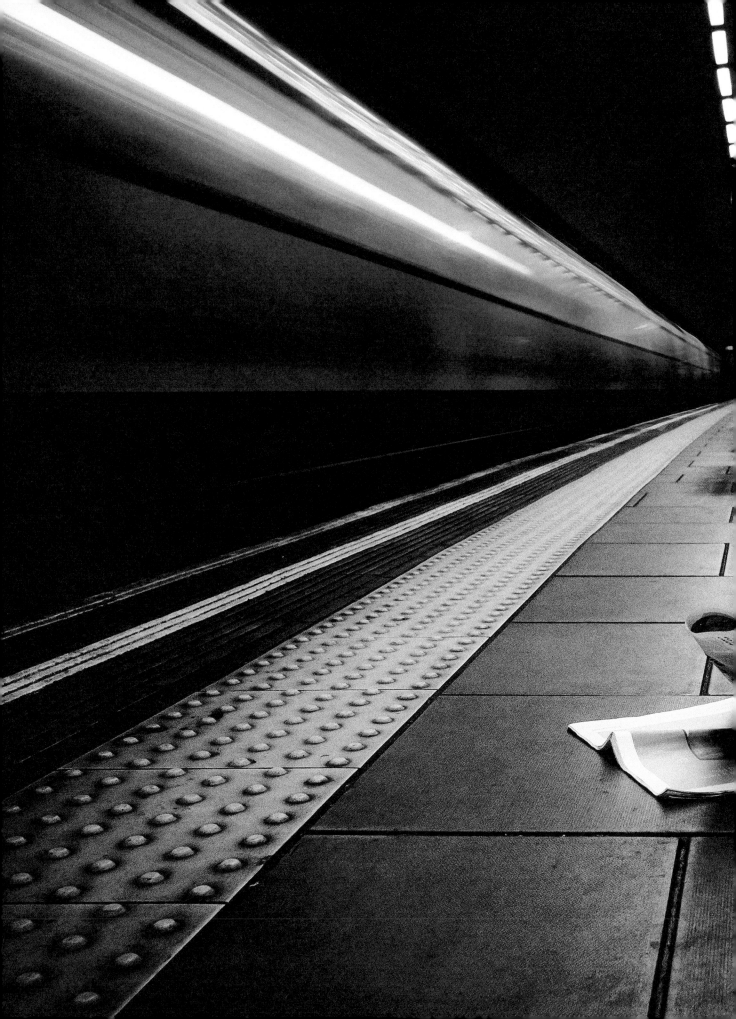

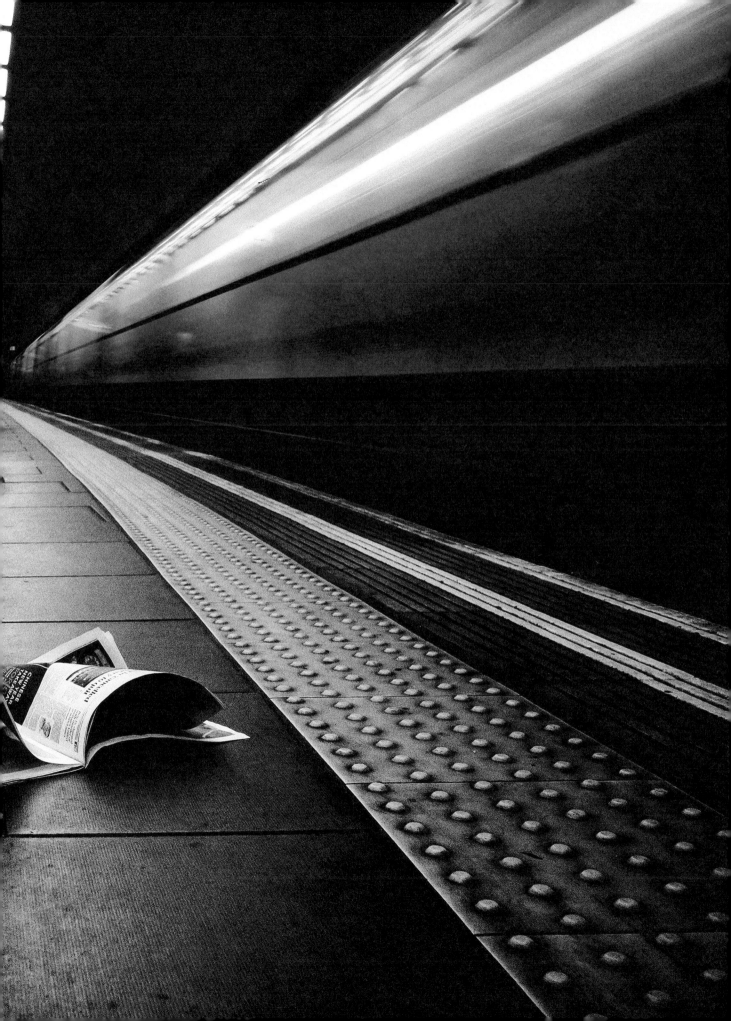

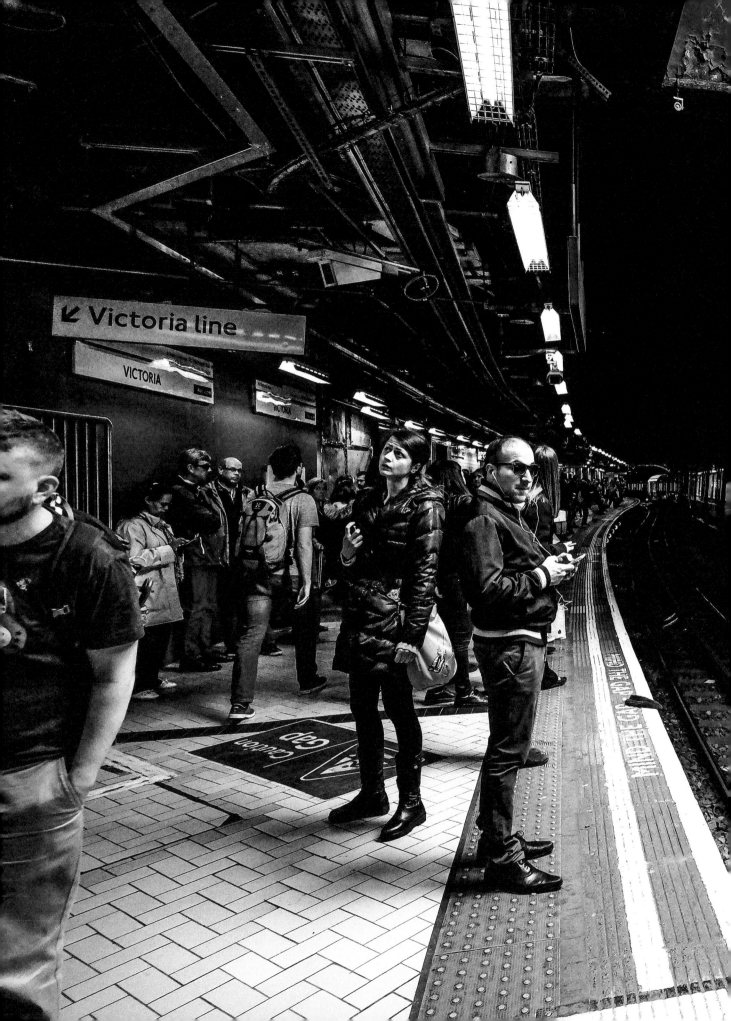

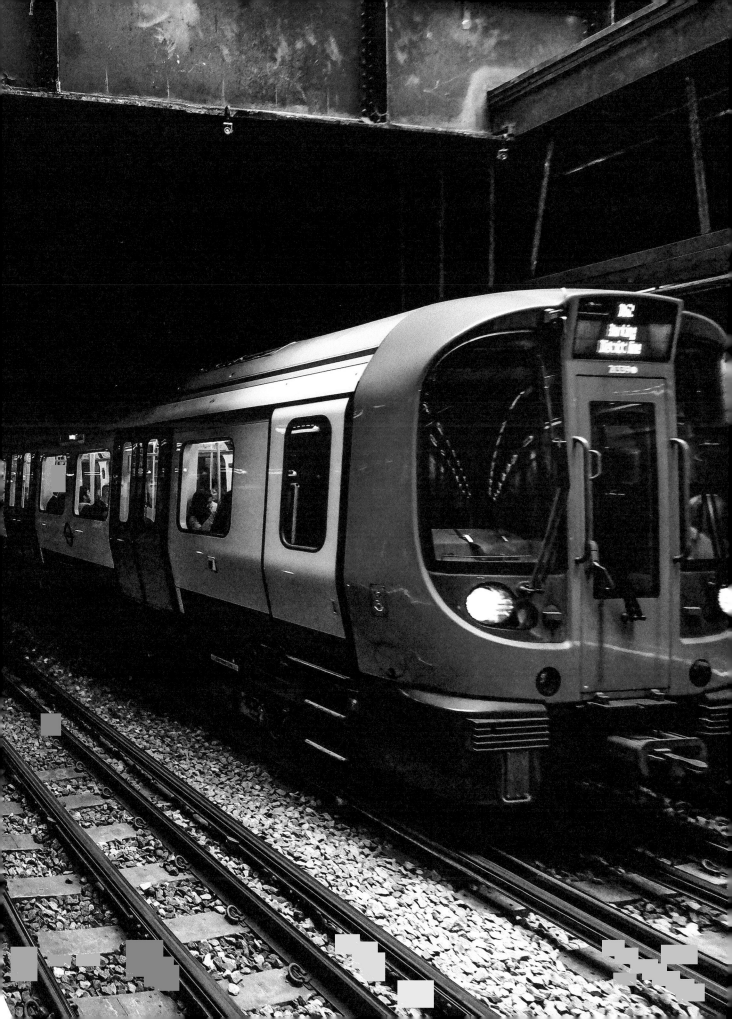

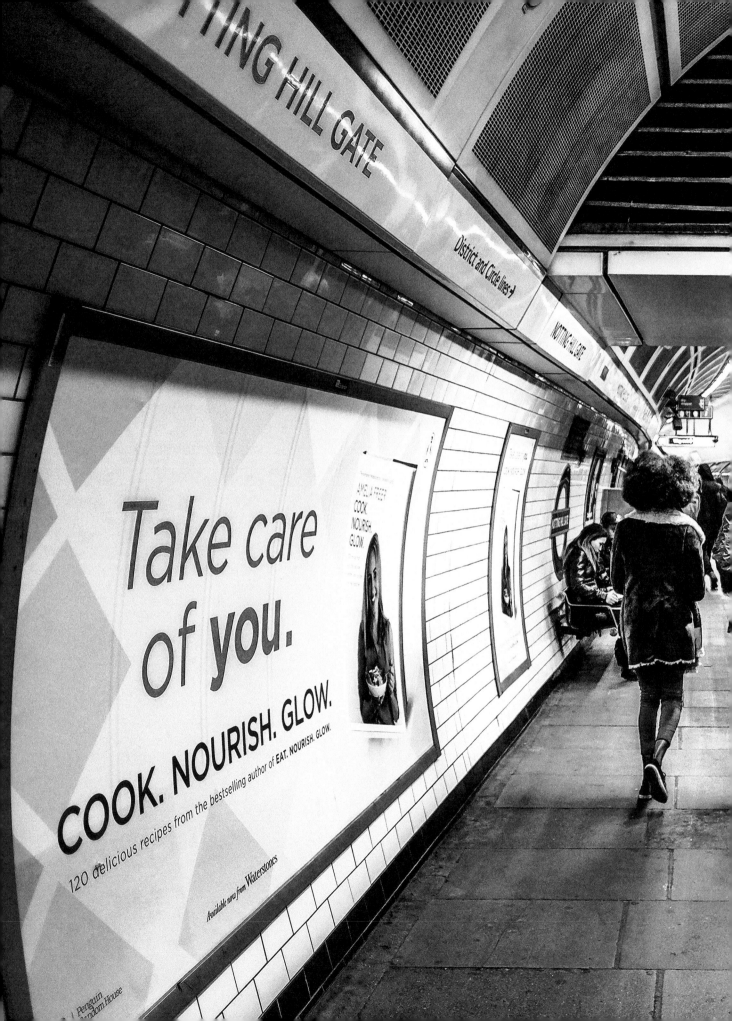

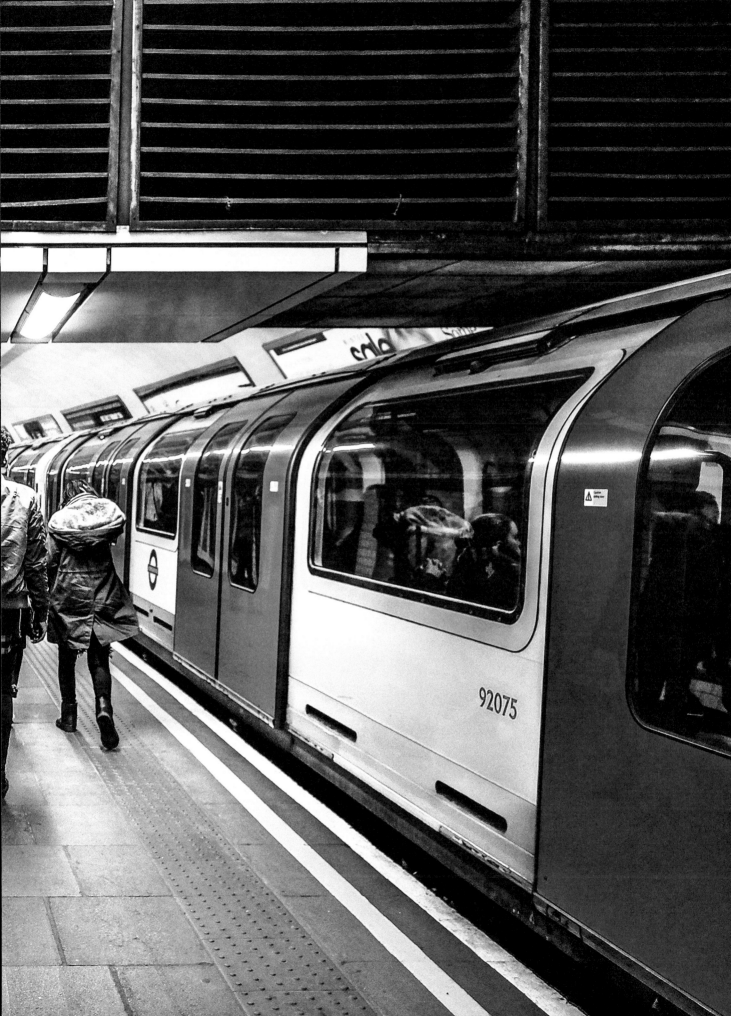

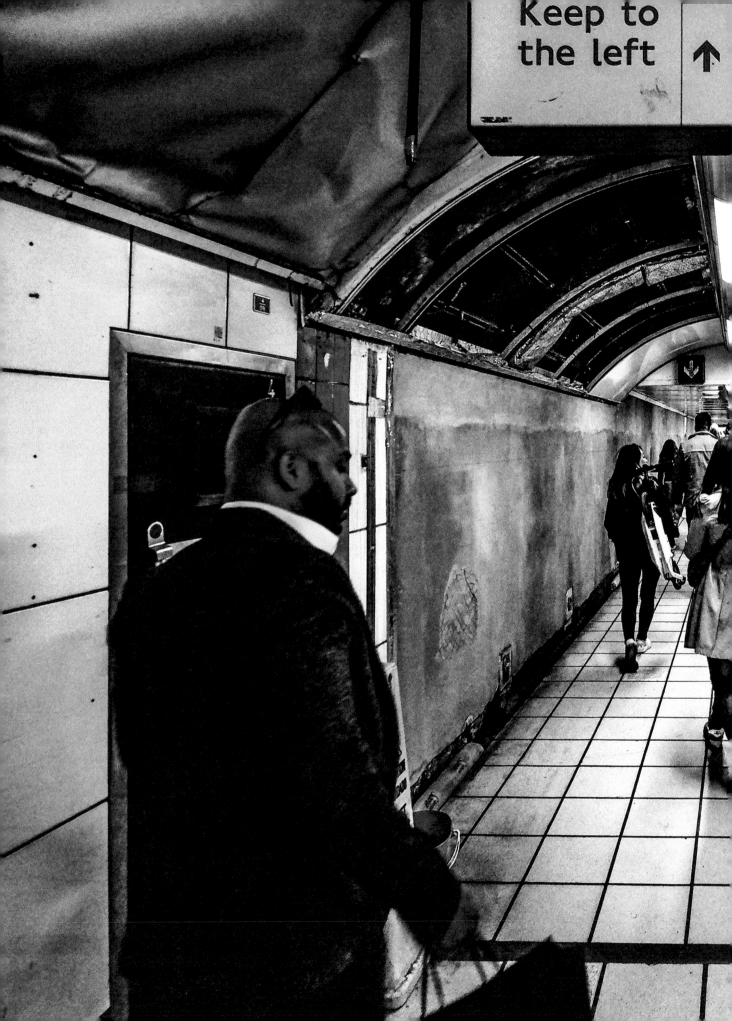

Keep to
the left ↑

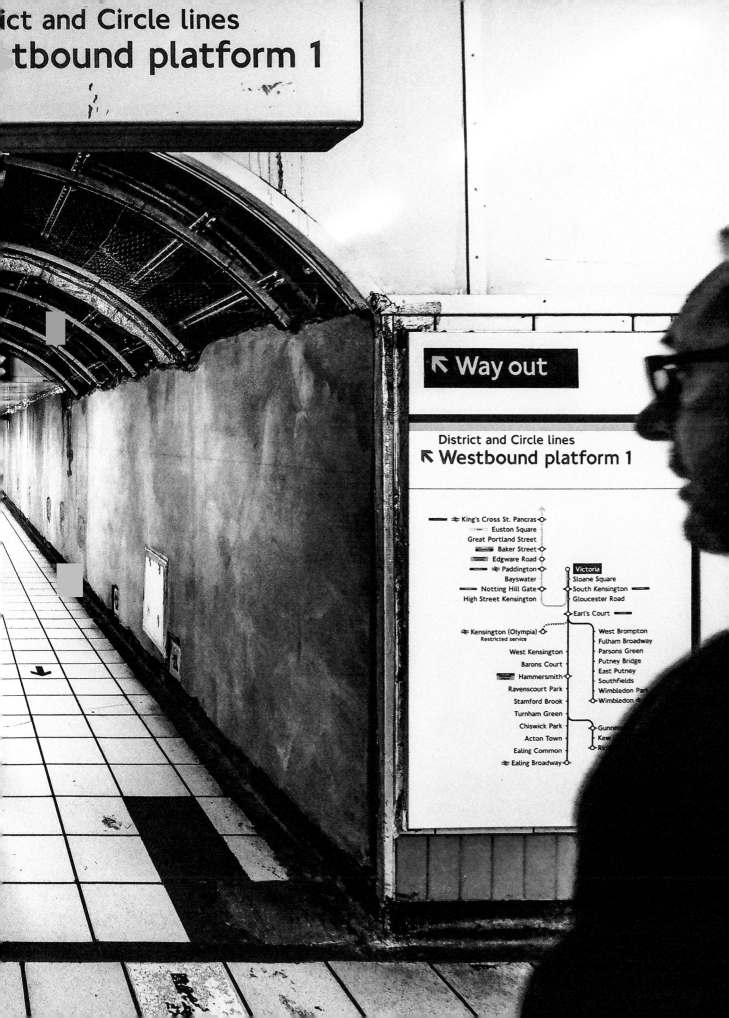

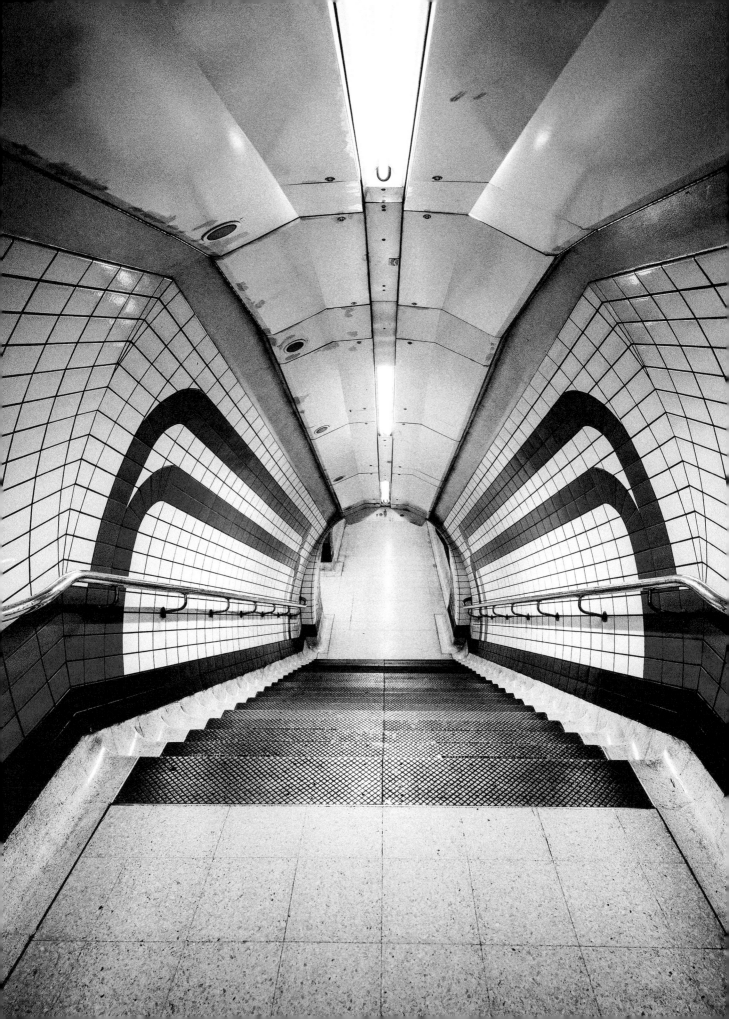

London is a world in itself... It contains within itself all that is gorgeous in wealth, and all that is squalid in poverty; all that is illustrious in knowledge, and all that is debased in ignorance; all that is beautiful in virtue, and all that is revolting in crime. Adequately to chronicle and to describe such a city... is a task beyond any individual powers.

CHARLES KNIGHT

Publisher and Author

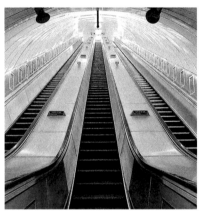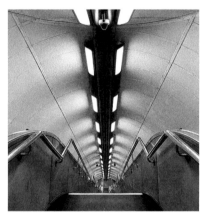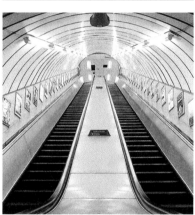

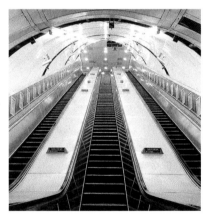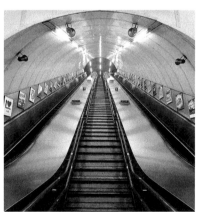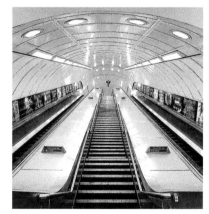

11 First Row, Left: Holborn Station

12 First Row, Center: Charing Cross Station

13 First Row, Right: Elephant & Castle Station

14 Second Row, Left: Waterloo Station

15 Second Row, Center: Hyde Park Corner Station

16 Second Row, Right: Moorgate Station

17 Third Row, Left: Bond Street Station

18 Third Row, Center: Charing Cross Station

19 Third Row, Right: Notting Hill Gate Station

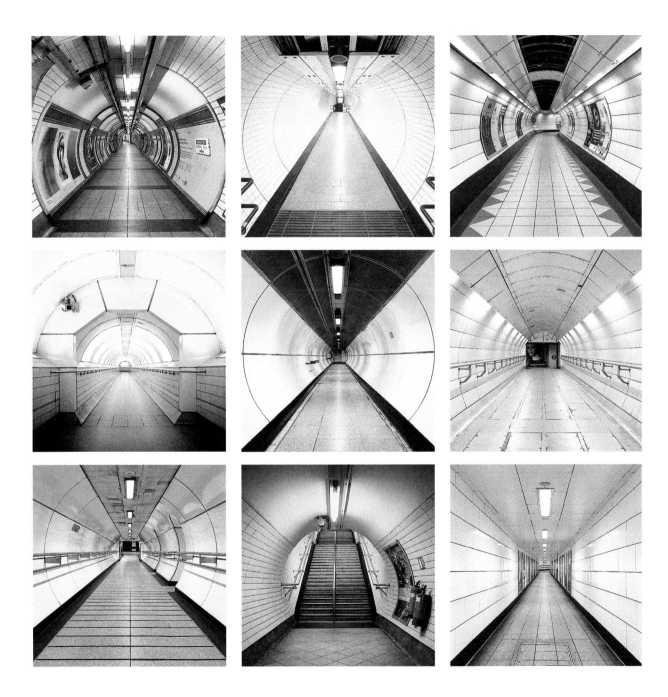

20 First Row, Left: Embankment Station
21 First Row, Center: Tottenham Court
 Road Station
22 First Row, Right: Bank Station

23 Second Row, Left: Bank Station
24 Second Row, Center: London Bridge
 Station
25 Second Row, Right: Waterloo Station

26 Third Row, Left: London Bridge Station
27 Third Row, Center: Embankment Station
28 Third Row, Right: Oxford Circus Station

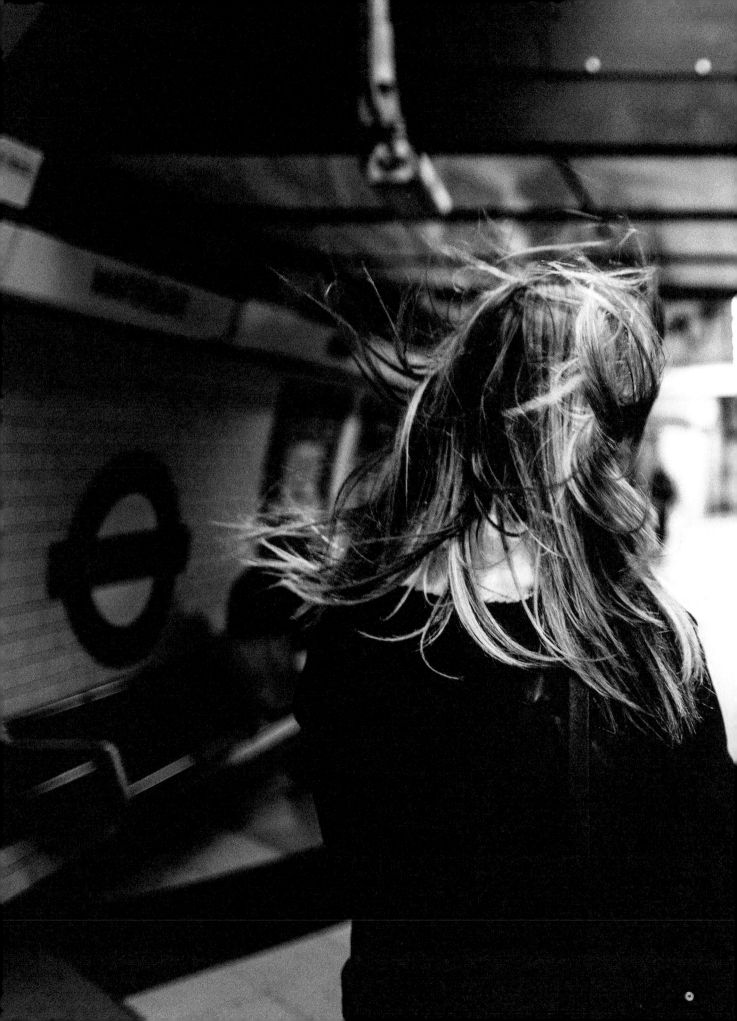

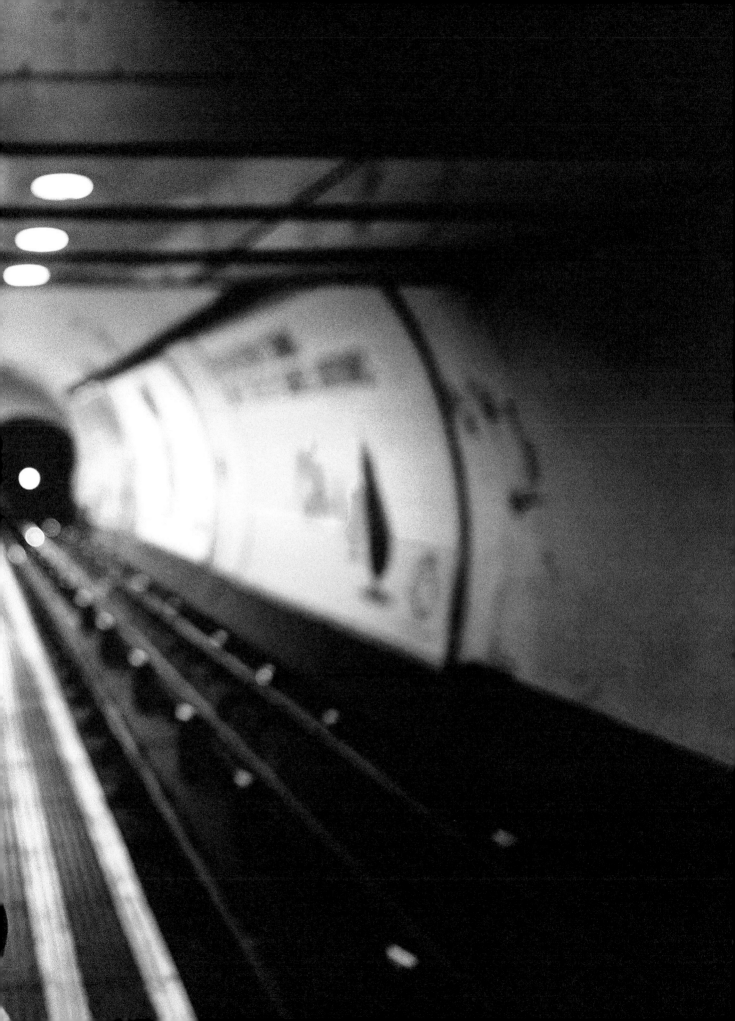

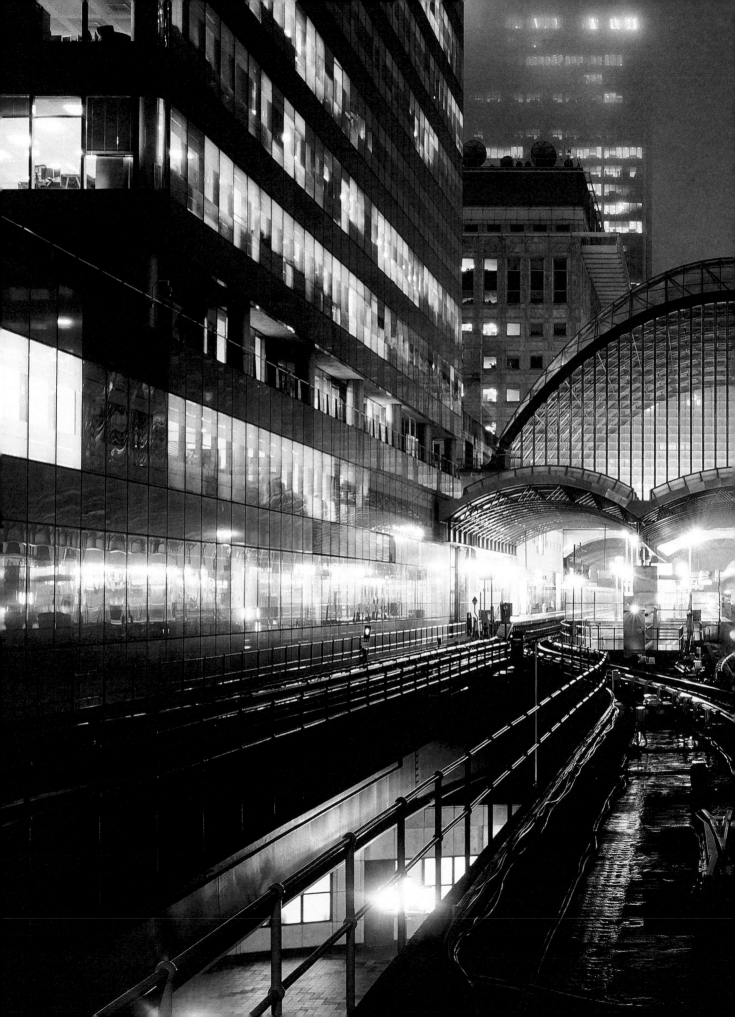

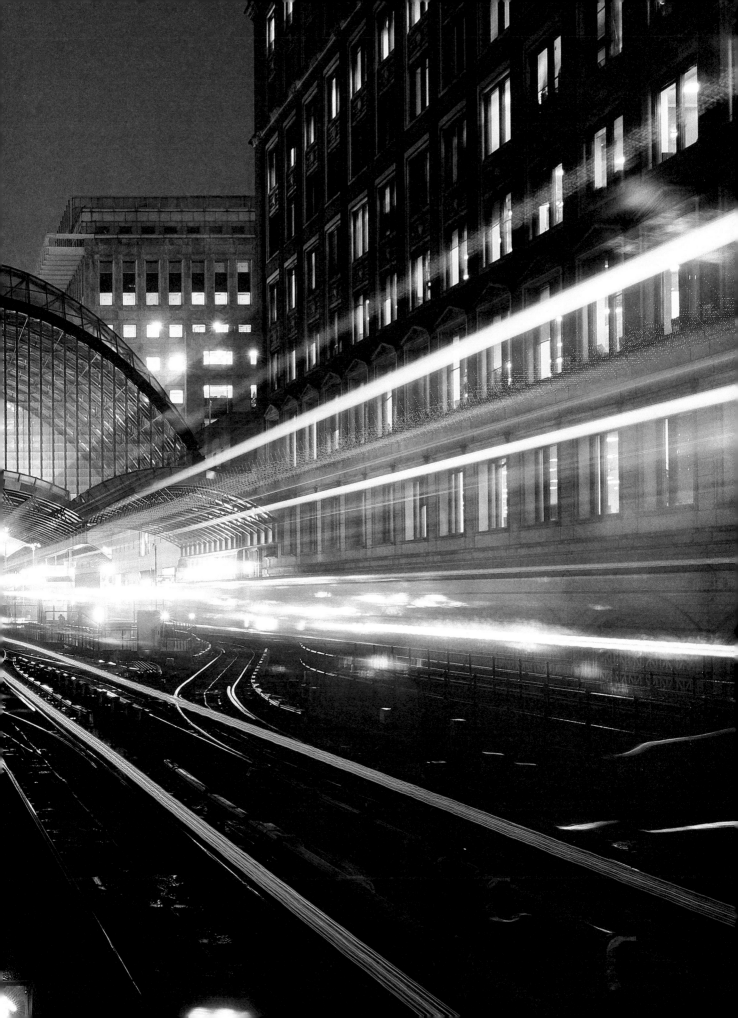

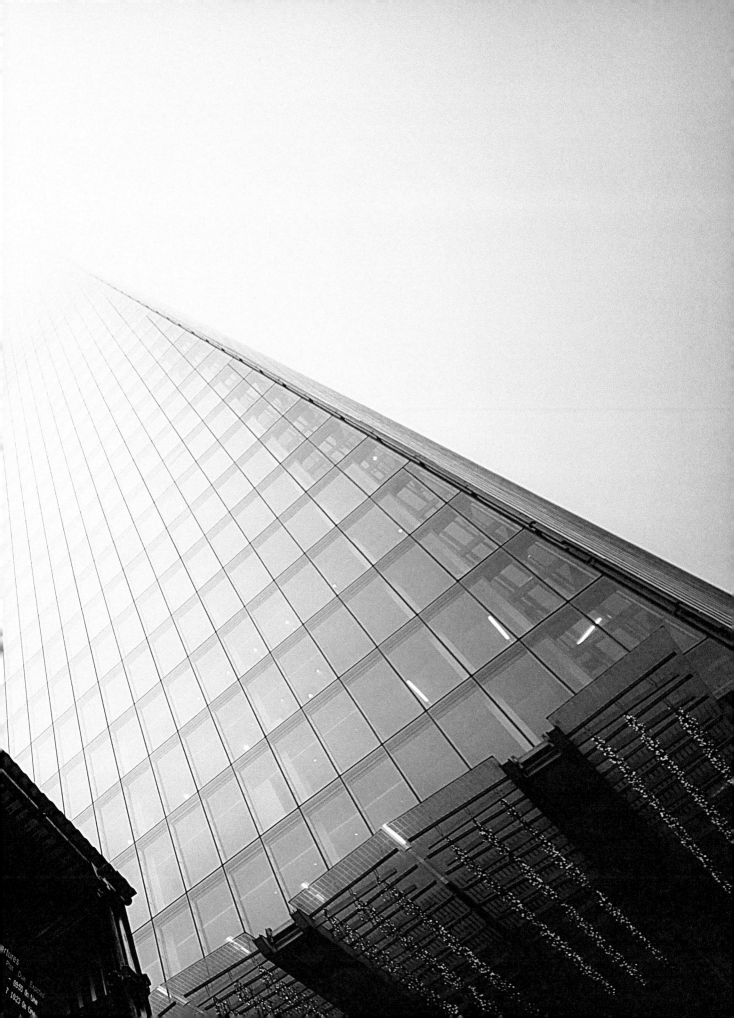

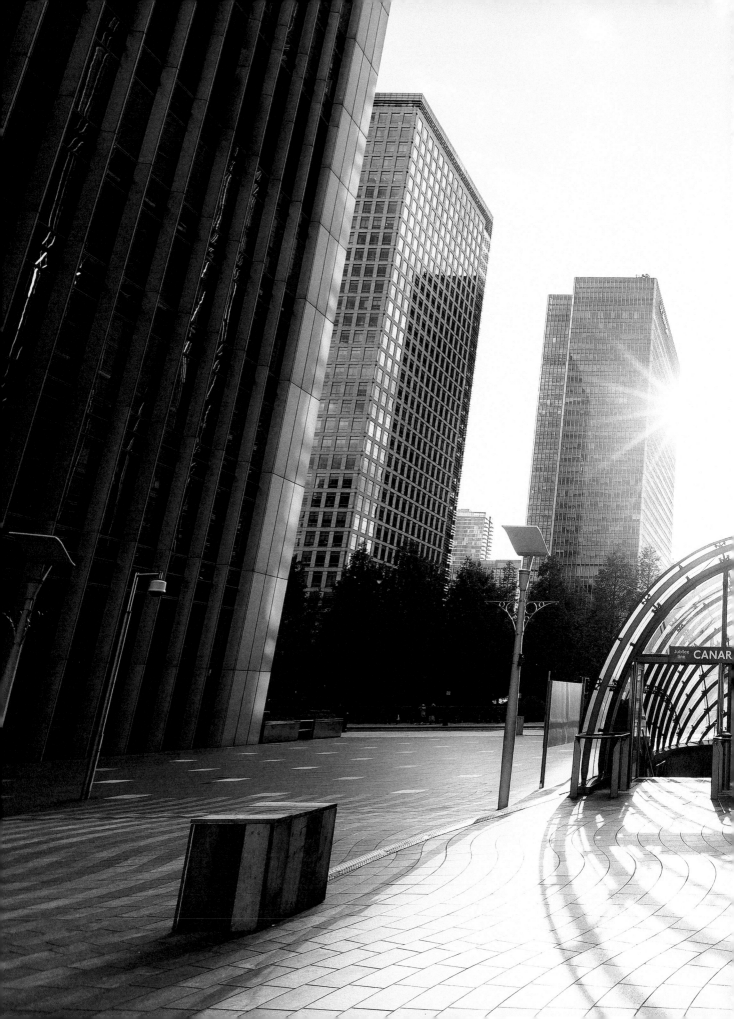

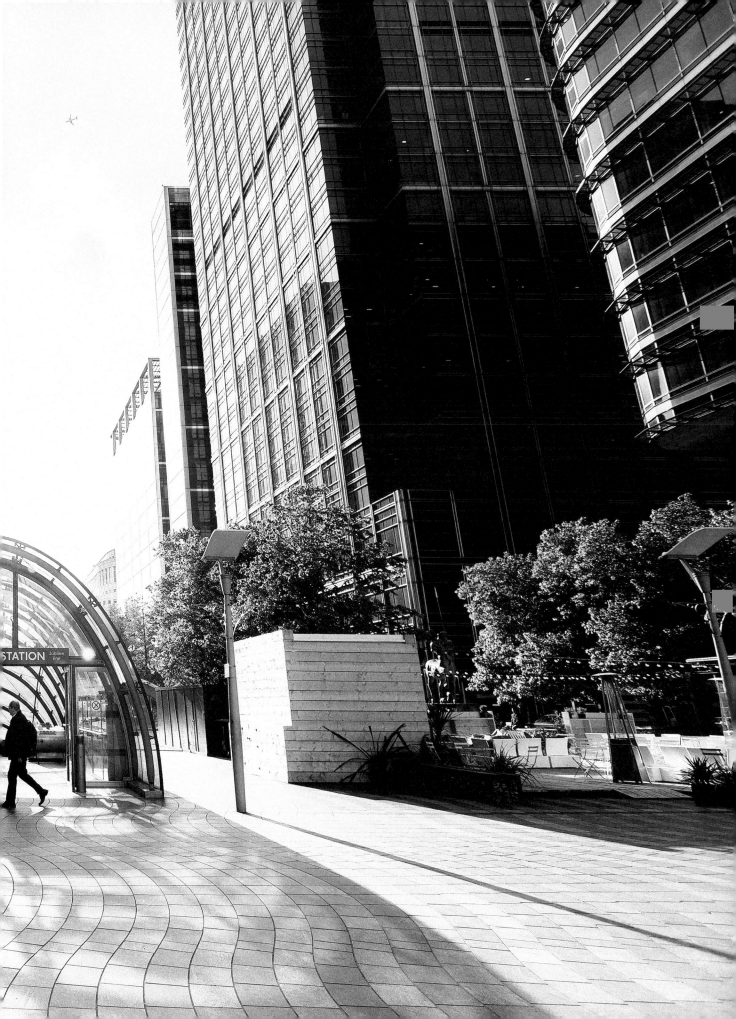

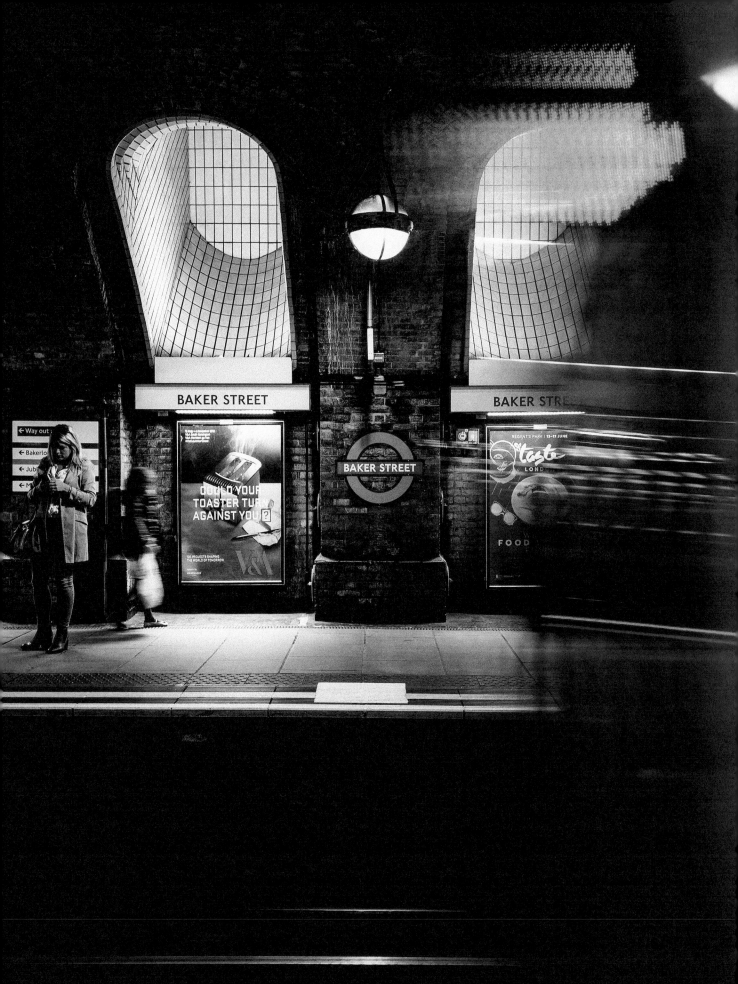

Behind everything in London is something else, and, behind that, is something else still; and so on through the centuries, so that London as we see her is only the latest manifestation of other Londons, and to love her is to plunge into ancestor-worship.

H. V. MORTON

Journalist

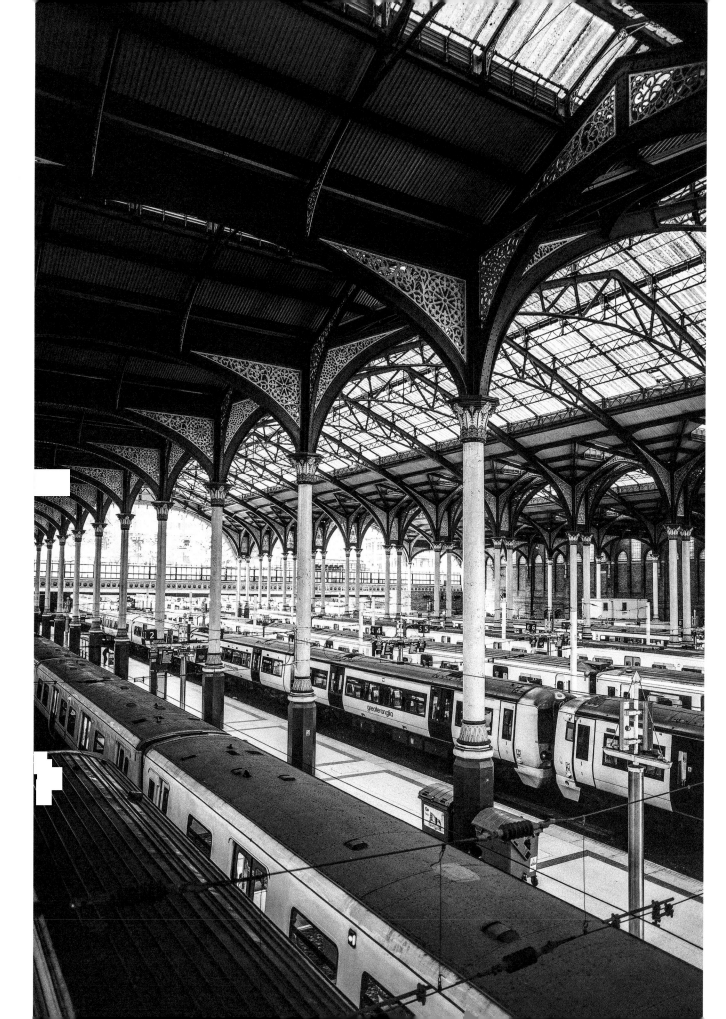

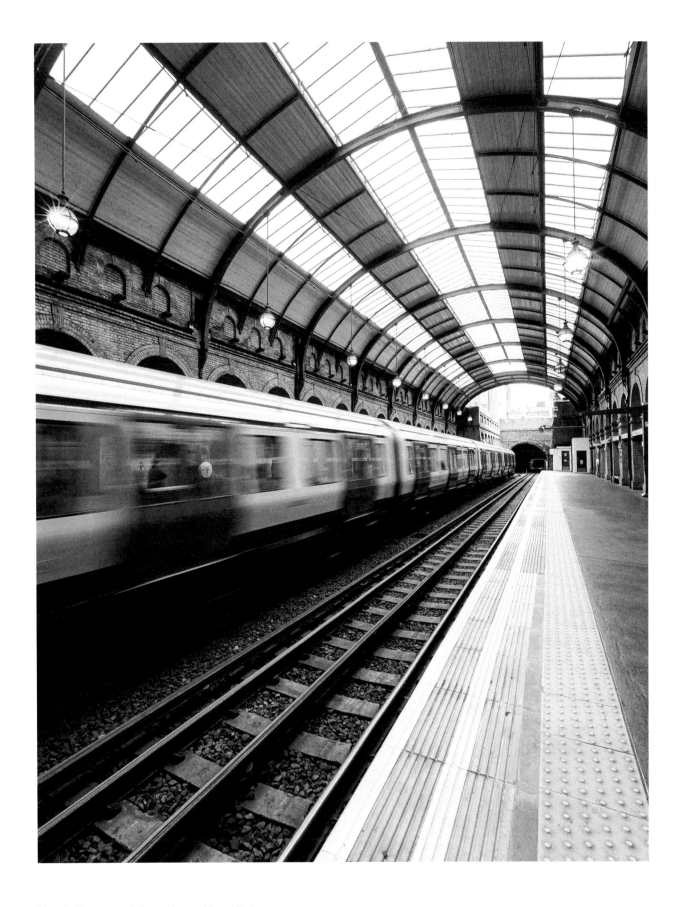

34 Left: View across platforms, Liverpool Street Station
35 Above: Circle Line platform, Notting Hill Gate Station

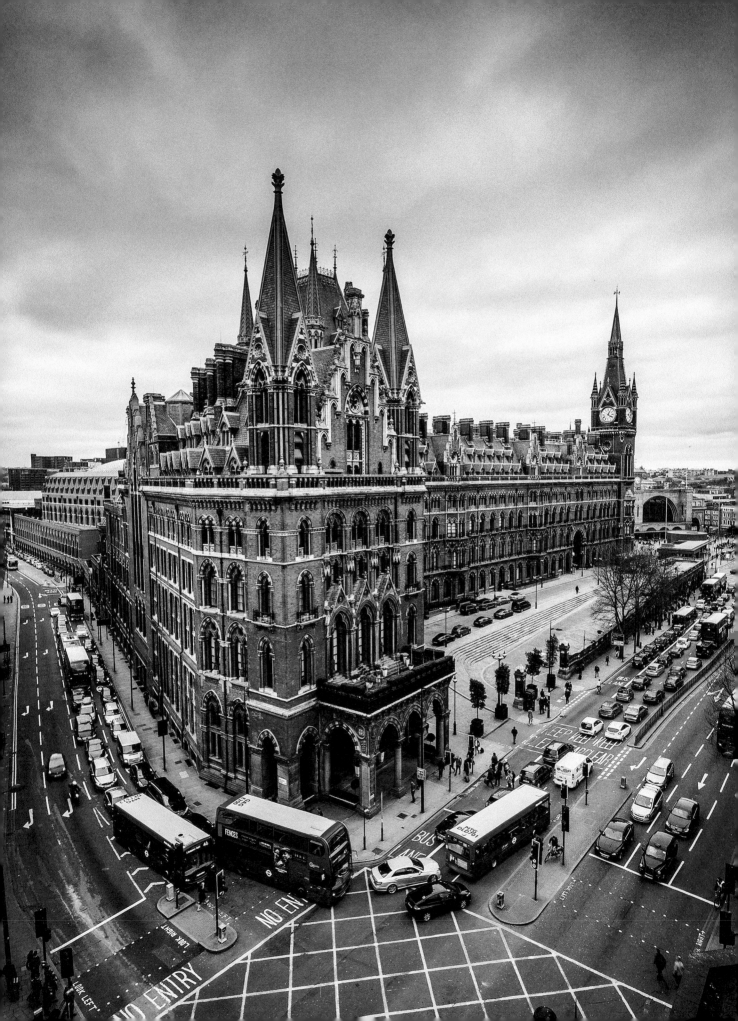

Keep calm and go to London.

ANONYMOUS

9

Tube & Rail

A11

WHITECHAPEL

POPLAR

A13

A1261

30 32

3

CANARY
WHARF

PECKHAM

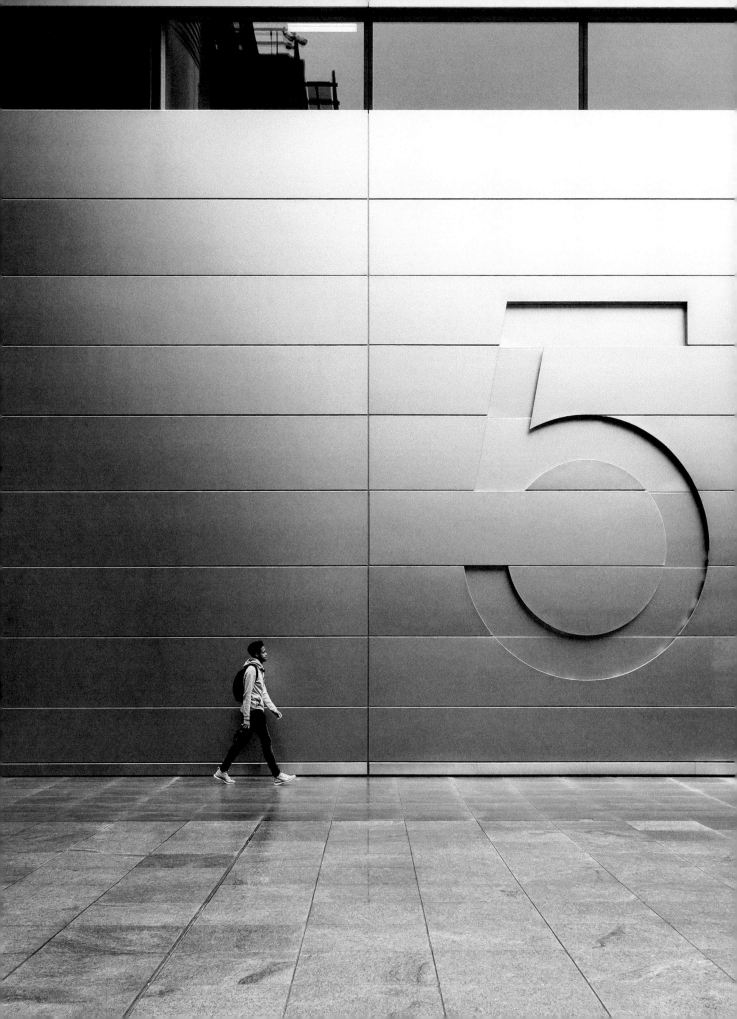

TROPE
CITY

EDITION

VOLUME II

NO. 1

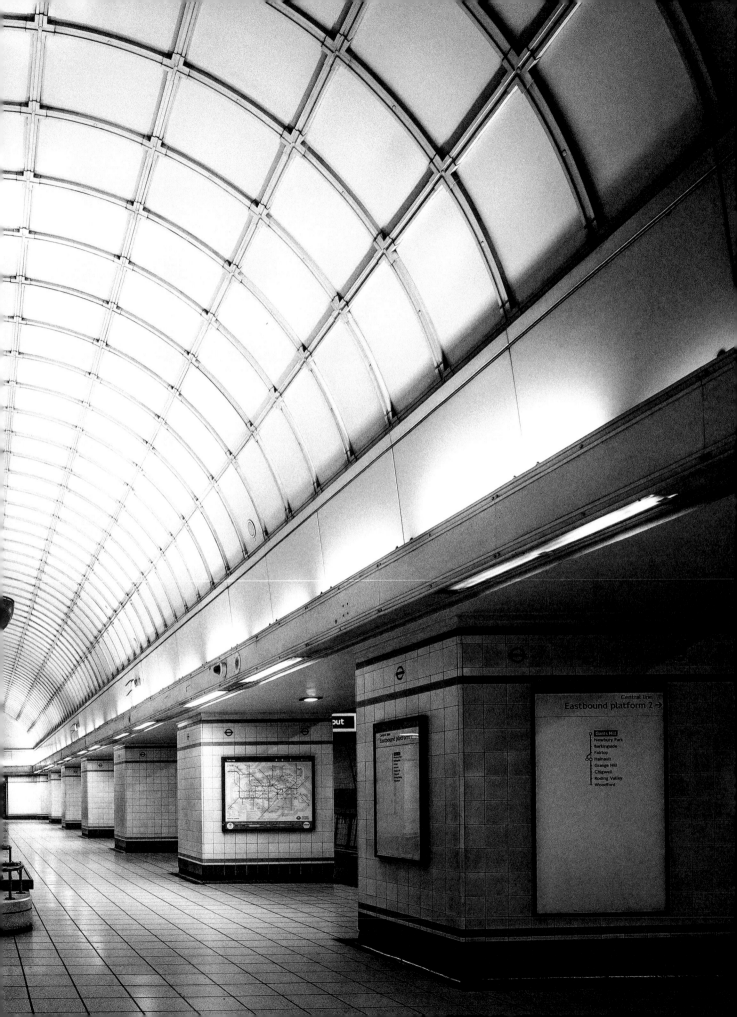

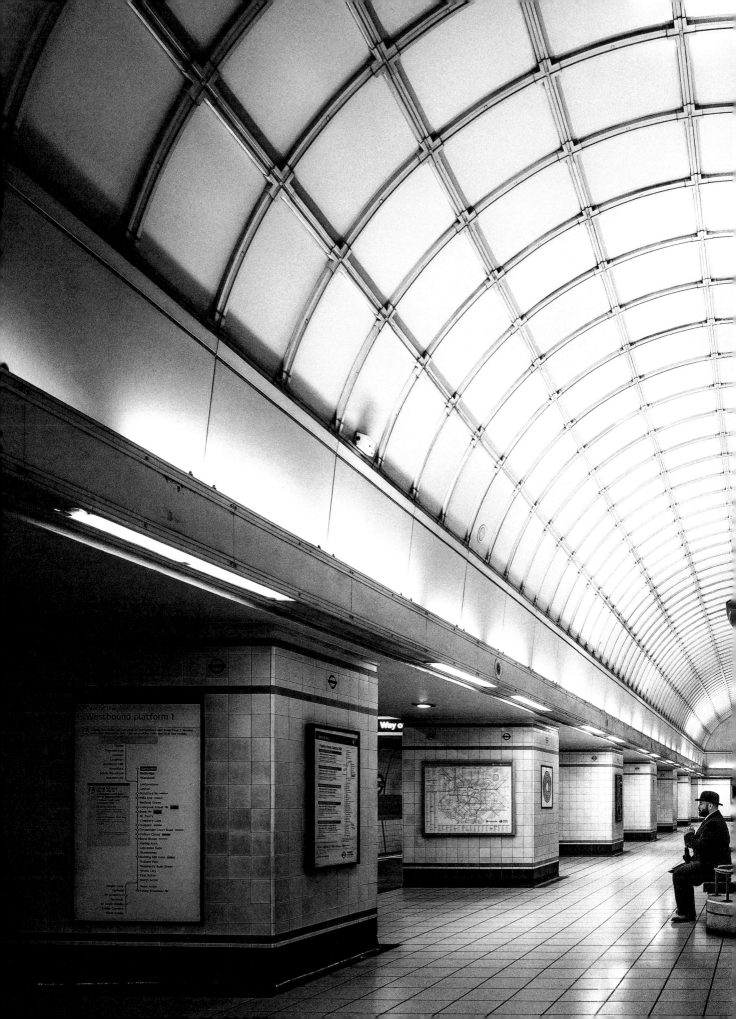

ACKNOWLEDGEMENTS

SPECIAL THANKS

+ We would like to thank all of the photographers who have generously donated their time and allowed us to use their images to create the Trope London Edition.

Additionally, we thank the following individuals who worked tirelessly through the production of Trope London including a special call out to Jonathan Petersen, who produced all the beautifully detailed maps in this edition:

+ **LINDY SINCLAIR**

+ **JONATHAN PETERSEN**

+ **TERRY MADAY**

+ **OSCAR AYALA**

+ **JEREMY GARCHOW**

+ **SARAH WHALEN**

+ **MAX LEITNER**

+ **JAMES HAMIDZADEH**

+ **LUCY HAMIDZADEH**

+ **KATHY RODERICK**

+ **CHRIS EICHENSEER**

+ **ANNIKA WELANDER**

ABOUT THE EDITORS

+ **SAM LANDERS**
Sam believes strongly that beautiful and thoughtful books have a place in the world today. He spent most of his career on the digital side of marketing, working at various creative agencies including nearly a decade with WPP, one of the world's largest global marketing communications companies. Sam is an avid student of photography and always travels with his camera and notebook @sam_landers

+ **TOM MADAY**
Tom is a photographer whose client assignments take him to every corner of the globe. His Tri-X and T-Max film pictures appear in the books *Great Chicago Stories* and *After the Fall: Srebrenica Survivors in St. Louis.* In addition to producing titles for Trope, Tom Maday's photography can be seen at www.tommaday.com and @tommaday

+ **INFORMATION:**
For additional information on the Trope City Edition Series, visit
WWW.TROPE.COM

Left: Tottenham Court Road Station, New Oxford Street exit « Chris Holmes
Following Spread: Gants Hill Station, Ilford « Sean Byrne
Back Cover: View from above the intersection of Princes and Mansion House Streets and Cornhill « Tobi Shinobi

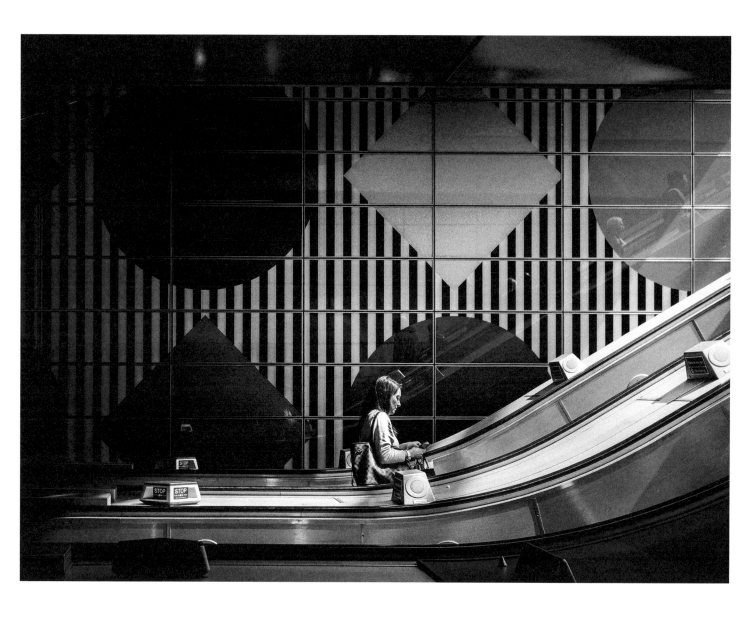

TROPE LONDON PHOTOGRAPHERS

+ **JESS ANGELL**
A former nursery school teacher -
self described as "a girl in love with
the London Underground" and avid
iPhone shooter
@missunderground

+ **SEAN BYRNE**
Landscape and travel photographer
who feels there are just not enough
bowler hats seen in London these days
@thebowlerman

+ **ALEX COCKWILL**
An engineering student in Coventry
with strong interests in photography
and cars
@alex_cockwill

+ **ARIJANA GURDON-LINDEY**
Born in Croatia, now based in Soho,
content creative and food and street
photographer
@ari55

+ **LUCY HAMIDZADEH**
South East London native and writer
with an undeniable passion for street
photography
@juicylucyham

+ **CHRIS HOLMES**
Self-taught photographer shooting
light and shadow while balancing a
non-creative corporate job
@brxtn_pistol

+ **RYAN HOWARD**
Fashion and commercial photographer
and filmmaker from North London,
specialising in architecture, portraits
and city life
@ryanxhoward

+ **MAX LEITNER**
Lives in Germany, focused on trends in
urban exploring and lifestyles
@maxleitner

+ **TOM MADAY**
A Chicago-based photographer whose
commercial and editorial work has
taken him around the world
@tommaday

+ **MR WHISPER**
Former ad-world creative director Bal
Bhatla, passionate about chronicling
London's everyday street life while
shooting for a wide variety of global
brands
@mrwhisper

+ **OPE ODUEYUNGBO**
Based in South East London, a proud
Arsenal supporter, travels the world
to shoot streetscapes, portraits and
architecture
@greatarsenal

+ **EREN SARIGUL**
London-based freelance photographer
and filmmaker specialising in urban
and travel photography
@erenjam

+ **TOBI SHINOBI**
Former lawyer Tobi Shonibare,
from London, now working in
advertising providing photography,
cinematography and creative direction
@tobishinobi

+ **RON TIMEHIN**
A South London native specialising in
cityscape and portrait photography
@rontimehin

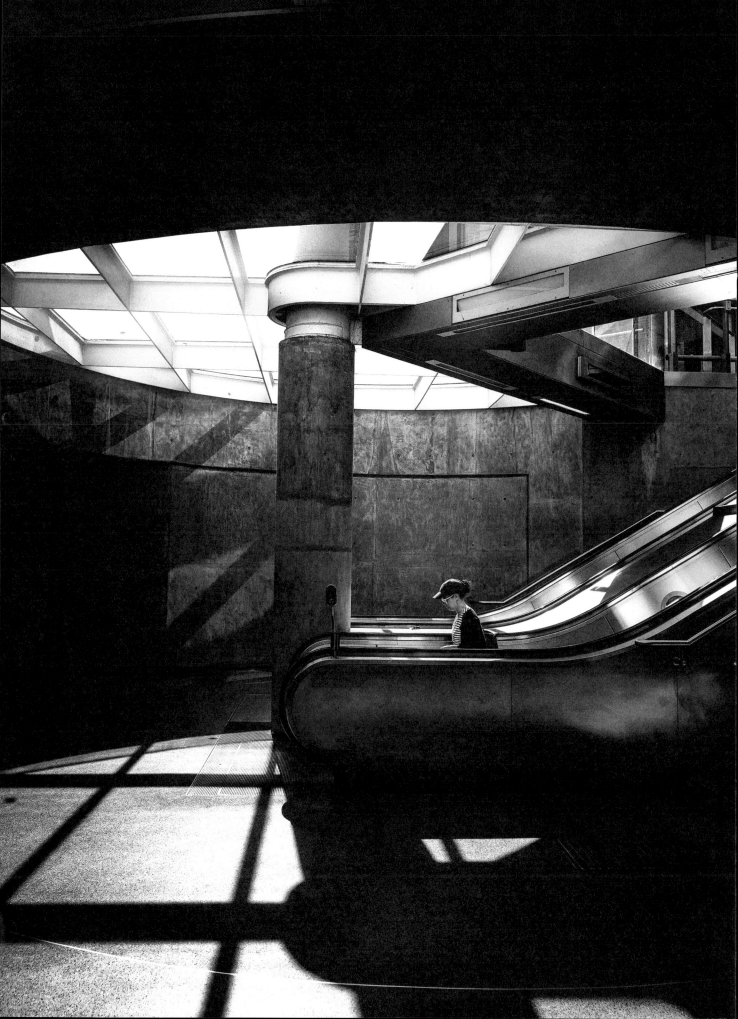

TROPE CITY EDITION

The language of photography is visual expression that uses images rather than words to explore and interpret the world. The images of London gathered in this title come from a cohort of emerging photographers whose work is featured on various social media channels seen by legions of followers across the globe.

The immediacy of social media-based photography makes a once-passive viewer into a participant observer. The distinct and original perspectives of these photographers provide us with a new visual vocabulary for understanding the urban spaces we showcase in this collection, the second in a series of photography books on important cities throughout the world.

These unusually talented photographers, individually and collectively, have accomplished what innovators have always given us: a new way of seeing the familiar for the first time.

End Notes